Panofsky
and the Foundations
of Art History

Panofsky and the Foundations of Art History

by MICHAEL ANN HOLLY

CORNELL UNIVERSITY PRESS

ITHACA AND LONDON

Cornell University Press gratefully acknowledges a grant from the Andrew W. Mellon Foundation that aided in bringing this book to publication.

First published 1984 by Cornell University Press.
First printing, Cornell Paperbacks, 1985.
International Standard Book Number (cloth) 0-8014-1614-0
International Standard Book Number (paper) 0-8014-9896-1
Library of Congress Catalog Card Number 84-45143

Printed in the United States of America

Librarians: Library of Congress cataloging information appears on the last page of the book.

The paper in this book is acid-free and meets the guidelines for permanence and durability of the Committee on Production Guidelines for Book Longevity of the Council on Library Resources.

Thanks to art, instead of seeing only one world, our own, we see it under multiple forms, and as many as there are original artists, just so many worlds have we at our disposal, differing more widely from one another than those that roll through infinite space, and years after the glowing center from which they emanated has been extinguished, be it called Rembrandt or Vermeer, they continue to send us their own rays of light.

MARCEL PROUST, *The Past Recaptured*

Art is not, as the view which exaggerates its opposition to a theory of imitation would have it, a subjective expression of feeling or the existential activity of certain individuals but rather the realizing and objectifying settlement (or conflict), aiming at effective results, between a forming power and a material to be overcome.

ERWIN PANOFSKY, "Der Begriff des Kunstwollens"

Contents

Preface

Art historians commonly assume that they know how art history works. Consider, for example, a statement made in 1976 by Mark Roskill in *What Is Art History?*—a book whose title promises much: "Art history is a science, with definite principles and techniques, rather than a matter of intuition or guesswork" (p. 9). It is easy to understand the pressure that led Roskill to make such a remark, just as it is easy to appreciate the longed-for reassurance that his declaration must have given many readers. Since the seventeenth century, rules of judgment and evidence have been governed by the so-called Scientific Revolution, with its supreme criterion of objectivity. Since the nineteenth century, and in some cases far earlier, however, it has been recognized that the notion of objective standards may veil the awareness of a dependence on other than objective assumptions. Surely philosophers of history have taught us that history is always something other than a science. Indeed, philosophers and historians of science are now telling us that science itself is always something other than a science.

How, then, can we confidently speak of the history of art as a "science"—and for that matter, how can we even call it a "history" if we refuse to acknowledge the historical character of its own principles and techniques? Historical understanding in the fullest sense of the word demands that historians think not only about the historical nature of the objects they investigate but also about the historical character of their own intellectual discipline.

9

This insight, of course, is not without precedent in the history of art. Giorgio Vasari, sometimes called the first art historian, recognized and tried to work both usefully and artfully with some of his assumptions. In the preface to part 2 of his *Lives*, he acknowledges that a writer on art is necessarily a contemporary critic and theorist of style as well as a "scientific historian." Complete repression of personal biases or theoretical commitments, Vasari suggests, would mean that the art historian merely compiled "lists." Is it possible that we today are more unwilling to examine the rationale for the methods we employ than Vasari was nearly half a millennium ago?

It is, of course, important for us to realize that there is still a question about what art history is, but in order to find the answer, might we not more effectively ask the prior question "What is the history of art history?" Where did the aims, values, tasks, principles, and techniques that today define the praxis originate? Although art history continues to be practiced at a great rate in institutions throughout the world, and although the curriculum of graduate schools has probably not changed remarkably in the last quarter of a century, the majority of the teachers and scholars of art historical methods are no longer preoccupied with the ultimate questions of meaning and mind that excited the imaginations of the architects of those methods. Yet art historians who do consider these questions are beginning to detect the inadequacies of the traditional answers. Therefore, it is important to excavate the foundations of contemporary scholarship in order to understand the principles upon which modern art history is based.

The history of a discipline, like the history of, say, politics or art, requires for its telling the identification and understanding of major events. In the history of modern art history, the primary "event" is undoubtedly the work of Erwin Panofsky. His great influence, however, is counterbalanced by fairly widespread incomprehension of the exact nature of his thinking. This misunderstanding in turn results from a lack of familiarity with Panofsky's early works (despite his popularity) and with

their labors to secure an epistemological foundation for the practice of art history. My book aims to rectify this situation.

My principal strategy will be to place Panofsky's historical theory in the wider context of late nineteenth- and early twentieth-century humanistic inquiry. I shall trace the influence of the work of the philosophers Hegel, Kant, Dilthey, and Cassirer and the art historians Wölfflin, Riegl, and Warburg, among others, in order to see how Panofsky's art history developed as a historical product of other intellectual movements. In attempting to lay bare the origins and mythology of the iconological method, I do not mean to dispute its significance; far from it. All understanding possesses an intrinsic temporality, and investigating the time-bound principles of a major "monument" such as iconology can encourage us to appropriate anew the timely elements and to discard the dated. The manifold analytic principles around which "iconology"—or to use Panofsky's words, "art history turned interpretative"—has come to be shaped can always withstand further exploration.

Another purpose of this book is to bring to English-speaking audiences some of Panofsky's early theoretical work. In America especially, we tend to know Panofsky only through his later works, which he wrote in English as an exile. As valuable as they are, these famed texts are in a theoretical sense only a pale reflection and distillation of his earlier seminal ideas, and so I shall quote at length and frequently summarize the untranslated essays composed between 1915 and 1925.

My first chapter investigates the general development of art historical scholarship by explicitly connecting it with Hegelian cultural history and by discussing the methodological quandaries within the discipline that were generated by the tension between metaphysical idealism and positivism in the late nineteenth and early twentieth centuries. In relation to this historiographic background, Chapter 2 concentrates on the works of Heinrich Wölfflin and then turns to Panofsky's early contextualist critique of the formalist approach to art. Chapter 3 examines Riegl's problematic notion of the *Kunstwollen* in

terms of both Panofsky's early disenchantment with this partic-
ular art historical concept and the contextualist direction that
his ideas were already taking by 1920. The fourth chapter sets
forth the work of other contemporary art theorists, from the
methodological debates waged in the leading journals of the
day to the work of Aby Warburg, whose unusual library be-
came a meeting place for scholars from a variety of fields.

The fifth chapter discusses Panofsky's often-acknowledged
debt to the work of his senior Hamburg colleague Ernst Cas-
sirer. I discuss both Panofsky's continuing concern for provid-
ing art historical commentary with a sound philosophical basis
and his interest in the conventionality of Renaissance perspec-
tive, relating them to a larger neo-Kantian project that informs
the work of Cassirer. In his three volumes of *The Philosophy of
Symbolic Forms*, composed during the 1920s, Cassirer elaborated
a morphology of symbolical values, from mythical thinking to
mathematics, through which human beings constitute the
world of their experience. I shall discuss Panofsky's "Die Per-
spektive als 'symbolische Form'" in detail because it reveals the
genesis of his iconological approach as it relates to Cassirer's
thought. Chapter 6 addresses Panofsky's later and better-
known English works, including *Studies in Iconology*, *Early
Netherlandish Painting*, and *Meaning in the Visual Arts*. I shall an-
alyze "iconology" in terms of its central interpretive principles;
I shall also consider the reasons why Panofsky's practical art
history only rarely fulfills the vision of his theoretical work, a
vision similar to the one that has inspired recent work in semi-
otics, the philosophy of history, and the philosophy of science.

I make no pretense to cover all of the nearly two hundred
listings in Panofsky's bibliography. My principal concern is with
his theoretical, not his practical, work, and I have selected a
few representative essays with this focus in mind. I recognize
that beneath every "ordinary" iconographic reading there lies
an "extraordinary" theoretical commitment, and in my final
chapter I identify this commitment as it is expressed in a few of
Panofsky's well-known later works. A full exploration of the

theoretical underpinnings of most of Panofsky's practical work would, however, demand another book of the same length.

Although I have narrowed my focus to a detailed exegesis of a couple of Panofsky's less-read essays, I have deliberately scanned a number of diverse developments in late nineteenth- and early twentieth-century German thought. To those historians who might dismiss a cursory survey of intellectual history, I can respond only that I was prompted by simple historiographic motives. I wanted to make this background material available to art historians, especially to those who have not considered the possibility that many of their discipline's aims and purposes ultimately derive from debates and issues with a source outside art history.

My analytic lexicon probably also merits a few proleptic remarks. Definitions of the concepts of "formalism" and "contextualism" sometimes seem to shift according to the writer who employs the terms. Nevertheless, in holding fast to their categorical usefulness, I probably err on the side of generality. Formalist art history is devoted to explicating the work of art by attention to its autonomous aesthetic properties in all their potent immediacy; a history of formal properties often results in a survey of the stylistic modes linking one work to another across time, apart from human content. Contextualist art history goes beyond the work of art in order to explain its presentation as a product of something else, by investigating such factors as the biography of the artist, the temper of the times, its literary antecedents, and so forth. Yet it is difficult to label major thinkers one way or the other, and perhaps it should be. Riegl, Wölfflin, Panofsky—the giants of the field—all viewed the problem in a variety of ways. Similarly, they read history along both a diachronic (horizontal, chronological) axis and a synchronic (vertical, structural) one. The positions taken by their work, plotted along these axes of historical description, of course differ from man to man.

Panofsky's name is usually identified so completely with the concept of iconography that it is useful to note that he himself

did not practice the method without occasional misgivings. He recognized, especially in his later work, that the contextualist approach he had fashioned could be accused of masking the *art* of a work of art and that the same iconographic reading might possibly be given to two works that differed immensely in quality, although the odds were against this eventuality. His unpublished correspondence frequently reveals a sense of humor about the situation. On one occasion, speaking of what Vladimir Nabokov might have called "a distant northern land," Panofsky remarked that iconology had had a great impact there for a simple reason: the country is remote, barren, and short on sunlight, and everybody knows that iconology can be done when there are no originals to look at and nothing but artificial light to work in. Although I have not written an intellectual biography of Panofsky, choosing instead to concentrate on the origins and institutionalization of his methodology, I am grateful for the sense of his personality that emerges so distinctly from his numerous communications with friends, scholars, and students. A devotee of the epistolary art, Panofsky circulated his letters widely, according to the model of Erasmus, one of his favorite historical figures.

The renaissance that Panofsky himself is experiencing amply demonstrates that the discussion he initiated seventy years ago is far from over. Art historians have always known that his ideas would not easily become passé, but thinkers from many fields now seem to be returning to his writings with renewed interest. A week-long conference on his work at the Pompidou Centre in Paris in fall 1983, for example, attracted participants from several different scholarly areas: art history, philosophy, semiotics, literary criticism, the history of science, and intellectual history. In addition, books and essays appearing in a variety of disciplines continue to refer to his thought.

Indeed, Panofsky's iconology offers a perfect model for the bridging of distinctions between different fields of historical research. Iconology does not unlock a painting or other representational form as a statement of explicit meanings as much as

it addresses itself to the elusive underlying cultural principles of representation. Its implied direction involves discovering how meaning becomes expressed in a specific visual order; that is, it asks, in theory, why certain images, attitudes, historical situations, and so forth have assumed one particular shape at one particular time.

In explicating the connections between historical models of the mind and art, Panofsky makes us consider questions that are not answerable in easily defined ways. It may be becoming impossible to learn enough to achieve the kind of universal perspective on the past that he envisioned. Yet his essays as we reread them make us want to try. As Panofsky persists in telling us, the allure of finding the link between thought and image clearly encourages peregrinations across disciplinary boundaries.

I must acknowledge both the institutional and individual support I have received while working on this book. For their help with the earliest draft I thank Robert Calkins, Esther Dotson, and Andrew Ramage of Cornell University. A Goldring Travel Fellowship and a Cornell University Fellowship made possible a year of research at the Warburg Institute in London. I learned much from the institute's seminars and scholars, particularly from Ernst Gombrich and David Thomason, and from Michael Podro, who deserves special thanks. Michael Podro's year-long *Kunstwissenschaft* seminar at the University of Essex in 1976–1977 provided me with several interpretive principles that I have brought to bear on Panofsky's work. I am also grateful for Podro's eagerness to share translations then and his willingness to discuss my work with me now. The "History of Ideas" seminar at Johns Hopkins University, directed by Nancy Struever, gave me the opportunity to present my ideas at a crucial midway point. I continue to appreciate her insightful comments.

This book has been transformed during the past two years with help from a number of sources. A stipend from the Na-

tional Endowment for the Humanities in summer 1983 facilitated my research considerably, and a travel grant from the American Council of Learned Societies enabled me to travel to Paris to present some of my work at the Pompidou Centre in October 1983. At my own institution, my work has been partially supported by both the Mellon Foundation and a faculty development grant. I am grateful to my colleagues and students at Hobart and William Smith Colleges, who all helped me finish this project in a variety of meaningful ways.

Four friends from Hobart and William Smith deserve special mention: Elena Ciletti, the late Richard Reinitz, Frank O'Laughlin, and Marvin Bram have kept me thinking anew about this study for seven years. I have been inspired by their criticism and encouraged by their enthusiasm. Julia Lon Grimsman deserves recognition for tirelessly tracking down the always-elusive German reference. I thank John E. Thiesmeyer and Beverly Ilacqua, and I am grateful for the combined endurance and intelligence of several secretaries equipped with ordinary typewriters; all were required to make word processing a modern convenience. I am also very grateful to William Heckscher, a lifelong friend of Panofsky's. The short time I spent with him in Princeton one summer, hearing his reminiscences and reading his correspondence, deepened my appreciation for my subject in many ways. Finally, I thank Lauren, Nicholas, and Alexander, for their cheerfulness, and Grant, for his patient assistance.

Permission to reprint significant excerpts from several essays and books has been granted by several individuals and publishers, and I thank them here: Gerda Panofsky, passages from "Die Perspektive als 'symbolische Form,'" *Vorträge der Bibliothek Warburg* 1924–1925 (Leipzig/Berlin, 1927); Verlag Volker Spiess, portions of Panofsky's "Der Begriff des Kunstwollens" and "Das Problem des Stils in der bildenden Kunst," from *Erwin Panofsky: Aufsätze zu Grundfragen der Kunstwissenschaft*, ed. Hariolf Oberer and Egon Verheyen (Berlin, 1964); the *Record of The Art Museum, Princeton University*, excerpts from William

Heckscher, *Erwin Panofsky: A Curriculum Vitae*, a pamphlet reprinted from the *Record* 28 (1969); Alfred A. Knopf, passages from Arnold Hauser, *The Philosophy of Art History* (Cleveland, 1958), copyright © 1958 by Arnold Hauser; and Dover Publications, excerpts from Heinrich Wölfflin, *Principles of Art History: The Problem of the Development of Style in Later Art*, 7th ed., trans. M. D. Hottinger (1932; reprint, New York, 1950); the Kunsthistorisches Institut, excerpts from Jan Białostocki, "Erwin Panofsky (1892–1968): Thinker, Historian, Human Being," *Simiolus Kunsthistorisch Tijdschrift* 4 (1970): 68–89; the Koninklijke Nederlandse Akademie van Wettenschappen, excerpts from Henri van de Waal, "In Memoriam Erwin Panofsky," *Mededelingen der Koninklijke Nederlandse Akademie van Wettenschappen* 35 (1972): 227–244; and Sir Ernst Gombrich and the Warburg Institute for excerpts from Ernst Gombrich, *Aby Warburg: An Intellectual Biography* (London, 1970).

<div align="right">

MICHAEL ANN HOLLY

</div>

Geneva, New York

Panofsky
and the Foundations
of Art History

1

Introduction: Historical Background

History is the record of facts which one age finds re-
markable in another.

JACOB BURCKHARDT

Before you study the history, study the historians. Be-
fore you study the historian, study his historical and so-
cial environment. The historian, being an individual, is
also a product of history and of society; and it is in this
twofold light that the student of history must learn to
regard him.

E. H. CARR

The 1980s mark the centennial of modern art history. Be-
tween 1885 and 1899, the founders of the discipline—Morelli,
Riegl, Wölfflin, Warburg, and many others writing at the same
time—all elaborated systematic principles of art historical in-
vestigation. The past 100 years, to be sure, have witnessed ap-
parent solutions to many art historical problems. Periods, prov-
enances, and patrons have been labeled, the oeuvres of famed
artists sorted out, questions of style and content periodically
answered. The categories of art historical thought appear to
have been established. Secure on the foundations laid by its pa-
triarchs and by such first-generation scholars as Erwin Panof-
sky, art history has continued to develop into a recognized and
active discipline.

Cracks are beginning to be detected in the structure of the
venerable edifice, however. Trenchant criticisms about the legit-

imacy of the tradition have recently been uttered, critics on the Left being most vocal. Marxist art historians, feminist art historians, semioticians, and historiographers have pointed to questions that for the most part seem deliberately not to have been addressed by the established practitioners of the field. The century-old institution is noticeably embattled.

At the close of the twentieth century, will we claim that the optimistic program for uncovering the history of art possessed by its founders at the beginning is secure? To respond to the charges leveled at the current state of art history, we need first of all to retrace its historical development, in the process surveying the ways in which the field delineated its areas of research and the methods it proposed for answering its own questions. The present state of the argument that pervades the discipline demands, in other words, an analysis of the heroic figures of the late nineteenth and early twentieth centuries who shaped the tradition, for it is in their works that we can discern the chartering of a historical institution as well as the origins of the contemporary controversy.

Such a project can draw support from many quarters. Ernst Gombrich, for example, sees the unquestioning "application of . . . existing and ready-made paradigm[s] [for example, Wölfflin's 'art history without names' or Panofsky's 'iconology'] as a threat to the health of our search and research." "We cannot and must not evade," he warns, "the demand of constantly probing the foundations on which the various paradigms are based."[1] A first step toward critical self-awareness might be to ask such questions as: is there a recognizable historical and epistemological context from which contemporary ideas about art and its history have emerged? And if there is such a recognizable context, are these ideas about art entailed by its program or ideology, by what might more generally be called its vision? In this regard David Rosand notes, "As we come to recognize the degree to which our activity as historians of past art is conditioned by current assumptions of value—assumptions which are for the most part tacitly held, with hardly any critical

self-awareness—we legitimately seek the foundations of our particular vision of art."[2]

In a way it is demoralizing that such self-conscious utterance is necessary at all, not only because other disciplines have been engaged in similar investigations for more than a decade, but also because much of the pioneer work in critical historiography that opens the way for such analysis, far from being new, derives from the writing of an important group of German art historians at the turn of the century. Many of their works, especially the early writings, are dense, untranslated, and therefore surprisingly little known outside of Germany. Yet these works provide a most significant area of study for a modern scholar interested in the theoretical bases of art historical scholarship. Riegl, Wölfflin, Warburg, Dvořák, and Panofsky, to name only the most celebrated figures, developed their ideas during a time when the still-young discipline of art history was undergoing an internal crisis, a crisis to some extent precipitated by initial methodological dilemmas in history writing at large. The theorists of this period were especially sensitive to the ways in which their individual methodologies impinged upon the study of the history of art. At the same time, however, they involved themselves in polemics concerning the efficacy of their individually chosen procedures. From this early twentieth-century controversy, the shape of contemporary thought about art and its history has emerged.

My book will focus on the origin of the basic ideas of Erwin Panofsky, arguably the most influential historian of art in the twentieth century. It will discuss in detail three of Panofsky's early untranslated works, all written in the decade 1915–1925 and responding to the intellectual challenges raised in turn by Wölfflin, Riegl, and Cassirer. It will follow two courses. First, the narrative will return to thinkers in the early twentieth century and will resurrect for discussion their speculations as to the nature and meaning of art. Second, I shall critically examine the nature of art historical knowledge in detail by focusing on the origins and purposes of Panofsky's use of iconology as

an investigative program. My discussion, both descriptive and analytic, aims to provide a preliminary critique of the principles around which the discipline has come to be organized. Indeed, this combination of description and analysis recalls the tradition of art historical speculation in the opening years of this century and answers an appeal expressed recently by Svetlana Alpers:

> It is characteristic of art history that we teach our graduate students the methods, the "how to do it" of the discipline (how to date, attribute, track down a commission, analyze style and iconography) rather than the nature of our thinking. In terms of the intellectual history of the discipline our students are woefully uneducated. How many have been asked to read Panofsky's early untranslated writings, or Riegl, or Wölfflin? Supporting this is that prejudice for the original object and against the desk-bound scholar. To think, to write is itself somehow to forsake the works. At issue is not the method one uses but rather the notion of art and its history, the notion of man and the form that his knowledge of the world takes.[3]

When Panofsky began writing essays on art in the second decade of this century, the discipline of art history was dominated by a preoccupation almost exclusively with form. In essence, formalism has always devoted itself single-mindedly to the aesthetic properties of the work and has deliberately, even forcefully, wrenched the object from its historical situation and broader human surroundings. Formalists are interested in the genius of the artist only insofar as it becomes expressed in the individual work. For the most part, all information extrinsic to the experience of the work on its own terms is relegated to auxiliary status—whether the information is biographical, historical, or sociological. The "pure visibility" trend in art criticism and Wölfflin's stylistic approach to the history of art, both of which tended to treat the subject matter of a work as a "mere pretext" for the exercise and display of significant visual constructs, epitomize this tendency in art theory in general in

the opening years of this century.[4] A concern either with sub-
ject matter per se or with cultivating the viewer's sense that the
work is the product of an identifiable cultural milieu was
deemed an impediment to the proper appreciation of its aes-
thetic complexities.

To a large extent, the development of art historical scholar-
ship in the nineteenth century was determined by the organiza-
tion of museums. The task of the connoisseurs—the work of
Morelli or Berenson is a case in point—was to produce a tax-
onomy for the classification of works by artist, style, and work-
shop. At the turn of the century, for example, galleries and
museums frequently identified their holdings only by the
names of artists and pertinent dates, seemingly avoiding any
information extrinsic to the experience of art qua art. Titles,
which by definition overtly signify subject matter, were most
frequently omitted.[5] The positivistic models provided by the
natural sciences allowed others, for example Semper, to pro-
duce analyses of works exclusively in terms of their material
constituents.[6]

The influential aesthetics of Benedetto Croce also played a
part in deflecting attention from matters of content regarded
for their own sake. Croce pointedly criticized abstract interpre-
tive schemata ("One should not explain Giotto by the Trecento,
but the Trecento by Giotto"),[7] disdained those historically
minded writers who ignored the artistic personality, and ex-
pressed dismay at the distinction commonly drawn between art
history and art criticism. Instead, he maintained that form and
content were inseparable in works of art and passionately af-
firmed that art is the expression of feeling, not merely a vehicle
for the communication of ideas.

Perhaps the most compelling justification for the need to
consider form apart from content was provided by continuing
radical developments in the practice of contemporary art. In a
cautionary note germane to my thesis in this book, Arnold
Hauser has observed that the modern art historian is all too of-
ten cast in the ironic mode of saying that an artist is condi-

tioned, historically and psychologically, by the times in which
he or she creates, while the art historian always manages to
present his or her position as remaining "outside time." "The
fact is" that the "art historian also is confined within limits set
by the artistic aims of his time; his concepts of form and cate-
gories of value are bound up with the modes of seeing and the
criteria of taste of a certain age." As supporting evidence for
this commonsensical but often overlooked observation, Hauser
claims that Wölfflin's "justification" for the Baroque would
have been inconceivable without the painterly vision of contem-
porary Impressionists, and Dvořák's devotion to Mannerism
would have gone unheeded if the Expressionists and Surreal-
ists had never handled color and line as they did.[8]

Stifled by this preoccupation with form as the dominant aes-
thetic of the period, in the practice of painting as well as in the
telling of its history, a concern for content in works of art man-
aged to surface through other channels. Yet, content was most
frequently regarded as ancillary and was invoked principally to
illustrate something else. In the later nineteenth century, con-
cern with content (and here I mean the straightforward identi-
fication of subject matter) was relegated to the auxiliary "sci-
ence" of iconography.[9] Nevertheless, a theoretical interest in
works of art as "embodied ideas" (ideas made manifest), with
an attendant desire to situate works of art firmly within their
cultural milieu, never became wholly dormant. In this broader
tradition of historical scholarship we must locate Panofsky first
of all.

In an early article that he published on the history of a
theme and its transformations throughout the Middle Ages
and the Renaissance, Panofsky took an approach to the study
of art that was to characterize much of his subsequent writing.
He wrote: "A successful content exegesis not only benefits a
'historical understanding' of a work of art but also—I will not
go so far as to say intensifies—but enriches and clarifies the
viewer's 'aesthetic experience' in a peculiar way."[10] Although
Panofsky apologized in this essay for his interest as an art histo-

rian in matters of historical content, it is clear where his interest lay. In many ways, he was a cultural historian who merely discovered a new field for the application of his theories. As P. O. Kristeller, a lifelong friend, once remarked, Panofsky conceived "of the visual arts as part of a universe of culture that also comprises the sciences, the philosophical and religious thought, the literature and scholarship of the Western world in the various phases of its history."[11]

Certainly since the time of Hegel, and perhaps earlier, there have been far-sighted historians who have written with the primary goal of creating a coherent picture of a specific historical period. In attempting to articulate the fundamental unity of culture and cultural expressions, they have explored connections between art and philosophy, religion and science. Hegel, Burckhardt, and Dilthey are conspicuous examples, but the list of nineteenth-century historians who proceeded along similar epistemological lines could include many others as well.

My book reflects the continuing assumption that understanding the nature of art history does not involve reading the works of only the important and formative art historians. It is necessary also to investigate the writings of art historians whose ideas embody the paradigms of their time and to read them in conjunction with works by the historians and philosophers who elaborated the paradigms in their own fields. In this chapter, I shall be specifically interested in the origin and significance of the concepts of history and philosophy that seem to have been either appropriated or challenged by most early twentieth-century art theoreticians. Certainly Hegel, Burckhardt, and Dilthey are not the only historians of culture that art historians ever read, but the range of thinking that they in particular displayed maps the epistemological field on which Panofsky's ideas grew. In order to understand the development of Panofsky's thought in its larger intellectual context, then, we will first look briefly at the writings of these three cultural theorists.[12]

With the work of Hegel, the writing of history gained recognition as a legitimate philosophical enterprise. Postulating an

"Infinite Spirit" or "Idea" behind history that works itself out dialectically through time by manipulating human actors caught in its path, Hegel never deviated from characterizing the past as exemplifying a logical, rational process. He recited history not merely as the continuing story of men, women, and events but as the biography of the "World Spirit." When the Spirit or Idea plants in the soil of human history one mode of action, one way of comprehending the world, it simultaneously sows the seeds of that era's destruction: the "thesis" of one period becomes the "antithesis" of the next, with the inevitable resolution, or "synthesis," functioning as a new thesis for the next stage of world events. Of necessity, the spirit or idea evolves only through struggle. It compels the actions and attitudes of men and women to alter incessantly throughout time, throughout varying cultures.[13]

As transparently as Hegel's system is ordered along diachronic lines, that is, the principle of dialectical struggle is always compelling the course of history to proceed, it also provides justification for the synchronic study of individual historical epochs. Since all ages, not just the universally recognized high points of civilization, play a role in the logical process, all are considered worthy of attention in their own right. Hegel's philosophy of history thus legitimizes the project of arresting the unfolding spiral of historical change, figuratively speaking, at any point in order to cut across individual moments and assess the interconnectedness of things.

The cultural explication of any one age thus depends upon the interpretation of all cultural phenomena in the context of their relation to one another. In this synchronic view, every civilization has its specific zeitgeist, an aspect of the universal spirit objectified in a defined time and place. A self-motivating principle that variously reveals itself through both ideas and objects, the zeitgeist is also itself always manifesting an inner principle of development, of change, of becoming. It is always giving evidence of a "presupposed potentiality which brings itself into existence."[14] Working and thinking in a particular

historical time and place, an artist (or artisan) of necessity makes his or her work conform to an essential "idea" or spirit of the age: "the spirit of a people: it is a definite spirit which builds itself up to an objective world. This world, then, stands and continues in its religion, its cult, its customs, its constitution and political laws, the whole scope of its institutions, its events and deeds. This is its work: this *one* people."[15]

In Hegel's mind, art, along with religion and philosophy, embodies a crucial aspect of the absolute spirit. The history of art is the expression of a succession of world historical principles as they unfold across time. Taking this perspective, we could certainly presume that the content of a work of art should receive attention, but—and this point is most significant, especially in Hegel's *Aesthetics*—content is spiritualized rather than historicized. His is not an analysis of works of art as they exhibit specific historical qualities and shed light on precise historical problems. Hegel presupposed a cultural unity and conceived of works of art as material illustrations of this formal system. The objects tend to lose their individual existence and are subsumed, abstractly, under the aura of a huge metaphysical construct.

Before a work of visual art is "clothed" in a "sensuous" shape of line and color, it is inspired at its source by a nonvisual impulse.[16] Yet we can confront the consciousness of the Spirit only through the forms it employs to bring itself to visibility. The Spirit materializes the work as a formal emergence of itself:

> The *forms* of art, as the actualizing and unfolding of the beautiful, find their origin in the Idea itself. . . . The consummation of the Idea as content appears therefore simultaneously as also the consummation of *form*. . . . The specific shape which every content of the Idea gives to itself in the particular *forms* of art is always adequate to that content. [Italics added][17]

Hegel's approach in both his lectures on aesthetics and his philosophy of history may thus be regarded as formalistic in

two senses. One the one hand, the power of his vision lies in its posing of a formal system, its abstract codification of the history of human creativity. On the other hand, the evidence supporting his chart of the metamorphic Spirit resides in its ability to detect historical particularities, the *formations* of the Spirit's consciousness, as revealed in laws, art, religion, and so forth. We comprehend the Spirit through the results of its enjoyment of itself as it engages in a "lust of activity" whose "essence is action": "The abstract thought of mere change gives place to the thought of Spirit manifesting, developing, and differentiating its powers in all the directions of its plenitude. What powers it possesses in itself we understand by the multiplicity of its products and formations."[18]

Hegel's impact on art historical thought was dramatic, and it could be argued on the basis of chronological evidence that the discipline actually flourished because of his work. Despite art history's many diverse areas of research during the last 100 years, there remains something of the Hegelian epistemology in the work of every art historian, and Panofsky, with his commitment to thinking in terms of larger cultural patterns, is no exception.[19] We saw the commitment to a Hegelian viewpoint demonstrated above in Panofsky's deferential remarks about the need to attend to matters of content in the visual arts. We cannot, however, fail to note the paradox that Panofsky took from Hegel not Hegel's attitude toward works of art, which is at heart formalistic, but his commitment to a historical understanding derived from a study of meaningful context. Yet both cultural historians and art historians are often markedly reluctant to recognize their own and their forebears' subtle but profound indebtedness to Hegel.

Jacob Burckhardt is a case in point. In all that he wrote, Burckhardt remained unmoved by the primary concern of Hegelian philosophy, the accounting for historical change:

> Hegel . . . tells us that the only idea which is "given" in philosophy is the simple idea of reason, the idea that the world

is rationally ordered: hence the history of the world is a rational process, and the conclusion yielded by world history *must* (sic!) be that it was the rational, inevitable march of the world spirit—all of which, far from being "given," should first have been proved. . . .

We are not, however, privy to the purposes of eternal wisdom: they are beyond our ken. This bold assumption of a world plan leads to fallacies because it starts out from false premises. . . . We . . . shall start out from the one point accessible to us, the one eternal centre of all things—man, suffering, striving, doing, as he is and was and ever shall be.[20]

As the second half of the quoted statement implies, Burckhardt's interest lay squarely in the middle of the historical phenomenon as such. As an example, consider the title "The State as a Work of Art," which he chose for the first part of *The Civilization of the Renaissance in Italy*. He was constantly concerned with synchronic, topical analyses. He regarded various aspects of the Renaissance, from politics to poetry, as objective historical entities whose temporal and spatial boundaries were clearly delimited. He was interested neither in where these entities came from nor in the directions in which they were tending. His overt metaphysical speculations were sparse, and he had little, if anything, to say about the problem of historical causation. When he wrote at all of causation—and any student of history inevitably does—he did so in terms, it has been stressed, of an "immediate" rather than a "fundamental" cause.[21]

Burckhardt's critique of Hegel is very similar to that of Ernst Gombrich a hundred years later, but Gombrich, curiously enough, has explicitly developed his remarks in order to account for Burckhardt's Hegelianism. Gombrich believes that Burckhardt's anti-Hegelian statements are belied by his deep commitment to a way of seeing that could only be Hegelian. Although Burckhardt was convinced that he was working solely with the objective facts of the Renaissance, what he finally found in these facts was the zeitgeist, "the Hegelian world spirit he had rejected as a speculative abstraction."[22] Gombrich ar-

gues that Hegel's project, to find in every factual detail the general principle that underlies it, was essentially unchanged in Burckhardt, who was still in some sense pursuing the elusive spirit of the age. To be fair, evidence for Gombrich's observation abounds in Burckhardt's prose, in both his letters and his histories, for example in this passage buried in *The Civilization of the Renaissance in Italy*:

> The most elevated political thought and the most varied forms of human development are found united in the history of Florence, which in this sense deserves the name of the first modern state in the world. . . . That wondrous Florentine spirit, at once keenly critical and artistically creative, was incessantly transforming the social and political condition of the state, and as incessantly describing and judging the change.[23]

Yet by his own admission, Burckhardt dismissed Hegel's abstract metaphysical substructure and the application of philosophy to the study of history: "We shall . . . make no attempt at system, nor lay any claim to 'historical principles.' On the contrary, we shall confine ourselves to observation, taking transverse sections of history in as many directions as possible. Above all, we have nothing to do with the philosophy of history."[24] Burckhardt consistently proclaimed his reservations about Hegelian cultural history and was skeptical of any theoretical model for the process of history that aspires to be absolute and definitive.

How, then, can we reconcile Burckhardt's clearly ambivalent sympathies? We should take precise note of just what aspect of Hegel's project he found appealing. He was not averse to the possibility, which Hegel's scheme offered, of establishing relationships between the various attributes and attitudes of an age. He appropriated Hegel's synchronic inclinations (the "transverse sections of history"), in other words, at the same time that he railed against the implications of Hegel's diachronic exegesis (Hegel's "longitudinal sections").[25]

Once the spatial and temporal boundaries had been clearly drawn, Burckhardt had little difficulty in drawing a parallel between the practice of city-state politics, for example, and the development of satire or between the interest in antiquity and the rise of schools in early Renaissance Florence. Works of art, ever Burckhardt's first concern, refuse to fit so neatly into this scheme, however. Despite his contextualist orientation, he reserved for art a privileged place in both his books and his personal life. His learned descriptions of individual Italian masterpieces in *Cicerone* are anecdotal to a large degree, tending to dwell upon questions of technique and individual genius.[26] Surprisingly, little attempt is made to situate the works against the background of a particular Italian spirit, even in the *The Civilization of the Renaissance in Italy*. In the final analysis, the first cultural historian ironically needs to be labeled a formalist as an art historian.

Consequently, Burckhardt's significance for my thesis lies in his lectures and essays on history proper. The close and careful scrutiny of one aspect of a cultural period, followed by its natural and subsequent placement in the larger context of an age, will forever be identified with him.[27] In breaking away not only from the constraints of political history, in which the narrative necessarily proceeds from one event to the other, but also from the pervasive Hegelian notion of a world plan, Burckhardt organized his material topically and attempted only gradually to build a coherent picture of an age on the basis of learned forays into one or another of its revealing aspects. Yet in his lucid and eloquent prose, a picture of a general "spirit" always emerges phoenixlike from the details.

Burckhardt made Renaissance man and the products of the Renaissance imagination the general object of his synchronic studies, as did his successors in the tradition, including Panofsky, who focused their attention on the culture and humanism of the age. As late as 1939, Panofsky acknowledged, for example, the usefulness of Burckhardt's description of the Renaissance as "the discovery both of the world and of man."[28]

Burckhardt was a Hegelian, but one who shifted priorities. He attempted, a priori, to articulate the consciousness of the individual in society and worked outward from that point, in the process analyzing the way in which a particular historical consciousness expressed itself in such-and-such an institution, idea, and so forth. Panofsky's much-celebrated later comment that "iconology" could finally be "apprehended by ascertaining those underlying principles which reveal the basic attitude of a nation, a period, a class, a religious or philosophical persuasion—unconsciously qualified by one personality and condensed into one work"[29] appears in conception indebted to Burckhardt's highly original historical consciousness. Although the later work of Panofsky may represent a more critical awareness of the Hegelian program, "those who have studied his works know that he too never renounced the desire to demonstrate the organic unity of all aspects of a period."[30]

Wilhelm Dilthey, writing at the end of the century, was similarly engaged in a project of contextualization: "Every single expression of life represents a common feature. . . . Every word, every sentence, every gesture or polite formula, every work of art and every historical deed is intelligible because the people who express themselves through them and those who understand them have something in common; the individual always experiences, thinks and acts in a common sphere and only there does he understand."[31] But the "something in common" was not synonymous with the "spirit" of the age, the controlling principle behind all historical objectifications, as it was for Hegel and Burckhardt. The so-called father of *Geistesgeschichte*, Dilthey had an even more ambitious project in mind—a method of inquiry that would relate all epochs to each other in a fundamental sense. In order to appreciate his weighty contribution to the climate of opinion underlying historical studies in Germany at the end of the nineteenth century, we must understand his concern above all with the nature of historical writing.

How, Dilthey asked himself repeatedly, are we to recapture

meaning in historical evidence? And in recapturing this meaning, how can we avoid the lure of Hegelian metaphysics? A biographer of Hegel and an astute student of him, Dilthey felt, as did Burckhardt before him, that Hegel's metaphysical trappings were the bane of sound writing about history, and he worried about the typical historicist[32] despair that Hegel's "spectre of relativism"[33] aroused in some historians. We cannot say, however, that Dilthey relinquished hope of finding meaningful patterns in history. It was Hegel's theodicy that troubled him. On the other hand, he also disparaged the simple-minded antiquarians—a breed of scholar reared on relativist despair and nursed by the scientism of Ranke's school—whose observations were towered over by the minutiae of the past. For the most part, the generation of scholars immediately succeeding Burckhardt had tended toward increasing specialization. The predominant inclination, in Carl Becker's memorable phrase, "was to learn more and more about less and less."[34] Dilthey's widely discussed Geistesgeschichte was a heuristic program designed to circumvent the nihilism toward which historiography was steering from the two different directions.

Dilthey correctly perceived his position. He felt caught not just between two different approaches to history writing but between two antithetical world views. It has recently been claimed that throughout the second half of the nineteenth century there existed only variants on two main currents of philosophical thought, metaphysical idealism and positivism.[35] Rooted in the Hegelian tradition, metaphysical idealism (for example, the work of Croce and Collingwood) contended that through a study of the particularities of history, the philosopher-historian can uncover generalized principles at work. Therefore, the claim was made that history writing is a special discourse, in possession of its own privileged tools of exploration. Positivism first defined itself in opposition to this tradition and was alluring precisely becuse it avoided mystery mongering. Positivist historians (for example, Ranke and Comte) swore

fidelity to the historical fact per se and confidently proclaimed that historical studies should be based on the verification procedures established by the scientific method.[36]

The late nineteenth-century thinkers' opportunity to choose between methods explains why Dilthey, with his German idealist background, was preoccupied in his earlier discourses with the distinction drawn between the methodology of the physical sciences (*Naturwissenschaften*) and that of the humanistic studies or sciences of the mind—history, law, economics, literature, art (*Geisteswissenschaften*)—a distinction that in turn owed much to formal divisions in Hegel's *Encyclopedia*. "We explain nature," Dilthey was fond of saying, "but we understand mental life,"[37] even if it occurred hundreds of years before. Of course, this "understanding" (*Verstehen*) has a scientific prelude. Historians, heeding Ranke, must in some way play the role of scientists. They must collect, sift through, and organize factual evidence but must at the same time be cognizant that this procedure is not without its own interpretive element: "We cannot first establish the facts scientifically, collect, arrange and interpret them and afterwards exercise our historical imagination on them. There must, rather, be a pendulum movement between the processes. Having got hold of some facts we try to glean from them some imaginative insight; this will help us to arrange these facts and to discover the relevance of others."[38]

Dilthey, of course, was not alone in his concern for joining imaginative insight with excavations of archival material. His meditations on the nature of historical thought are reflected, in only slightly altered form, in Panofsky's corresponding essay on the pendular process of history writing. "The real answer," says Panofsky, to the challenge of art history

> lies in the fact that intuitive aesthetic recreation and archaeological research are interconnected so as to form, again, what we have called an "organic situation". . . . In reality the two processes do not succeed each other, they interpenetrate; not only does the re-creative synthesis serve as a basis for the archaeological investigation, the archaeological investigation in

turn serves as a basis for the re-creative process; both mutually qualify and rectify one another. archaeological research is blind and empty without aesthetic re-creation and aesthetic re-creation is irrational and often misguided without archaeological research. But, "leaning against one another," these two can support the "system that makes sense," that is, an historical synopsis.[39]

Panofsky's repeated emphasis here on the duty of the historian to "re-create" the historical object reveals a second significant point of contact with Dilthey's epistemology. The earlier thinker recognized the fallacy of believing that the past, when prodded, simply serves up its delicacies on a silver platter for the feasting historian. Acutely conscious of limits to objectivity, Dilthey frequently worried about the principles of selection in historical discourse that predispose historians to attend to their subjects in certain conceptually predictable ways. Yet it was also his contention that historians could derive meaning from past objects and documents if they would only contemplate the artifacts with proper acquiescence. Historians must learn to reexperience (*erleben, nachleben*) the time in the terms that the historical expression (*Ausdruck*) sets before them. In characterizing the process of historical understanding as the "rediscovery of the I in Thou," he assumed that his sensitized scholarly consciousness was by itself sufficient preparation for reanimating the stillness of the past:

> We understand when we restore life and breath to the dust of the past out of the depths of our own life. If we are to understand the course of historical development from within and in its central coherence, a self-transposition from one position to another, as it were, is required. The general psychological condition for this is always present in the imagination; but a thorough understanding of historical development is first achieved when the course of history is re-lived (*nacherlebt*) in imagination at the deepest points.[40]

The disposition to relive, to recreate—this is the stuff of which a sensitive historian is made. In many ways the following

passage from Panofsky's "The History of Art as a Humanistic Discipline" can be viewed as a summary of Dilthey's two cardinal dicta, the one concerned with expressing distinctions between the physical sciences and mental sciences, the other devoted to "rediscovering the I in Thou":

> In defining a work of art as a "man-made object demanding to be experienced aesthetically" we encounter for the first time a basic difference between the humanities and natural science. The scientist, dealing as he does with natural phenomena, can at once proceed to analyze them. *The humanist, dealing as he does with human actions and creations, has to engage in a mental process of a synthetic and subjective character: he has mentally to re-enact the actions and to re-create the creations.* It is in fact by this process that the real objects of the humanities come into being. [Italics added][41]

The two sets of paired quotations reveal how the thought of Panofsky, like that of Dilthey, gave expression to the same essential issues that had been generated by the idealist/positivist controversy in German intellectual history. The statements also indicate how both men tried in their own work to reconcile the polarities of historical consciousness. We can identify that tendency toward reconciliation as the product of the so-called critical positivist movement. Coinciding with the revival of neo-Kantianism in Germany, critical positivists, including Dilthey and Panofsky in this case, recognized that since the practice of science itself depended upon the limited codification of interpretive principles, other modes of knowledge could legitimately claim to complement positivist research by focusing on their own special avenues to understanding—hence the publication in 1883 of Dilthey's *Einleitung in die Geisteswissenschaften*.[42]

By the late 1890s, however, Dilthey had abandoned his confidence in an effortless rediscovery of past human experience, and he sought to systematize his own project of historical recreation. When he discovered Husserl's *Logical Investigations* in 1900, he claimed to have found the principles of interpretation

for which he had been seeking. Although Husserl's phenome-
nological approach held little attraction for him, he did fix
upon Husserl's concept of *Besserverstehen* (higher understand-
ing), a process of contemplation that equips the interpreter
methodologically to distinguish between a speaker's simple ver-
bal expression and the more complex meaning that it em-
bodies.[43] Since Dilthey's cultural sciences focus on the mean-
ing expressed in historical constructs and not simply on their
existence as physical acts or objects, the understanding re-
quired to reexperience them must be based on interpretive
principles that go beyond elementary understanding. Finally,
Schleiermacher's work in hermeneutics, in addition to Hus-
serl's philosophy, gave Dilthey the decisive epistemological con-
firmation for his own Geisteswissenschaften.[44]

Hermeneutics recognizes that insofar as historical objects
and events can be said to have existed physically at one time,
they can be subject to scientific modes of analysis. But that
statement is not enough, according to Schleiermacher, who
concentrated upon a theological and philological reading of
texts. As human works, they are more amenable to humanistic
methods of interpretation. Disinterested objectivity just will not
do; the individual must be provoked into a primal encounter
with the work. In rediscovering the object on its own terms, we
must enter into a dialogue with it, human being speaking to
human being, across space, across time: a confrontation of like
with like. Before we may do so effectively, however, higher un-
derstanding must always situate the object or event in a larger
fabric of meaning.[45]

Dilthey's repeated emphasis on reconstructing the *Zusammen-
hang* (connectedness, context) of the historical experience is re-
inforced by the hermeneutical circle. We can understand the
part only by connecting it to the whole, and the whole only by
concentration on the expressiveness of the part. If a historian is
faced with a text, a gesture, or a work of art, he or she does it
no service by staring at it in isolation. To subject it to higher
understanding—to relive the originary act, in Dilthey's terms

—we must resituate the document in the matrix of sociological and cultural values from which it arose. Conversely, the whole of the cultural universe that the historian has the duty of circumscribing can be made meaningful only by an intensive dialogue with one or two texts or objects that he or she understands especially well: "Inner states find outward expressions and . . . the latter can be understood by going back to the former." The uncovering of meaning is inevitably an historical project: "It is a relationship of whole to parts. . . . Meaning and meaningfulness . . . are contextual":[46]

> One would have to await life's end and could not survey the whole on the basis of which the relations between the parts can be determined until the hour of death. One would have to await the end of history in order to possess the complete material for the determination of its meaning. On the other hand, the whole only exists for us insofar as it becomes understandable on the basis of the parts. Understanding always hovers between these two approaches.[47]

It will probably have occurred to a reader familiar with Panofsky's work that Dilthey's hermeneutical circle as applied to his cultural sciences shows some congruence with Panofsky's iconological program as applied to an analysis of works of art. If we recall in particular that both historians, as inheritors of Hegel's contextualist orientation, were interested in recovering general cultural attitudes that reverberate in specific historical objects (for Dilthey a text, for Panofsky a work of visual art), the posing in hermeneutical theory of the relationship between part and whole becomes a telling point of comparison.

In brief, Panofsky's methodological scheme for achieving a higher understanding of works of Renaissance art involves three formal and empirically controlled stages of analysis that themselves progress from part to whole and then back again:[48]

> The preiconographic stage relates to "factual" meaning, to recognition of the work in its most "elementary" sense. For

example, to use Panofsky's analogy drawn from the world of gestures, when a man tips his hat in recognition of my passing, I am confined on this level to noting only the objects involved (a hat and a gentleman), and I must leave the matter at that. Applied to Leonardo's *Last Supper*, this reading would factually record only that thirteen men are seated around a table laden with food.

The iconographic stage relates to the "conventional" meaning, to recognition that the man greeting me in this manner is consciously being polite with reference to the world of articulated values that he has acquired as a member of a community. Similarly, Leonardo's *Last Supper* is observed at this stage to have its conscious source in the Christian ethos as manifested in the biblical story.

The iconological stage involves a reading of the work as a possibly unconscious bearer of meaning beyond what the creator might have intended; this level involves an analysis of the meaning in terms of underlying cultural principles. For example, the gesture of lifting a hat in greeting indicates a whole range of twentieth-century world views, both conscious and unconscious, while also providing a biography of the man who interacts with the world when he greets me in this manner. The *Last Supper* is now seen not only as a "document" of Leonardo's personality but also as an expression of the world view of the High Renaissance. The act or object is resituated in the context from which it was first extracted for examination in isolation on the initial level.

The progression through Panofsky's tripartite scheme here, like the swing through the hermeneutic circle, moves from part to whole and back to part with renewed interest and enhanced understanding. The circular flow of interpretation—"circulus methodicus," as Panofsky called it[49]—leads the interpreter to reexperience the fabric of meaning in which the object of investigation was once entangled. The context thus laid bare, the

interpreter is historically equipped to return to the work with renewed fervor and to understand it in some ways better than its original creator did, because the network of relationships—social, cultural, political, theological, and so forth—that constitute its conditions of existence have been exposed to the analytic and sympathetic eye. To know the text, as it were, finally from within, we must reexperience, in Panofsky's terms, the "unifying principle which underlies" the production of the "visible event."[50]

Again the emphasis falls on context, content, connectedness. Yet my elaboration of the correspondences between Dilthey and Panofsky is not meant to suggest that Dilthey was the single most important intellectual influence on Panofsky's thought —far from it. Rather, I have emphasized these points in order to show that Panofsky's thinking was itself a product of a certain context, a result of established underlying principles of inquiry that he shared with other thinkers of the time. In effect, we are turning the scheme back onto the schemer. Where did Panofsky's iconology, as the "visible event" in this case come from? What submerged connections might it have with other forms of knowledge?

We have begun our search for answers in the legacy of Hegelian history, which we have identified with the contextualist projects of the cultural historians Burckhardt and Dilthey. In the next few chapters we will inquire more deeply into Panofsky's ties to art history proper and to philosophy, two obvious places in which we might look for the intellectual background of a critical art historian. Furthermore, it would be naive to presume that a historian can be affected only by the discipline of history.

In passing, we must also mention research in linguistics and other studies of sign systems, for the contemporaneous problems, procedures, and even vocabulary of those areas of inquiry display striking parallels to Panofsky's mature investigational program. At the end of the nineteenth century in Germany, the faith in language as a "natural" signifying system had been shaken by the Neogrammarians. These linguists drew

attention to the process that links linguistic forms to the conventions of something like a collective unconscious, and they charted the evolution of rules of formation along a diachronic axis.[51]

Ferdinand de Saussure, in lectures given at the University of Geneva between 1906 and 1911, accorded the earlier studies a synchronic reorientation. By focusing on the "underlying principles" that govern the events of ordinary linguistic usage, Saussure was able to express a crucial distinction between the systems of *langue* and *parole*: *langue* refers to the submerged context or network of relationships that conventionally determine what becomes manifested in *parole*, the domain of speech acts intentionally uttered.[52] In order to conceptualize the workings of the formal system of langue, and its dominion over the manifested level of parole, Saussure studied the structure of its operations without respect to development over time. He was intrigued, not by the way in which these rules or formal operations of the submerged system alter chronologically, but instead by the way in which they contribute to and depend upon a matrix of conventional meanings of a particular time and place. The linguistic act, in other words, can best be understood in the context of broader cultural and sociological values.

It was also Saussure's conviction that the structural principles of analysis could be extended to other nonlinguistic sign systems. He envisioned an ultimate "science" of semiology that would study the life of all "signs within society" and the "laws that govern them,"[53] even those as seemingly insignificant as the rules of etiquette.[54] The parallels with Panofsky's hat tipping are obvious. But also obvious is the possibility of treating works of art, which overtly signify one thing and covertly embody a host of others, in a similar semiological way. The American linguist and philosopher Charles Sanders Peirce, with whose work Panofsky was familiar, corroborated a fundamental tenet of much of the iconological program when he said, "Every material image is largely conventional in its mode of representation."[55]

Some of the fundamental issues that early semioticians were

addressing, then, were simultaneously being explored by a few art historians—notably Riegl and Panofsky. We can hypothesize, but not prove, that Panofsky was an attentive student of their works because his own way of looking at objects of art as part of a larger context, refined by the legacy of Hegelian history, already shared certain epistemological predispositions with semiotics. Not until 1939 in *Studies in Iconology* did Panofsky systematize his methodology; however, the inclination to regard works of art not simply as material objects but as bearers of complex meaning that are themselves ready to reveal a network of internal and external relationships[56] was already present in some of his earliest essays. Iconology, like early semiotics, was devoted to exposing the existence of the conscious and unconscious rules of formation that encircle a language and make possible its sudden emergence—both visual and linguistic—on the surface of human history.

Because Panofsky clearly conceived of the visual arts as a nonlinguistic language whose expressive forms are laden with meaning, his musings can be shown to reverberate intellectually with the analytic philosophy of language. Wittgenstein's *Tractatus Logico-Philosophicus*, published in Germany in 1921, is expressly concerned with just how much language can say. Wittgenstein focused his *Sprachcritik*[57] on the ways in which meaning arises when propositions purport to say something about the world. Panofsky's important paper on Renaissance perspective, in particular, is close in its theoretical implications to Wittgenstein's picture theory of language. Of course, the philosopher to whom Panofsky most often acknowledged his indebtedness was Ernst Cassirer, whose work was also crucially concerned with the symbolic aspects of language.

Lest this enumeration of intellectual influences begin to read like a catalog of the saints, and the reader start to fear that even the young Einstein will come to play a part, I shall cut it short. But I shall have several occasions to draw additional connections between the development of art history and contemporary thought in philosophy, cultural history, semiotics, and

even the history of science. The learned works of art historians are as much products of their time as are the works of art of which they write, and the scholars who write them are just as susceptible, or perhaps just as resistant, to intellectual fashions and contemporary philosophical predicaments as are the artists with whom they are concerned. Art history was sometimes demonstrably in the vanguard of contemporary thought, and the ideas that the historians of art formulated while contemplating their artists and artifacts became relevant for other fields as well. Indeed, Panofsky provided the model for his own intellectual biography with his refusal to confine his thought within disciplinary boundaries. We are but being faithful to his principles of investigation when we bring his methodology to a historical understanding of his own work and its underlying principles.

Having thus summarily sketched the general intellectual background of turn-of-the-century German historical studies, I shall now focus on a privileged detail within the larger composition: the historiography of art history. We may suspect—like Wölfflin, who thought that "the influence of one picture upon another is much more effective as a stylistic factor than anything deriving directly from the observation of nature"[58]— that Riegl's, Wölfflin's, and Warburg's histories of art were more effective as historiographic influences in the development of Panofsky's art history than anything deriving directly from other fields of study. In the next three chapters I shall explore Panofsky's response to the paradigm of art historical scholarship he inherited when he began to write essays on art theory in the second decade of this century.

2

Panofsky and Wölfflin

Methods of art history, just like pictures, can be dated.
This is by no means a depreciation of pictures or
methods—just a banal historical statement.

F. ANTAL

A survey of the intellectual development of modern art his-
tory must begin with a study of Alois Riegl and Heinrich
Wölfflin, for their influential essays together defined the limits
of art and its history in the opening years of this century. As a
student, Panofsky had to master Riegl's and Wölfflin's catego-
ries of analysis, and it was their ideas with which, as an aspiring
theoretician of art, he had to contend upon the completion of
his inaugural dissertation at Freiburg in 1914 under the direc-
tion of Wilhelm Vöge.[1] Although Riegl and Wölfflin can read-
ily be distinguished from one another—by the difference in
their interest in periods, for example, or by the obvious tem-
peramental differences that inform their discourse—in a fun-
damental sense the two historians' theories on stylistic change
in art are congruent. Consider, for example, the similarities
noted by the German historian of art history Lorenz Dittmann:

Like Riegl, Wölfflin understood the development [of art] as a
continuous, gradual process.

The direction of this development is also already known. For
both Riegl and Wölfflin, it was essentially the same thing;
only the expressions and the actions differ.

Riegl and Wölfflin both agree that this development is neces-
sary and proceeds according to laws.

The knowledge of these laws constitutes the supreme goal of
art history as a science.

46

The inexorable process of development according to these laws determines what the artists do.

The carriers of this development are the period and the civilization.

Finally, both Wölfflin and Riegl see the stylistic period as paralleling the cultural period.[2]

Reduced to essentials, this series exhibits a current of the neo-Hegelianism that ran throughout the discipline of art history in its younger years. Different times generate different art: different periods compel artists to see things in different ways. According to the Hegelian view of history, there are neither "greater" nor "lesser" periods of artistic expression. All epochs, all styles—despite their varying motives and representations—have a part to play in the unfolding plot of human creativity. And it is incumbent on the "scientific" observer of the panorama to detect underlying laws at work. Wölfflin, in his original introduction to *The Principles of Art History*, may have invented the phrase "anonymous art history" (*Kunstgeschichte ohne Namen*)[3] to account for the pace of historical transformation, but Riegl similarly saw the history of art as dependent less upon the desires of individual artists than upon the inexorable laws of stylistic change.[4] Before we examine Riegl's ideas and Panofsky's response to them, however, we should pause to consider Panofsky's problematic reaction to Wölfflin's history of vision. My strategy here is first to disclose the kernel of Wölfflin's thought so that we can knowledgeably turn next to Panofsky's critical response.

Far better known to English readers than Riegl's work, Wölfflin's essays have been widely translated, and his ideas have provided the rallying point for methodological discussion in the field. "No other book in 20th century art history has received so much critical attention," said Kleinbauer a decade ago, referring to the 1915 *Kunstgeschichtliche Grundbegriffe: Das Problem der Stilentwicklung in der neueren Kunst* (*The Principles of*

Art History); Wölfflin "has become what no one can be in his own time: a classic," remarked Marshall Brown in 1982.[5] His theories have continued to hold their methodological grip on formalistic analysis for almost eighty years, especially in the practice of American art history, with its pragmatic and empiricist bent. He is especially appreciated because of his objectivity. His descriptive categories, particularly as they are employed in his well-known comparative method (the source, perhaps, of the tendency of most teaching American art historians to show two slides at once in the classroom), appear to divorce the object of art from all feeling and from *subjective* notions of worth and, most important, meaning.[6]

Wölfflin received his first scholarly attention with the publication in 1888 of *Renaissance und Barock*, a book that reflected his debt to his teacher, Burckhardt, and Burckhardt's sympathy for discovering the temper of an age in all of its diversified expressive aspects, as well as his debt to psychological theories of empathy.[7] In 1893, Wölfflin succeeded Burckhardt in the chair of art history at the University of Basel, and in 1899, he published *Klassische Kunst*. This work, Sir Herbert Read maintains, made art history into a science. In his preface, Wölfflin praised the "salutary" influence of Hildebrand's *Problem der Form* (1893) as it diverted the discussion of art from "mere biographical anecdotes" and "a description of the circumstances of the time" to some reckoning of "those things which constitute the value and the essence of a work of art. . . . *Problem der Form* fell like a refreshing shower upon parched earth."[8] Clearly the praise of Hildebrand included veiled criticism of the larger cultural historical project of Wölfflin's mentor, Burckhardt.

Wölfflin did not go as far as to say, however, that there is no validity in seeing works of art and architecture as the expression of an age; he said only that he was no longer interested in viewing the aesthetic process from this angle. Consequently, in his conclusion to *Classic Art*, he spoke of a "double root" to explain changes in style: on the one side, the cultural ethos, on the other, the visual tradition as an independent phenomenon.

Explanations that draw on material extrinsic to the work "take us only so far—as far, one might say, as the point at which art begins." Still, in returning to the objects themselves and concentrating on their method of presentation alone, Wölfflin claimed to have no critical stake in formalistic criticism. He saw such analysis as only the proper prelude to a greater understanding of the artistic process: "It is indeed the function of light to make the diamond sparkle."[9]

Wölfflin's powers of formalist illumination reached their apogee with the appearance of *Kunstgeschichtliche Grundbegriffe* (*The Principles of Art History*) in 1915. It is obvious from his own description of this work as "a history of form working itself out inwardly"[10] that the author had by now split the roots of stylistic change and had chosen to dissect only the one nourished by the autonomous visual tradition. The essay consequently presents a descriptive model of investigation based on two compatible and "easily replicated" aspects of close visual analysis: "the formal analysis of individual works of art and the comparison of two styles [Renaissance and Baroque] to determine their general characteristics."[11] A Renaissance work of art can be distinguished from a Baroque work by the opposed modes of perception in five "categories of beholding," which by now have become well known:

Linear versus painterly
Plane surface versus recessional depth
Closed (or tectonic) form versus open (or atectonic) form
Multiple, or composite, unity versus fused, or uniform, unity
Absolute clarity versus relative clarity[12]

It is certainly conceivable, in view of the strong impulse toward positivism that I described in Chapter 1, that Wölfflin regarded the establishment of the five polarities through the reduction of antithetical stylistic traits as a step toward making the history of art conform to a rigorous scientific methodology—toward creating a science of art grounded in formal

laws. His approach to the evolution of artistic styles appears on the surface to be patently inductive. He surveys an extensive field of empirical evidence, reaches some conclusions about what he finds, and then tests his hypothesis against more objects of the same kind in much the same way that a biologist might explain the evolution of a species. Like an exquisite butterfly, which emerges from its cocoon after having encased itself as a caterpillar away from the outside world, a great work of art, in Wölfflin's terms, has "a life of its own and a history independent from contemporary culture"[13]—and as many critics of Wölfflin's ideas have added sarcastically, "independent from the artist as well."

Predictable phrases such as "Rembrandt's style is only a particular side-track of the general style of this epoch"[14] hint that positivistic sympathies are only part of Wölfflin's view, as they likewise formed only part of the view of Wilhelm Dilthey, his teacher from the University of Berlin. Wölfflin offers no mere taxonomy, no arid classificatory scheme, but a morphology of living forms.[15] Like Hegel, he wants to feel the pulse of life, of process, of diachronic change over time. And again like Hegel, he sees human actors, in his case the artists, as caught up in a grander scheme of historical inevitability.

Therefore, in many ways the Swiss art historian was still heir to the grand nineteenth-century programs that I discussed in Chapter 1. He contextualized his objects, if in a highly idiosyncratic way. He was a connoisseur with a historiographic inclination: he grounded his perceptions in sharp observation and then, on the basis of this keen visual analysis, sought to situate them in a historically generated stylistic system or formal context. This system is itself transparently animated by a Hegelian prototype of thesis/antithesis, for Wölfflin's study of Renaissance art depended on his knowledge of the Baroque and vice versa.[16] Were it not for the existence of an opposite mode of imagination (for example, the seventeenth-century Baroque), a sixteenth-century Renaissance painting could not be analyzed as exhibiting a distinct and revealing periodic form. In focus-

ing solely on the stylistic aspects of the work or group of works without reference to what they are "about"—perhaps on the way in which space is treated, or on color, or on line—Wölfflin became intrigued with articulation as it differs in works created in various times and places. Style is form grounded in history. Works of art undeniably change over time. The crucial query is: why does art have a history?

To answer the question, he elaborated in *The Principles of Art History* a morphology of form, taking the frames surrounding his paintings as literally confining them. He considered his approach most untraditional: "The isolated work of art is always disquieting for the historian. . . . Nothing is more natural to art history than to draw parallels between periods of culture and periods of style."[17] He singularly refused to regard anything outside the world of the painting (he viewed architecture and sculpture as being also hypothetically framed, or "boundaried off" from the world outside) as relevant for an understanding of the art's essential, formal expression. Wölfflin regarded stylistic "development as internally determined; outer conditions [could] only retard or facilitate the process; they [could not be] among its causes."[18]

We tend to read Wölfflin primarily as a positivist, especially in this country, because of his manifest empiricist faith in the physical evidence, that is, in the formal properties of the work of art. Yet his unilateral concentration on the existence of the physical object per se could just as well have been a response to the contemporary obsession with the problem of "validity" in interpretation, indicating his familiarity, as it did Dilthey's, with two prominent directions in late nineteenth- and early twentieth-century thought: phenomenology and neo-Kantianism.

The concern with validity in interpretation was itself an offshoot of the positivist theory of scientific validity, which contended that truth is independent of the observer or researcher who discovers it. Adapting this view to discuss the role of authorial intention in the creation of works of art, many aestheticians wondered whether artists and authors do not also incor-

porate timeless verities in their works without being cognizant either of all that the process of discovery entails or of the meanings later commentators would providentially find in their work. "This distinction between genesis and validity," Hauser claims, is "certainly one of the most important discoveries" of the philosophy of art: "It finds expression in the principle of the irrelevance of circumstances of origin to the meaning of intellectual structures; or in the assertion that no intellectual creation, no cultural achievement or institution, is to be explained in terms of motives—neither by the personal aims of the originators nor by the needs of the social group in which they originate."[19] Arguments about the legitimacy of this notion constituted most of the significant debates of the time as well as one of the major influences on Wölfflin's art history without names. Dilthey, for example, repeatedly emphasized that the meaning of an artifact has little to do with an individual's biography (although he regarded cultural explanations differently): the works of Shakespeare do not disclose the poet to us; "these works are as silent about their creator as they are revealing about the way of the world."[20]

Early twentieth-century philosophers, of course, never held exclusive rights to this theory of interpretation. It is as new as contemporary semiotics and as old as Socrates:

> I went to the poets; tragic, dithyrambic, and all sorts. . . . I took them some of the most elaborate passages in their own writings, and asked what was the meaning of them. . . . Will you believe me? . . . there is hardly a person present who would not have talked better about their poetry than they did themselves. Then I knew that not by wisdom do poets write poetry, but by a sort of genius and inspiration.[21]

It is the responsibility of the interpreter who appears long after the creative impulse has been spent to reveal those aspects of a creation of which the creator was not aware. In Wölfflin's case, this process of revelation is accomplished by reference not to extrinsic cultural principles, as it would later be for Panofsky,

but instead to the time-bound vocabulary of stylistic possibilities (ways of articulating line, space, color, and so forth) to which the painting as a product of visual history is always permanently affixed. Unlike its originator, the work of art continues to have a life of its own, remains forever new, inhabiting a perpetual present. The work itself, and not the conditions surrounding its existence, speaks to us through its own phenomenological presence.

Works dating from 1900 reveal that the essence of Husserl's phenomenology (with which Wölfflin would have been familiar via Dilthey) is direct apprehension of the objects themselves: for a higher understanding (*Besserverstehen*) of their significance, we must seize them "immediately in an act of vision." The phenomenological method "consists in pointing [*Aufweis*] to what is given and *elucidating* it. . . . it fixes its gaze directly upon whatever is presented to consciousness, that is, its object."[22]

Wölfflin, it seems safe to suggest, was engaged in essentially the same project with the Renaissance and Baroque works of art that were his objects of study. We have already spoken of his insistence on adhering to the "frame" of his work, refusing to look for explanations beyond the boundaries that delimit the physical dimensions of the object. In this regard, he seems to have appropriated directly Husserl's contested notion of bracketing. The eidetic reduction brackets, or frames, the object in question, for it defines the object only as a visible phenomenon presented to the perceiving consciousness. The phenomenologist places himself "in the presence of pure essence and ignores all other sources of information."[23] For Wölfflin, the formal structure of a painting, and not its genesis in a particular societal milieu or artistic personality, was of supreme importance. He distinguished between his roots of style in order to achieve some sort of validity in interpretation.

My explanation thus far suggests that Wölfflin could brook no historical perspective in his formalist scheme. Clearly, however, history is always the spectral presence behind Wölfflin's

categories, looming silently and discreetly behind every concept from which it may appear to have been excluded. History—or more specifically the history of the immanent process of stylistic variation as opposed to the history of cultural intervention in formal operations—is that which generates "style" in the first place. To quote Wölfflin, "Every artist finds certain visual possibilities before him, to which he is bound. Not everything is possible at all times. Vision itself has its history, and the revelation of these visual strata must be regarded as the primary task of art history."[24]

Wölfflin could not rest content with an "isolated" formal analysis, no matter how astute, of one object only. He grouped works of art excessively. The formal attention given to one painting, for example, propelled him to take interest in another of the same generation, and in the end, his system of analysis makes sense only with reference to a large body of similar objects. He was fascinated by laws and principles of ordering that go beyond both testable scientific propositions and phenomenological efforts to indicate what is given and intuitively to elucidate it. Despite his deliberate positivistic attempt to derive a history of art solely from observation, Wölfflin remains an idealist because of his continuing fascination with the grand historical design.

The relentless rhythm of history animates Wölfflin's sense of stylistic change over time. But this history, missing the complex polyphonic connections with a world outside itself, moves only to the thin monotone of the inevitable effect of one visual form upon another: "Every form lives on, begetting, and every style calls to a new one. . . . the effect of picture on picture as a factor in style is much more important than what comes directly from the imitation of nature."[25]

Wölfflin deliberately shunned cultural history in the tradition of Burckhardt while exalting a history of artistic forms modeled on biological parenthood. His only synchronic or contextual impulse was to situate one painting or building or piece of sculpture in a matrix with other objects of like kind. For ex-

ample, Leonardo's *Last Supper* (1495–1498) can obviously be appreciated by itself in isolation; but to understand better the distinctive historical High Renaissance vocabulary of pictorial form with which Leonardo was working, the historian of art needs to consider the painting in relation to one of its contemporaries, say, Raphael's *School of Athens* (1509). Despite the difference in subject (*what* the paintings express), there is undeniably a certain formal syntax (*how* the paintings express) that they share, for both are ordered according to symmetrical, planar, and linear pictorial values. The introduction of a Baroque counterexample makes it easier to recognize the formal kinship of two High Renaissance works. Tintoretto's *Last Supper* (Mannerist/early Baroque, 1592–1594), like the painting of the same subject by the late Baroque artist Tiepolo (1745–1750), is restless, painterly, recessional. Less than a century later the mode of perception has already begun to shift.

Why? Not because the world of the Baroque has articulated different religious and philosophical values, but rather because the laws of history mandate development and change. For Wölfflin, it is not a cause-and-effect relationship between different spheres of activity, as it would later be for Panofsky. In Wölfflin's scheme, one painting calls to another, and each successive work, as time passes, is in some crucial way a variant on its predecessor—to the point where the pictorial vocabulary of one representational form (a paradigm, perhaps, in Thomas Kuhn's terms) is depleted and a new set of formal problems articulates fresh artistic problems to be solved.

Wölfflin was not always dogmatic. In his earliest book, *Renaissance und Barock*, which was written "in the spirit of the Winckelmann-Burckhardt tradition," he asserts: "To explain a style cannot mean anything but to fit its expressive character into the general history of the period, to prove that its forms do not say anything in their language that is not also said by other organs of the age." And sentiments such as those expressed in the statement "the transition from renaissance to baroque is a classic example of how a new *zeitgeist* enforces a new

form"[26] are far more prevalent even in *The Principles of Art History* than his critics willingly see. We must constantly bear in mind that Wölfflin's manifest purpose in writing "a history of form working itself out inwardly" was to establish a valid or empirically verifiable method of visual analysis. He recognized that stylistic change had other causes, but they were not testable, not logically provable:

> For Wölfflin to circumscribe form was not so much to deny a relationship between art and culture as to provide the means to reject the task of interpreting that relationship. To propose a history of form, and reject the questions of the relationships between form and other things, was to distinguish the scientific history of art from evocative, judgmental, and interpretive literature.[27]

Obviously, Wölfflin's reservation about adopting a method of cultural analysis, which would be structured imperfectly upon the tentatively and speculatively defined connections between style and society, indicates his sympathy with the positivists' charges against the grand generalizations of idealist historians. It simultaneously suggests his familiarity with an aspect of neo-Kantianism, the route German idealism took when challenged by critical positivists at the beginning of the twentieth century. The neo-Kantians concentrated on formal laws of thinking, hoping to discover the ways in which consciousness gives form to perception. Like Kant, the neo-Kantians held to the premise "percepts without concepts are blind; concepts without percepts are empty." Dilthey, Wölfflin, and the neo-Kantians all took epistemology as their point of departure, asking simultaneously, "how do we know what we know?" and "why do we only look for what we can see?" Wölfflin's central assumption is always: "The observation of nature is an empty notion as long as we do not know in what forms the observation took place. . . . It is true, we only see what we look for, but we only look for what we can see."[28]

Locating his ideas regarding the sources of stylistic change in

this neo-Kantian context, we can suggest that Wölfflin's epistemology is directed not so much toward styles of seeing ("modes of vision," in his terms) as toward changes in intellectual perception ("modes of imagination"), a point made especially evident by the last part of the statement just quoted.[29] The changing eye symbolizes a continually shifting view of the world: "Just as we can hear all kinds of words into the ringing of bells, so we can arrange the visible world in very different ways for ourselves, and nobody can say one way is truer than the other."[30] Imagination and vision and art are inextricably linked. They are the indivisible stuff of which the changing history of human perception is composed. Goethe once said, "The simplest observation is already a theory."[31] Wölfflin at his most eloquent is a thinker after the heart of the great German poet: "Beholding is just not a mirror which always remains the same, but a living power of apprehension which has its own inner history and has passed through many stages."[32]

Immediately upon the completion of his inaugural dissertation, Erwin Panofsky challenged what he considered to be the most untenable of Wölfflin's ideas. In 1915, the same year that Wölfflin's *Kunstgeschichtliche Grundbegriffe* first appeared in print, Panofsky published "Das Problem des Stils in der bildenden Kunst," which by its title perhaps recalls Hildebrand's *Das Problem der Form in der bildenden Kunst*. Panofsky's article was originally written in response to a lecture on the problem of style in the visual arts (an abbreviated prelude to the 1915 work) that Wölfflin delivered before the Prussian Academy of Sciences on December 7, 1911.[33] According to Panofsky, his reasons for writing the critique were the obvious: "Wölfflin's article is so important methodologically that it is unexplainable and unjustifiable that neither art history nor the philosophy of art has yet taken a position on its outspoken views."[34] Panofsky first sets forth what he sees as the larger implications of Wölfflin's commentary: "Every style has no doubt a certain expressive content: the Gothic style or the style of the

Italian Renaissance mirrors a certain mood of the times or conception of life." He then quickly narrows his critique to address "the double root of style," which he regards as the single most important issue in Wölfflin's aesthetic. "But all of this is first only one side of what constitutes the essence of a style: not only what is said, but also how it is said, are for Wölfflin characteristic: the means of which it makes use in order to fulfill an expressive function."[35]

Thus Panofsky easily introduces the problematic notion of periodicity in art historical styles. "The fact that Raphael, for example, forms his lines in such and such a way can be explained to a certain degree by his talent; but what becomes most significant for Wölfflin is the degree to which every artist in the sixteenth century—Raphael or Dürer, for instance—is compelled to use line as an essential expressive technique rather than the brushstroke." It is most significant that this fact can be explained not by reference to nebulous categories such as mind, spirit, temperament, or mood but only by "reference to a common or general form of seeing and representation, which has nothing whatsoever to do with any inner aspect that is demanding expression and whose historical transformations, uninfluenced by mutations in the soul, can only be comprehended as a result of changes in the eye."[36] A historical shift in style, in other words, cannot be accounted for by changes in the spirit; it must be explained, rather, by alterations in the optical perception of the world.

The deliberately doctrinaire position forces Wölfflin, in Panofsky's view, to distinguish between two principal roots of style in the visual arts: (1) an epistemically ("psychologically," in the nineteenth-century definition of the word) meaningless form of perception and (2) an expressive or interpretable source of content or feeling. In order to develop his five pairs of polar concepts for describing the process of purely formal development from the high Renaissance to the Baroque, Wölfflin, Panofsky implies, unfortunately concentrated only on the first source of style for describing the "optical, representational pos-

sibilities" (p. 24) and deliberately ignored, for the time being, the impressive significance of the second. In deference to Wölfflin's insight and keen analytical eye, Panofsky stresses that for the purposes of his own polemic he must ignore the empirical and historical accuracy of the ten categories in order to concentrate on their methodological and philosophical significance. He does not ask whether it is correct to call the evolution from the cinquecento to the seicento a development from the linear to the painterly, from the planimetric to the recessional—and by not doing so implies that visually the ten categories are legitimate. Instead he inquires whether it is correct to describe the development from the linear to the painterly, from the planimetric to the recessional, as merely formal:

> We are not asking whether Wölfflin's categories—which in regard to their clarity and heuristic usefulness are above both praise and doubt—correctly define the general stylistic tendencies of Renaissance and Baroque art; rather we are asking whether these stylistic stages which they define can be accepted as mere modes of representation, which as such have no expression but rather are "in themselves colorless, only gaining color and a dimension of feeling when a certain expressive will makes use of them."[37]

Most of Panofsky's article addresses what he sees as the central problematic notion in Wölfflin's scheme: the singular assertion that "variations in the eye" (p. 23) produce different stylistic periods. He is troubled by "the decidedly strange separation" (p. 24) between contentful, expressive art and formal, representational art, a distinction that he believes Wölfflin must make in order to support his theory, because in the latter category only a certain optical, "colorless" factor appears—that is, a certain "connection of the eye to the world" (pp. 24–25), to quote Wölfflin directly, that is perplexingly independent of the "psychology" (the collective consciousness) of the period. How can it possibly be so?

Panofsky responds to the concept of the independent eye

with a number of pointed questions. Can we really accept this idea, he asks, without countering it with an argument? Must we really conclude that only the changed adjustment of the eye generates changes in style, so that works of art are now linear, now painterly, now subordinating, now coordinating? Can we consider the so-called eye as so completely organic, so much an unpsychological instrument that its relation to the world can be distinguished from the relation of the mind to the world?

The posing of these questions, Panofsky suggests, indicates where a critique of Wölfflin's teaching should begin. The trouble with Wölfflin's eye is that it is both relentlessly historicist and eminently passive at the same time, merely recording, in mechanical fashion, what it registers in its stylistically trained line of sight. Panofsky, on the other hand, remains secure in the knowledge that there is no such thing as the passive eye. Seeming to rely on Kant for theoretical support (but it is interesting to note that at this early date in his scholarship he makes no explicit reference to Kantian hypotheses, as he did later), Panofsky insists that although our eye receives some sort of rudimentary information from the world as it directs its gaze, or has its gaze directed, at an object, the data it collects become intelligible and meaningful only when placed by the mind in temporal and spatial constructs. The eye itself is merely "form-receiving, not form-constructing" (p. 25). The mind must still perform most of the labor: "That one epoch 'sees' in a linear way, while the other sees in a painterly way, is neither the root nor the cause of style but rather a stylistic phenomenon—not the explanation itself but that which permits the explanation."[38]

Now, Panofsky does take pains to say that Wölfflin is himself a long way from describing the artists of the seventeenth century as having differed from artists of the sixteenth century in the construction of their retinas or the form of their lenses. So what can Wölfflin have in mind? Panofsky asks. What does it mean to say that the eye "brings something to a certain form?" Who does the bringing? Wölfflin would have answered, "Rep-

resentational possibilities." In Panofsky's terms, there can be only one answer: the mind. But of course, Panofsky continues, "the perception of the appearance of something can only acquire a linear or a painterly form through the active intervention of the mind; so that the 'optical focus' should be interpreted as a mental or spiritual focus on the optical, and consequently, the 'connection of the eye to the world' [he quotes Wölfflin again] is in truth a connection of the mind to the world of the eye."[39]

Panofsky seems in this youthful article to pride himself on finding a quagmire in Wölfflin's thought. He accomplishes this feat, he says, by simply investigating the ways in which Wölfflin's ideas "rest basically upon an unconscious play of two distinct meanings of the concept of seeing" (p. 26). When we consider that only a few paragraphs earlier, Panofsky explained that Wölfflin had to "divide the concepts, through which he sets out to define the essence of style into two fundamentally distinct groups"—the formal and the contentful, that is, "a 'psychologically' meaningless form of perception and an expressive interpretable content," it seems odd that he would refer to their "unconscious play." After all, when we speak of two different ways in which the eye can be interpreted as registering or making sense of what it sees in the world,[40] it is hardly a long step to the realization that this perceptual model can serve to characterize two different possible sources of visual stylization. I translate Panofsky directly:

> To say of an art that interprets the thing seen in a linear or painterly sense that it sees in a linear or painterly way is, so to speak, to take Wölfflin at his word, and—because he does not consider that, so used, the concept designates no longer the properly optical but the mental process—he has assigned to artistic-productive seeing the role which belongs to natural-receptive seeing: the role that underlies the capacity for expression.[41]

Indeed matters are here becoming "confused," as Panofsky would have it, but not so much for Wölfflin as for Panofsky

himself. He suddenly turns around and attacks Wölfflin for precisely the opposite reason, saying that with this "dialectical" distinction (only a moment ago he said Wölfflin was "confused" about his use of the term "seeing") between *ausdrucksbedeutsam* (expressively significant) and *nicht ausdrucksbedeutsam* (expressively insignificant) stylistic variations, Wölfflin has resurrected the age-old battling ghosts of content and form: "on the one side, intention, on the other, the optical; on the one side, feeling, on the other, the eye."[42]

And here the going becomes more difficult, for Panofsky seems deliberately to reverse both Wölfflin's terms and his status as a formalist. Before we speculate about Panofsky's reasons, let us see how he accomplishes his purpose. Content for Wölfflin, according to Panofsky, "is something which has expression, while form is something which merely serves this content." Content is no one thing in isolation; it is the "sum" of all that which is not form, which is to say almost everything, for as Panofsky is correct in noting, Wölfflin's formal properties, for example, "formation of lines" and "disposition of planes," are at times also acknowledged by the formalist as "expressively significant" (p. 27).

But Panofsky's question is legitimate: can formal properties be "expressively significant" while at the same time being "accepted as mere modes of representation"? Panofsky continues, observing how "infinitely far we must go in the application of the concept of content" (p. 28) if we are to take Wölfflin's categories seriously. Form is itself colorless; once it is seized by an expressive impulse, then it becomes content. Content is all, if we "subsume under this concept everything with an expressive significance." As Michael Podro says, "if all form is expressive," then "no form-content distinction is possible."[43] That Raphael and Dürer, for example, could paint portraits with a "similar form" indicates, in the last analysis, "that they had certain intersubjective content, transcending, as it were, their individual consciousnesses" (p. 28). With this terminological maneuver, Panofsky has the formalist Wölfflin denying the individual significance of form.

Because of the morass of self-annihilating terminology that he discovers, Panofsky suggests that we abandon altogether "the distinction of form and content proposed by Wölfflin" and "withdraw into the more workaday distinction between form and object." If we do so, he continues, we can "justifiably ignore the concept of expressive significance and by 'form' simply refer to the aesthetic factor which is not the object." In the process we could easily unite qualities such as "the feeling of line" or the "articulation of brushstrokes" under the concept of form—and "then and only then could Wölfflin's formalistic criteria be justified" (p. 28). They would be not only justified but necessitated. Having eliminated the most troubling aspect of Wölfflin's theory—the curious nondistinction between form and content—Panofsky seems in one of his concluding passages to be thinking as a strict disciple of Wölfflin: "That an artist chooses the linear, as opposed to the painterly approach, signifies that he . . . is confined to certain possibilities of representation; that he deploys his line in such and such a way and applies his paint as he does means that from the unending multiplicity of these possibilities, he extracts and realizes just one."[44]

A close reading would make any sensitive reader (including Panofsky) aware, however, that Wölfflin himself never fails to notice the difference between content and form. In fact the distinction is precisely the one addressed by Wölfflin's "double root of style." Content is ever more than just subject matter. A subject—for example, a *Last Supper*—gains its expressive power both by its formal arrangement and by its effective evocation of a historical ethos. We may take as an example two passages from Wölfflin's *The Principles of Art History*:

> Here we encounter the great problem—is the change in the forms of apprehension the result of an inward development, of a development of the apparatus of apprehension fulfilling itself to a certain extent of itself, or is it an impulse from outside, the other interest, the other attitude to the world, which determines the change? . . .
> Both ways of regarding the problem are admissible, *i.e.*

each regarded for itself alone. Certainly we must not imagine that an internal mechanism runs automatically and produces, in any conditions, the said series of forms of apprehension. For that to happen, life must be experienced in a certain way.

But we will not forget that our categories are only forms —forms of apprehension and representation—and that they can therefore have no expressional content in themselves.[45]

And Panofsky generously acknowledges in a footnote that Wölfflin did indeed understand the dynamics of the dialectical situation perfectly well:

> What Wölfflin himself never failed to notice is shown by the concluding passage of his article "On the Idea of the Painterly." With the sentence "with each new optical form a new ideal of beauty is bound up" (and therefore a new content) he still, however, fails to draw the necessary conclusion, that is, that this optical form is no longer optical at all but constitutes, with content, a specific view of the world, extending far beyond the limits of the merely formal.[46]

Consequently, Panofsky feels that he is left with something "far beyond the formal" to discuss. What has happened to meaning, content, cultural significance of any sort, in Panofsky's revisionist interpretation of Wölfflin? The answer is obvious for Panofsky and is as well consistent with what we have already described Wölfflin as wanting to accomplish.[47] It is present but hidden, awaiting a later explorer who is already scanning the panorama. In this early article, Panofsky has rather painlessly extracted worries about "meaning" from Wölfflin's body of concern. Secure in his grasp of "content," he feels comfortable using Wölfflin in a complementary fashion: "It should never be forgotten that art, because it decides in favor of one of these [optical] possibilities [e.g., linear or painterly] and renounces the others, *rests not only upon a specific view of the world but upon a specific world view*" (italics added).[48]

One real question remains, however. Has Panofsky's surgical

procedure been dictated by Wölfflin's own symptoms? Not exactly, for as Gombrich has diagnosed him, "Wölfflin throughout his life . . . was a physiognomist with an uneasy conscience."[49] Let us return just briefly to our earlier discussion of his works. To what extent was Wölfflin able to eliminate cultural significance as a concern from his "history of form working itself out inwardly?" Many historiographers of art history, for example Kleinbauer and Hauser, say he exorcized it completely,[50] and Panofsky's reason for writing this essay was to expose the traps into which Wölfflin's truncated approach can lead us. Yet despite the way in which a variety of commentators would have us read Wölfflin, clearly there is no such thing, for Wölfflin or for Panofsky, as the "innocent eye." The notion that it can exist is, rather, challenged by each of them in a different way. Panofsky would say that the mind and its culturally conditioned idea of how to perceive the world make the eye experienced. Wölfflin, on the other hand, would say that the artistic eye gains its experience from looking at other objects of art—that life, in effect, mirrors art: "Every artist finds certain visual possibilities before him, to which he is bound. Not everything is possible at all times. Vision itself has its history."[51]

Our interest in Wölfflin lies in what he necessarily repressed as much as in what he made manifest. Panofsky seems not to have been sensitive to this subtle issue, perhaps because his article was responding to only the condensed version of the lecture, not the whole 1915 book, or perhaps because his own stake in the controversy was emerging. Wölfflin concentrates on establishing a morphology of visual forms rather than on the complex and logically unverifiable problem of what an artist, as a spokesman for his culture or as himself, "means."

The problem is one of definition. Is the optical form ever free of cultural causes? Wölfflin could answer both yes and no and still not be accused of equivocating. In truth, the two cannot be separated, for the root of style is indeed double: two strands of influence intertwining and compelling styles of art to change over time. "Outer and inner explanations of develop-

ment of form," he said later, "always necessarily belong to-
gether, like man and woman."[52] In theory, however, the dis-
tinction works well, for it permits the historian to achieve
some sort of validity in interpretation. He looks at the physical
evidence per se, relates it to other evidence of like kind, and
then reaches some legitimate conclusions about the hegemony
of certain optical paradigms without ever resorting to specula-
tion about untestable origins. Again, we cannot accuse Wölfflin
of thoroughly denying that cultural, personal, and intellectual
factors play a role. Noteworthy phrases surface in his history of
form:

> It goes without saying that the mode of imaginative behold-
> ing is no outward thing, but is also of decisive importance for
> the content of the imagination, and so far the history of
> these concepts also belongs to the history of the mind.
>
> Different times give birth to different art. Epoch and race
> interact.
>
> It remains no mean problem to discover the conditions
> which, as material element—call it temperament, *zeitgeist*, or
> racial character—determine the style of individuals, periods,
> and peoples.[53]

So a certain cultural and intellectual determinism lurks in the
shadowy recesses of Wölfflin's architectonics. It is not brought
into the open, because Wölfflin had other things in mind. Nev-
ertheless, its presence is fleetingly perceivable. That so many
successive critics, beginning with Panofsky, have characterized
Wölfflin as having remained dogmatically impervious to cul-
tural factors is itself a historiographic curiosity. Kleinbauer says
Wölfflin "ignored" criticism of his visual grammar until 1933,
when in an article written for *Logos* he seemed more sympa-
thetic to the position of critics who demanded that he evince
some recognition of the role that mind and culture play in
the creation of works of art. First Panofsky and Frankl opened
fire simultaneously; Timmling marshaled a second attack in
1923.[54]

In the 1933 revision, Wölfflin himself declared that his *Principles of Art History* had been largely "misunderstood." While the tone and focus of this later essay do appease the cultural historians somewhat more, the revision is certainly not as radical as some critics of Wölfflin's method would have it be. He again defends his earlier work in the same way in which he first defended it: there is indeed a "double root" of style. Wölfflin was intent on elaborating formal laws of stylistic change, and he was willing to accommodate no unverifiable propositions in his system, although he readily acknowledged them outside it. Panofsky, for his own neo-Kantian reasons, applauds Wölfflin for his attempt to construct actual categories of perception, but he remains troubled by what he sees as Wölfflin's denial of the role of the mind in the formation of the visual arts.[55]

Yet Panofsky's early essay remains frustrating in its vagueness about the connection between mind, culture, and content in art—about the ways in which the artistic mind organizes its formal perception of objects into meaningful works of art. Is the mind the artist's own, or is the artist only its caretaker, activated by his or her culture, period, or nationality? Panofsky is articulate about what content is and is not in Wölfflin, but he is regrettably hesitant to specify its meaning, or that of its companion, "form," in his own developing thought.

Much more clearly presented is the position that Panofsky is beginning to take on the meaningful analysis of works of art. Already evident here is the eagerness with which Panofsky as a young scholar justifies analyses of works of art by referring to other modes of thought. This is the beginning of an intellectual trend that we will repeatedly encounter in his later work. Wölfflin's ambitious attempt to reduce artistic vision to a fundamental ordering inspires Panofsky with no misgivings; the trouble lies rather in Wölfflin's lack of a certain ecumenical point of view, which is to say that Wölfflin treats visual arts as art and not as physical embodiments of certain intellectual constructs. Art as idea is ignored. Panofsky, just having completed a dissertation on the effect of Dürer's theoretical ideas about

Italian art on his own work,[56] could not let the matter stop there. A work of art is a work of art, and it needs to be appreciated both visually and stylistically; but for Panofsky it is also—and this point is most significant—a historically revealing intellectual document.

3

Panofsky and Riegl

What you call the spirit of the age is really no more
than the spirit of the worthy historian in which the age
is reflected.

<div align="right">GOETHE</div>

Wölfflin shares the legacy of nineteenth-century "histori-
cism" in the history of art with another equally important
scholar, Alois Riegl. Although Riegl's earliest theoretical work,
Stilfragen (1893), slightly antedates Wölfflin's *Klassische Kunst*
(1899), I am discussing them in reverse chronological order so
as to consider Panofsky's responses in proper sequence. His es-
say on Wölfflin was written in 1915 and his essay on Riegl in
1920. For both Riegl and Wölfflin, the existence of varied
styles in works of art is physical evidence of meta-artistic or
guiding principles at work in history:

> With his doctrine of the "artistic intention" . . . maintaining
> the absolute uniqueness and incomparability of artistic
> achievements, Alois Riegl represents the one pole, whereas
> Heinrich Wölfflin, with his thesis of "an art history without
> names" and his depreciation of the artist's individuality as a
> factor in history, represents the other. As two of the last
> great exponents of the ideas of the Historical School, they
> belong together and have much in common in spite of the
> fundamental contrast between their doctrines.[1]

In this sense, both scholars may indeed represent a culmina-
tion of nineteenth-century thought, but at the same time this
characterization should not cause us to overlook their signifi-
cance for thinkers in the twentieth century. For in another

sense, according to the philosopher Bertalanffy, the art historian Riegl initiated a relativist point of view with epistemological reverberations that spread throughout the twentieth century. His concept of "artistic intention" permitted the historian to describe the art of "primitive" peoples as reflecting not lack of skill but a response to nature different from our own and not concerned with imitating natural appearances. From Riegl, Bertalanffy suggests, the concern with the cultural relativity of interpretive concepts passed into Worringer and from there into other fields: at the one extreme to Spengler's history and its awareness of "styles of cognition" and at the other to von Uexküll's theoretical biology and its interest in the species-specific *Umwelt* which, Bertalanffy colorfully observes, "essentially amounts to the statement that, from the great cake of reality, every living organism cuts a slice, which it can perceive and to which it can react owing to its psycho-physical organization."[2]

Despite his role as harbinger, Riegl did not deliberately start out to reform contemporary modes of thought. A philologist by training, he worked as a curator of Oriental rugs and other textiles for eight years in the Österreichisches Museum in Vienna.[3] His determined and self-conscious reluctance to be judgmental about the past, however, altered not only the course of history writing in general but also the tenor and direction of art historical studies in particular. He was a historicist whose relativistic views indisputably animated the whole discipline. In the words of one of his most recent appraisers, "he completely re-opened the field of art history" by countering most of its fundamental convictions at the end of the nineteenth century; for example,

> factual positivistic history which archeologists practice and which represented his own training; an iconographic point of view that stresses the subject matter of a work of art; biographical criticism, which interprets the work in light of the artist's life; the primacy of the individual artist's consciousness and will; the "materialistic" or mechanistic explanation of stylistic evolution; any aesthetic theory that severs art from

history; any normative system that attempts to reach a defini-
tive interpretation or judgment; the hierarchical distinction
between the applied or decorative arts, on the one hand, and
the higher arts (painting, sculpture and architecture), on the
other, where the latter alone are considered to be art in the
strict sense of the word.[4]

In his devotion to the minor arts as a productive field of study,
Riegl also opposed Dilthey, who believed that knowledge of a
civilization can be gained by study of only its supreme prod-
ucts. Riegl exposed his ideas to criticism precisely because he
failed to discriminate between art and artifact.[5]

Curatorial interests and research into the development of an-
tique plant ornament resulted in Riegl's publication in 1893 of
Stilfragen, a most influential essay in Germany and Austria on
account of its theoretical foundation. Concentrating on the his-
toricity of the decorative arts, Riegl postulated the existence of
an autonomous evolutionary process that gradually but percep-
tibly transforms styles of plant ornament, especially the motif
of the Egyptian lotus into the classical acanthus. He traces the
development of the motif, from early Near Eastern sources
through Greek, Roman, and Byzantine examples, as though
the forms had merely evolved as aesthetic solutions to formal
problems posed by their stylistic predecessors, irrespective of
the environmental, social, technical, and cultural milieu of
which the forms were a part. In advancing this idea, Riegl si-
multaneously opposed the popular mechanistic explanation of
the minor arts associated with Gottfried Semper, according to
which all decorative form resulted from technique and mate-
rial, and anticipated Wölfflin's perspective in *The Principles of
Art History*.[6]

Riegl advances the gist of his critique in the first chapter:

In this chapter, which as the title announces is about the es-
sence and origins of the geometric style, I hope to demon-
strate that not only has no compelling reason been submitted
which would make us regard the oldest geometric decoration
as resulting from a certain technique, especially in the textile

arts, but rather that the oldest historical artistic monuments much more likely contradict this assumption. So it appears we have to overthrow art teachings of the last twenty-five years which simply identify textile ornaments with surface [body] ornamentation and decoration.[7]

What Riegl saw as the revolutionary aspect of his ideas in 1893—the overthrow of the supremacy of materialistic explanations—posterity has tended to ignore. Instead, modern historiographers of art have identified the theoretical substructure of his discussion as most formative. In his introduction, Riegl provides the reader with intriguing, although somewhat puzzling, hints of his explanation for artistic change: "Still, it always remains uncertain in such a case where the domain of that spontaneous process by which art is created stops and the historical law of inheritance and gain comes into play."[8]

The disturbing lack of theoretical cogency that this explanatory sentence shows is due to its reference to a curious and irresolvable tension between historicist and formalist analyses of the reasons why art looks different in different times. Things change, but why and how? Does their alteration manifest a grand historical spirit working itself out through history, or does the impetus for this change come from an inexorable law of artistic evolution? The difference between the two may be subtle, but without opting for either one, Riegl leaves his ideas open to a number of questions. Just how is the reader to make sense of a phrase to the effect that the tendril ornament attained a "goal" which "centuries have persistently sought"? Does Riegl mean a goal for which the history of art has striven, or does the goal flash on the distant horizon like a Hegelian star, urging all historical progress ever onward, irrespective of the developmental exigencies of the artistic situation? "Essentially," Ernst Gombrich says in a historiographic survey for *Das Atlantis Buch der Kunst*, Riegl's scheme is a "translation" of Hegel's "spiritual history" deliberately set in opposition to Semper's "materialism": "The change in motif from the palmette . . . Riegl explains neither as a technical necessity nor as a

'spiritless copy of nature' but rather as a 'goal' of the 'art spirit' or the 'tendency' of the artistic will."[9]

Riegl apparently avoids some precise definition of these terms and complex issues because he is trying to make his history of ornament conform to some other established epistemological order. Margaret Iversen, who emphasizes Riegl's interest in and indebtedness to contemporary linquistic theory, has recently suggested what this system might be. She claims that *Stilfragen* is "neo-Grammarian" in both its method and its approach to its subject matter. In his book the "etymologist" Riegl explains the diachronic development of foliate ornament from Egypt to Rome according to "grammatical" laws that govern the principles of design.[10]

The force behind the evolution of the syntactical structures is none other than the *Kunstwollen*, a concept not fully expounded until the publication in 1901 of *Die Spätrömische Kunstindustrie*.[11] Where *Stilfragen* had been descriptive in intent, *Spätrömische Kunstindustrie* was analytic. The book is basically an effort to understand the long history of art in terms of changing modes of spatial perception, a shift from a "haptic" to an "optic" orientation. Haptic (tactile) perception of the sort originally embodied in Egyptian and Roman art isolates the objects in the field of vision as independent, circumscribed, tangibly discrete entities. By late antiquity, there are leanings toward an optic mode, which reaches its culmination only in modern art (the art of the Renaissance on through contemporary Impressionism). The optic articulation of the visual field unites objects in an open spatial continuum and increasingly appeals to the spectator's recognition of shared realities. For Riegl, the continuous linear evolution from the haptic to the optic operated with all "the binding force of a natural law."[12] Purpose and design and final causes define the nature of art and its history: "In *Stilfragen*, I was the first to advocate a teleological conception of art. . . . I see the work of art as being the result of a certain purposeful *Kunstwollen* that emerges in the battle against use, matter, and technique."[13]

One benefit of this scheme for the history of art resides in Riegl's refusal to regard any style of art as degenerative or devoid of artistic merit. Each period is its own testimony to an artistic intention. All is relative. Roman art does not represent a decline of the classical ideal, and the period between the Edict of Milan and the rise of Charlemagne demands recognition not conveyed by the appellation "Dark Ages," with which it was condescendingly burdened. Works of antiquity must be judged only by "their materiality, their contour and color, on the plane and in space."[14] All ages have a part to play in the ongoing evolution of the artistic will.

The notion of will, however, does reveal some problematic aspects latent in the concept of the Kunstwollen, most crucially the role of artistic genius in the development of style. The Kunstwollen itself—that which Gombrich translates as a "will-to-form," Pächt as "that which wills art," and Brendel as "stylistic intent"[15]—has both a collective and an individual side. On the one hand, the Kunstwollen is the immovable mover, a kind of inescapable historical compulsion, forcing styles of art to change one into the other—in Gombrich's memorable words, "a ghost in the machine, driving the wheels of artistic developments according to 'inexorable laws.'"[16] Yet, on the other hand, it seems to denote the individual artist's need to solve particular artistic problems: a burst of creative energy emanating from one artist who singlehandedly alters the course of stylistic development. Riegl's emphasis on psychology and individuality differentiates his concerns from Wölfflin's in this respect. Riegl's definition "demands a degree of freedom for the arts to express a deliberate choice. It loses all meaning when no choice is left to the artist to exercise a 'formative will.'"[17]

The modern difficulty in fixing the terms of Kunstwollen can be directly attributed to the interaction of or contradiction between the two poles of the definition.[18] The resolution of the conflict might have followed Dilthey's claim, made only a year earlier, "to understand the artist better than he understood himself" or (more than likely to the detriment of the

original theory) might have followed the point that Hans Tietze, Riegl's student, made a decade later: "The individual artist can fail, but the artistic intention of the age is bound to be fulfilled."[19] Riegl's solution, however, followed both a more moderate and a more imaginative course.

Otto Pächt has attempted to use Riegl's own words to mediate between the two extremes of his central concept. When Pächt asks what connects the intentions of the artist as an individual with the larger tendencies of his stylistic period, he finds Riegl already prepared with an "unequivocal" answer: "Geniuses do not stand outside their national tradition, they are an integral part of it. . . . The great artist, even the genius, is nothing but the executor, though the most perfect executor, the supreme fulfilment, of the *Kunstwollen* of his nation and age."[20]

History figures here in a role very differently from that which it had in *Stilfragen*, to be sure. Note, for example, the impulse to map the texture of the artist's cultural milieu rather than to define the artist's position in a formal development evolving with time. Riegl is now interested in the artist as microcosm, exhibiting within his or her work all the aims and tensions of the "nation and age" at large: "The change in the late antique world view was a necessary phase in the development of the human spirit."[21]

Iversen would attribute the change in focus to new linguistic influences on Riegl, specifically the work of Ferdinand de Saussure. Opposing the diachrony of the Neogrammarians, Saussure viewed language as a synchronic system. Its rules of operation and its meanings originate in the conventions of a community of speakers, and we can understand it as a system locked in place and time only by reference to the interrelationships at work in a "single language state."[22]

Other writers plausibly contend that Riegl was responding to new developments in both the history and the practice of art. Zerner suggests that Hildebrand's *Das Problem der Form*, published in the same year as *Stilfragen*, possibly exerted a theoretical influence on Riegl's first major work. Iversen also mentions

the art historian Karl Schnaase, who considerably modified the Hegelian system by concentrating on an autonomous development of art "denied by Hegel's aesthetic." Gombrich and Brendel view the work of Franz Wickhoff, who held the chair of art history at Vienna, as having been most important. In his 1895 *Wiener Genesis*, Wickhoff rescued late Roman art from oblivion by describing its impulse toward "illusionism." In an art world afire with debates over the work of Impressionists, such a positive reinterpretation of artistic aims that ran counter to a "naturalist" point of view had far-reaching historiographic implications.[23]

It is, of course, as impossible for later commentators to unravel the braided strands of influence on Riegl's ideas as it would have been for Riegl himself to do so. In general, he appears to have been guided by a faith in Hegelian process, with the qualification that his Kunstwollen translated much of Hegel into psychological terms. In Ackerman's words, "He promoted a principle that typifies art history in this century, that the best solution to an artistic problem is the one that best fulfills the artist's aim."[24] The artist initiates change but is also initiated. A late nineteenth-century thinker under the spell of evolutionary ideas, Riegl saw the history of art as an organism perpetually undergoing change, adaptation, development. In the end, there is no way around the fact that Riegl's thought exemplifies historical determinism. For this reason it rubs against the grain of modern historiographic theory. Nothing, in Riegl's master plan, "escapes history."[25]

Yet Riegl was also sensitive to the issue. Recalling Bertalanffy's laudatory remarks, which I quoted earlier, we may say that Riegl's value lies in his rejection of normative standards. His historicist perspective gave rise to his careful and methodical mapping of the historical inevitability of stylistic evolution that he perceived in the minor arts. Without this perspective he would have been unable to reform the course of art historical studies. With it, he was able ingeniously to combine a sense of positivistic, scientific procedure with a basically theoretical inclination:

To grasp the *Kunstwollen* of a past epoch whose taste may be completely alien to our own there is no other way open to the historian than to view the stylistic phenomena genetically, to reconstruct their genealogical tree, and to find out their ancestors as well as their offspring. For, once we can see a work of art as a halt on the road between past and future, its own artistic intention becomes clearer. We need the historical approach to get the specific aesthetic phenomenon properly into focus, to reveal the inherent stylistic tendency.[26]

Yet perhaps Riegl attempted more than any one late nineteenth-century thinker could constructively handle. In terms of our earlier discussion regarding the two conflicting strains in nineteenth-century thought, it seems uncertain where we should place Riegl. In principle, he was a positivist. Without a doubt he wished "to establish art history as a science and to define its autonomy" as such.[27] Because of his avowed opposition to Hegelian metaphysics—"as for what determines the aesthetic urge to see natural things by emphasizing or repressing the characteristics that either isolate or bind them, the art historian would have to engage in metaphysical suppositions that he should refuse to make"[28]—it seems natural to associate him with the "scientific" strain of thought. But Riegl's writing resists facile categorization, for there is always another side to the story.

Certainly more than any art historian who preceded him, Riegl sought the grand scope, the bird's-eye view, the perspective from which the course of art history could be interpreted for theory's sake as a positing and solving of enduring formal problems, irrespective of contextual exigencies. But Riegl had second thoughts, as did Wölfflin. In his 1908 review of Riegl's *Die Entstehung der Barockkunst in Rom*, Wölfflin defends his avocation and that of Riegl: "Just because art history depends upon seeing does not mean that it should avoid thinking."[29] What Hegelian sentiments these two men held compelled both of them to employ the theme of world view as a kind of counterpoint to their visual historicism. In *Spätrömische Kunstindustrie*, for example, Riegl sometimes relates changing notions of

spatial representation to changing philosophies about man's place in the world. By the book's conclusion, he is overtly stressing the necessity of juxtaposing synchronic and diachronic axes of historical description: "The character of this will is determined by that which from time to time we call a world view in the broadest sense of the word; in religion, philosophy, science, state, law, etc."[30] His hope that the history of art would be useful for scholars whose range of interests extended beyond the visual arts is encapsulated in the ambitious title of his 1898 essay "Kunstgeschichte und Universalgeschichte."[31] Having noted the synchronic aspect of his words, we should recall that Riegl's intent in writing was largely historicist. His single ambition was to interpret the course of art history through all epochs in terms of "one unitary principle,"[32] a self-generated Kunstwollen that realizes itself in changing and evolving modes of perception throughout time.

While Riegl stressed the formative power of each artist and the singularity of each work of art and emphasized individual, historically conditioned roles in formulating cultural values, he nevertheless depreciated the individual in favor of a supraindividual creative impulse. In this respect, his thought exemplifies the particular bind in which historicism found itself at the turn of the century:

> [The Historical School] . . . adopts the mystifying method of referring every historical event to some superindividual—ideal, divine, or primeval—origin, but combines with this an individualizing treatment that asserts not simply the uniqueness, but also the absolute incomparability of historical structures, and so concludes that every historical achievement, and thus every art-style, must be measured only against its own acknowledged standards.[33]

Riegl's writings may thus be seen to represent the logical and thorough culmination of nineteenth-century thought rather than a new and exciting innovation in historiographic theory, although such a description of them is intended in no way to question their proven significance for future historiographic

theory and the immensely influential position that Bertalanffy saw them as occupying. Once again, however, it remains to be determined why art has a history. Wölfflin offers the next-to-last word on Riegl; the *warum*, the question, he says, remains unanswered.[34]

In a 1920 essay entitled "Der Begriff des Kunstwollens," Panofsky took up the same question, issuing a long critique of Riegl's most cogent and influential ideas.[35] Panofsky regarded this later essay as picking up where his earlier critique of Wölfflin had left off. As in the earlier article, he was obviously concerned with distinguishing his own thoughts on the nature and meaning of art from those of previous art theorists, and the intellectual ability of Alois Riegl especially challenged him. But in the later essay Panofsky took as his point of departure the erroneous, ill-considered, even interesting, elements not in Riegl alone but in the theory and practice of art history in general. Contrary to what we might expect from his earlier criticism of Wölfflin's visual grammar, the problem that Panofsky now identified (apart from Riegl) lay not in the fact that works of art were being superficially described in formal terms, while questions of meaning and content were being neglected, but rather that both formal and contextual approaches when invoked remained haphazard in their concerns and organization. Panofsky wanted to see philosophical tests of the premises on which either kind of art history was based—with systematic reference to some judicious epistemological principles:

A purely historical consideration, whether it proceeds in terms of the history of content or the history of form, explains the phenomenon of the work of art always by reference only to other phenomena, not from a source of knowledge of a higher order: to trace back a certain iconographic theme, to derive a certain formal complex from a typological history or from other specific influences, to explain the artistic achievement of a particular master in the context of his epoch or in terms of his individual artistic character, means, within the whole complex of actual manifestations to be in-

vestigated, to link the one with the other, and not to deter-
mine their absolute situation and significance from a fixed
Archimedean point outside the art work's own sphere of be-
ing: even the longest "developmental series" represents al-
ways only the lines which their beginning and end points
must have within that purely historical complex.[36]

Panofsky was not quibbling with the project of historical dis-
course per se. Instead, he asked that both the history of cul-
tural conditions surrounding the work of art and the history of
its situation in a formal, developmental sequence be deemed
secondary and tertiary concerns. Before a historical investiga-
tion of any sort is launched, we need some understanding of
the art work as a *single* intelligible phenomenon in itself, not as
part of a series or as an example of something else. It is not
sufficient, Panofsky suggested, to elucidate one work of art by
reference to other works of art (in the manner of Wölfflin) or
even by reference to other events occurring during the same
time (thus he contradicted the position he took in his earlier
critique of Wölfflin): as philosophers first of all, we need to es-
tablish some epistemological principles that will enable us to re-
gard the work in terms of its own intrinsic value, and by doing
so we will also conveniently escape the trap of relativism.

Why do we, as historians of art, need to take such prelimi-
nary measures? Why are we asked to perform this extra, diffi-
cult task before we even begin discussing the work's historical
significance? Other historians have an easier job of it. A politi-
cal history, for example, "as the history of human action" (p.
33), can be satisfied by a purely historical analysis of cause and
effect, because a political event, unlike a work of art, is not a
"forming accomplishment of the content of reality"; a political
event is "exhaustible through purely historical inquiry and
even resists ahistorical interpretation" (p. 33). On the other
hand, artistic activity presents not just the activity of certain
subjects, which may or may not appear random, but the endur-
ing physical forms of its material as well—not, to use Schopen-
hauer's terminology, effects or events (*Begebenheiten*) alone but

enduring products or results (*Ergebnisse*). Political events are explainable only by history; they exist in a concatenation of causes and effects. Removed from this series, they disappear. Works of art, on the other hand, have reality apart from their place as links in a chain. In many ways, a great work of art succeeds in shifting the weight of the world. "The work of art is a work of art and not just any arbitrary historical object" (p. 33):

> And with this emerges for the consideration of art the demand—which is satisfied in philosophical realms by a theory of knowledge—that an explanatory principle be found, on the basis of which the artistic phenomenon not only can be comprehended through ever more extensive references to other phenomena in its existence but also can be perceived by a consciousness which plunges below the sphere of its empirical being into the very conditions of its existence.[37]

So far, the "most important representative," according to Panofsky, of the "serious philosophy of art" has been Alois Riegl. His notion of Kunstwollen, in fact, has been "the most acute (*aktuellste*) in modern art historical inquiry," for it attempts to free works of art from "theories of dependence" and gives in turn an untraditionally "recognized autonomy"[38] to their existence. Knowing as we do what Panofsky had earlier felt was wrong with Wölfflin, we can discern his appreciation of Riegl's Kunstwollen in his remark that it "at least potentially encompasses content as well as form" (p. 34) in its circumscription of the forces responsible for determining the existence of works of art.

Much needed as such a concept is, Riegl's Kunstwollen is "not without its dangers" because it hovers around, or "pivots" on, troublesome questions of psychology and will, notions that bring an element of "intention" or "purpose" into works of art, the role of which must be elucidated. At times, the Kunstwollen seems almost synonymous with the vexing issue of "artistic intention" and seems to lose much of its theoretical potency as a result. Panofsky urges semantic precision. Let the Kunstwollen

(artistic volition) "cover the total artistic phenomena, e.g., the work of a period, a people or a whole personality" and reserve the phrase *künstlerische Absicht* (artistic intention) for elucidating the "intentionality behind individual works" (p. 34).

Now, obviously Panofsky was about to encounter several obstacles if he pursued this argument. He claimed to have been searching, with Riegl as his guide, for an "Archimedean point" outside the usual web of references in order to describe objectively what he sees as he looks down on individual works. We can picture him as having been transfixed by the crystal ball of art history. He contemplated it intensively until an object suddenly appeared in the glass, demanding interpretation. In its immediate presentation, it was bright and sharp-edged, but it had emerged from the dark and murky waters of history (both formal and contextual) to which he wanted to pay no heed. So what could he say about it? If he wanted to avoid judgments of quality, and if he refused to locate the object historically, what was left—a description à la Riegl of how its figures were articulated in relation to the ground on which they appeared?

Riegl would not cooperate in this project for several reasons, a fact that Panofsky did not immediately recognize. First, Riegl's Kunstwollen had been defined in its opposition to artistic intention as a concept that derives its sustenance from the collective ("the period, the race, the whole artistic personality"), while Panofsky wanted it to comprehend "individual works" in their purity. Second, Riegl's groups of objects were framed and forged by a historical consciousness that is perpetually sensitive to periodicity in art historical styles ("ancient Greek," "Near Eastern," and so forth). Third, as anyone acquainted with his meticulous drawings in *Stilfragen* can affirm, Riegl grounded his theories in a careful survey of the existing empirical evidence. Because Riegl's procedure was patently inductive, it seems odd for Panofsky to have claimed that Riegl's viewpoint arose independently from or beyond the purview of the materials. Granted that even in Riegl the Kunstwollen was a vague and problematic notion, was not Panofsky making it even

vaguer and more elastic, stretching it almost past the point of usefulness? Ernest Mundt, commenting briefly on this essay, agrees with Sedlmayr before him that "Panofsky's definition [of the Kunstwollen] is not only as vague as Riegl's, it also misses the dynamic quality of Riegl's conception, the insight that what Riegl had in mind here was 'a real force.'"[39]

Essentially Panofsky's argument in the introductory section of his essay had little to do with Riegl. Panofsky was invoking the authority and position of the earlier theorist only to legitimize his own project of making the analysis of works of art dependent, a priori, on some valid theory of knowledge (by 1920, certainly, he was already sympathetic to this Kantian task, as we shall see).

It is philosophically invalid, he warned, to seek an interpretive viewpoint within the materials, inside the objects supposedly under investigation. Reliance on both extrinsic documents and intrinsic histories is not sufficient. Scholars must command some basic epistemological principles before approaching the work, or else "the fundamental sense residing in the artistic phenomenon"[40] will always elude their grasp.

We may notice that at this stage Panofsky had not yet specified principles of explanation. And he was not going to do so for a time, if at all. As we saw in his critique of Wölfflin, he was often very articulate about what something is not while remaining hesitant to say what it might specifically be. The middle part of his essay is no exception to this pattern, for it spends much time laboring to reveal the variety of ways in which the concept of the Kunstwollen can fail us. To begin with, Panofsky describes three categories reflecting the term's usage, all of which he labels "psychologistic": (1) the straightforward identification of the Kunstwollen with the will of the artist and with his or her psychological and historical situation; (2) the more complex identification of the Kunstwollen with the collective historical situation, which would judge the "will" in a work of art as it was comprehended consciously or unconsciously by people of the same period; and (3) the identification of the

Kunstwollen in a work of art as it affects contemporary observers, who believe that they, as spectators who enjoy art, can derive it from the "declarative tendency" of the "aesthetic experience" by way of aesthetic processes executed in their own minds (p. 35).

Even though we would expect to find Panofsky dismissing the first definition most quickly because of his desire to avoid any "psychologistic" explanation, he devoted most of his critical energies to this category. Panofsky's strategy in these early essays is obvious. In the critiques of both Riegl and Wölfflin, he traced and retraced his tracks as he found fault with every other explanation in art history. As his own position retreats with frustrating frequency, the reader awaits in ever greater suspense its final, dramatic appearance.

Panofsky spent a long time on the first definition because his fellow combatants from a variety of fields confronted each other in this arena. We have already discussed one aspect of the general controversy about how to achieve validity in interpretation with regard to any sort of text, a question that worried Wölfflin and others. The insistence on deciphering authorial intention also troubled Panofsky: the view "that Rembrandt or Giotto is encumbered with everything that appears in his work . . . cannot possibly be correct" (p. 35). The second, complementary aspect arises from late nineteenth-century developments in the study of psychology. Empirical psychologists were discovering at this time that ordinary visual experience, rather than being a simple phenomenon, as it might first appear, is a complex process that synthesizes stimuli from "the full gamut of the senses under widely varying conditions of perception, depending on different life-situations."[41] Riegl, of course, had attempted to analyze the "style" of the visual arts by demonstrating how objects of art can be interpreted as embodiments of a couple of fundamental categories of visual perception.

For Panofsky and others, the admission of psychological evidence in art historical studies frequently devolved upon one

classic topos: the riddle of why the Greek painter Polygnotus did not paint "naturalistic" landscapes. Rodenwaldt was the first to raise the issue in a well-known statement in the leading journal, *Zeitschrift für Ästhetik und allgemeine Kunstwissenschaft*: "There is no question of 'can' in art history, only a question of 'will'. . . . Polykleitos could have sculpted a Borghese fencer, Polygnotus could have painted a naturalistic landscape, but they did not do these things, because they did not find them beautiful." Proclaiming his debt to Riegl and to Riegl's notion of "artistic intention," Rodenwaldt asserted, "Polygnotus did not paint naturalistic landscapes because he did not want to, not at all because he could not."[42] Ability and cultural context seemed to be irrelevant.

Panofsky eagerly reviled—and at great length—this "inappropriate" pseudo-psychological explanation. Even if we concentrate on the artist's "will" as a starting point for analysis (and he was always anxious to stress how invalid such a course of action would be), Rodenwaldt's position is logically untenable because a

> will can only direct itself toward something known and because it therefore conversely makes no sense to talk about a "not-willing" to do something in the psychological sense of disinclination ("Nolle" as opposed to "non-velle") where a possibility which differed from that "wished for" was not conceivable with respect to the subject in question: Polygnotus did not fail to paint a naturalistic landscape because he declined to do so since it "appeared to him not beautiful," but because he could never conceive of doing so, because he—by virtue of a predetermined necessity of his psychological will—could not want anything other than an unnaturalistic landscape; and for just this reason it makes no sense to say that he voluntarily refrained from painting another kind.[43]

In his discussion of the "can" versus the "will" in personal artistic intention, Panofsky remained mindful that he did not initially want to associate the Kunstwollen in any sense with the

individual artist. As he had stated earlier, it would be foolhardy and purposeless to consider the Kunstwollen as a "psychological act of any historically individual subject" (that is, the artist). As the "predetermined necessity," the force of convention consistently delimits the mandates of artistic intention. Although it might be interesting, for example, to "deduce the state of the sensibility of the artist" (p. 35) from what we think we see in the works, such an act serves no real interpretive purpose. Even if surviving documents were to reveal authentic statements by the artist about his own art, we would still be taking our information only from the objects themselves or from documents "parallel to the artistic phenomenon" (p. 36). Such research only locks us into the phenomenon we are supposed to be investigating from our external "Archimedean point of view."

The second and third definitions of Kunstwollen also involved Panofsky in contemporary issues, but he treated them more cursorily than the first. "Period psychology" he regarded as merely a more complex and less verifiable version of "personal psychology." Worringer's "Gothic man," for example, was a figure deduced from the visual evidence of a "striving quality" in Gothic art—"the hypostatizing of an impression." Once again there arises the same problem of inference that was posed by personal statements of the artist. The period intention is "inferred" from "the same artistic phenomenon which it is being asked to elucidate" (p. 37). What Worringer saw as a virtue in 1907—"an attempt will now be made to arrive at an understanding of Gothic art on the basis of its own presuppositions"[44]—Panofsky regarded as the source of epistemological confusion in 1920. As much as Worringer's sort of interpretation contributed to an "extraordinarily interesting. . . *geisteswissenschaftlichen*" investigation, it still ran counter to Panofsky's desire for postulating a "methodologically graspable *Kunstwollen*" (p. 37) distinct from the objects it interprets.

Lastly, Panofsky dismissed contemporary aesthetic theory, specifically the sort originating in the popular work of Theo-

dor Lipps. With his doctrine of "empathy" in art, Lipps, in the words of Worringer, his disciple, took "the decisive step from aesthetic objectivism to aesthetic subjectivism, i.e., that which no longer takes the aesthetic as the starting-point of its investigations, but proceeds from the behavior of the contemplating subject, culminates in a doctrine that may be characterized by the broad general name of the theory of empathy."[45] Panofsky found the real subject of aesthetics far removed from the study of art history, for aesthetics is concerned not with the historical work of art or even with the artist who created it but only with the impression it makes, in the present, on the mind of the contemporary observer (p. 37).

Panofsky believed that all three interpretations of the Kunstwollen lead us far afield. They are useful approaches only if we are seeking specific and limited information, and they certainly are not the source of real knowledge. They do nothing to enable us to comprehend the total artistic intention manifest in a work of art; its internal coherence goes unrecognized. As Panofsky was quick to admit, Riegl initially felt concerned with such problems. Unfortunately he and his successors "overpsychologized" their solutions. Like Riegl, Panofsky was intent on finding a typology valid for all works of art. He was determined to find a principle of interpretation that would in no sense be subjective, that in no way could arise from within the artistic phenomenon itself or from our perceptions of it, either through its impact on the viewer or through some postulated historical cause (formal, cultural, or individual). So far in this essay, however, Panofsky's key phrases—terms such as "internal coherence" and a "forming accomplishment of the content of reality"—are matched in vagueness only by his failure to offer theoretical guidance. We know what we should not do in analyses of works of art, but what can we do? The rest of the essay attempts to be more direct.

On the basis of Panofsky's arguments, we must conclude that the "Kunstwollen as the subject of a possible kunstwissenschaftlicher knowledge is not a psychological reality."[46] And as

we know from the evidence that Panofsky mustered against Wölfflin's ideas in the earlier essay, the Kunstwollen can have nothing to do with abstract generalizations. The general stylistic characteristics that Wölfflin formulated "lead directly into a phenomenal classification of particular styles" (p. 38) and have nothing to do with characteristics "seen" from inside. If our analysis is to accomplish anything worthwhile, we must strive for some comprehension of the way the art work forms itself or brings together all its elements on its own terms; we need some way of "discovering stylistic principles which underlie all its characteristics and would elucidate the content and formal character of the style from the bottom up."[47] This principle of explanation must, above all else, respect the integrity of the art's phenomenal character. A stylistic synthesis, in the manner of Wölfflin, depends upon the invocation of large numbers of works for comparison's sake. Riegl's work also, despite its several virtues, is basically a grand and imaginative synthesis of historical changes in style. Riegl was very informative, according to Panofsky—working from the general toward the more specific—about "Baroque art" or "Dutch Baroque works" or the oeuvre of Rembrandt in general, but he told us little or nothing about one single work such as *The Night Watch* (p. 38).

The Kunstwollen, then, can in no way be based on a synthesis of any sort. It must reveal itself, or rather, reveal its "immanent sense" ("immanenten Sinn")—an immediate meaning enclosed within its own physical presentation—in isolation: the Kunstwollen must be directed toward or must be synonymous with the "ultimate meaning residing in the artistic phenomenon (not for us but objectively)."[48] Returning to the Rodenwaldt example, Panofsky observed in a footnote that thus "Polygnotus could neither have wished to represent nor have been capable of representing a naturalistic landscape because this kind of representation would have contradicted the *immanenten Sinn* of fifth-century Greek art."[49]

With these words, which occur more than halfway through the essay, we meet with the first actual definition of Riegl's

term Kunstwollen as Panofsky wanted to use it. Unfortunately, as scrutiny of the two excerpted statements demonstrates, the new definition is quickly aged by old problems. First of all, a strong positivist faith is implicit in the view that an analyst can be "objective" about the material with which he or she is dealing and can offer a valid interpretation not just for the present but for all times ("not for us but objectively"). The sentiment arose from—or perhaps opposed—a general relativist despair. Theorists at the beginning of this century from a variety of fields hoped to free their scholarship from value judgments and cultural preconceptions: they aimed, in other words, to make their studies conform to the established principles of scientific discourse. In this article, certainly, Panofsky proved to be no exception. Still, despite the climate of opinion, we would expect to find Panofsky more subtle in his use of the notion of objectivity for several reasons, primarily because he had been addressing himself publicly to the issue off and on for some time. In the Wölfflin essay written five years earlier, for example, Panofsky's whole argument was based on the conviction that works of art are products of the mind, culturally crystallized precipitates that form when the intellect reacts with the world. He failed, however, to take the next logical step, to acknowledge that the art historian's perceptions of the objects the artist creates are similarly conditioned. In Panofsky's ideal scheme, art history, conducted from the art historian's Archimedean viewpoint, could be said to remain outside time ("not for us but objectively"), although Panofsky simultaneously admitted (without the slightest irony, even at this point in the essay) that the objects discussed remain locked within time.

At first, especially on the basis of his statements in the same essay, we might consider the perceived difficulty to reflect an incorrect assessment of Panofsky's ideas at an early stage of his career. The inconsistency, however, was Panofsky's. Indeed, he continually referred to the necessity of examining works of art in isolation: the "single artistic phenomenon" remained uppermost in his mind. But a second perusal of his words reveals, de-

spite his protestations to the contrary, that to a considerable degree he was still writing from a belief in the primacy of a periodical ordering of art historical styles. The qualifying part of his definition of Kunstwollen demonstrates this point: "Polygnotus could neither have wished to represent nor have been capable of representing a naturalistic landscape because this kind of representation would have contradicted the *immanenten Sinn* of fifth-century Greek art" (p. 46). From all else that he has said, it is clear that Panofsky wanted to achieve a receptivity to the work's immanent sense on its own terms, but at the same time we find him referring to the individual work as a microcosm of fifth-century Greek art in general.

The problem becomes one of sequence. How far can an analyst go in discussing the particular without the universal or vice versa? The relationship between the two especially vexed neo-Kantians and hermeneuticists, and Panofsky in his work unconsciously exhibited similar methodological quandaries. Should the interpretive procedure progress from the single case to the general, or might we contextualize the single object in isolation, drawing on our knowledge of its stylistic and cultural etiology as a whole? Or do we understand the general trends only because we have precisely ordered individual objects? The point on which to challenge Panofsky here is plain: how can we deduce from the examination of only one example (as he advocated with the reference to Polygnotus) the immanent sense of fifth-century Greek art? Perhaps Polygnotus's choice of themes and articulation of formal elements were only aberrations, imperfect realizations or even revolutionary alterations.

Other problems proliferate. If we could somehow attain this immanent sense, this realization of the Kunstwollen, we would find, according to Panofsky, that the highly artificial distinction between form and content is untenable. Form and content are not double roots of style, as Wölfflin asserted, but expressions "of one and the same principle," "externalizations of a common basic tendency." "Tendency" toward what? And what tends—

the mind, the culture, other works of art? "To circumscribe" these tendencies, he suggests, "is precisely the task of authentic *Grundbegriffe der Kunstgeschichte*" (p. 39), but clearly the tendencies become apparent only when we make comparisons across time. In attempting to be more reductive and less psychological in orientation than Riegl, Panofsky's essay leaves us either with nothing or with far too much to discuss, depending on how we view the situation.

Such inconsistencies and vague notions about how art "works," far from being sorted out in the essay, produce their own contradictions and ambiguities that sometimes turn "circumscription" into mere labyrinthine meandering. Panofsky has a center in mind somewhere, but it eludes his circuitous and indirect methods of reaching it. He therefore makes the end his beginning and confidently reveals the conclusion to which he had originally hoped we would naturally be led: art theory should correspond to a fixed theory of knowledge.

To explain the point, Panofsky takes from Kant's *Prolegomena* the statement "the air is elastic" (p. 39). Following Kant, Panofsky observes that we can regard the sentence historically, psychologically, or grammatically. We can do the same when we view works of art. Given either a verbal or visual "statement," we might adopt any of an assortment of attitudes toward it. We might situate it in its historical context, or we might focus on the subjective predispositions of the person who created it, or we might examine its "grammatical" construction (p. 39). For works of art, the first two considerations obviously relate to questions of meaning and content, while the third invokes formalistic analysis. No theory of art—with the possible exception of some implications of Riegl's thought—has managed to go beyond this tripartite orientation.

Nonetheless, says Panofsky (heeding Kant), we must struggle to overcome the habitual modes of analytic behavior. For epistemological purposes, we should sever all threads that connect the work to the three kinds of concern and should instead fixedly concentrate on the "pure knowledge" or "cognitive con-

tent" (*reinem Erkenntnisinhalt*; p. 39) contained within it. So far, so clear. But what is there left to discuss? In Panofsky's words, the intrinsic determinative principle (*Gestalt des Kausalitäts-begriffes*) of the work. We must find a way of comprehending the phenomenon of a work of art in accordance with Kant's dictum of acknowledging how the mind of the "judging self" conjoins the ideas of air and elasticity, revealing by their relationship that the statement belongs to the domain of science (p. 40).[50] The language is abstruse and wordy, but Panofsky seems to be saying that a primary or proper response should reflect the internal order or validity of the work of art — the way it coheres (or fails to cohere). That is, does it make sense? Does the art work embody an ontological assertion that creates our experience of the world rather than being derived from it?

A work is art by virtue of its connectiveness, which is similar to the idea of causality in science. We should be able to "test" a work's internal "causal" truth as definitively as we can verify Kant's sentence by expanding it to an "if . . . then" proposition. A causal hypothesis should be testable; its logic should hold it together internally, irrespective of its ultimate significance. Panofsky is adamant in stressing that we need some viable means of discovering the work's validity without seeking confirmation outside it. He offers no apologies for drawing a parallel between a proposition and a picture, does not qualify the analogy, and provides no guidelines for applying the procedure to a work of visual art. Exclusively and in isolation it demands our near-sighted vision. A work of art, like a sentence uttered within the realm of scientific discourse, has a certain identifiable ontological nature. It posits a specific "argument" about the nature of being and representation that can be "uncovered" by being considered from the point of view of the concept of cause, with "cause" in this context referring only to the internal dynamics structuring the individual work, not to the extrinsic conditions of its being, such as cultural or art historical factors.

We have reached the point at which art theoreticians can ef-

fectively employ Riegl's concept of Kunstwollen. The Kunstwollen should reveal the work's inner "necessity," a necessity that resides within and has nothing to do with individual aspects ordered sequentially or causally (this time in the broader sense) but instead testifies to the presence of an ideal unity in the total artistic phenomenon. Retain, Panofsky advises, the notion of artistic intention, but define the terms cautiously. Remember that by "artistic" we should mean not "of the artist" but "of the living work of art." The work of art must be considered in terms of its own measure—its own "coordinates"—the "conditions of its own being." Lest the analysis seem to verge on formalism, Panofsky notes that he has another, more primary concern in mind. After the work's immanent sense is made manifest, then and only then can it be related to larger comparative notions and descriptive terms such as "linear" or "painterly." Analysts should never try, before making their initial trenchant observations, to bring stylistic categories or the attendant vocabulary to bear on their own interpretations. The work must focus itself and must create its own conditions of existence in "the mind of the judging viewer" (p. 40). It should be "the task of Kunstwissenschaft to create a priori valid categories which . . . can be applied to the artistic phenomenon under study as the determining measure of its immanent sense."[51]

Riegl had tried to fulfill this obligation, but he was a visionary limited by his own choice of categories. "Optic" and "haptic" are terms based on "empirical . . . psychological" data, and any "psychological consideration" inevitably "confuses art and the artist, subject and object, reality and idea" (p. 42). Clearly, Riegl's concepts "work" to a certain degree, but they are insufficiently reductive, because in no way do they "exhaustively" characterize artistic phenomena. For example, the art of the Middle Ages or individual works by Rembrandt and Michelangelo still need to be "classified outside of this objective/subjective axis." The terms are effective, Panofsky says, as expressions for the possible mental (*geistige*) attitude of the artistic self to the object. Yet "the effective artistic intention in a work of

art must be strictly separated off from the sensibility of the artist." "Haptic" and "optic" are overpsychologized concepts (p. 41). Panofsky's position has obviously shifted from that articulated in the earlier essay. His disagreement with Wölfflin had reflected the assumption that the eye's relation to the world is not just "organic" but "psychological."

At least Riegl's categories aim no longer for a generic elucidation or generalization across phenomena, as do Wölfflin's concepts of linear and painterly, for example, but instead for a "classification of the work's immanent sense" (p. 41). Riegl, far more than any art theoretician who preceded him, placed art history on a sound philosophical or epistemological footing: "A method, as Riegl introduced it, deals—properly understood—with the purely historical recognition and analysis of the valuable individual phenomena and the description of their relationships in art history just as little as the theory of knowledge deals with the history of philosophy."[52]

Panofsky discusses Riegl summarily once again, and we approach the conclusion of the essay without having been informed about the categories that might replace Riegl's. Panofsky has written many pages indicating the need, as he sees it, for the development of new a priori "transcendental kunstwissenschaftlichen" (p. 42) categories of description, but he unfortunately provides only general indications of their nature:

> But these categories would describe not the form taken by the thought which creates experience but rather the form of the artistic contemplation. The present essay in no way undertakes the deduction and systematization of what we have called the transcendental–art historical categories but only tries to secure the idea of the Kunstwollen against erroneous explanations and to clarify the methodological presuppositions of an activity that seeks to comprehend the concept. I do not intend to pursue the content and significance of such fundamental principles of artistic contemplation beyond these intimations.[53]

The end of the essay takes the same conciliatory tone that we found in Panofsky's critique of Wölfflin. Once again, art histor-

ical affairs prove to be in not really as perilous a state as Panof-
sky first intimated might be the case; what the discipline finally
requires is a more refined procedure.

The concluding paragraphs, in fact, summarize and even ex-
alt more traditional types of analysis in an effort to demon-
strate how they can heuristically complement the new sort;
Panofsky seems to forget that he has not yet described the new
method in specific terms. A "transcendental Kunstwissen-
schaft," for example, in no way "usurps the place of pure art
historical description," and it even requires "historical" infor-
mation in order to provide a complete picture: we must "use
documents to establish with certainty the purely phenomenal
understanding of the given artistic appearance" (p. 42). Docu-
ments, for example, can not only "verify" but also actually "cor-
rect reconstructively" or "exegetically" certain presuppositions
of the Kunstwollen; still, they never "spare us the struggle for
the knowledge of the Kunstwollen itself, penetrating below the
sphere of appearances."[54]

Panofsky, like many of his fellows, has recognized that his-
torical inquiry by its nature poses a special problem. Although
the article's title addresses Riegl, the essay has in actuality been
a long and somewhat tortuous plea for the development of a
relentlessly objective approach to works of art that will free ob-
jects from the burden imposed by certain patently historical or
psychological critiques. Without providing specific details, Pa-
nofsky has advocated the delineation of a generally applicable
intellectual procedure in art historical interpretation: "univer-
sal categories of art," in Hauser's critical words, "which are to
be independent of all concrete experience, all psychological ac-
tuality, and all historical time."[55] He has suggested that we
need to discover a single permanent Archimedean viewpoint
from which to interpret various cultural artifacts, for the arti-
facts and the cultural complexes they embody offer only intrin-
sic principles of interpretation. The residue of cultural varia-
tions that survives from the past needs to be sorted, so that the
diversities can be viewed from this distant point and not just
with reference to each other. It is incumbent upon conscien-

tious analysts to elevate themselves to a transcendental position, the position of epistemology, in order to recognize and discuss "coherence" and "cause" in works of art.

Although we can certainly fault Panofsky for his lack of specificity and feel frustrated by the absence of procedural guidelines, he has demonstrated an ambition and scope worthy of all the great theoreticians of art, from Alberti on, who have attempted philosophically to ground the discussion of works of art. He has argued that the crucial question to be addressed by the art historical community is age-old: what creates "the ideal unity" (p. 42) in a great work of art? What can we learn from the work's singular presentation? With its grounding in neo-Kantian epistemology, much of the essay, it is true, can be read as an effort to discover how "works of art are like special kinds of discursive thought."[56] But we can also view Panofsky's assessment the other way around. In the final analysis his essay on Riegl has been a tortuous and exhaustive struggle (Panofsky's word) to indicate ways in which words might be capable of matching in impact the ontological potency of a single, ordered visual representation.

4

Contemporary Issues

The significance of a writer, whether poet or philosopher or historian . . . , does not reside principally in the conscious intentions behind his work, but rather in the precise nature, as we can now see it, of the conflicts and imaginative inconsistencies in his work. . . . any form of civilized life is sustained at the cost of some denial, or reversal, of feeling, and . . . at the cost of fabricating myths and speculative hypotheses, which will seem, to an entirely detached and scientific eye at some later date, a kind of madness, or at least an indulgence in illusion. . . . It is generally only in retrospect that we can see why a concern that might at the time have seemed marginal, scholastic, academic in the abusive sense of this word, was in fact a working out in apparently alien, or even trivial, material of an exemplary conflict of values, which had a much wider relevance.

STUART HAMPSHIRE

Panofsky was far from alone in his concern with giving art historical commentary a sound epistemological basis during the second and third decades of the twentieth century. Wölfflin's generation, it has been said, was "eminently a generation of 'philosophers.'"[1] In the leading journals of the day, many thinkers pursued philosophical systems that eliminated the need either to develop new principles for the analysis of each work of art or to yield to all-encompassing subjectivity. "The underlying problem confronting the generation of interpreters was how to be articulate about the origins of painting and how to register properly the autonomy of painting as opposed to any message conveyed by it."[2] Both practicing art historians and speculating art theorists were caught up in the dispute.

97

Panofsky responded directly to Wölfflin, Riegl, Worringer, and Rodenwaldt, as we have seen, but he resurrected issues addressed in other writers' work as well. Therefore, before we leave art historical territory and venture more deeply into the realm of neo-Kantian philosophy to probe Ernst Cassirer's highly significant influence on Panofsky, we should sketch the trends in this theorizing about systems in art as well as survey several directions that new works in both formalism and art as cultural history were taking in the 1920s.

When Colin Eisler interviewed older scholars during his biographical research for "Kunstgeschichte American Style," he discovered that the authors of the "endless disputes in the realm of theory over which so many pages of ink were spilled in lengthy articles in the *Zeitschrift für Kunstwissenschaft* and other journals . . . today claim . . . upon re-reading them . . . that they are less than entirely sure what they meant when they were written."[3] To trace in any detail the lines of a controversy that now seems to have been forgotten would be an immense and thankless task, but we may profitably sample several of the more frequently quoted articles.[4]

In 1913, Hans Tietze published *Die Methode der Kunstgeschichte*, which surveyed contemporary methodological biases in art historical research.[5] At the same time the book attempted to turn the course of art historical studies in a new direction that, it optimistically suggested, could resolve several long-standing conflicts. Tietze, with his Hegelian sensibility, was as eager as Panofsky half a decade later to explain why art history must be distinguished from other types of historical narrative. No doubt, he says, "a work of art is a sensually perceivable fact" and can be aligned with other sorts of historical documents, but every art work is also in some fundamental way "isolated" and subject to its own internal logic.[6]

Tietze provides traditional reasons, however, for the need to "group" works of art for "scientific" analysis.[7] Such an analytic procedure requires a decision regarding the kinds of groups to be employed. The conflict, as he perceives it, between *Gesetzwis-*

senschaft (aesthetics) and *Tatsachenwissenschaft* (factual art history) is the source of most of the contemporary methodological bewilderment. Quoting voluminously from contemporary aestheticians, Tietze tries to bridge the gap in a new Kunstwissenschaft by making aesthetics and the historical perspective "mutually tolerant"—or better yet, so interdependent that they even serve as "handymen" to one another.[8] The predominant formalistic method is only a necessary transition to a new iconography,[9] a statement ratified twenty years later by Panofsky's *Studies in Iconology.*

Following publication of Tietze's "manual," less ambitious essays tended to fall into two principal categories: some elected to confront the ideas of Riegl and Wölfflin, and others chose to address the limitations and utility of a so-called scientific study of art. But in fact the categories overlapped because the issues overlapped in their fundamental concerns (as they obviously did in Panofsky's essay), especially when the essayist invoked the distinctions between idealist and positivist modes of interpretation.

The writers who articulated their own ideas by attacking those of Riegl and Wölfflin were often vitriolic. In 1917, Ernst Heidrich called the work of any evolutionist historian of art, from Vasari through Riegl, "one gigantic fiction" because it made overtly facile connections between periods, almost always proceeding from antiquity to the Renaissance without taking the Middle Ages into account.[10] Adolph Goldschmidt on many occasions "disavowed" the "metaphysical speculation" of Riegl and Wölfflin and turned instead to the science of classifying groups of works "analytically, formally, and historically."[11] Bernhard Schweitzer and Edgar Wind chose Wölfflin as their target, attacking his history of form for reasons similar to those of Panofsky when he indicted Riegl. They worried, on the one hand, that Wölfflin's antithetical categories were not yet sufficiently "basic" or reductive. Because the forced contrasts between Renaissance and Baroque had not been established according to a priori principles, they seemed to go beyond "mere

[scientific] registration and classification."[12] Moreover, Wind, in an argument similar to Panofsky's in the critique of Wölfflin, declared that a mere classificatory description, apt as it is for some art historical "problems," could never fail to encroach on larger issues of "meaning."[13] Wilhelm Pinder wanted to ignore the work of both Wölfflin and Riegl altogether and to develop anew the concept of stylistic periodicity; he found the earlier theorists' work too "simple" to be of use. Anticipating the work of Kubler forty years later, Pinder objected to the notion of "one style for one period," which presupposes the dominance of "one single trend" within each kind of art.[14] "Contemporary artistic achievements are obviously not all on the same level of stylistic development. Not only in the different arts, but also within the same species of art, we find more or less 'contemporary,' more and less 'advanced' works, as if some had run on ahead of their time and others were lagging behind."[15] Aside from attacking Riegl and Wölfflin, theorists also challenged each other's interpretations of the two "systems" with unrestrained rancor. Alexander Dorner, for example, says Panofsky made the "confusing" mistake of "blending" the methods of art history and art theory in his call for a "knowledge of the Kunstwollen through a priori deduced Grundbegriffe."[16]

The second group of writers attempted to articulate ways in which art history could be more "scientific" or, in Panofsky's terms, at least epistemologically verifiable. Richard Hamann and Karl Mannheim, in essays separated by several years, are two notable examples. Hamann claimed that an analyst has the obligation to correct even written documentary sources if they seem to conflict with the results of purely empirical (visual) information. Mannheim, caught up in contemporary historicist issues, doubted whether history of any sort could ever have "scientific" value, but historians who wished to confer some upon it might at least make their investigations meet two criteria: "An explanation of a work must, on the one hand, be free from contradiction and must fit every perceptible feature of

the work in the interpretation; on the other hand, it must be compatible with the historical circumstances of origin in so far as these can be ascertained from documents or by other objective methods."[17] In Vienna, Julius von Schlosser compiled a history and theoretical survey of writings on art from the ancient Greeks to the nineteenth century. *Die Kunstliteratur* (1924) became a frequently consulted bibliographic reference work for a wide variety of scholars.[18] The sociologist Max Weber entered the arena with several pertinent comments on the concept of "style." In his estimation, "style" should be regarded merely as an "ideal limiting concept" against which specific examples could be measured for purposes of discussion.[19]

Iconography, even though it lacks an overt theoretical orientation, should be mentioned in this empiricist context as well. Absorbed in their archival research for over half a century ("The general upsurge," Białostocki notes, "of historical science in the latter part of the nineteenth century exercised a powerful influence over the development of iconographical studies"),[20] iconographers countered the purely aesthetic approach to works of art so typical of late nineteenth-century writings. In their attempt to develop a descriptive classification of the subject matter represented in images, they practiced rigorous objectivity and "scientific exactitude," creating what seems to have become almost a subdiscipline of art history.[21]

Theoretical neopositivist sentiments culminated, a decade later, in Sedlmayr's creation of what he actually believed was a science of art history (Kunstwissenschaft) in Vienna. His "insistence on beginning with the observation and description of primary data, works of art; his emphasis on historical facts; and his focus of analysis on structural composition signal a move away from idealistic history toward an empirical concern with facts."[22] Yet his aims were traditional. His idealist "second science," concerning itself more with "understanding" and being based on the observations of the first science, strove to interpret and assess the principles of structural composition in

larger spiritual complexes (*Strukturanalyse*).[23] This so-called "rigorous scientific method," it may be recalled, led ultimately to the discovery of some rather absurd "facts." In *Verlust der Mitte* (1948), Sedlmayr condemned modern art on the ground that it lacked a conception of the "divine"; like Spengler before him, Sedlmayr dismissed the works of the Impressionists and their followers as creations of a "mere civilization," not the supreme products of a great "culture."[24]

Other scholars, more obviously concerned with the practical application of speculation, located their theoretical biases in a more traditional notion of research: the discussion of specific works of art. Periods and styles were still meaningful subjects of investigation, but it was equally important to describe and interpret the significance of actual physical objects. This world of past art, of course, varied, depending on whether it was being considered by formalists or contextualists. Yet Panofsky more than most—if we juxtapose the principal themes of his arguments in the essays on Riegl and Wölfflin—would seem to have prepared himself to be sympathetic to the eventual development of both kinds of art history, which, for the purposes of summary, we will identify with the *Strukturforschung* school on the one hand[25] and the work of Warburg and Dvořák on the other (although Dvořák in many ways better represents a bridge between the two).

The Strukturforschung school, which developed from the ideas of Alois Riegl, was active throughout Germany and Austria, but especially in Vienna, during the 1920s. Its leading exponent, Guido von Kaschnitz-Weinberg, held several views similar to those of Panofsky. He sought, for example, fundamental categories of analysis that could come to terms with the work of art as a unique, isolated statement. By formulating a system of structural categories basic to existence (for example, the connection between empty space and solid objects), and then by showing how civilizations choose or mediate between these categories in order to produce a work of art, Kaschnitz hoped to "be able to deduce *from the form* of the work . . . the

whole range of assertions about being, knowledge and value posited by it."[26] He specifically applied his ideas to studies of Egyptian sculpture and Roman architecture. By noting in a preliminary description of the interior structure of a work how a certain civilization "apprehends" space, he was able to infer what he considered to be crucial data about the mechanism of thinking that operated in a culture.[27] Thus form became content, and his essentially positivistic account led into wider questions of meaning: "The work of art appears as a complex metaphoric . . . structure, in which references to a wide range of human experiences (by no means exclusively, or even mainly, those given in acts of immediate sense-perception) are interwoven both hierarchically and at the same level."[28]

Max Dvořák, who had been trained in techniques of visual analysis by Riegl and Wickhoff in Vienna two decades before the development of the ideas of the Strukturforschung school, in 1904 in his first published work attempted to distinguish between the Van Eyck brothers' roles in the creation of the Ghent altarpiece.[29] In addition to this crucial exercise in connoisseurship, he also situated the work of the brothers in the wider context of fifteenth-century Netherlandish art and culture, a project that Panofsky was to emulate forty-nine years later in *Early Netherlandish Painting* (1953). For the most part, Dvořák, like Riegl, was a strict evolutionist. "By placing the art of the Van Eycks within a larger context, Dvořák conceived of a continuous evolutionary development from the early Renaissance to Impressionism, in which greater naturalism was achieved, he maintained, due to both ever increasing technical skill and the assimilation of the formal values of Italian Trecento art into Northern manuscript illumination about 1400."[30]

Dvořák, however, was a student not only of Riegl. Inspired by Dilthey's Geistesgeschichte and idealist history writing in the tradition of Hegel, he came increasingly to emphasize, during lectures known throughout Europe, the necessity of sketching a total weltanschauung for the work or period in question. In *Idealism and Naturalism in Gothic Art* (1918), he interpreted

works of art as the expression of a zeitgeist informing all cultural phenomena in the late medieval world and accordingly traced thematic analogies or parallels between one aspect of a culture and another, as Panofsky was to do thirty-three years later (1951) in *Gothic Architecture and Scholasticism*. In 1920, he articulated his view of Kunstgeschichte als Geistesgeschichte (art history as the history of the spirit): "Art consists not only in the development and solution of formal tasks and formal problems; it is always in the first place devoted to the expression of ideas which govern humanity in its history no less than in its religion, its philosophy, its poetry; art is a part of the general history of the spirit."[31] Because he suggested connections only between an artistic form and the religious and philosophical context from which it arose, however, Dvořák removed his studies from the conceptual framework of cause and effect. He saw art, in his words, as only a *reflection* of a "*Weltanschauung* . . . [which] had set *a priori* a specific limitation to each form of imitation of nature."[32]

At heart, Dvořák remained a thoroughgoing Viennese scholar who purposefully limited himself to questions of style and form, as Riegl had done.[33] His sole reason for drawing upon material outside the work of art was to create a background against which to view the evolutionary progress of stylistic forms. In the collective works of the great scholars of the Vienna school (from Riegl to Dvořák to Strzygowski to the Strukturforschung school and eventually even to Sedlmayr), which Heckscher has characterized as "the most powerful fortress of art historical knowledge of that day," the "references to meanings and to the causes of historical change," according to Meyer Schapiro, "are usually marginal or are highly formalistic and abstract." For Dvořák, a "stylistic analysis and the intensive study of the development of style were the essential tasks of art history as a science."[34] Despite his identification with Kunstgeschichte als Geistesgeschichte, he repeatedly called for a return to the "Erforschung des erforschbaren Tatbestandes der Kunstgeschichte" (an investigation of the investigable "facts"

of art history) and warned of the dangers of "cultural-historical trespassing perpetrated by some of his unnamed colleagues."[35]

"Naming" one of these colleagues is an easy task. Aby Warburg was a cultural trespasser of the first order. In the conclusion to his lecture given before the Tenth International Congress of Art History in Rome in October 1912—the month and year, according to Heckscher, in which "iconology was born"—Warburg spoke of his studies of cosmology in the zodiacal representations of the Schifanoia Palace as "an iconological analysis which does not allow itself to be hemmed in by the restrictions of the border-police."[36] He crossed borders with impunity, venturing into any territory, from family diaries to astrological symbolism to anthropological field reports, that could help in his explication of the "historical dialectic"[37] of ancient, medieval, and Renaissance images.

The life, work, and imagination of Warburg have been comprehensively treated in Sir Ernst Gombrich's biography of him.[38] Certainly his most enduring contribution to scholarship was his private Kulturwissenschaftliche Bibliothek Warburg. An eclectic and idiosyncratic library that still reflects in London today the many facets of Warburg's interests in Hamburg seventy years ago, it was conceived as early as 1900 and was assembled with family financial assistance during the next fifteen years. Originally inspired by the *Universalgeschichte* of his teacher Lamprecht, Warburg grouped his expanding holdings according to what Saxl remembers as the "law of the good neighbour": "The overriding idea was that the books together—each containing its larger or smaller bit of information and being supplemented by its neighbours—should by their titles guide the student to perceive the essential forces of the human mind and its history."[39]

And certainly there was much to organize. Pursuing a "form of voracious collecting that bordered on an obsession,"[40] Warburg was ever on the lookout for new material. Books on theology were placed alongside those with relevant art historical information; anthropological studies stood side by side with

family records and alchemical handbooks. Where Warburg perceived a relationship, the catalog listings noted it. He understood his own role as a historian and knew that his library served human studies, in Gombrich's memorable description, as a "'seismograph' responding to the tremors of distant earthquakes, or the antenna picking up the wave from distant cultures. His equipment, his library, is a receiving station, set up to register these influences and in doing so keep them under control."[41]

As exceptional a personal undertaking as the library appears in retrospect, Peter Gay's *Weimar Republic* reminds us that the founding of institutes—for example, the Psychoanalytisches Institut in Berlin, the Deutsche Hochschule für Politik, the Institut für Sozialforschung in Frankfurt—and the avid pursuit of humanistic knowledge in general in the face of rampant militarism were not uncommon in the energetic state of post–World War I Germany.[42] Heckscher, a product of that world, is "convinced that it is not just sensible but absolutely necessary to speak of the achievements made at this time in fields as divergent from one another, and from art history, as those of Einstein's Theory, Freud's Method of Psychoanalysis, of a number of technical and social advances, of the Motion Pictures and of Motion Photography and, last but not least, of the figurative arts."[43] Generated from a paradoxical cultural situation—in Gay's words, from "two Germanies: the Germany of military swagger, abject submission to authority, aggressive foreign adventure, and obsessive preoccupation with form, and the Germany of lyrical poetry, Humanist philosophy, and pacific cosmopolitanism"—the intellectual energy expended on such projects reflected a "Weimar style [that] was older than the Weimar Republic"[44] finally declared at the end of World War I in November of 1918.

Although Warburg's published work is slight[45] and therefore does not show his intellectual significance as much as his library does, he exerted considerable influence on art historical studies, having initiated a new regime in the study of the picto-

rial arts. Most writers who discuss Warburg's method first describe his work in terms of what it is not. For example, art historians who know only Warburg's name and his work with "symbols" commonly identify his efforts with iconography. Calling it a "travesty" to connect Warburg with this "branch of art history," Gombrich says Warburg relied on iconographic research, the "field" most of his colleagues were "cultivating" at the turn of the century, only as a "preliminary first step," a "marginal" activity that aided him in his identification of the symbols that were central to his iconological analysis.[46]

To connect Warburg with any sort of stylistic analysis, or with notions of Geistesgeschichte, is also to misconstrue his work. Although some commentators frequently compare the ideas of Dvořák and Warburg because both men were to some degree concerned with parallels between the visual arts and other expressions of thought, the disparity between the two is extensive enough to indicate the split between two opposing "camps" (formalism and contextualism) in German art history.[47] Instead of concentrating on styles or periods in the manner of the Vienna school, Warburg focused on "individuals involved in situations of choice and of conflict."[48] Rather than using general concepts such as the zeitgeist to explain art in the manner of the historicists, he strove to illuminate the concrete and the specific.

Several followers have loosely characterized the Warburg method as a kind of Kulturwissenschaft (as opposed to a Kunstwissenschaft), an intellectual perspective born from antipathy to "art for art's sake" and "rescuing," in the words of Warburg's associate Gertrud Bing, "the work of art from the isolation with which it was threatened."[49] In numerous lectures and a few essays on the artistic taste of Florentine patrons during the life of Lorenzo de Medici, Warburg identified specific threads that connect works of art to the society of which they are part—for example, the relationship between artists and their patrons, the practical purposes for which objects were designed, and their documentable connections with a so-

cial milieu. All explanations that referred to ineffable or meta-physical aspects of art were abjured, or almost all. Ever sensitive to an artist's "choice of images," Warburg regarded the images from the past as important in revealing the "psychological fabric"[50] of their period: "Art historical analysis, as Warburg envisaged it, would restore to the frozen and isolated images of the past the dynamics of the very process that generated them. . . . The driving question of why a work of art resulted in a particular form and quality demanded an answer. Memory, as the abstract sum total of human history, gave an ever-changing response to different situations."[51]

His evidence ranged broadly, but most of it tended to bear on particulars, on the practical exigencies of the historical situation in which the work of art was embedded. "Der liebe Gott steckt im Detail" ("God lies in the details") was his favorite dictum. He saw in the saying "a distinct hint at the methodic dismantling of borderlines in the realm of art historical research, a widening of both subject and range of investigation."[52] But certainly Warburg did not approach these studies as an antiquarian. Considering his work almost a matter of life and death, he was concerned with objects of art as "human documents"[53] that can tell us, historically, about the human psyche in all its contradictory and potentially threatening aspects.

"Contradictory" is the key word. Warburg was preoccupied, as Freud was at this time, with the contradictory nature of the human mind. Warburg's interests, furthermore, were echoed in his temperament. His personality, Panofsky recalled in his obituary, was structured "on a tension between the rational and the irrational, . . . a fascinating combination of sparkling wit and dark melancholy."[54] Warburg regarded the concept of "polarities" as his own invention until he found it in Goethe (and in Nietzsche and Freud) and contemplated Italian Renaissance art with the eye of a person who wishes to uncover psychoanalytic "symptoms." More often than not, his work revolved around the discovery of revealing polarities. He studied the appropriation of antique images in Lorenzo's Florence, in

particular, as it illuminated the eternal clash of forces between the new and the old as well as between the Apollonian and Dionysian aspects of man. He was similarly interested in Leonardo's genius as it brought contradictory impulses into harmony:

> In a period when Italian art was already threatened with the danger, on the one hand of falling victim to sentimental mannerism through an excessive leaning toward calm states of the soul, and on the other hand of being driven by a preference for excessive movement toward an ornamental mannerism of ragged outlines, Leonardo did not allow himself to be deflected or deterred and found a new pictorial manner for the rendering of psychological states.[55]

In one lecture he analyzed stylistic contradictions in Ghirlandaio's Santa Maria Novella frescoes, dealing specifically with the anomalous Nympha rushing in from the right in the *Birth of St. John,* who symbolizes, in Warburg's opinion, "the eruption of primitive emotion through the crust of Christian self-control and bourgeois decorum."[56]

Perhaps the most famous of Warburg's examples of conflict, and the one that most clearly demonstrates how he regarded tradition, appears in his discussion of Dürer's *Melencolia.* Dürer, like Leonardo, was a genius who sublimated the "dangerous impulses of the past" and brought them under control by "harnessing them to the creation of serenity and beauty." The result is a "humanization" of the ancient and dark fear of Saturn, which is accomplished by turning his image into a representation of "deep thought" or "meditation": "We are witnessing a chapter in modern man's struggle for intellectual and religious emancipation. But what we see is only the beginning of the struggle, not its victorious consummation. Just as Luther is still filled with the fear of the cosmic *monstra* and portents . . . , so Melencolia does not yet feel free from the fear of the ancient demons."[57]

The subject of Warburg's obsessive scholarship, the struggle between the forces of truth and beauty and those of evil and ig-

norance that try to vanquish them, was obviously associated
with problems in his own life. He became increasingly unstable
as he saw the battle within him reflected in World War I. As
the fighting began, Warburg devoted all of his considerable en-
ergies to monitoring the political and military struggles of the
hour. With his passion for collecting, he gathered scores of
newspaper clippings daily in an effort to comprehend the
enormity of the events.[58] "Like Freud," Gombrich has said,
Warburg "was not an optimist. He was not sure that reason
would ever win a permanent victory over unreason. But he
conceived it as his task—sometimes perhaps naively overrating
his own resources—to assist the struggle for enlightenment
precisely because he knew the strength of the opposing camp."
Warburg suffered nervous breakdowns repeatedly, was in and
out of asylums throughout his career, and was confined, in
1918, to a closed ward in a mental institution.[59]

Warburg's institute continued in his absence. Fritz Saxl, his
assistant, took charge and, in consultation with the Warburg
family, affiliated the private library with the newly founded
University of Hamburg (1919).[60] In the heady atmosphere of
the early Weimar Republic, Saxl organized a well-received lec-
ture series, inviting experts from a variety of fields, and pub-
lished many of the talks as monographs. As a scholar, he
pursued Warburg's investigation of Kulturwissenschaft, concen-
trating on collecting books for the library that suggested or
explicated links between ancient and Renaissance imagery. Saxl
was temperamentally unlike Warburg, however; he studied the
images with "the detached sympathy of the intellectual histo-
rian who looks with understanding and compassion at astrol-
ogy as fulfilling the religious needs of the uneducated."[61] He
also chose a very able staff to assist him. Its most notable mem-
bers were Gertrud Bing, who would aid Warburg for many
years upon his return in 1924, and Erwin Panofsky.

In 1921 Panofsky had been appointed a privatdozent[62] at
the University of Hamburg, and he visited the Warburg Li-
brary shortly after the completion of his essay on Riegl. He had

met Warburg as early as 1912, after the famous "iconology"
lecture at the Congress in Rome, but had since gone his own
way, writing his dissertation on Dürer's theory of art. When
Karl Giehlow, a Viennese art historian, was not able to com-
plete his study of Dürer's *Melencolia*, his editors invited War-
burg to finish it. Warburg fell ill, however, and Saxl, taking
Warburg's place, asked Panofsky to assist him in the project.[63]
According to Gombrich, they worked together, following War-
burg's model:

> What distinguishes their monograph [*Dürer's 'Melencolia I':
> Eine quellen- und typengeschichtliche Untersuchung* (1923), Stu-
> dien der Bibliothek Warburg 2] from earlier attempts at icon-
> ographic interpretations of the print is precisely the atten-
> tion devoted to the traditions of certain images, the
> renderings of Geometry, the rendering of the children of
> Saturn, and the illustrations of the melancholic complexion.
> *In showing how Dürer contended with these traditions to express a
> new conception of that mental state, the authors demonstrated a new
> method in action.* [Italics added][64]

Panofsky was to pursue the study of a theme's history and its
transformations through time for what these changes can re-
veal about the outlook of a particular age or a particular artist
in his later monograph *Hercules am Scheidewege*. In 1930, nine
years before his well-known exposition of the "iconological
method" in *Studies in Iconology*, Panofsky was already refining
Warburg's ideas with reference to categories of content:

> There are doubtless historical epochs . . . which limited
> themselves to the illustrations of the primary level of mean-
> ing and in which, therefore, an exegetic interpretation of its
> meaning would be neither necessary nor apt. . . . There are
> likewise, however, artistic periods which delved more or less
> deeply into the realm of secondary levels of meaning. In the
> interpretation of evidence from these latter periods, it would
> constitute an unhistorical blurring of categories . . . and it
> would amount to unhistorical arbitrariness to presume to dif-
> ferentiate between the essential and nonessential content on

the basis of a modern preconception. What we sense to be the difference between essential and nonessential content is generally only the difference between those representational motifs which fortuitously still appear generally comprehensible to us, and those which are only comprehensible through the aid of texts. Under no circumstances have we the right to pass over those sources which, to us only, appear buried: on the contrary, it is our duty to expose them as fully as possible.[65]

Panofsky was not the only scholar at the University of Hamburg to be captivated by Warburg's method and library. Ernst Cassirer, a new professor of philosophy at the University of Hamburg and Panofsky's senior by eighteen years, came to the institute in 1920 to have a look around. Saxl later recalled the day:

Being in charge of the library, I showed Cassirer around. He was a gracious visitor, who listened attentively as I explained to him Warburg's intentions in placing books on philosophy next to books on astrology, magic, and folklore, and in linking the sections on art with those on literature, religion, and philosophy. The study of philosophy was for Warburg inseparable from that of the so-called primitive mind: neither could be isolated from the study of imagery in religion, literature, and art. These ideas had found expression in the unorthodox arrangement of the books on the shelves.

Cassirer understood at once. Yet, when he was ready to leave, he said, in the kind and clear manner so typical of him: "This library is dangerous. I shall either have to avoid it altogether or imprison myself here for years. The philosophical problems involved are close to my own, but the concrete historical material which Warburg has collected is overwhelming." Thus he left me bewildered. In one hour this man had understood more of the essential ideas embodied in that library than anybody I had met before.[66]

Later Cassirer "became our most assiduous reader. And the first book [*Die Begriffsform im mythischen Denken*] ever published by the Institute was from Cassirer's pen."[67] In 1926 Cassirer

publicly acknowledged his sympathies with Warburg by dedicating his book *Individuum und Kosmos in der Philosophie der Renaissance* to the ailing scholar.[68]

Panofsky had failed to feel completely satisfied with any existing theory of art for several sound reasons—because the theorists lacked an epistemological point of view, or were too "psychological" or "stylistic" in their accounts, or else blindly ignored the intellectual and cultural aspects. He was, he later acknowledged, ready to try new and imaginative ways of thinking.[69] During the early 1920s, he eagerly followed the exciting and philosophically cogent work of his senior colleague Ernst Cassirer. And to Cassirer's work we must now turn.

5

Panofsky and Cassirer

For it is the same thing that can be thought and can be.
PARMENIDES

What we call nature . . . is a poem hidden behind a
wonderful secret writing; if we could decipher the puz-
zle, we should recognize in it the odyssey of the human
spirit, which in astonishing delusion flees from itself
while seeking itself.
CASSIRER

In a lecture delivered before Columbia University's depart-
ment of philosophy in April 1925, the respected art historian
and philosopher Edgar Wind characterized the state of con-
temporary philosophical thought in Germany for his American
audience by referring to the influential work of the neo-Kanti-
ans.[1] The task of the neo-Kantians, according to Hermann
Cohen, the founder of the Marburger Schule, was to read Kant
as Kant himself had advocated reading Plato: to "understand
him better than he understood himself."[2] In both *The Critique
of Pure Reason* (1781) and *The Critique of Judgement* (1790), Kant
had asserted that philosophers must inquire into the processes
of knowing before they can claim (if they ever can) "a knowledge
of something beyond . . . called reality."[3] This basic tenet re-
mained essentially unaltered for the neo-Kantians in the late
nineteenth and early twentieth centuries. The principal expo-
nent of this school of thought, according to Wind, was Ernst
Cassirer.

Cassirer and Panofsky were colleagues at both the University
of Hamburg and the Warburg Institute from the early 1920s

114

onward. Cassirer's reputation was prodigious and was not confined to philosophical circles. He was, according to Panofsky, "the only German philosopher of our generation who to the cultured was a substitute for the Church—when you were in love or otherwise unhappy."[4] So struck was he with Cassirer's mind and range of interests that Panofsky broke with tradition at German universities by attending his fellow professor's lectures, and he did so frequently over the years, according to Heckscher's remembrances.[5] Panofsky's art historical theory soon reflected what he learned from Cassirer.

In *The Problem of Knowledge*, Cassirer illuminates Kant's concern with provoking a "Copernican revolution" in philosophy in general and attributes its influence in particular to one specific formative notion:

> Kant does not stand merely in a position of dependence on the factual stuff of knowledge, the material offered by the various sciences. Kant's basic conviction and presupposition consists rather of this, that there is a universal and essential *form* of knowledge and that philosophy is called upon and qualified to discover this form and establish it with certainty. The critique of reason achieves this by reflective thought upon the function of knowledge instead of upon its content. . . . What had formerly been accepted as the real basis for truth is now recognized as questionable and attacked with critical arguments.[6]

The conservative appellation "neo-Kantian," however, fails to indicate Cassirer's originality and understates the impact of his work. Despite Cassirer's fundamental commitment to Kant, his thought had by 1925, according to Wind, entered a completely new era:

> No matter whether religion, mythos, or language is concerned, it appears to him as a universal rule that in the search for definite determinants, the idea of independently existing things or qualities more and more vanishes before the primacy of the methods of determination; until, finally, all that is thought, said, or believed, all the laws of science, all

the messages of religion, all the expressions of language, ap-
pear to be only symbols, created by the mind in producing a
world of understanding.[7]

In the end, Cassirer's program created a world of experience
considerably less stable than Kant's. He relinquished all hope
of comprehending the efficacy of the thing itself (*Ding-an-sich*)
in the world—which Kant had always implied would be impos-
sible (human knowledge is restricted by the "scope" of our
"sensible perceptions"; apart from experience the "categories
are empty")[8]—and instead investigated concepts of interpreta-
tion, concepts that alter with reference to the system of inter-
pretation that encompasses them. Kant had based his modes of
constructive thinking on Newtonian mathematics and declared
that the understanding of the empirical world was directed by
a limited number of concepts.[9] Cassirer found this limitation
too restrictive and, in response, scanned far more constructs as
he surveyed experience.

The "contents" of individual categories—language, myth, art,
religion, mathematics, history, science, and so forth—as histor-
ical entities are interesting only to a degree; more significant
for Cassirer is the *form* of knowledge each exhibits. How does
each as a closed system bring order to the chaos of perception?
What rules of epistemology can be discovered by a philosophi-
cal investigation into their distinctive and revealing configura-
tions? Kant, Cassirer claimed, had revolutionized philosophy
by concentrating upon the essential form of knowledge rather
than upon its contents. For this reason, Cassirer's work is better
read as a new and developing formalism than as an old Hege-
lian metaphysic.

Cassirer's fascination with Kant began during his undergrad-
uate years. Having become interested in the eighteenth-century
idealist during a seminar given at the University of Berlin by
Georg Simmel, Cassirer journeyed in 1896 to the University of
Marburg, one of the most famous but despised schools in Ger-
many, in order to continue his study of Kant under the expert
direction of Hermann Cohen. Because Cohen critically ques-

tioned the propositions and methodology of the natural sciences, he contributed to the Marburg School's reputation for being antipositivist.[10] The primary aim of Cassirer's teacher, according to Cassirer's friend and biographer Dimitry Gawronsky, was to purify Kant's philosophy of the "contradictions" with which it abounded and to find a productive way of concentrating anew on his fundamental precepts.[11] In the central chapter of *The Critique of Pure Reason*, "The Transcendental Deduction of the Pure Concept of Reason," Kant had evaluated the power of the intellect and its role in comprehending the world external to it. His conclusion was most suggestive: the meaning and coherence of human experience are grounded upon "premises" that are in no way "derived from experience." The "order of the objects of knowledge [is] a product of the activity of the mind."[12]

Cassirer, adopting the tendencies of the Marburg scholars, stretched his conception of the premises beyond the limits presented in Kant. The "objects of experience" to which Kant had clung, considering them sacrosanct, in Cassirer's mind cease to be objects in themselves and function instead as mere "appearances." Trained in neo-Kantian methods by Cohen, Cassirer divested the object existing in the external world of its substantiality and thereby eliminated the restrictive notion of the Ding-an-sich.[13]

Cassirer's thought as a serious student, like Kant's, began with the negative conclusions of skepticism. The belief that "things" have an essential nature, a knowledge of which increases a person's knowledge of the world, has traditionally been disputed by the skeptic. The skeptical challenge culminated, historically, in the work of Hume, who saw that even cause-and-effect relationships were imposed by the perceiving mind rather than embodied in the objects perceived. In the work of Hume, which Kant said in his preface to the *Prolegomena* (1783) "roused him from his dogmatic slumbers," the creation of all knowledge achieved the status of a problematic situation.

Cassirer completed his doctoral dissertation on Leibniz in

two years at Marburg.[14] Seeking a teaching post as a privatdo-
zent, he returned to Berlin and presented a controversial lec-
ture on Kant. "Time and again Cassirer tried to explain the
true meaning of the Kantian criticism, that human reason cre-
ates our *knowledge* of things, but *not* the things themselves; yet
without avail." Responses to his ideas were predictably dra-
matic and uncomprehending: "You deny the existence of real
things surrounding us," said the empiricist philosopher Riehl.
"Look at that oven there in the corner: to me it is a real thing,
which gives us heat and can burn our skin; but to you it is just
a mental image, a fiction!" Only Wilhelm Dilthey, an aged
scholar and professor emeritus, is reported to have supported
the young scholar's candidacy, saying decisively, "I would not
like to be a man of whom posterity will say that he rejected
Cassirer."[15]

 At Berlin, Cassirer read widely, particularly in linguistic re-
search and mathematical theory. Heinrich Hertz's *Die Prinzi-
pien der Mechanik* (1894) posed a new ideal by discrediting the
naive "*copy theory* of knowledge." In Cassirer's own words, "the
fundamental concepts of each science, the instruments with
which it propounds its questions and formulates its solutions,
are regarded [by Hertz] no longer as passive images of some-
thing given but as *symbols* created by the intellect itself."[16] Cas-
sirer's concern with the role of symbols in scientific thinking
convinced him that all thought is inextricably bound to specifi-
able modes of expression. In repeatedly asking himself, accord-
ing to Susanne Langer, his most famous student, "By what pro-
cess and what means does the human spirit *construct* its physical
world?" he was led to the speculation that all the "forms of ex-
pression" which determine how and what we think can aptly be
regarded as "symbolic forms." It was then only a short theoreti-
cal step to the central problem that would occupy him for the
rest of his life: "the diversity of symbolic forms and their inter-
relation in the edifice of human culture."[17]

 All of Cassirer's early works that lead up to his magnum
opus, *The Philosophy of Symbolic Forms* (1923–1929), reveal his

preoccupation, inherited from his neo-Kantian teachers, with affirming that the philosophical understanding of any one symbolic form requires recognition that each route to understanding has its own mode of necessity and its own distinctive perspective on reality.[18] He investigated the "conditions of possibility"—both historical and epistemological—that exist for the realization of each of the various branches of knowledge. The development of his ideas can be traced beginning with the first two volumes of *Das Erkenntnisproblem* (1906 and 1908)[19] and *Substanzbegriff und Funktionsbegriff* (1910) and continuing through his 1916–1918 *Kants Leben und Lehre* (one chapter of which I shall discuss in detail) and his 1921 interpretation of both Einsteinian physics (*Zur Einsteinschen Relativitätstheorie*) and nineteenth-century poetry (*Idee und Gestalt*), as well as in his early publications under the auspices of Saxl and the Warburg Institute (*Die Begriffsform im mythischen Denken*, 1922, and "Der Begriff der symbolischen Form im Aufbau der Geisteswissenschaften," 1923).[20]

The notion of a full-fledged philosophy of symbolic forms incongruously appeared to Cassirer in a vision on a streetcar one evening in 1917. Suddenly it became clear to him that the narrow view of cognition that the neo-Kantians had taken from Kant was inhibiting: "It is not true that only the human reason opens the door which leads to the understanding of reality, it is rather the whole of the human mind, with all its functions and impulses, all its potencies of imagination, feeling, volition, and logical thinking which builds the bridge between man's soul and reality, which determines and moulds our conception of reality."[21] The "constitutive character of symbolic renderings"[22] in a variety of fields—art, language, myth, religion, science, history—demanded philosophical investigation:

> Philosophical thought confronts all these directions—not just in order to follow each one of them separately or to survey them as a whole, but under the assumption that it must be possible to relate them. . . . With all their inner diversity, the various products of culture—language, scientific knowl-

edge, myth, art, religion—become parts of a single great problem-complex: they become multiple efforts, all directed toward the one goal of transforming the passive world of mere *impressions,* in which the spirit seems at first imprisoned, into a world that is pure *expression* of the human spirit.[23]

Throughout his many and varied writings, Cassirer's entire philosophical system is grounded in the conviction that an inviolate line must be drawn between human and beast and that this distinction is apparent in the exclusively human power to symbolize, which can be studied in its physical manifestations. Cassirer had always presupposed that the nature of man is embodied in his "work." Human cultural manifestations in all their variety function as a kind of symbolic formal language through which men and women "disclose meanings to each other" at the same time that they try to impose order on the chaos of experience:

Man cannot escape from his own achievement. . . . No longer in a merely physical universe, man lives in a symbolic universe. Language, myth, art, and religion are parts of this universe. They are the varied threads which weave the symbolic net, the tangled web of human experience. . . . No longer can man confront reality immediately; he cannot see it, as it were, face to face. Physical reality seems to recede in proportion as man's symbolic activity advances.[24]

His concern with the variety of these symbols—taken not as "indications" but as "organs of reality"—animated his long scholarly career, both in Germany and in the United States. He devoted himself to proving that no "reality" as such can be "meaningfully" understood "except under the implicit presupposition of the symbolic (constitutive) 'forms' of space, time, cause, number, etc. and the symbolic (cultural) 'forms' of myth, common sense (language), art, and science, which furnish the contexts (*Sinnzusammenhänge*) within which alone 'reality' is both encounterable and accountable."[25]

As it confronts the stuff of which the raw material world is created, the mind, according to Cassirer, never just passively reacts (we should remember Panofsky's dispute with Wölfflin); instead it becomes very active in the construction of its "universes of perception."[26] He repeatedly emphasizes the creative and synthetic powers of the mind as opposed to the "passive receptivity of sense-perception. The mind exercises its intellectual functions and in this consists its *a priori* character."[27] Metaphorically speaking, something creative and synthetic is interposed between the givenness of objects in the world on the one hand and human cognition with its compulsion to make these givens intelligible on the other. He refers to this mediating formal territory as a kind of "symbolic net," "the tangled web of human experience," whose "varied threads" are labeled art, language, myth, science, history, religion, and so forth. As in Kant, the "schema" is the "uniting 'representation,' the synthetic 'medium' in which the forms of understanding and the sensuous intuitions are assimilated so that they constitute experience."[28] In all of his work Cassirer assumes that no experience comes to us unmediated; the machinery of symbolizing always "interferes with" it. The world becomes "constituted" for man according to the forms of both his reason (Kant) and his imagination (Cassirer). This middle realm is the realm of knowledge. It is the "medium," in Cassirer's descriptive phrase, "through which all the configurations effected in the separate branches of cultural life must pass."[29] Into one side of the net comes the record of events and objects in the world; from the other we see evidence that an observer has tugged at the threads. The symbols, in this sense, create objects rather than merely indicate them. A symbolic form in general—whether it be a work of art, a spoken word, a mathematical proposition, etc.—"is an active interpreter, binding an intellectual content to a sensuous show."[30]

Cassirer's emphasis, Susanne Langer says, on "the constitutive character of symbolic renderings in the making of 'experience' is the masterstroke."[31] The symbolic form is neither the

world nor the source of thinking about the world but is, instead, a representation of the process of human creativity:

> In science and language, in art and myth, this formative process proceeds in different ways and according to different principles, but all these spheres have this in common: that the product of their activity in no way resembles the mere *material* with which they began. It is in the basic symbolic function and its various directions that the spiritual consciousness and the sensory consciousness are first truly differentiated. It is here that we pass beyond passive receptivity to an indeterminate outward material, and begin to place upon it our independent imprint which articulates it for us into diverse spheres and forms of reality. Myth and art, language and science, are in this sense configurations *towards* being: they are not simple copies of our existing reality but represent the main directions of the spiritual movement, of the ideal process by which reality is constituted for us as one and many—as a diversity of forms which are ultimately held together by a unity of meaning.[32]

From 1923 to 1929, when he was lecturing to his students and to Panofsky at Hamburg, Cassirer published three volumes of his *Philosophie der symbolischen Formen*, acknowledging in all three the importance and influence of Warburg and his library. Each addresses itself to a particular cultural "configuration": *Language* (volume 1, 1923), *Mythical Thought* (volume 2, 1925) and *The Phenomenology of Knowledge* (volume 3, 1929). He encouraged other scholars to add volumes under this rubric, addressing other fields of knowledge as "symbolic forms," and himself planned to expand the series in later years.[33] All three extensively researched volumes from the 1920s are rich in concrete details and original ideas. Collectively, they address themselves to what Cassirer defines in the second volume as the essential task of critical philosophy: "*The Philosophy of Symbolic Forms* . . . seeks the categories of the consciousness of objects in the theoretical, intellectual sphere, and starts from the assumption that such categories must be at work wherever a cosmos, a characteristic and typical world view, takes form out of the chaos of impressions."[34]

In the first volume, *Language*, Cassirer acknowledges that he has taken to heart Berkeley's words on the same subject from *A Treatise Concerning the Principles of Human Knowledge*: "In vain do we extend our view into the heavens and pry into the entrails of the earth, in vain do we consult the writings of learned men and trace the dark footsteps of antiquity. We need only draw the curtain of words to behold the fairest tree of knowledge, whose fruit is excellent, and within the reach of our hand."[35] Because of its primacy, the subject of language becomes the first course of study in the cultural sciences. It is the basic "'artifice' to which all other cultural forms may be related."[36] Like the ancient philosopher Heraclitus, Cassirer repeatedly asks whether there is a natural connection between the world and verbal accounts of it or whether the connection is only "mediate and conventional." Addressing itself to that "middle region of words that is situated *between* man and things,"[37] the first volume reflects upon language's intermediary capacities. On one level, words obviously connect individuals to one another. Perhaps more significantly, however, language serves to connect the human mind and the world of objects. As a symbolic form, it "presupposes," in the words of one recent critic of Cassirer, "a fundamental identity between the objective and subjective spheres" and concludes, in the words of one older literary critic, that "verbal meaning arises from the 'reciprocal determination' of public linguistic possibilities and subjective specifications of those possibilities."[38] According to Cassirer, language "is a magic mirror which falsifies and distorts the forms of reality in its own characteristic way."[39]

Not only language, however, is interposed between the perceiver and the perceived, as Humboldt had earlier stressed. Myth, the subject of the second volume, performs an analogous "distortion":

In the very first, one might say the most primitive, manifestations of myth it becomes clear that we have to do not with a mere reflection of reality but with a characteristic creative

elaboration. Here again we see how an initial tension be-
tween subject and object, between "inside" and "outside" is
gradually resolved, as a new intermediary realm, growing
constantly more rich and varied, is placed between the two
worlds.[40]

Yet writing about myth presented difficulties. Anthropological
data, unlike linguistic studies, were sparse in the mid-1920s.
Cassirer often used the resources of the Warburg Library to
supplement his own pioneering research (Warburg himself, it
may be recalled, was interested in the subject as well and even
traveled to the American Southwest to study the Pueblo Indi-
ans).[41] One of the original "armchair anthropologists," Cas-
sirer was primarily interested in understanding myth
philosophically; "insight" begins with the idea that myth "does
not move in a purely invented or made-up world but has its
own mode of *necessity* . . . , its own mode of *reality*."[42] He fre-
quently defined mythical thinking by opposing it to "contem-
porary" scientific procedure ("Whereas the scientific causal
judgment dissects an event into constant elements and seeks to
understand it through the complex mingling, interpenetration,
and constant conjunction of these elements, mythical thinking
clings to the total representation as such and contents itself
with picturing the simple course of what happens"). The
broader semiotic implications are obvious. All thought, not
only that of the mythical world, "is and remains a world of
mere representations—but in its content, its mere *material*, the
world of knowledge is nothing else."[43]

The significance of myth, then, lies in its ability to exhibit the
symbolic attitudes that are less exposed in "higher" intellectual
projects. Less exposed but nevertheless fully functional, these
attitudes characterize all human endeavor and, in the end,
make a priori assumptions and imaginative responses an inevi-
table fact of human existence:

It seems only natural to us that the world should present it-
self to our inspection and observation as a pattern of definite

forms, each with its own perfectly determinate spatial limits that give it its specific individuality. If we see it as a whole, this whole nevertheless consists of clearly distinguishable units, which do not melt into each other, but preserve their identity that sets them definitely apart from the identity of all the others. But for the mythmaking consciousness these separate elements are not thus separately given, but have to be originally and gradually derived from the whole; the process of culling and sorting out individual forms has yet to be gone through.[44]

Language and Myth, the book in which this passage appears, is not part of the series *Symbolic Forms*, although it too was published during the 1920s. In *Symbolic Forms* Cassirer had been concerned only with each form in its historical and cultural *specificity*. After completing the first two volumes, however, he paused to explore the braided relationship between the first two symbolic threads, language and myth. Implicit in this passage is the conclusion that while mythic thought differs from modern in its lack of distinctions, it provides in its conception of the world an initial perspective from which we can develop a more discriminating view, a view which will allow "the process of culling and sorting out individual forms . . . to be gone through." Constantly revitalized by elements of myth in metaphor and in other figures of speech, language represents a kind of continuing prologue to the possible, enabling the mind to make more and more penetrating analyses into the nature of experience by constructing, as Cassirer says, "forms of its own self-revelation."[45]

Because it was not published until 1929, *The Phenomenology of Knowledge*, volume 3 of *The Philosophy of Symbolic Forms*, does not exactly lie within the temporal purview of Panofsky's early essays. I shall mention it only in passing, insofar as it brings to fruition ideas found in the earlier two volumes. In the third book Cassirer takes on the "objective" realm of mathematical and physical science and explores it through its "structure of meanings." Any science, he says, "can never jump over its own

shadow. It is built up of definite theoretical presuppositions, within which it remains imprisoned. . . . There is now no road back to that relation of immediate congruence and correspondence which dogmatism assumed to exist between knowledge and its object."[46] The proper route of analysis lies ahead, and we can locate it only by reversing the traditional direction of inquiry: "We should seek true immediacy not in the things outside us but in ourselves. . . . The reality of perception is the only certain and utterly unproblematical—the only primary—datum of all knowledge." Scientific knowledge is itself the epitome of a complexly articulated symbolic form.[47]

After scanning the vast array of subjects to which Cassirer turned his gaze, from Goethe's poetry to Melanesian mana to Newtonian physics, we can hardly find the breadth of his vision other than staggering. Some critics, however, have identified its scope as its weakness.[48] Cassirer is equally interested in all sorts of human endeavor, because all embody, in their architectonics, the symbolic forms that the mind uses to comprehend reality. These forms of human thought had traditionally been regarded as incapable of indicating the "real" nature of reality because of their fictitious, imaginary, or unscientific nature (for example, myth). For Cassirer, however, they include the purest and most valid forms of evidence. "For the mind, only that can be visible which has some definite form," and it is solely by the agency of these forms "that anything real becomes an object for intellectual apprehension."[49]

The Philosophy of Symbolic Forms takes as one premise that each of the forms must be regarded as distinct from each other, if only for methodological legitimacy. "For the fundamental principle of critical thinking, the principle of the 'primacy' of the function over the object, assumes in each special field a new form and demands a new and dependent explanation."[50] Cassirer investigates each special "odyssey"[51] of the human mind as a "scholar working in a well-stocked library." For him, the world is "something known only indirectly . . . an object postulated and described by a series of authorities."[52]

A historical survey of the authorities is the necessary prereq-

uisite to analysis of the forms. "In order to possess the world of culture we must incessantly reconquer it by historical recollection."[53] In practice, Cassirer's particular historical technique is similar to Warburg's. The Warburgian method consisted in following a key theme or a telling visual motif through history (from ancient times to the Renaissance) in order to watch its kaleidoscopic transformations, which in turn, provide insight into changing philosophical and cultural attitudes. Similarly, Cassirer frequently takes one of his symbolic forms and traces within a historical framework not only its alteration in the course of time but also that of the philosophical commentary on it. "With steady grasp," declares his biographer, "he picked up the development through all its stages and ramifications" and showed "how the *same* concept acquired a *different* meaning, according to the diverse philosophical systems in which it was applied as a constructive element."[54]

Having situated each of the forms in its historical context, Cassirer advises the analyst to elaborate certain philosophical principles valid for its understanding. In a sentence that might well recall Panofsky's plea in his critique of Riegl for the discovery of an Archimedean viewpoint from which to view "the phenomenon of a work of art," Cassirer declares that philosophy must find a "standpoint situated above all these forms and yet not merely outside them: a standpoint which would make it possible to encompass the whole of them in one view, which would seek to penetrate nothing other than the purely immanent relation."[55] Critical analysis must always begin with the "given, from the empirically established facts of the cultural consciousness; but it cannot stop at these mere data. From the reality of the fact it must inquire back into the conditions of its possibility."[56] Without doubt, the historical and philosophical understanding of each of these different symbolic forms (science, religion, morality, art, myth, language, and so forth) is primary. Each one must be described and classified as distinct from any other; all can then be painstakingly laid out side by side, creating a vast array of human culture.

Still the philosopher's task is not complete. In the end, the

scattered and disordered array is neither sufficient nor mean-
ingful. The morphology of the human spirit must give way to a
general Kulturwissenschaft. "The particular must not be left to
stand alone, but must be made to take its place in a context."
The philosopher must "ask whether the intellectual symbols by
means of which the specialized disciplines reflect on and de-
scribe reality exist merely side by side or whether they are not
diverse manifestations of the same basic human function."[57]
Contending that philosophy traditionally "both aimed and fell
short of elaborating principles of such high generality that
would, on the one hand, be valid for all domains and, on the
other, be susceptible of modifications characteristic of the spe-
cific differences distinguishing these domains," Cassirer advo-
cates striving toward "a systematic philosophy of human cul-
ture in which each particular form would take its meaning
solely from the *place* in which it stands."[58] The task of Kultur-
wissenschaft should be to find a "unity of spirit" rather than to
discover the "multiplicity of its manifestations." Scholars of cul-
ture must search for the "medium through which all the con-
figurations effected in the separate branches of cultural life
must pass . . . , [the] factor which recurs in each basic cultural
form but in no two of them takes exactly the same shape."[59]

If such statements sound reminiscent of Hegel, Cassirer in-
tends to profit by the association. I do not suggest that Cassirer
had outright pretensions to be a Hegelian; in each of the three
volumes of *Symbolic Forms*, he concentrates on the particularity
of language, myth, and science in their singular contexts. Still,
in designating as his goal the "phenomenology of human cul-
ture"[60] (a term that he coined in deference to Herder and his
"'thousand protean forms' of the spirit"),[61] Cassirer deliber-
ately invoked Hegel's *Phenomenology of the Spirit*. As a compari-
son of the two titles suggests, however, Cassirer wanted to re-
main with "known" objects and "knowable" attitudes. He
wanted to keep the "unknown" at bay.[62] He acknowledged the
possibility that the various symbolic forms had a "unified, ideal
center," but for him this center consisted not in a spiritual es-
sence but in a "common project" (that of "transforming the

passive world of mere *impressions* . . . into a world that is pure *expression* of the human spirit").[63] The hub of his wheel of cultural history, as distinct from Gombrich's model of the Hegelian method, is not a divine plan working itself out through history but rather a specific historical and cultural propensity to symbolize: "We must renounce such reified carrier standing behind the historical movement; *the metaphysical formula must be changed into a methodological formula.*"[64]

Cassirer's methodological formula is both simple and elegant. While emphasizing the structural integrity of individual symbolic forms, he always reserves the right to postulate the closest connection among them. Collectively, the objectifications of the versatile human spirit create a harmonious and organic whole. The separate fields of inquiry on which the linguist, for example, or the art historian, anthropologist, or philosopher of science labors are necessary for their "intellectual self-preservation,"[65] a term Cassirer borrows from Wölfflin, but to limit one's inquiry as a scholar is to deny one's fulfillment as a humanist:

> Undoubtedly human culture is divided into various activities proceeding along different lines and pursuing different ends. If we content ourselves with contemplating the results of these activities—the creations of myth, religious rites or creeds, works of art, scientific theories . . . , so many variations on a common theme . . . , it seems impossible to reduce them to a common denominator. But a philosophic synthesis means something different. Here we seek not a unity of effects but a unity of action; not a unity of products but a unity of the *creative process.* If the term "humanity" means anything at all it means that, in spite of all the differences and oppositions existing among its various forms, these are, nevertheless, all working towards a common end. . . . Man's outstanding characteristic, his distinguishing mark, is not his metaphysical or physical nature—but his work. It is this work, it is the system of human activities, which defines and determines the circle of "humanity."[66]

> The image is a product of the empirical faculty of the pro-
> ductive imagination—the schema of sensuous conceptions
> (or figures in space, for example) is a product, and, as it
> were, a monogram of the pure imagination a priori, whereby
> and according to which images first become possible, which,
> however, can be connected with the conception only medi-
> ately by means of the schema which they indicate, and are in
> themselves never fully adequate to it.[67]
>
> Kant, *Critique of Pure Reason*

Art, like any other symbolic form, is "not an imitation but a
discovery of reality."[68] Yet art itself plays no major role in Cas-
sirer's three volumes, except as he uses it to illustrate a sym-
bolic form in general. He did not elaborate his notion of art as
a particular symbolic form until he wrote *An Essay on Man*
(1944), which appeared decades after the publication of *Philo-
sophie der symbolischen Formen*, and even then it received only a
chapter's attention. But as Katharine Gilbert has noted,

> we are not . . . without indication of the direction his [Cas-
> sirer's] applications might easily have taken in the field of vi-
> sual arts. . . . Dr. Erwin Panofsky['s] . . . rich iconographical
> studies in the main illustrate what Cassirer would like to have
> understood as the application of his theory of art to painting
> and sculpture. . . . For period after period [Panofsky in "Die
> Perspektive als 'symbolische Form'"] matches the artistic han-
> dling of spatial relations, the particular variant of perspective
> worked out by a period's artists, with wider tendencies in
> philosophy and science. . . . There is in any case in any age a
> world-outlook characteristically coloring both art and philos-
> ophy. . . . Within the "symbolic form" are condensed "symp-
> toms" of the political, scientific, religious, and economic ten-
> dencies of the age that produced the work.[69]

Panofsky's "Die Perspektive als 'symbolische Form'" appeared
in the 1924–1925 *Vorträge der Bibliothek Warburg* (published
in 1927).[70] I shall discuss this essay in detail, because it makes
plain the theoretical connections between Panofsky and Cas-
sirer, mentioning more briefly several other essays written dur-
ing the 1920s in which Panofsky demonstrates familiarity with

and responsiveness to Cassirer's work. Although no published translation exists, the essay on perspective is well known and is still frequently cited in the continuing debate among art theorists and perceptual psychologists on the "conventionality" of perspective. The controversy surrounding the essay arises from Panofsky's assertion that perspectively constructed paintings have no absolute validity, no claim to representing space as we actually see it.

It is my contention that Panofsky's interpretation of the system of perspective has been consistently misunderstood by his many vocal critics. Gilbert's analysis, for example, operates on only one level—the most obvious one and the one with which most commentators stop in their identification of the thought of Cassirer and Panofsky (also the level, ironically, at which Panofsky himself seems to stop in the first part of his essay). If we deliberately juxtapose this essay with Cassirer's work (and in the title "Perspective as Symbolic Form" Panofsky has himself intentionally taken a position at Cassirer's side), we can eliminate much of the critical confusion while also reading this ambitious piece of scholarship as its young writer intended.

The optical "accuracy" of paintings executed according to the laws of linear perspective has long been the subject of lively debate among scholars in several disciplines—art historians, perceptual psychologists, philosophers, and historians of science. Recently, Marx Wartofsky, a philosopher of science, has refueled the ancient argument with the bold assertion that the *convention* of linear perspective developed in the Renaissance has, in fact, taught us how to *see*. During the past centuries this "widely practiced convention of our visual activity" has gradually conditioned our habits of seeing; and so it is very tricky to determine what is "real" and "accurate" about an optical system that is itself a "historical artifact."[71] Wartofsky—unlike, say, Goodman or Gombrich—does not argue that a perspective painting works or does not work according to the laws of geometry. Instead he is concerned to discover why a system so transparently ordered by geometrical laws became adopted and

has been maintained as *the* mode of seeing for 500 years. However well-argued, his is not the first statement of this thesis.

One of the most interesting writers on the subject, and one whose work Wartofsky has neglected to note—is, of course, Panofsky. More than half a century before Wartofsky's studies appeared in print, Panofsky wrote the essay on perspective as a symbolic form, in which he posed many of the same problems and, not surprisingly, offered many of the same ingenious answers. Because Panofsky's essay is often quoted, but also because it is frequently misread, I would like to take a fresh look at it by reading it in conjunction with Wartofsky's essay. My intention here is twofold: first, to project "Perspective as Symbolic Form" into the present by setting it against Wartofsky's contemporary work, and second, moving backward in time, to trace Panofsky's work to its origin in the work of Ernst Cassirer. This second task will occupy us more fully, for only a careful reading of Panofsky's paper, situated in its own time and place, will reveal to us in the present the scope of his vision in 1924.

To understand the issue as it is perceived in the 1980s, we should return briefly to Wartofsky's essay. Most recent writers on perspective stress, in avowed opposition to Panofsky, the inexorable necessity of using this two-dimensional system to depict a three-dimensional world.[72] When Gombrich, for example, notes the paradox that "The world does not look like a picture, but a picture can look like the world," he is reaffirming the efficacy of this particular system for creating the illusion of space. It is not just another "mapping method"; there is "something compelling in the trick."[73] As a geometrical system, at least, linear perspective is internally consistent and in no sense arbitrary, as Panofsky would have it.

Wartofsky, on the other hand, concentrates on precisely this issue, the "arbitrariness" and "conventionality" of linear perspective: "I will argue that our seeing the world perspectivally, so to speak, is the product of specific modes of . . . visual praxis, and that perspective representation is therefore not a

'correct' rendering of the way things 'really look,' but rather a choice of seeing things in a particular way." Completely arbitrary it is not, however. Perspective representation has been arrived at through a time-bound and historically "achieved canon of representation." We do not see with our eyes alone. The mind, with its culturally induced predispositions, tells us what to look at: "Human vision has a history which develops in relation to the history of culturally dominant forms of representation." Gradually, over the centuries, we learn not to see the convention for what it is. Why? Because the perspective of Renaissance painting has become the "perspective of the world."[74] Human vision is historically conditioned. Art has taught us how to see; perspective has become, for the most part, an unchallenged aspect of our own visual cognition.

If such statements sound familiar to theorists of art history, it is because ideas very close to those of Wartofsky are usually attributed to Panofsky; to be sure, many of Wartofsky's statements have the ring of Panofsky. Still, Panofsky's essay is much more subtle than the mere refutation of the legitimacy of Renaissance perspective that most writers have predictably taken it to be. Let us look more closely at its argument.

The first part of the essay analyzes the Renaissance system of perspective, which has been traditionally regarded by art theoreticians as an instrument, or at least a measure, of objectivity. To Panofsky, however, perspective construction, like neo-Kantian philosophy, reveals to us the ways in which the perceiver determines the perception. After summarizing Alberti's system of perspective, Panofsky challenges its representational legitimacy by declaring that it involves "an extremely bold abstraction from reality." "This whole 'central perspective,' that it may ensure the formation of a fully rational . . . space, tacitly makes two very important assumptions: first, that we see with a single, motionless eye; second, that the plane section through the cone of sight is an adequate reproduction of our visual image."[75] He includes a reference more than a page long to Cassirer, in-

dicating that "geometrical space" has no "independent content" of its own and that it is a "purely functional not a substantial being" (pp. 260–261; pp. 2–3).[76]

Although most art theorists from Alberti onward would agree that the perspectival image is synonymous with the retinal one, neither Panofsky, nor Wartofsky for that matter, is so certain. Panofsky distinguishes between a "retinal image" (*Netzhautbild*) and a "visual image" (*Sehbild*) (p. 261; p. 4), and he challenges perspective first on the ground that it claims to represent the world as our eyes see it. In order to see things perspectivally (that is, by making the perspectival image synonymous with the retinal one), we must restrict our view in peculiar ways. Like Cyclops, we must stare straight ahead with one fixed and motionless eye, and we cannot permit our personal or cultural predispositions to color what we see. In his critique of Wölfflin, Panofsky had already dispensed with a similar notion as naive. Putting aside these once-voiced objections, he has ready what he considers to be a new mathematical/optical line of attack, or at least a rediscovered and very old one.

The "retinal image," Panofsky says, "shows the shapes of things projected not on a plane but on a concave surface" (p. 261; p. 4). The problem with Renaissance theorists was that they let themselves "be governed by the rule of pictorial perspective that a straight line is always seen as straight, without considering that the eye actually projects not on a plane but on the inner surface of a sphere. . . . While plane perspective projects straight lines as straight, our organ of sight perceives them as curves" (pp. 263, 262; pp. 6, 5). Ancient optics had understood the plan of curvature and had "adapted its theory much more closely than the Renaissance could to the actual structure of the subjective visual impression." Accordingly, Renaissance theorists "suppressed" the relevance of the eighth theorem of Euclid and "in part so amended it that it lost its original meaning" (p. 264; pp. 7–8).

Because Panofsky wants to stress that perspective is a "mythical structure" (possibly emphasizing the "artificiality" of a sym-

bolic form more than Cassirer would), his optical and mathematical demonstrations (the essay contains more than thirty diagrams) can be viewed as curiously unnecessary for his principal point. His use of mathematics might be seen as the recourse of a person who is insecure with the direction in which his imagination is taking him, and therefore he resorts to a rationalistic accounting of a problem that his particular impulse to theorize on perspective suggests is basically irrational. To state the matter more positively, as Panofsky himself does in his characterization of Plato's theory in another work, "the value of a work of art" can be determined in the same way that a "scientific investigation" can—"by measuring the amount of theoretical and especially mathematical insight invested in it."[77]

Having rather hastily argued that perspective is not retinally exact, Panofsky asks the obvious question. If we "see" objects in the world as curved, why do we claim that plane perspective depicts the world as we see it? His answer here is the same as Wartofsky's: because the intellectual disposition of our culture tells us to do so. Whether or not the laws of linear perspective are valid geometrically (and on this issue Panofsky does equivocate), the most significant issue for him, as for Wartofsky, is why we tend to use the system of geometry to transcribe what we see. Modern perspective differs from that of antiquity because our modes of beholding have been tampered with. Not only have we been persuaded by the representational coherence of Renaissance paintings and had our attitudes "reinforced" (p. 263; p. 6) by advances in photography (precisely Wartofsky's "new" argument), but more important, we think differently from the ancients. We possess a philosophical view of the world, of which our rectilinear spatial system is part and parcel. In the second part of the essay, Panofsky addresses himself to the still-contested problem of whether or not the ancients, specifically Vitruvius, had some sort of linear perspective system (p. 267; p. 11).

Clearly problems are surfacing that begin to undermine his

argument. At this point, Panofsky seems in doubt as to which question he should ask. How accurate is perspective, or is verisimilitude not in question? In part 1 he disputed the validity of Renaissance perspective, but by part 2 he has granted it a certain authoritative primacy and is judging other spatial systems against the standard of the fifteenth century. In other words, he is simultaneously undercutting and exalting perspective as a diagnostic instrument—an inconsistency that leads to several epistemological quandaries. Does he want to challenge the accuracy of the perspectival system's use of geometry or to acknowledge its geometrical accuracy while asking why we choose to depict our lived and intuited sense of space in abstract, mathematical terms (as Wartofsky does)? Finally, returning to his statements in the first part, he dismisses accuracy as a pictorial value: "If perspective is of no moment for value, it is of moment for style," and he refers at this crucial point to Cassirer: "More than that, it may, to apply to the history of art Ernst Cassirer's happily coined term, be called one of those 'symbolic forms,' through which a spiritual meaning is joined to a concrete sensuous sign and becomes an essential property of that sign" (p. 268; p. 12). In this case, what is "significant for the different periods and spheres of art" is not the attempt to construct a coherent spatial system but the kind of system that exists and the ways in which it relates to other imaginative constructs of the age—for example, to philosophy, literature, religion, and science.

As he attempts to muster support for this rather radical hypothesis, Panofsky calls upon the authority of Riegl and mentions the Austrian theorist's interest in the problem of changing conceptions of space (he does so without mentioning Riegl explicitly). Wary of the haptic/optic dichotomy, Panofsky would nevertheless agree with Riegl that for the ancients space was that which was "left as it were between bodies." Once again he sets the ancient conception of space against the "norm" of the Renaissance: Roman space, for example,

remains a spatial aggregate; it never becomes what modern perspective demands and realizes—a spatial system. . . . For the modern tendency we designate with this name always posits that higher unity above empty space and above bodies, so that from the very start by this assumption its observations get their direction and unity. . . . While antiquity because of the lack of that higher unity must pay as it were for each gain in space by a loss in body. . . . And it is just this that explains the almost paradoxical phenomenon that the world of ancient art, as long as it made no attempt to reproduce the space between bodies, appears by contrast with the modern as more solid and more harmonious, but as soon as it includes space in its representation—especially therefore in landscape painting—it becomes singularly unreal and contradictory, a world of mists and dreams.[78]

In the last paragraph of the second part, Panofsky proposes to conclude, with a rather spurious use of the word "therefore," what he says he has already demonstrated: "Ancient perspective is therefore the expression of a determinate conception of space diverging fundamentally from the modern conception . . . and at the same time of an idea of the world, equally determinate and equally divergent from the modern."[79] From Democritus to Aristotle, he declares, ancient philosophers conceived "the whole of the world" as "something through and through discontinuous" (pp. 270–271; p. 15). In effect, they had no fixed "perspective" on things. When a Greek artist set out to paint objects in space, "therefore," he arrayed them according to the intellectual principles of his time.

Initially focusing his essay on the perceptual "accuracy" of linear perspective, he has leapt in a few pages from curvilinear retinal perception to a survey of changing styles of spatial depiction. Now, by way of summary, he is attempting to link these changing methods of depiction to changing modes of intellectual expression. His scope is ambitious, to be sure, but it involves a number of concealed premises that should not be al-

lowed to escape notice. In no way has Panofsky justified linking perception, depiction, and expression. Perhaps these links are warranted when we speak of the Renaissance, but he is specifically talking about ancient art.

In a slightly earlier essay on a somewhat similar subject, "Die Entwicklung der Proportionslehre als Abbild der Stilentwicklung" (1921), Panofsky defined the limits of his investigation more cautiously.[80] He examined the history of canons of proportions: "Not only is it important to know whether particular artists or periods of art did or did not tend to adhere to a system of proportions, but the how of their mode of treatment is of real significance." He says in the introduction that he wants to account for the change with meaningful explanations: "If we concentrate not so much on the solution arrived at as on the formulation of the problem posed, they will reveal themselves as expressions of the same 'artistic intention' (*Kunstwollen*) that was realized in the buildings, sculptures and paintings of a given period or a given artist."[81] Most of the essay, however, confines itself to a formal and stylistic analysis. He keeps his investigations of the Kunstwollen to a will-to-form shared by all artists of a period.

Similarly, in his two-volume study of medieval German sculpture, *Die deutsche Plastik des elften bis dreizehnten Jahrhunderts* (curiously—considering its methodology—written in 1924, the same year as both *Idea* and "Perspektive"),[82] Panofsky asserts that his task is above all to define the "essence of style" by concentrating on workshops, internal artistic influences, and so forth in the manner of the Viennese school. For reasons earlier elaborated in his critique of Riegl, he deliberately remains oblivious to the cultural historical situation. When he does resort to a cultural "text," he does so not to provide background material but rather to show that the organizing aesthetic and theoretical principles are the same. Nevertheless, constituting a piece of sculpture entirely through its form[83] only partially answers his plea in the Riegl essay for a *Sinninterpretation* that is

"valid not for us but objectively," because it still concentrates on notions of style rather than on the "essential meaning."

In the first part of the later essay on perspective, his synchronic historical program is much more ambitious. Riegl's Kunstwollen has been replaced by Panofsky's interpretation of Cassirer's *das Symbolische*. Panofsky wants to link not only all artistic productions of an era but all productions in general, from philosophy to sculpture, thereby weaving a tangled web of culture. Everything becomes symptomatic of everything else. He sets forth a sort of protoiconology gone wild (as Gilbert's passage has suggested), or perhaps more accurately, a popularization of Cassirer's more restrained enterprise—a facile roundup of all the symbolic forms of an era, regardless of function, shape, or individual significance. Cassirer, we may remember, deliberately refrained from such a project, feeling that the time was not yet at hand for a grand philosophical synthesis: "The particular cultural trends do not move peacefully side by side, seeking to complement one another; each becomes what it is only by demonstrating its own peculiar power against the others and in battle with the others."[84] Did Panofsky remain insensitive to the problem, as he seems in the first synchronic section of his essay (comprising parts 1 and 2)?

Much of the middle section (part 3) shows us that he did not. Granted, his words about finding "analogues" (p. 273; p. 17) between philosophy and art still have a synchronic edge: "Again this achievement in perspective is only a concrete expression of what had been put forward at the same time on the part of epistemology and natural philosophy."[85] For the most part, however, his confidence as a juggler of many and various symbolic forms now seems to have been undermined, and he acknowledges that his center is not holding. He seems to be looking within the visual tradition itself (as Riegl or Wölfflin might have done) for ways to account for changes in perception, and he offers us a new concept of art historical periodicity: "Out of the wreckage of the old edifice comes the rearing

of the new" ("das Abbruchsmaterial des alten Gebäudes zur Aufrichtung eines neuen zu benutzen"):

> Where work on definite artistic problems has gone so far that . . . going further in the same direction seems to be fruitless, it is usual for those great setbacks or reversals to occur which, often joined with the transference of the leading role to a new province or style of art, precisely through a renunciation of what has already been achieved (that is, through a return to apparently more "primitive" forms of representation) provide the possibility of using the wreckage of the old edifice for the rearing of a new, precisely by establishing a distance to prepare for the creative taking up again of the old problems. Thus we see Donatello emerging not from the faded classicism of the followers of Arnolfo but from a definite Gothic tendency . . . and thus, intervening between the ancient and the modern and presenting the greatest of these "setbacks" came the Middle Ages, whose historical mission in art was to fuse into a genuine unity what had previously appeared as a plurality of individual things.[86]

The pictorial mode of organization is linked no longer only synchronically to the culture of which it is a part but diachronically as well to the visual development of one symbolic form. (Much later, Wartofsky, in the tradition of Kuhn, would see this connection as evidence of paradigmatic supremacy.) In a way, Panofsky is trying something he had earlier reprimanded Wölfflin for doing. He locates his cause-and-effect relationship securely within the visual tradition itself, sealing the work of art off from the cultural influences that threaten its integrity. Giotto and Duccio, for example, with their representation of "closed interiors," began the "overthrow of the medieval principle of representation." They created a "revolution in the formal significance of the surface of representation" by painting "a 'picture plane' in the exact sense of the word . . . , a piece cut out of space" (p. 278; p. 23). The Lorenzetti, Masaccio, and even Alberti then continued to consider painting within this

one particular articulated visual format for the organization of representational space.

Clearly Panofsky is searching for another route of analysis to explain the existence not only of contradictory trends within one style (for example, Carolingian art) and oppositions between artists of the same period (for example, Rogier van der Weyden and Petrus Christus) but also of seemingly conflicting characteristics within the work of one artist (for example, Donatello). The larger symbolic form, *art* (or even perhaps Renaissance art), contains within itself several varying ideas and techniques—some old, some "revolutionary"—for expressing spatial relationships.

Such speculation anticipates by half a century the diachronic concerns of George Kubler, who in his book *The Shape of Time* develops the notion of varying formal sequences within a specific period or style, the organization of figures in space being defined as a sequence of formal relations, for example. Just because an artist and a philosopher, or two different artists, were born in the same era does not mean that the cultural analyst should burden them with the same imagination. The morphological identification of the elements that constitute a series, Kubler says, should remain independent of questions of meaning and unaffected by symbolic interpretations. He attributes overemphasis on questions of meaning to the influence of Cassirer.[87] Yet a closer reading of Cassirer (of the sort that Panofsky seems to have given him) discloses a similar pervasive interest in the problem of *formal* sequences: "The result is an extraordinary diversity of formal relations, whose richness and inner involvements, however, can be apprehended only through a rigorous analysis of each fundamental form."[88]

Panofsky's thinking on the system of perspective in general and on perspectively constructed pictures in particular becomes much more complex and labyrinthine as we progress through the essay, and the narrow position rather dogmatically argued in the first two sections, which we have related to Wartofsky's thesis, is moderated in the last. In some sense, we can

read Panofsky's response to the complex issue as showing affinities with Cassirer's thought in another text, the 1916 commentary on Kant (published in 1918), *Kants Leben und Lehre*.[89] I do not want to stress the influence of this work on Panofsky, for I am not sure he ever read it, but I think it merits some attention as it helps us locate some of the basic philosophical assumptions that the two thinkers shared.

In the sixth chapter of the commentary, "Die Kritik der Urteilskraft," Cassirer turns to Kant for guidance in thinking about works of art and about the idiosyncratic problems they pose for the philosopher. The problem of central concern is how the pure, concrete forms of art require modes of investigation different from those employed in scientific inquiries. In the physical sciences, analysts proceed with their "research and discovery by constructing a whole out of parts," but another model of cognition is clearly needed for aesthetic understanding: "The truth in its actual and perfect sense is opened up to us first if we no longer begin with single things as given and real but rather end with them."[90]

The model for this discourse has already been provided by the biological sciences, and the comparison of biological and aesthetic problems is revealing. "There is, as Kant calls it, a 'principle of formal purposiveness' involved in our understanding of individual form in nature."[91] In any one organism, the biologist (and here he is assisted by the findings of Leeuwenhoek) discovers the whole as already given and constitutive of its various parts. It is "both cause and effect of itself."[92] The biological organism as such requires no external completion outside itself in order to be characterized in its organic individuality. "But," according to Hendel, "the most direct and immediate apprehension of individuality and form is in art, which is a concrete representation where the phenomenon is experienced as the whole being determinant of the parts and disclosing itself through them." Only in art, says Cassirer, where the "resonance of the whole in its particular and single circumstances is treated, do we stand in the freedom of play and perceive this freedom."[93]

A work of art is a single and self-contained whole that is based upon itself, with a purpose that exists solely within itself (precisely Panofsky's earlier sentiments in the critique of Riegl, written only two years after Cassirer's text was published). Taking as his point of departure the problem of *Zweckmässigkeit*, Kant, in *The Critique of Judgement*, attempted to "establish the direction our knowledge takes when it judges something as purposeful, as the expression of an inner form."[94] According to Cassirer, the entire teleological system of the Enlightenment mistook purposiveness (Zweckmässigkeit) for common usefulness (*Nutzbarkeit*). A work of art bespeaks a certain purposiveness without purpose. The pleasure (*Lustempfindung*) that we derive from its contemplation is disinterested. We experience satisfaction not because we realize that this individual work exemplifies an empirical law that we can put to use or classify but rather because we are affected by its "internal ordering of appearances," which seems to reify the appropriateness or suitability (Zweckmässigkeit) of our own perceptions.[95] The laws of purely mechanical causality do not carry us sufficiently far. In confronting a work of art, we are interested not in "causal connections . . . but only in pure presences." Only the aesthetic understanding does "not ask what the object is and how it works, but what I make of its presentation." The aesthetic observation does not require any external completion; it has no basis or goal outside itself.[96] The feeling of the "sublime" that it can engender is divorced from other concerns. The idea of a nonpurposive purpose "serves not the basic idea of mathematical physics . . . , not analysis, but synthesis, because it first creates a reflective unity which only later can be dissected into causal elements and conditions."[97] The single thing here is not evidence of an abstract universal standing behind it but rather is the universal itself, because it holds its contents symbolically within itself.[98] It is a picture of a total mental cosmos.

In this long and often repetitive critique, Cassirer makes two principal points that are interesting precisely as they lead us to recall Panofsky's attempts to cope with them, one after the

other, in different parts of his essay on perspective. First of all, Cassirer emphasizes that a work of art is an autonomous and isolated object, independent of every purpose but its own, and its interpretation has little to do with the cultural or artistic context from which it arose. In this sense, Cassirer's aesthetic understanding seems at odds with Panofsky's, at least as exemplified in the first three parts of his essay which we have just reviewed. As we shall see, however, concern with the formal integrity of art becomes primary by Panofsky's highly speculative fourth and concluding section. Cassirer, like Kant, is interested for the most part not in causal connections but only in pure presences, the nonpurposive purpose of a work of art.

Yet, on the other hand, Cassirer also stresses the compatibility of different methods for understanding a work of art. Kant understood the aesthetic sphere to be self-contained, but he placed it alongside a universe explained in causal and mechanistic terms. A "work of art possesses its own center of gravity at the same time that it interacts with other essences." Just as individual causal laws are cases of laws in general (according to a mechanistic model), so a work of art joins with other works of art, and all carry with them the symbolic import of a total causal ordering. The claim of purpose in Kant, says Cassirer, was not to correct or complete the thinking on causality, for a work of art can always be seen as subject to causal law. Just as there is no contradiction between the self-contained "beauty of nature and the laws of nature," there can be no conflict between the nonpurposive purpose of a work of art and the causal conditions of its existence. "Every special form has to be explainable out of the preceding conditions of the surrounding world."[99]

The antinomy between the conception of a nonpurposive purpose (*Zweckbegriff*) and the causal connections (*Kausalbegriff*) disappears as soon as we think of both as two different but complementary methods of ordering through which we strive to bring unity to the manifold phenomena of experience:

The *Critique of Judgment* aims to prove that there is no antinomy whatsoever between these two *forms of order* in knowledge. They cannot contradict one another because they relate to problems in distinct fields that must be kept carefully apart. Causality has to do with knowledge of the objective temporal succession of events, the order in change, whereas the concept of purpose has to do with the *structure* of those empirical objects. . . . To appreciate this structure . . . in its characteristic and specific form does not mean that we must desert the general domain of causality in order to explain it or catch at some sort of superempirical or supersensuous cause. It is enough if we recognize a special kind of being —that of "natural forms"—and understand it in its systematic order as a unified self-contained structure.[100]

That the "reconciliation of teleology and mechanism" is perhaps possible in transcendental contemplation suggests above all else that for explanation's sake we need to avail ourselves of both forms of order.[101] The principle of purpose does not so much "resist meaning as prepare for it, as it calls the causal principle to it and assigns it its tasks." Every individual form "encloses within itself unlimited entanglements."[102]

As we proceed through Panofsky's essay, we see him trying to unscramble these entanglements within the system of perspective. Following Cassirer, who follows Kant, Panofsky "experiments" with different ways of ordering his problem. Consequently, his essay should be criticized for its randomness less than it is praised for its scope. Earlier he experimented with separate approaches in separate works. *Die deutsche Plastik*, for example, almost excluded iconographic questions; "Melencolia I" raised them to the status of a science.[103] Wölfflin was reprimanded for not being "cultural enough"; Riegl was admonished for not being more "rigorously" formal. Panofsky has attempted, within the confines of the essay on perspective, what he accomplished only in piecemeal fashion earlier: a totally comprehensive (formal, cultural, philosophical) treatment of one particular visual form. Although the various approaches

are not completely reconciled, being considered separately in the essay, they are nonetheless arrayed, so that the insights afforded by each are highlighted by its proximity to the others.

The first two approaches discussed in Panofsky's text are thus patterned on what Cassirer would call mechanistic laws, although they differ in intent, to be sure. The first section (comprising parts 1 and 2) attempted to establish causal connections synchronically—examining the work of art in relation to other forms of thought manifested in the culture. The third part, on the other hand, focused on diachronic connections—explanations of causal development conceived within the visual tradition alone. It is appropriate to recall here that Panofsky had earlier criticized both Riegl and Wölfflin for not being broadminded enough in their analyses.

In the last part (part 4) of Panofsky's essay, the work's internal structure or intrinsic meaning (*Sinn*)[104] occupies a position of considerable importance, playing a role, offering a new method of ordering, that has received little attention to this point in the text. Panofsky now begins to approach the system of perspective from what Cassirer would call a teleological vantage point or from what Panofsky himself would elsewhere call the Archimedean viewpoint. He considers the symbolic form of perspective construction no longer in terms of causal connections but rather in itself alone, as a singly centered symbolic form, or a "forming accomplishment of the content of reality," examining its internal coherence and wholeness as Cassirer advocated with the first approach he described in the Kant commentary. "The painting in perspective may cease to be consistent with the world around it, but it remains closely knit within its own system of references."[105]

The last part of the essay reconciles in so many ways not only the principles of investigation set forth in the earlier parts but also the concerns, especially those dependent on the distinction between form and content, that we have traced through all of Panofsky's early works. We must situate this most significant

section in its own intellectual and historical context, then, in order to read it in detail.

Still concerned with the "intellectual poverty" (*Begriffsarmut*) of the history of art, in 1925 Panofsky composed a new theoretical manifesto, "Über das Verhältnis der Kunstgeschichte zur Kunsttheorie: Ein Beitrag zu der Erörterung über die Möglichkeit 'kunstwissenschaftlicher Grundbegriffe,'" a brief examination of which may help to clarify his rationale for conjoining several methods in his essay on perspective.[106] He again expressed his dissatisfaction with both Riegl's and Wölfflin's a posteriori categories of art historical analysis, especially Riegl's Kunstwollen, which, because it is a psychological reality, fails to explain art as a "metaempirical object."[107] He sought above all else, as he had in 1920, to make Kunsttheorie philosophically legitimate, and the only way he could see to accomplish this task was by developing a priori categories: Grundbegriffe that only perform the "positing and not . . . the solutions of the artistic problem," asking the questions of the object but not providing the answers.[108] In order to be valid in Kantian terms, these categories must be independent of all experience; they must be based on "purely intellectual routes" ("auf rein verstandesmässigem Wege").[109] Like philosophy, art history requires a "transcendental analysis of the very possibilities of art."[110]

Panofsky then proceeded to adopt the a priori categories posited by his Hamburg friend the philosopher and art historian Edgar Wind.[111] The most general ontological antithesis in art, according to Wind, is that between *Fülle* and *Form* (in neo-Kantian terms, Panofsky defines them as corresponding to "time" and "space"). For a work to come into existence, a sort of balance, or "settlement" (*Auseinandersetzung*),[112] must be achieved between these opposing poles of value: "The manner in which elements are composed in a work of art reveals a specific creative principle, i.e., a specific principle of solving problems. In a given work the set of principles used for solving ar-

TABLE 1

Panofsky's schematic representation

Universal antithesis inside the ontological sphere	Specific contrasts inside the phenomenal and, to be sure, visual spheres			Universal antithesis inside the methodological sphere
	1. Contrast of elementary values	2. Contrast of figurative values	3. Contrast of compositional values	
The *Fülle* stands opposed to form	*Optischen* values (open space) stand opposed to *haptischen* values (bodies)	The deep values stand opposed to surface values	The value of "into one another" (merging) stands opposed to the values of "next to one another" (division)	Time stands opposed to space

SOURCE: Panofsky, "Über das Verhältnis der Kunstgeschichte zur Kunsttheorie: Ein Beitrag zu der Erörterung über die Moglichkeit 'kunstwissenschaftlicher Grundbegriffe,'" *Zeitschrift für Ästhetik und allgemeine Kunstwissenschaft* 18 (1925): 129–161 (reprinted in H. Oberer and E. Verheyen, *Erwin Panofsky: Aufsätze zu Grundfragen der Kunstwissenschaft* [Berlin, 1964], 51).

tistic problems constitutes a unity."[113] (Panofsky's schematic representation, shown in table 1, is intended, he says, to make things clearer).[114] This unity is synonymous with the Sinn, the intrinsic meaning of a work of art or of a particular period. This concept is elegant in its methodological usefulness, because it permits the art historian "to join two methodological positions usually opposed in the study of art . . . , the method which stresses the autonomy of artistic phenomena and the method which stresses their links with the other elements of the historical process." Employed in the right way, it can posit a "common factor in the intrinsic meanings found in the various fields of culture."[115]

In the essay on perspective, the concept of Sinn is stretched to span the traditional distinction between form and content. In the system of Renaissance perspective, the bridge that re-

sults is as broad as the geometry on which it is based. Sinn refers not simply to subject matter, but to content—the "revelation" achieved when idea and form approach a "state of equilibrium."[116] The "specific creative principle," anchored by the poles of "necessity" (p. 289; p. 33), which gives a painting in perspective its actual material existence, reflects a traditional neo-Kantian dialectic involving the opposition of the mind and the world, of subject and object, or, perhaps we could argue, of Fülle and Form.

A painting in perspective is not just an exercise in mimesis but an expression of a desire to order the world in a certain way—a definition in space of the Kantian relationship between I and not-I. Where Cassirer says each symbolic "sphere not only designates but actually creates its particular and irreducible basic relation between 'inside' and 'outside,' between the I and the world,"[117] Panofsky defines perspective as being

> by its very nature a two-edged weapon. . . . It subjects the images of art to fixed, that is mathematically exact rules, but on the other hand, it makes them dependent on man, even on the individual, insofar as these rules refer to psychophysical conditions of the visual impression and insofar as the way in which they are carried out is determined by the freely chosen position of a subjective "point of view."[118]

Renaissance perspective, described as "mythical" and "culturally conventional" in the first half of the essay, is now being assessed as a viable, almost empirically verifiable, way of articulating space. It is now doubly enhanced, being not just one very effective spatial construction but itself a philosophical reflection on constructiveness.

Referring to the "categorical distinction between 'I' and 'not-I' [that] proves to be an essential and constant function"[119] of Cassirer's thought, Panofsky stresses that a perspective painting owes its existence to the necessary "distance" between man and the objects in his world. Quoting Dürer (following Piero della Francesca), he uses the notion of distance to

suggest that the system of perspective, somewhat arbitrarily, reconciles the metaphysical opposition between subjectivity and objectivity: "Das Erst is das Aug, das do sicht, das Ander ist der Gegenwürf, der gesehen wird, das Dritt ist die Weiten dozwischen" (p. 287; p. 31). ("The first is the eye that sees, the other is the object that is seen, the third is the distance between.") The "distance between" depends upon the relationship between eye and object, as does Cassirer's notion of a symbolic form. The middle territory, which in itself exists only as it is expressed in various symbolic forms, becomes, in effect, the sole "object" of study in both Dürer's painting and Cassirer's epistemology.

Panofsky attributes the historical attack on perspective "from two quite different sides" to its being midway between realism and idealism:

> If Plato condemned it in its modest beginnings because it distorts the "true sizes" of things and puts subjective appearance and caprice in the place of reality and law, the ultramodern criticism of art makes exactly the opposite charge that it is a product of a narrow and narrowing rationalism. . . . in the end it is hardly more than a question of emphasis whether the charge against perspective is that it condemns "true being" to the appearance of things seen or that it binds the free and as it were the spiritual intuition of form to the appearance of things seen.[120]

In his *"Idea": Ein Beitrag zur Begriffsgeschichte der älteren Kunsttheorie* (written in the same year as the essay on perspective and in response to Cassirer's lecture "The Idea of the Beautiful in Plato's Dialogues," given at the Warburg Library), Panofsky continues to pursue what he calls the subjective/objective problem and its historically changing polarities: "the problem of the relationships between 'I' and the world, spontaneity and receptivity, given material and active forming power."[121] Renaissance art theorists may be distinguished from those of the Middle Ages by their concentration on the notion of distance. Fifteenth-century theorists set a "distance between 'subject' and

'object' much as in artistic practice perspective placed a distance between the eye and the world of things—a distance which at the same time objectifies the 'object' and personalizes the 'subject.'" Yet Panofsky emphasizes that Renaissance art theory was practical, not speculative. Calling Alberti no "anticipative neo-Kantian," Panofsky stresses his lack of a philosophic point of view. The "naive" purpose of Renaissance art theory was only "to provide artists with firm and scientifically grounded rules for their creative activity."[122]

The task of art theory has altered substantially since the Renaissance. Because Kant discounted the notion of universally valid laws, the art theoretician, by choice or not, operates in a new universe of discourse:

> In epistemology the presupposition of this "thing in itself" was profoundly shaken by Kant; in art theory a similar view was proposed by Alois Riegl. We believe to have realized that artistic perception is no more faced with a "thing in itself" than is the process of cognition; that on the contrary the one as well as the other can be sure of the validity of its judgments precisely because it alone determines the rules of its world (i.e., it has no objects other than those that are constituted within itself).[123]

The ideology behind spatial configuration can no longer reflect the "naive" assumption that a perspective painting is in any way isomorphic with the world it depicts. In its formal representation of perception, however, the Renaissance painting remains consistent with a neo-Kantian vision of the human project.

Panofsky tried to explore perspective neither from the point of view of the artist who practiced it nor in terms of the mathematical principles upon which it was founded (these matters should receive only preliminary consideration) but finally in terms of the rules according to which the discourse operates. For Cassirer a symbol is "not only an ideal object [located] halfway between man and his world and binding the two. It is also a busy messenger running back and forth between [them] with

the office of conciliation,"[124] or to continue, "Art can no more be defined as the mere expression of inward life than as a reflection of the forms of outward reality."[125]

In these neo-Kantian terms, the Sinn of perspective can be viewed less as a "two-edged weapon," as Panofsky calls it, than as a two-sided mirror. Alberti's model of the cross section through the visual pyramid, with its apex in the eye and its base in the object, is, in this context, a visual metaphor of the artist's perspective upon the chaos of experience at large, with the concept of the symbolic form becoming the picture plane in the pyramidal design. In Panofsky's mind, this particular symbolic form, the system of perspective—as witness the history of its success—enters the Renaissance exactly halfway between the two worlds of subjective and objective experience:

> So the history of perspective may be understood with equal right as a triumph of the feeling for reality, making for distance and objectivity, and as a triumph of the human struggle for power, denying distance; it may be understood equally well as a fixing and systematizing of the external world and as an extension of the ego's sphere. It had therefore constantly to pose for artistic thought the problem as to the sense in which this ambivalent method was to be used.[126]

From one side of the glass, we receive the record of events in the world behind it, while the other brings in systems of order generated by the mental processes of the observer. Perspective, an artist's language in Cassirer's sense, is "*at once* a sensuous and an intellectual form of expression."[127] The mutual interaction of these two forms of expression on the surface of the glass indicates the presence of a symbolic form that is in itself both a humanly originated experience and the revelation of another reality. The "perspective view . . . mathematicizes . . . visual space, but it is still visual space that it mathematicizes; it is an ordering, but an ordering of visual appearance" (p. 290; p. 35).

Neither the contextualist nor the formalist approach to Renaissance paintings, then, is sufficient unto itself. Even taken together they might fail to detect the larger epistemological implications of this particular systematization of space. Interpretation only partly consists in historical reconstruction of each type. To explain a painting is not simply to discover its antecedents, either painted or written, and to link them in a concatenation of cause and effect. Rather it is the role of interpretation to explain the phenomenon of perspectival spatial representation in a system that itself depends upon certain canons of representation. Perspective is an ambiguous organon located precisely at the midpoint on the representational spectrum between a device of representation and the object represented and being both at once.

Concepts such as "form" and "content" take us only part way toward comprehending the intrinsic meaning, the Sinn, of a representational painting. Not just content, let alone subject matter, is culturally determined, but form as well. The representational device of perspective bespeaks historicity. That it does so does not detract from its authenticity. A painting executed in perspective does bear some resemblance to the world, but as both Wartofsky and Panofsky remind us, it is a curiosity in itself that physical likeness is "not the only choice open to us," especially physical likeness dependent upon abstract geometric principles.[128]

Wittgenstein's picture theory of knowledge offers an interesting parallel here. In his 1921 *Tractatus Logico-Philosophicus* (which appeared in Germany three years before Panofsky's essay), Wittgenstein defines "propositions" about the world (such as mathematics) as those statements that "picture" a state of affairs. A proposition, like a picture, is an argument but not an arbitrary one. Like the system of perspective, it shares a "pictorial and logical form" with the thing it purports to represent.[129] We might consider propositions, as Panofsky construes perspectival ordering, as a framing device. "It is impossible to say anything about the world as a whole," says Bertrand Rus-

sell, introducing Wittgenstein; "whatever can be said has to be about bounded portions of the world."[130] In Wittgenstein's words, "a spatial point is an argument place."[131] A proposition confirms only the reality of the propositioner; like linear perspective, it deifies the viewer. All things exist in relation to him or her who contemplates them: "How much truth there is in solipsism. . . . The world is *my* world: this is manifest in the fact that the limits of *language* . . . mean the limits of *my* world."[132]

In the tradition of both Wittgenstein and Cassirer, in an essay directly inspired by the latter, Nelson Goodman inquires in this vein: "If I ask about the world, you can offer to tell me how it is under one or more frames of reference; but if I insist that you tell me how it is apart from all frames, what can you say? We are confined to ways of describing whatever is described. Our universe, so to speak, consists of these ways rather than of a world or of worlds."[133] Perspective construction, which understandably intrigued Goodman in an earlier work,[134] is emblematic of the distinctly human propensity to symbolize: to frame worlds within worlds. All representational devices, but especially such a durable one as linear perspective, ceaselessly locate us in the world. We would clearly "disappear" without them.

The pictorial form does not merely signify a meaning outside itself but instead unveils a space in which it can be connected with other contemporaneous symbolic forms whose traces it bears. It lays bare the formalities of a cultural space. Homologies appear among different cultural productions. Indeed, the formal system of perspective interrelates with other issues in the Renaissance (social, philosophical, scientific, and so forth), but at the same time it exhibits—because it is transparently a system of relationships—the formal principles underlying all Renaissance structures, including itself. As a framing device, it perhaps depends upon Renaissance philosophical principles and modes of scientific investigation, but its internal coherence and holism in turn systematically engender certain ways of viewing the world (see Panofsky's *Galileo as a Critic of*

the Arts).[135] The underlying systems of formal conventions that permit both a painting by Leonardo and, say, a Copernican model of the solar system to convey "content" produce and reinforce one another. To understand each, historical reconstruction must pay attention not only to what they "say" but also to the formal system that permits both to "speak." Form and content are "not double roots of style," Panofsky had said in his critique of Wölfflin, but expressions "of one and the same principle."

Where does Panofsky's statement leave us? Can we label Panofsky a formalist or a contextualist? The history of art history tells us that all scholars identify Panofsky with the contextualist approach. To be fair, they have evidence, even in Panofsky's closing words in this essay, that he himself—as he first hinted almost ten years earlier in his essay on Wölfflin—would do so:

> It is accordingly only a matter of course that the Renaissance interpreted the meaning of perspective quite differently from the Baroque, Italy quite differently from the North: there—to speak very generally—its objective significance was felt to be the more important, here its subjective significance. . . . We see that a decision could only be reached . . . on the basis of those large oppositions we are accustomed to call caprice and norm, individualism and collectivism, irrationality and reason or the like, and *that times, nations, and individuals would have to take an especially definite and evident position on these modern problems of perspective.* [Italics added][136]

Yet because he emphasizes that the perspective system is a holistic formal structure in turn dependent upon deeper formal codes of knowledge, we cannot fail to see something far more ambitious in his work than simply interest in situating a picture in its societal context or interest in describing its deployment of line, color, shape, and so forth. The formalism of his conclusion is itself difficult to describe, because no Archimedean viewpoint is available to us. Panofsky is writing, and we are reading, from the standpoint of the engaged observer. All that we can do is acknowledge that in discussing the perspec-

tival organization of a Renaissance painting from our particular perspective as described by Alberti's model, we are conforming to the system that the painting itself has promoted in the West.

Perspective painting originates in the human intellect.[137] It is a fixing and systematizing, on a painted surface, of what Kant called a "synthesis of recognition" and Herder "reflection": "Man demonstrates reflection when the force of his soul works so freely that in the ocean of sensations that flows into it from all the senses, he can, in a manner of speaking, isolate and stop One wave, and direct his attention toward this wave, conscious that he is so doing."[138] As a convention of both seeing and transcribing the seen (scene), "painter's perspective" arose in an identifiable historical situation and, as David Summers says, "by implication states a new consensus about the senses, the mind, and the world."[139] Once established, according to Patrick Heelan, the system of perspective "implies the notion that reality itself is pictorial."[140]

Before it ends, Panofsky's long and experimental essay on ways of "ordering" artistic impressions provides the "convention" of perspective with a new and broader meaning. It is no longer the limited and creatively limiting structure that it seemed in the first half of the paper. The culturally "achieved canon of representation" has become in Panofsky's view itself expressive of a creative interdependence of the mind and the world—a symbolic form, representing artist and nature on the painted canvas as they mutually inform each other's meanings. In works of art—those of Rembrandt, for example—"the perspective treatment of space transforms reality into appearance [and] seems to reduce the divine to a mere content of human consciousness, but to that end, conversely, [it] enlarges human consciousness into a vessel for the divine."[141]

Panofsky has translated Alberti's description of perspective into a neo-Kantian model of perception. He calls perspective an artificial convention neither because the Renaissance called the mathematical method of constructing pictures *perspectiva*

artificialis nor because this construction historically distorts our "real" view of the world but because it is a system of knowledge that can be viewed, in its most enduring sense, as a powerfully revealing construct, a symbolic form, interposed between the perceiver and the perceived. As Cassirer, paraphrasing Goethe, eloquently puts it: "In the continuous mobility of the spirit, all sight . . . passes into contemplation, all contemplation into speculation, all speculation into combination, so that at every attentive glance into the world we are theorizing . . . the most important thing . . . is to recognize that all fact is in itself theory."[142]

6

Later Work:
An Iconological Perspective

Wenn ich mich beim Urphänomen zuletzt beruhige, so
ist es doch auch nur Resignation; aber es bleibt ein
grosser Unterschied, ob ich mich an den Grenzen der
hypothetischen Menschheit resigniere oder innerhalb
einer hypothetischen Beschränktheit meines bornierten
Individuums.

If I find peace at last in the realm of original phenom-
ena, it is only a matter of resignation, but there is a
great distinction between my resignation at the limits of
hypothetical humanity and my resignation within the
hypothetical limits of my narrow-minded individuality.

GOETHE

Contemporary art history in large part depends upon the
methodological vision of Erwin Panofsky. It is now orthodox
for a student of past art to attempt to situate his or her study in
a context and to decipher, on some level, the personal and cul-
tural ideas that it embodies. Pursuing the always-elusive "mean-
ings" of works of art, scholars trained within the last thirty-five
or forty years continue to demonstrate their special debt to
Panofsky's later works. Of the almost 200 listings in his bibliog-
raphy, *Studies in Iconology* (1939), *Gothic Architecture and Scholas-
ticism* (1951), *Early Netherlandish Painting* (1953), and *Meaning in
the Visual Arts* (1955) have together come to represent the so-
called iconological method.

Ironically, however, these later works ("later" in comparison
with the 1915–1925 theoretical papers), which are generally
regarded as the theoretical culmination of Panofsky's career, in

158

fact only recreate the initial stages of a program implicit in his earlier writings. Art historians not acquainted with the background of many of Panofsky's ideas frequently see in his later work merely a practical program for the deciphering of specific and not-so-hidden symbols in visual images. Iconology, despite Panofsky's emphasis on semantics, is still understood as only a slightly more refined and sophisticated version of iconography. In some sense, this situation originated with and was perpetuated by Panofsky himself, especially in his English writings. Having investigated the epistemological assumptions associated with the genesis of Panofsky's approach to art history, we should not let the success and popularity of his later work distract us from continuing our critical examination of its principles.

Although Panofsky first posited the iconological approach as a possible direction for art historical inquiry in *Hercules am Scheidewege und andere antike Bildstoffe in der neueren Kunst* (1930) and "Zum Problem der Beschreibung und Inhaltsdeutung von Werken der bildenden Kunst" (1932), as a "method" it lacked a coherent systematization until 1939.[1] *Studies in Iconology* categorizes, in tabular form, three levels of meaning or subject matter present in every visual image and provides specific suggestions as well for their interpretation:

A "preiconographical description," on the basis of "practical experience," interprets "primary or natural subject matter."

An "iconographical analysis" ("in the narrow sense of the word") is interested in the "secondary or conventional meanings" that can be discovered by a knowledge of literary sources.

An iconological interpretation ("iconography in a deeper sense")[2] directs itself to Panofsky's original concern with "intrinsic meaning or content." To reveal the meaning of a work of art on this level, we must familiarize ourselves with

the "essential tendencies of the human mind" as they are
conditioned by cultural predispositions and personal psy-
chology.

Iconographic and iconological readings both present the art
historian with symbols that demand decoding. But the similar-
ity between the two goes no further. Although their names orig-
inate in the same root word, Panofsky categorically distin-
guishes between what he calls "symbols in the ordinary sense"
and "symbols in the Cassirerian sense."[3] As ordinary symbols,
he cites examples such as the Cross or the Tower of Chastity,
images that can be rather perfunctorily deciphered in light of a
learned acquaintance with the literary and visual traditions. A
Cassirerian symbol, on the other hand, requires a subtler sensi-
tivity. "Humanists cannot be 'trained'; they must be allowed to
mature or, if I may use so homely a simile, to marinate."[4]

If we wish to interpret motifs and images as "manifestations
of underlying principles," we must become familiar not only
with the work of art in both its stylistic form and its storied con-
tent but also with all of the possible ineffable and ultimately
unverifiable forces (psychological, societal, cultural, political,
spiritual, philosophical, and so forth) that have jointly shaped
its singular existence—forces that may well be "unknown to
the artist himself and may even emphatically differ from what
he consciously intended to express":

> This means what may be called a history of *cultural symp-
> toms*—or "*symbols*" in Ernst Cassirer's sense—in general.
> The art-historian will have to check what he thinks is the *in-
> trinsic meaning* of the work, or group of works, to which he
> devotes his attention, against what he thinks is the *intrinsic
> meaning* of as many other documents of civilization histori-
> cally related to that work or group of works, as he can mas-
> ter: of documents bearing witness to the political, poetical,
> religious, philosophical, and social tendencies of the person-
> ality, period or country under investigation.[5]

As compelling as this idea or method is in theory, it nevertheless has led to a certain confusion in practice. Let us recall a few of Panofsky's later "practical" works as illustration.

Take, for example, an essay published as an illustration of the iconological approach, "The Neoplatonic Movement and Michelangelo." As many scholars before Panofsky had demonstrated, Michelangelo came into contact with Neoplatonic ideas in his Florentine circle. "All this is not exceptional. With an Italian artist of the sixteenth century the presence of Neoplatonic influences is easier to account for than would be their absence." But Panofsky's intention in his essay is to prove how deeply a Neoplatonic conception of life infused Michelangelo, not just as "a convincing philosophical system, let alone as the fashion of the day, but as a metaphysical justification of his own self. . . . Michelangelo resorts to Neoplatonism in his search for visual symbols of human life and destiny, as he experienced it."[6] Frequently paraphrasing philosophers such as Ficino and Pico della Mirandola, Panofsky labors to provide a working sketch of Neoplatonism. Without the least self-consciousness, he equates Michelangelo's weltanschauung with his understanding of this specific philosophical doctrine. This particular philosophy, he suggests, became *intentionally* expressed in Michelangelo's works of art. In *Gothic Architecture and Scholasticism*, Panofsky again confers a certain primacy on philosophical thought as it is embodied in one particular doctrine. The work of scholastic scholars carried a compelling and determinative force, whose "mental habits" and "controlling principles" became appropriated, *unintentionally* in this instance, by the architects working in the great cathedrals affiliated with the universities.[7]

In practice, Panofsky's "system" of iconology in such inquiries—which direct themselves toward the discovery of "intrinsic analogies," according to Hermerén—is a unidirectional enterprise: a world view *or* a particular philosophy results in a specific work of art.[8] The direction of the equation exemplifies,

however, an inherent confusion in the iconological method. In his introduction to *Studies in Iconology*, Panofsky obviously intends to draw a significant distinction between a world view, on the one hand, and, on the other, a particular philosophy that either contributes to or articulates, but does not itself form, that weltanschauung: "The intrinsic meaning or content . . . is apprehended by ascertaining those underlying principles which reveal the basic attitude of a nation, a period, a class, a religious or philosophical persuasion—unconsciously qualified by one personality and condensed into one work."[9] In this sense, Panofsky's purpose seems to be to study a world view that is expressed in a work of art. If so, Hermerén thinks, then the traditional model of Panofsky's work should be replaced by that which he suggests in theory.

It is often the case that Panofsky's more practical essays are structured upon analogies between pictures and propositions. Yet to be faithful to the theoretical views set forth in the introduction to his method, he should be interested primarily in the ways in which larger world views affect not only paintings but "philosophical doctrine" as well. In turn, the study of the relationship between art and philosophy would help expose the predominance of a certain weltanschauung affecting all artifacts and attitudes of an age. So viewed, the "discrepancy" between practice and theory would disappear.[10] But the ideal is lost sight of, and the practical iconological program turns out to be much narrower in scope. In the words of Kurt Forster, a harsher critic, such establishment of direct connections, for example between Neoplatonic philosophy and Michelangelo's art, "led to highly questionable results . . . , where philosophical propositions are given a generative role for the making of art."[11]

The reversal in direction leads to other problems with Panofsky's iconological method, as Otto Pächt intimated twenty-five years ago. In a book review of *Early Netherlandish Painting* written for the *Burlington Magazine*, Pächt questions the integrity of Panofsky's dictum of discovering "'symbolical values' . . . which

are generally unknown to the artist himself and may even emphatically differ from what he consciously intended to express." If it is true that the new materialism in Northern art was secretly and ingeniously strewn with hidden symbolism, as Panofsky proposes in his central chapter, "Reality and Symbol in Early Flemish Painting: 'Spiritualia sub Metaphoris Corporalium,'" then, Pächt asks, what is unusual about these symbols' need to be deciphered?[12] When Panofsky remarks "that this imaginary reality was controlled to the smallest detail by a preconceived symbolical program,"[13] he obviously means to suggest that this disguised symbolism was intentionally planned and incorporated in paintings by artists such as the Master of Flemalle and Jan Van Eyck and is, therefore, part of a consistent iconographic program. The significant question in this case is, in short: how can this sort of decoding of the intentional be called iconological rather than second-level iconographic? Panofsky's objective here differs markedly from that which he advanced in "Perspective as Symbolic Form" and the introduction to *Studies in Iconology*: "Since the creative act is placed on the level of consciousness and is imagined to be of non-intuitive nature, art-historical interpretation is orientated in a new direction; its ultimate aim being no longer to understand the philosophy embodied by, and implicit in, the visual form, but to discover the theological or philosophical preconceptions that lie behind it."[14] As practiced in 1953, the iconological method, in Białostocki's view, had "developed in the direction of interpreting 'conscious' rather than 'unconscious' symbolism. . . , [and] iconologists are frequently more interested in interpreting the second level, that of conventional symbolism, than in analyzing a work of art as a cultural symptom."[15]

Creighton Gilbert attacked the practice of iconology from the other side. Taking iconology to be the result of a method rather than the technique itself, he argues that the iconologist's problems begin just at that point when he or she decides not to stay with the iconographic evidence but to press on into the

"deeper" content and significance of a work. Accordingly, Gilbert preaches moderation. Must every Renaissance painting possess a secret—a deeper meaning than that which it first appears to convey? Is every nativity scene a prefiguration of the Lamentation; every beam of sunlight passing unbroken through a pane of glass a symbol of Mary's chastity?[16]

Panofsky, as we might expect, was not insensitive to the obvious ensnarements that iconology presented. In a private communication with William Heckscher in which he described a Northern Renaissance symposium from which he had just returned, his response to yet another reading—this one perhaps sillier than most—regarding Arnolfini's *real* identity was to quote the Latin epithet: "I was dumbfounded, my hair stood up, and my voice stuck to my mouth."[17] Accordingly, he cautioned against letting the imagination run wild: "There is, however, admittedly some danger that iconology will behave, not like ethnology as opposed to ethnography, but like astrology as opposed to astrography." "There is, I am afraid," he concludes,

> no other answer to this problem than the use of historical methods tempered, if possible, by common sense. We have to ask ourselves whether or not the symbolical significance of a given motif is a matter of established representational tradition; . . . whether or not a symbolical interpretation can be justified by definite texts or agrees with ideas demonstrably alive in the period and presumably familiar to its artists; . . . and to what extent such a symbolical interpretation is in keeping with the historical position and personal tendencies of the individual master.[18]

A familiarity with contexts, translated in practice primarily as "texts," became the necessary prerequisite to any art historical analysis. Panofsky's pursuit of humanistic knowledge, in particular his mastery of Greek and Latin commentaries, increasingly came to distinguish his philological research from that of his formalist predecessors.

We have reached the most perfunctory criticism leveled at iconology: the notion that Panofsky knew nothing about art as

art. From his reputation as a classical scholar, says Gombrich, "there was only a short step to the misunderstanding that Panofsky was mainly interested in texts explaining the meaning of symbols and images, and that he did not respond to the formal qualities of art." Walter Friedländer, however, upon being told by a mutual colleague that Panofsky was very erudite but lacked the discerning eye of a connoisseur, retorted, "I think it is just the other way round. . . . He is not as learned as all that, but he has a wonderful eye."[19]

As a matter of fact, so it is said, Panofsky was very proud to have one nearsighted and one farsighted eye,[20] and he humorously interpreted this quirk of nature as prefiguring his art historical destiny. As I have repeatedly noted in earlier chapters, Panofsky undoubtedly restored an emphasis on content to the practice of art history, but it is equally important to stress that he hardly forsook an admiration for formal qualities in the process. In his "History of Art as a Humanistic Discipline," he even goes as far as to assert that "in the case of a work of art, the interest in the idea is balanced, and may even be eclipsed, by an interest in form."[21] It is not in the least unusual to discover, in the midst of his erudite iconographic expositions, an attention to other matters. When he deciphers Titian's "abstruse" *Allegory of Prudence,* for example, he closes his study with an eloquent tribute to Titian's formal virtuosity, even though form is here defined only in its relation to meaning:

> And it is doubtful whether this human document would have fully revealed to us the beauty and appropriateness of its diction had we not had the patience to decode its obscure vocabulary. In a work of art, "form" cannot be divorced from "content": the distribution of color and lines, light and shade, volumes and planes, however delightful as a visual spectacle, must also be understood as carrying a more-than-visual meaning.[22]

On what basis, then, is Panofsky's reputation as an art historian identified with his interest in meaning to the exclusion of

form? First of all, from the very start of his scholarly career (re-call the 1916 critique of Wölfflin), his interest lay in addressing questions of both form and content in his analyses—to treat both as mutually expressive of meaning, or as he would later say, of the "essential tendencies of the human mind."[23] He ex-tended the notion of "meaning" beyond the traditional identifi-cation of subject matter into an exploration of more general ways of thinking and perceiving that could have helped to shape the style of a painting as easily as they could account for the choice of motif. Style, according to Schapiro's essay on the subject, "is then viewed as a concrete embodiment or pro-jection of emotional dispositions and habits of thought com-mon to the whole culture."[24] Style is form grounded in his-tory. Viewed from this angle, content and form become parallel manifestations of the same historical urge or mentality. This, at least, was Panofsky's expressed goal early in his career: it was the rationale behind his critique of Wölfflin, the philo-sophical aim of his paper on Riegl, and the source of his tour-de-force in the essay on perspective. But the task was easier to recommend than to practice and, as a result, we see Panofsky in the much later "History of Art as a Humanistic Discipline" struggling to redefine the traditional art historical vocabulary:

> Anyone confronted with a work of art, whether aesthetically re-creating or rationally investigating it, is affected by its three constituents: materialized form, idea (that is, in the plastic arts, subject matter) and content. . . . One thing, how-ever, is certain: the more the proportion of emphasis on "idea" and "form" approaches a state of equilibrium, the more eloquently will the work reveal what is called "con-tent."[25]

Content is regarded as the precipitate produced when form reacts upon idea: it is "that which a work betrays but does not parade. It is the basic attitude of a nation, a period, a class, a religious or philosophical persuasion—all this *unconsciously* qualified by one personality, and condensed into one work"

[italics added].[26] To anyone familiar with the iconological "system," these three constituents—form, idea, and content—might seem to correspond, respectively, to Panofsky's three levels of iconography. The preiconographic description attends to the *formal* presentation of the objects in "certain configurations of line and colour" apart from their significance; the iconographic analysis "in the narrower sense" investigates the specific *idea* (literary) behind the formal presentation; and the iconological interpretation ("iconography in a deeper sense") uncovers the hidden attitudinal contents that generate the "need" for a "form" to give shape to an "idea" in the first place. Almost Freudian in its stress on discovering deeper and deeper strata of meaning, this sequence, despite Panofsky's protestations to the contrary ("In actual work, the methods of approach which here appear as three unrelated operations of research merge with each other into one organic and indivisible process"), presents in tabular form a sort of hierarchy of art historical investigation. The moment any description of a work exceeds its limited vocabulary of colors, lines, and so forth, it necessarily trespasses on the territory of meaning.[27]

While the separation of form and content has undoubtedly been responsible for confusion in art criticism, as Panofsky would be the first to admit, he nonetheless made certain irreversible choices when he first began to investigate an object of art according to Warburg's method, which implied that it was possible to pull an image apart into its two formative components. "So long as we are speaking of conventions the distinction" between form and content, Ackerman declares, "not only is permissible but necessary for description, because the life of symbols and the life of forms has not been everywhere coexistent in history."[28] With his concentration on the significance of the separation of classical themes and classical motifs in medieval art (for example, the motif of Hercules and its transformation into an image of Christ), Panofsky drove a kind of permanent methodological wedge in his work between the idea of a work of art and the particular shape this idea variously as-

sumed. The form becomes partly revelatory, a clue to the more significant ideational content: its role is one of offering contributions to the "more-than-visual meaning."

Although both activities must be acknowledged in their own right—the formal analysis of the connoisseur and the interpretive enterprise of the iconologist—the iconologist utters the last word. Iconology subsumes, under its own interest in "contexts," the necessary first steps of formal analysis. The metaphor that van de Waal applied to Panofsky's project also fits the final "focus" of his scholarly attention:

> For many years historiography has known two complementary forms: the first, particularizing, directed towards the thorough study of a single item; the second, more general, directed towards the exposition of the characteristics of a larger whole. In the first case the researcher may be said to use a microscope to arrive at the most precise specification possible of the material under scrutiny. In the second—to continue our metaphor—he uses a reversed telescope in his effort to sketch an overall view of a wide panorama. . . . In art history critical connoisseurship is clearly a "microscopist" discipline *par excellence*. In Panofsky's day every form of art history that was oriented towards cultural history presented itself exclusively in the second, the panoramic variety. . . . Panofsky now set himself to study the single, individual work of art, working just as scrupulously as the connoisseur (and often led by an intuition at least as strong). It was his innovation to practice this detailed form of art study within the broad framework of general cultural history. His question, "What did this individual work of art mean in its own time?" tended to cause raised eyebrows, because, with regard to an *individual work* of art, the posing of such questions had fallen into disfavour.[29]

Although Panofsky preferred to assume, for theory's sake, that form and content are inseparably wed and can only together give birth to iconological meaning and "Cassirerian" significance in a work of art, the kind of art historical analysis he tended increasingly to practice in his English works—and especially the historiographic techniques his students saw fit to con-

tinue—belies this theoretical stance. The methodology of the art historian, as opposed to that of the "more advanced" literary critic, according to Svetlana and Paul Alpers, with its stress "on a clear separation between style and iconography, form and content," can be traced directly to Panofsky. "The poles of this methodology . . . dramatize this split [between] . . . Wölfflin's *Principles of Art History* and Panofsky's iconographic studies."[30] Panofsky himself of course recognized the extent to which he had driven a wedge into art historical studies. In a letter to Booth Tarkington, his wartime correspondent, he refers to both his new focus and his Hegelian legacy:

> What I have tried to make clear [in *Studies*] is really not entirely original. It is perhaps only in contrast with so many purely formalistic interpretations of works of art that iconographic efforts appear as something unusual. In reality, my methods are reactionary rather than revolutionary, and I should not be surprised if some critics would tell me what the old doctor in "Doctor's Dilemma" tells his young friend: "You can be proud that your discovery has last been made forty years ago," or something to that effect.[31]

We must employ both Alpers's and Panofsky's own vocabulary with caution, however, for obviously Panofsky's contribution is not limited to the field of iconography. "The link between thoughts and images, between philosophies and styles is a problem," Gombrich asserts, "which far transcends the confines of iconography."[32] Iconography is a method of research; iconology is an art historical vision: an "intuitive, aesthetic recreation," in Panofsky's words, of a work of art as it existed in its own time and place. As my earlier quotation from van de Waal implies and Panofsky's long time friend P.O. Kristeller corroborates, Panofsky was a sort of cultural historian in the grand old tradition who took as his point of departure works of art.[33] A work of art, for whose survival we must be forever grateful, is an intact physical "piece of history," one of the "frozen, stationary records . . . [which have emerged] from the stream of

time."[34] In his most "iconological" moments, for example in regarding high medieval architecture in *Gothic Architecture and Scholasticism,* Panofsky sees neither the individual stones of the edifice nor the thrusts and counterthrusts of the architectural structure. Instead he regards the cathedral as embodying, in stone, a historical argument or metaphysical explanation of the world.

Discerning, a priori, the symbolic significance "in the Cassirerian sense" of the individual work of art or architecture, he broke through the frames Wölfflin had held sacrosanct. Panofsky was not interested in the forced isolation of artifacts; he recognized that, beyond the "illuminated zone" in which most art historical research operates, there is a "knot of relationships" that "extend and branch off infinitely into the immense area"[35] of other cultural phenomena, conscious or unconscious. And when the going got rough, Gombrich recalls, Panofsky became "joyful."[36] He took pleasure in the intricacies of relationships and loved nothing more than to provide ingenious solutions that brought order from apparent chaos. An avid reader of Sir Arthur Conan Doyle, Panofsky sided with the master detective Sherlock Holmes: "If all that which is impossible has been excluded, the improbable that remains must be true."[37] A number of influential figures in the twentieth century seem to have shared the conjectural paradigm upon which this delight in puzzle solving is based. In "Morelli, Freud, and Sherlock Holmes," Carlo Ginzburg suggestively maintains that the procedure of "diagnosis through clues," so important to physicians and sleuths of all sorts, ultimately had its origins in the hunters and diviners of the primeval world.[38]

At what point can the investigator be satisfied that the mystery has been solved? How many of the cultural ties that produce this knot of relationships must be sorted out? And does this iconological act of detection conform—if we want to make art history an epistemologically respectable discipline—to the established rules of logic?

Panofsky believed that a work of art signifies a variety of

things. Only one of them is the subject represented; art also testifies to an assortment of cultural "symptoms." In terms of Gombrich's Hegelian wheel, the work of art is the hub in Panofsky's scheme, the physical piece of evidence, the *locus classicus* from which we can elicit symbolic beliefs, habits, assumptions. More often than not Panofsky's array of cultural "spokes" comprises the standard influences of philosophy, literature, theology, and psychological predispositions (studies of Piero, Titian, Poussin, Michelangelo, and Suger are all cases in point)—with other possible lines of influence being ignored (economics, politics, social pressures, and so forth). Yet Panofsky was only acting like any cultural historian in need of a starting point. Practicing what Jacques Barzun has called the "crooked ways" of cultural history, he abandoned the straightforward historical approach. Panofsky began with a tangible element, the work of art, and followed it into the "imponderable influence" of cultural *habits* at large.[39]

He used his initial study of a work of art (steps 1 and 2 of the iconological method), in other words, as a means to understanding something else (step 3). This procedure is consistent with that employed in most cultural histories. But Panofsky refused to stop with step 3, and the course set by his imagination and training as an art historian eventually led, at his third level of investigation, to the posing of a tautology. The final goal of his enterprise was always the comprehension of the "intrinsic meaning" of a lone work of art. Yet is it sensible to say that in understanding the "something else" in the culture, we will be better equipped to study the singular presentation of a work of art? David Rosand (who may have been unfamiliar with Panofsky's early work) did not think so:

> Historicism, unfortunately, tends to avoid confronting some fundamental issues of hermeneutics. Our methods of style description, iconographic interpretation, and contextual commentary depend upon external comparisons—with other works of art, cultural conventions, and social situations. Hardly ever do we attempt to deal with the communicative

functioning, the visual mechanics, so to speak, inherent in the work of art itself.[40]

Did not Panofsky simply find what he had decided to look for in the first place? Being philosophically inclined himself, he held fast to the a priori conception of the work as a philosophical entity. When he regarded a work by Michelangelo, he *assumed* or *presupposed* that it embodied a philosophical understanding of the subject:

> The preter-individual or even preter-natural beauty of his figures, not qualified by conscious thoughts or distinct emotions, but either dimmed as in a trance or glowing with the excitement of a *"furor divinus"* reflects—and is reflected by—his Neoplatonic belief that what the enraptured mind admires in the "mirror" of individual forms and spiritual qualities is but a reflex of the one, ineffable splendour of the light divine in which the soul has revelled before its descent to the earth. . . . Michelangelo's works reflect this Neoplatonic attitude not only in form and motifs but also in iconography and content, although we cannot expect them to be mere illustrations of the Ficinian system.[41]

Should an analyst begin with the work of art, form some ideas about it, seek confirmation of those ideas in philosophy, and return to the work with knowledge thus gained? Kurt Forster, one skeptical critic, regards the whole project as spurious:

> Just as philosophy according to Hegel's aesthetic finally outstrips and supplants art, so art is transfigured for the time being, both from history and from itself, into the sphere of philosophy. . . . Instead of seeing through the mystifications that the work may reproduce, the interpreter makes himself another quasi-believer of the very ideology he is setting out to analyze.[42]

Do not Rosand's and Forster's remarks indicate an implicit fallacy in iconology's prescribed line of deductive reasoning? Panofsky postulates, in effect before he ever reaches the objects

under investigation, that philosophical views affect works of art. There seems to exist, in other words, a putative *pre-preiconographic* commitment to a certain sort of interpretation. Only secondarily does Panofsky regard the work itself. Is it logical to conclude, therefore, that the work of art necessarily has buried within it a specific philosophical understanding? Not according to the rules of logic. The proposition

If A→ B	(Philosophical views affect works of art)
B	(Here is a work of art)
Therefore A	(Therefore, we see expressed in this work a philosophical view)

is neither logical nor commonsensical. Michelangelo might well have expressed Neoplatonic beliefs in his art, but the marble figures for the Tomb of Julius II could just as conceivably indicate the artist's unqualified love of sculpturally beautiful nudes or specific patronage requests or guiding theological principles or the demands of certain kinds of funerary art, not to mention their intended position in the church. The A's of the major premise, in fact, are innumerable—and as a result they continue to be tapped today as a resource. The "new" emphasis on contexts in art historical studies (for example, the physical [Philip] or the social [Baxandall]) falls well within the iconological purview as Panofsky conceived it, even though the "spokes" of cultural history that are investigated appear to be new ones.[43] Panofsky himself, of course, would not deny this observation. It is one of the many exciting and promising aspects of the iconological method that, in principle, it excludes nothing reasonable from the interpretation of works of art. But does it not also continue to be true that the dangers inherent in the old major premises have slipped unnoticed into the new ones?

Panofsky undoubtedly gave a certain primacy to hidden philosophical meanings in his own research projects, and this tradition of analysis is identified as his legacy. The impact of a work often seems dependent not upon the length of time for which we look but upon the amount that we read. To one familiar

with Panofsky's earlier theoretical works, this recognition is indeed disappointing. What happened, for instance, to the kind of art history envisioned in the second half of the essay on perspective or in the introduction to *Studies in Iconology?* Suggested routes of analysis were tentative, to be sure, but at least they existed. When Panofsky spoke of a philosophical understanding of works of art, he did not refer merely to parallels drawn between doctrine and painted subject. How did the "meaning" of a work come to be restricted to such a degree? Henri Zerner does not mince words when it comes to assigning the responsibility to the art historical establishment:

> Meaning can only be revealed by the methods and techniques of interpretation. This is the sense in which we should understand Panofsky's development. His aim was to work out a technique of reading which would be limited to artistic themes and valid only for the Christian West. But his final objective was the "iconological" level, i.e., the objective immanent meaning. Because his followers lost sight of his theoretical preoccupations (*which he himself appears to have neglected more and more as time went on*), the discipline he created has been transformed into a mere technique of deciphering. The ultimate iconological level has been generally abandoned and, what is worse, iconographical deciphering has too often taken the place of meaning. [Italics added][44]

If we agree with Zerner's bleak assessment, we could suppose that as far as theory goes, the discipline has come to a dead end; not only the champion of theory in his last works but art history in general has abandoned the early twentieth-century debate about the proper methods and intentions of art history.[45] If art history has decided to forsake "theoretical preoccupations"—or at least to turn them over to philosophical aestheticians—because as a discipline it has other tasks at hand, we can still find some examples of contemporary thought in the history of science, intellectual history, and literary criticism that redirect us to some of Panofsky's older ideas about art theory and cause us to think about them anew. I shall discuss Ger-

ald Holton's *Thematic Origins of Scientific Thought* (1973), Michel Foucault's *The Order of Things* (1966), and a selection of recent essays on art and semiotics not simply because they appear to represent the avant-garde in representational theory but because I believe brief attention to them can renew our interest in the scope of Panofsky's early theoretical essays.

Holton, who is interested in "the way the scientific mind works," says that the human intellect in general regards the physical universe and manipulates it on at least three levels. He describes the first two levels in the following way:

1. "Empirical": a result of sensations, experience, "facts," experiments.
2. "Analytic": uses reason, logic, common sense, hypotheses, generalizations, to make sense of level 1.

The first way, called the "empirical" (keep in mind Panofsky's "preiconographic" step), concerns itself with the "givenness of things," and its observations are those which are derived from sense experience. The second level, the "analytic," devotes itself to making sense of and theorizing about the givens posed as significant by the first level of determination. These two levels, however, are not necessarily sequential, Holton notes, for it may be the case that we indeed can experience the world only by reference to terms posed by our own prior explanations of it, our own hypotheses about what we can expect to experience (compare Cassirer's definition of a symbolic form). It is, in any event, the dialogue between these two ways of knowing the world that makes science "meaningful."[46]

In 1916 (approximately the time at which our study of both Panofsky and Cassirer began), Einstein was similarly intrigued by the intellectual processes responsible for scientific thinking. Our tendency, he says, is to accept scientific explanations as facts graciously handed to us by nature rather than to view them as explanations with a human origin:

> Concepts which have proved useful for ordering things eas-
> ily assume so great an authority over us, that we forget their
> terrestrial origin and accept them as unalterable facts. They
> then become labelled as "conceptual necessities," "*a priori* sit-
> uations," etc. The road of scientific progress is frequently
> blocked for long periods by such errors. It is therefore not
> just an idle game to exercise our ability to analyse familiar
> concepts, and to demonstrate the conditions on which their
> justification and usefulness depend, and the way in which
> these developed, little by little.[47]

Holton reads this passage by Einstein as indicative of a third
level of determination, which he calls the "thematic," and here
attests to the existence of preconceptions—either innate or cul-
turally induced—that "appear to be unavoidable for scientific
thought" but are themselves derived neither from observation
nor from analytic reasoning. A thematic commitment (the be-
lief in cause and effect, for example), Holton suggests, might
well be a prerequisite to perception itself. What a human being
sees in the world, Kuhn has reminded us, depends not only on
what he or she looks at but also on what his or her previous
visual/conceptual/cultural/linguistic experience and training
have taught him or her to see. In the absence of such "the-
mata," there can only be what William James calls "a blooming,
buzzing confusion" out there in the world. The world extrinsic
to the senses is too complex to warrant random exploration.
We must begin somewhere. The thematic "map," whose details
are *subsequently* elaborated by "normal" scientific research on
levels 1 and 2, "forces," as it were, the scientist to regard the
data with an attention earlier rooted in metascientific needs:[48]

3. "Thematic": consists of beliefs, assumptions, expectations,
 prejudices, intuitions, "essential tendencies of the mind"
 (compare Panofsky's third level), which are subject to nei-
 ther empirical nor analytic verification.

Levels 1 and 2, Holton notes, are far more likely to undergo
changes in range and scale, while the themata alter very slowly.

A couple of contemporary examples of themata might be (1) the belief that the order of things has a numerical basis; a faith in the "efficacy" of mathematics as an explanatory system, or (2) since Freud, a belief in the unconscious. A historical example, valid until the time of Copernicus, is the reigning conception of the universe as a "static . . . harmoniously arranged cosmos" with the earth at the center. Even when Copernicus discovered that the earth was not the center of the universe, astronomical illustrations continued to be dominated by the thema that the solar system was purposefully ordered, God-generated, "God-expressing," and so forth. There was no room in this ordered world for random and nonhierarchical phenomena.[49]

If we are willing to acknowledge the possibility of this third level, we must also consider a corollary. The distinction between scientific and humanistic thought—which is undisputed in many ways (see, for example, Panofsky's essay "The History of Art as a Humanistic Discipline")—becomes far less substantial if we attend to the thematic origin of scientific theories. And at this point Panofsky's avant-garde vision of art comes in. In a speech delivered in 1945 as a tribute to the physicist Wolfgang Pauli at the Institute for Advanced Study in Princeton (where Einstein himself was a long-time colleague), Panofsky addressed the issue: "On a more fundamental—and, at the same time, more human-plane . . . , the twain [humanist and scientist] can meet and exchange their experiences. . . . There are, after all, problems so general that they affect *all* human efforts to transform chaos into cosmos, however much their efforts may differ in subject matter."[50]

While a painting is perhaps easier to understand as "made up" than a scientific proposition, Panofsky's interpretation of Leonardo's *Last Supper* in *Studies in Iconology* can be usefully compared to the sort of analysis to which Holton thirty-four years later subjects Copernicus, Leonardo's contemporary. Both interpreters, it seems to me, are seeking to discover the

same sort of fundamental interpretive principles, and by way of comparison, I would like to suggest what these might be. What is now considered radical in the history of science has been traditional in the theoretical underpinnings of the history of art for at least four decades.

Keeping in mind Holton's tripartite scheme, let us consider what Panofsky sees as the "three strata of meaning" implicit in the *Last Supper* ("But we must bear in mind that the neatly differentiated categories, which in this synoptical table seem to indicate three independent spheres of meaning, refer in reality to aspects of one phenomenon, namely, the work of art as a whole. So that, in actual work, the methods of approach that here appear as three unrelated operations of research merge with each other into one organic and indivisible process"):[51]

1. The preiconographic (Holton: "empirical") level deals with form, lines, colors, expressions, and sensations. On the basis of our "practical experience" alone, we might discern thirteen men seated around a "dinner table" laden with food, and we might discuss the colors and shapes they assume.

2. The iconographic (Holton: "analytic") level makes sense of the first-level reading by way of hypotheses, generalizations, and interpretations. This level requires a "knowledge of literary sources"; the scene is "apprehended by realizing . . . that a group of figures seated at a dinner table in a certain arrangement and in certain poses represents the Last Supper. . . . [An] Australian bushman would be unable to recognize the subject of a Last Supper; to him it would only convey the idea of an excited dinner party."

3. The iconological (Holton: "thematic") level is the realm of the "essential tendencies" of the human mind, consisting of beliefs, assumptions, expectations, attitudes, and religious and cultural values. "When we try to understand it as a document of Leonardo's personality, or of the civili-

zation of the Italian High Renaissance, or of a peculiar religious attitude, we deal with the work of art as a symptom of something else which expresses itself in a countless variety of other symptoms, and we interpret its compositional and iconographical features as more particular evidence of this 'something else.'"[52]

When considering this third level, we can reasonably ask whether or not it is merely coincidental that Copernicus's model of his heliocentric universe and Leonardo's patently symmetrical painting, whose perspectival lines all converge behind the head of Christ, together also seem to embody, diagrammatically, the political and theological hegemony of early sixteenth-century Italy. The same kinds of thematic quests for symmetry and order appear to underlie both the scientific and artistic practice of the day:

> It is in the search for *intrinsic meanings* or *content* that the various humanistic disciplines meet on a common plane instead of serving as handmaidens to one another. . . . The art-historian will have to check what he thinks is the *intrinsic meaning* of the work, or group of works, to which he devotes his attention, against what he thinks is the *intrinsic meaning* of as many other documents of civilization historically related to that work or group of works, as he can master: of documents bearing witness to the political, poetical, religious, philosophical, and social tendencies of the personality, period or country under investigation.[53]

In some cases, aesthetic principles actually can be shown to have predetermined a scientific sensibility. This is precisely Panofsky's argument in *Galileo as a Critic of the Arts*, a work that Holton invokes for his own argument.[54] Positing the influence of one sphere of knowledge upon the other is significant, to be sure, but more to the point, for both the philosopher of science and the historian of art, is the argument for common "underlying principles" that can be shown to exist in both the scientific and artistic products of an age.

The "context of discovery," as Holton puts it, that "is about to come into its own"[55] in the history of science has been present (although it is an ideal often ignored) for a long time in the history of art. Although both Panofsky and Holton pose this "deep context" as a kind of third step for the historian of science or art, they characterize it as a "force" fundamental and primary for the scientist or artist at work. Clearly both thinkers imply that if there is indeed any identifiable sequence involved in the genesis of both scientific and visual "explanations" of the world, then this thematic or iconological level provides the ground on which the first two strata of meaning perform their operations. This deep structure acts as a kind of hidden field of possibilities upon which the grammar of representation (both scientific and artistic) plays out its game. It is "apprehended by ascertaining those *underlying* principles which reveal the basic attitude of a nation, a period, a class, a religious or philosophical persuasion—*unconsciously* qualified by one personality and condensed into one work." Never perceiving it directly, but only having its structure implied by a juxtaposition of "as many other documents of civilization"[56] as possible, the scholar soon understands that although this thematic level never provides the answers, it at least begins to limit the questions. It may indeed be only preliminary—a tentative "tabula," in Foucault's terms, of the "conditions of possibility"[57] in which the single work of art, always the professed end of Panofsky's work, can exist.

Thus understood, the iconological level is not a final stage but a beginning, with the art historian (or "talented layman") having achieved, by a sequence of steps, the same "intuition" concerning the "underlying principles" that the artist had at the outset.[58] Maybe the search for the deep structure of a work has led to problems and predicaments in art historical scholarship because most art historians are convinced that once the iconological level *transitively*[59] declares its statements of cultural meanings—says that a given work is about such and such (some extrinsic state of affairs)—their work is over. Perhaps,

on the other hand, they should consider this stage only an initial process, as Panofsky once clearly did.

Try as he might to locate the development of perspective, for example, within both a synchronic and diachronic "context of discovery," successive sections of his essay on perspective manifest, as we have seen, the struggle to return to the individual work on a sort of preiconographic level: to understand what he persists in calling its *immanenten Sinn*, or intrinsic meaning. By the conclusion of his essay, he has, I believe, a far more interesting *intransitive* project in mind. From the moment when he wrote the essay on Riegl (or perhaps from the moment when he read Cassirer's commentary on Kant), he conceived of the work of art as an "organism" that ultimately displays its own meaning within its own system of references, following its "own rules of becoming," as he wrote in the critique of Riegl. A work of art is not ultimately *about* anything except itself. A perspective painting is not, finally, only a "window on the world"; it is a system of knowledge articulated in paint. Panofsky's last questions regarding perspective deal with its processes of *signifying*, apart from what is in the end actually signified. And because of this focus, the concluding part of his essay can be legitimately called "proto-semiotic."

Giulio Argan has, in fact, called Panofsky the Saussure of art history.[60] In asserting that the content of a work cannot be restricted to just literary subject matter—that there is indeed a "meaning" beyond the iconographic—Panofsky addressed matters that have recently been appropriated by a variety of semioticians.[61] Semiotics and iconology share an interest in uncovering the deep structure of cultural products. There are problems, however, in simply calling Panofsky's work "semiotic," as Christine Hasenmueller has noted, because the current revisionist mode of interpretation specializes in reading all works as a commentary on their own epistemological problematics. Contemporary semiotics presumes not to be accountable to anything outside itself. Iconology, as a mode of interpretation, is more temperate, more conservative. It is a method that

uncovers the materials (the signified) with which the signifying plays its game. Intellectual history is not just a "support" but a "form of explanation."[62] The language of art (in semiotic terms, the "intertextuality of the work") does not arise in a hermetic environment (the issue raised by the Wölfflin critique). The historical content (both cultural and artistic) is established so that when the art historian investigates the grammar of the work, its signifying structure, he has some sense of the rules of syntax and semantics with which he is dealing. We could never "give a correct pre-iconographical description of a work of art without having divined, as it were, its historical 'locus.'"[63]

Despite the way in which we tend to read his table, Panofsky treats each of his levels of interpretation not as goals but as conditions and implies, in a footnote, that their operations should properly be viewed as cyclical rather than sequential. The first referential reading (toward which steps 1, 2, and 3 are directed) enhances a rereading of the nonreferential (step 1):

> Whether we deal with historical or natural phenomena, the individual observation assumes the character of a "fact" only when it can be related to other, analogous observations in such a way that the whole series "makes sense." This "sense" is, therefore, fully capable of being applied, as a control, to the interpretation of a new individual observation within the same range of phenomena. If, however, this new individual observation definitely refuses to be interpreted according to the "sense" of the series, and if an error proves to be impossible, the "sense" of the series will have to be re-formulated to include the new individual observation. This *circulus methodicus* applies, of course, not only to the relationship between the interpretation of *motifs* and the history of *style*, but also to the relationship between the interpretation of *images*, *stories* and *allegories* and the history of *types*, and to the relationship between the interpretation of *intrinsic meanings* and the history of *cultural symptoms* in general.[64]

Having delimited the conditions of possibility by research on the third level, the theorist might find it advisable to return to

the preiconographic step and to investigate how the lines, colors, volumes, and so forth come together as semiotic "conventions" to generate meaning.

Panofsky, of course, never consciously articulated a "semiotic" position. But the congruence of much of current semiology with writings by Panofsky in both theory (*Studies in Iconology*) and practice ("Perspective as Symbolic Form," where perspective construction is seen as a carrier of meaning distinct from what it signifies) remains noteworthy. Iconology, like any theory worthy of the name, has assumed a life of its own and has become a living testimony to the imagination of its originator:

> If it is possible to do iconological history of perspective, proportions, anatomy, representational conventions, symbolic references of color, and even of rituality and gesturality in technique, no one has said that it must stop there and that it is not possible to study historically, like so many other iconologics, line, chiaroscuro, tone, penstrokes, and so forth. It certainly would be possible and it would be a very useful kind of research, one to recommend to young art historians desirous of exploring new fields. The name would change, however, and this research would no longer be called iconology but, following modern terminology, semantics or, more exactly, semiotics. . . . In many aspects, then, the iconological method begun by Panofsky, although by design rigidly philological, can be qualified as the most modern and efficacious of historiographic methods, open moreover to great future developments which truthfully it has not as yet experienced, perhaps because Panofsky's own followers have reduced its range, making of it an almost esoteric science of a few initiates and providing thereby a case for the ideal-formalists who consider it a heterodox methodology.[65]

Meyer Schapiro, for example, in several articles on the semiotics of the visual arts, has returned with renewed fervor to the preiconographic level. But he has come equipped with the tools of an iconological historian, in order to distinguish between natural and conventional signs in the work. He wonders, as he

gives a series of illustrative examples, how the nonmimetic ele-
ments in a painting—for instance, frame, direction, colors,
movement, and size—acquire a "semantic value" and contrib-
ute to the general meaning of a work.[66] Panofsky, as Argan
has noted, was perhaps too modest when he claimed that ico-
nology, because of its obsession with subject matter, seems to
ignore the role that formal qualities play in the construction of
the "sense" of a painting:

> If a Madonna with Child by Raphael is not simply a cult ob-
> ject but a work of art which visibly expresses the tie between
> natural and divine which can be seen in a determined histori-
> cal moment, this meaning is not established solely by the fact
> that the madonna is a beautiful woman seated in a lovely
> landscape but also by the progression of the lines which is
> the same in figure and in landscape, by the relationship be-
> tween the blue of her cloak and the blue of the sky, and by
> the subtleties of color which make one feel the diffused pres-
> ence of the atmosphere.[67]

Collectively, the three levels teach us how to read images.
They initiate us, by an almost ritualistic process, into the secrets
of a historic visual order. Images are culturally determined,
and if we wish to "recreate" the dynamics of a work, we must
uncover its context of discovery; we must familiarize ourselves
with the subjects, on a variety of levels, about which the images
are "speaking." Only a careless student of iconology thinks his
or her work at an end when he or she can enumerate, one by
one, the hidden symbols, for example, in a Northern Renais-
sance painting. Panofsky never viewed iconology as a technique
by which to accumulate information of the sort that allows a
freshman instructor to utter some statement of displacement
such as, "The dog in the Arnolfini portrait is really not a dog;
it stands for marital fidelity." Although this kind of reading is
undoubtedly part of an iconological program, it represents
only the beginning.

Uncovering the intentional meaning behind the representa-
tional form is merely part of the labor. The detection of the

elusive underlying principles of representation completes the task: "The intrinsic meaning or content . . . may be defined as a unifying principle which underlies and explains both the visible event and its intelligible significance, and which determines even the form in which the visible event takes shape."[68] Iconological analysis is based upon the posing of one major question; that is, it persistently asks why this image has assumed this shape at this historical moment.

Because Panofsky says we really "read 'what we see' according to the manner in which *objects* and *events* were expressed by *forms under varying historical conditions*,"[69] in his scheme, content finally becomes a formal problem. A painting may be derived from a once-existing physical or mental universe, but it transforms this world according to the dictates of its own laws. The microscopically detailed world of physical objects in a Van Eyck painting is ultimately a depiction of an "imaginary reality."[70] A painting in perspective is not just an exercise in mimesis; it is an expression of a desire to order the world in a certain way— a definition, by way of spatial configuration, of the Kantian relationship between I and not-I.

We have discussed on several occasions in this chapter how Panofsky's own practical art history often contradicted—or, more affirmatively, only rarely fulfilled—the challenge of his theoretical work. Perhaps this situation resulted from his having ideas that exceeded the paradigm of cultural history that he inherited. In theory, Panofsky would not have been content to draw parallels between philosophy and painting, or between theology and architecture, in the traditional "Hegelian" sense. In theory, as we have seen, many of the ideas that he expressed in his early papers and in the introduction to *Studies in Iconology* frequently fit more appropriately into the framework of recent thought.

In this regard one particular contemporary scholar deserves mention last. Panofsky's repeated emphasis in 1939 on "those basic principles which *underlie* the choice and presentation of *motifs*, as well as the production and interpretation of *images*,

stories and *allegories*, and which give meaning even to the formal arrangements and technical procedures employed,"[71] antici-pates the work of the French philosopher of history Michel Foucault. In *The Order of Things* (1966), Foucault describes what can aptly be termed as his iconological task (although he calls it "archaeological"):

> What I am attempting to bring to light is the epistemological field, the *episteme* in which knowledge, envisaged apart from all criteria having reference to its rational value or to its ob-jective forms, grounds its positivity and thereby manifests a history which is not that of its growing perfection, but rather that of its conditions of possibility; in this account what should appear are those configurations within the *space* of knowledge which have given rise to the diverse forms. . . . Such an enterprise is not so much a history, in the traditional meaning of that word, as an "archaeology."[72]

Like Panofsky, Foucault is interested in the "essential ten-dencies of the human mind" but believes that that mind can be known only as it manifests itself in the surfaces of things it pro-duces. He wants to describe the mechanisms by which a "cul-ture experiences the propinquity of things," from coins to the classification of plants, for example, and, in doing so, to reveal the "rules of formation, which were never formulated in their own right, but are to be found only in widely differing theo-ries, concepts, and objects of study."[73] When Panofsky defines his goal as divulging the principles that underlie the choice of images,[74] he too is clearly pursuing the essential order of a certain submerged code of knowledge, and one of its surface manifestations is the presence of a physical work of art. By implication, he asks: what order of knowledge—what "under-lying, unifying principle" (or, to return to Holton, what thema) —permits this visual world to take shape?

In their concentration on submerged or "underlying" his-tory, both Foucault's and Panofsky's writings have been related (directly in the first case, indirectly in the second) to work by the founders of the Annales school of French historiogra-

phy.[75] Febvre and Braudel, in particular, postulate the existence of deep patterns, or "habits," of thought that can account for the unity that later historians often perceive in the artifacts and attitudes of an age. Conversely, the "submerged" history can be only faintly discerned through a close reading of its "conspicuous" products—works of art, political acts, economic forces, and so forth. Braudel asks, for example, is it not "possible somehow to convey simultaneously both that conspicuous history which holds our attention by its continual and dramatic changes—and that other, submerged, history, almost silent and always discreet, virtually unsuspected either by its observers or its participants, which is little touched by the obstinate erosion of time?"[76] "Reality," says Ginzburg, is "opaque," but for the trained analyst, there are "certain points—clues, signs —which allow us to decipher it."[77] For Panofsky, the eruption of Renaissance spatial construction on the surface of human history was just such a "sign." Consequently, he labored to explore the system of perspective neither from the point of view of the artist who practiced it nor in terms of the formal principles upon which it was founded (matters given only preliminary consideration) but finally in terms of the hidden rules of knowledge that "come into play in the very existence of such a discourse."[78]

The impulse to acknowledge such a unifying principle seems to have faded in time. "The Neoplatonic Movement and Michelangelo," for example, only hints at the possibility that Renaissance knowledge manifested a well-defined regularity. In later works such as this one, Panofsky frequently resorts to drawing simple parallels between manifestations rather than inquiring into their shared principles of form.[79] Something seems to have been lost; or rather, considering the obvious congruence of Panofsky's early twentieth-century essays with Foucault's and Holton's contemporary work, something in Panofsky needs to be rediscovered so that art history as a discipline may avoid the rebuke that "most of the recent critical impulses have come from 'outsiders' (in respect to the mainstream of academic history of

art)."[80] The defeat of iconology by iconography can yet be undone if the insiders, the art historians, will yet realize that, according to the structure of Panofsky's thought, as the circulus methodicus demonstrates, the foundation of the iconography so typically practiced should indeed be iconology itself.

Apart from his art historical insights, Panofsky's reflections on the nature of historiography merit rediscovery. Contemporary art historians, as we saw in my first chapter and as a variety of critics from Ackerman to Alpers have claimed, think their histories are "not made but discovered."[81] "As scholars," Alpers contends, "art historians all too often see themselves as being in pursuit of knowledge without recognizing how they themselves are the makers of that knowledge."[82] In retrospect, we can identify numerous instances in which Panofsky deliberately avoided such naivete. His research into the rules of art, especially the hidden rules such as spatial organization (Panofsky considered perspective not a tangible image with attached meanings but rather an invisible technique of organization that he nevertheless showed to have a thematic constituent), clearly awakened him not only to the existence of a submerged code of knowledge structuring the object at which he was looking but also to the existence of hidden rules of order in his own work as a historian.

In 1939, the Renaissance system of perspective was invoked not just as an example of a particular iconology of space but as a controlling metaphor for the modern claim to historical *re-presentation*:

> Just as it was impossible for the Middle Ages to elaborate the modern system of perspective, which is based on the realization of a fixed distance between the eye and the object and thus enables the artist to build up comprehensive and consistent images of visible things; just as impossible was it for them to evolve the modern idea of history, which is based on the realization of an intellectual distance between the present and the past, and thus enables the scholar to build up comprehensive and consistent concepts of bygone periods.[83]

Although Panofsky may have been naive himself in his conviction that "to grasp reality we have to detach ourselves from the present,"[84] he recognized early the need to establish a historical distance and, as time went on, devoted entire essays to the problem ("The History of Art as a Humanistic Discipline" and "Three Decades of Art History in the United States"):

> We are chiefly affected by that which we allow to affect us; and just as natural science involuntarily selects what it calls the phenomena, the humanities involuntarily select what they call the historical facts.
>
> Even when dealing with the remote past, the historian cannot be entirely objective.[85]

In passages such as these, Panofsky speaks words that he might well have wished his most self-conscious Renaissance painter (or twentieth-century historian) to utter, certain that he was representing something in the world but well aware of his own contribution in explaining or giving order to that something. And he viewed his own work, as Svetlana Alpers has observed, in precisely this light:

> For all of Panofsky's claims to employing an objective method (his three levels of meaning, for example) he accepted the responsibility for his own thought and his commitment to certain values. In studying Renaissance art he was aware of having made certain choices; he was aware of the phenomena he excluded by making them. He celebrated the accomplishment of a humanistic art and despaired at the loss of it.[86]

Forever lost in time are the emotions, the motives, and the desires that gave birth to medieval and Renaissance art. Panofsky, composing most of his work in the shadow of war and persecution and the threatened destruction of the values of humanism that he had long cherished, was acutely aware of this inaccessibility. Art historians may be deluded into thinking that because they confront an actual physical object—a painting, a

building, a piece of sculpture—they have direct access to the past. From the second decade of the century, however, Panofsky never rested secure in this feeling. Although we may view his whole corpus as a carefully reasoned attempt to be certain and objective about what he was saying, he never lost sight of the means by which the historian renders an account of the past intelligible. Implicit in many of his essays, but particularly in his very early and late ones, interestingly enough, is the need to come to terms with his own struggle as a scholar between the otherness of the past and the familiarity of the present.

Once again, Panofsky's work in this regard can be situated in the vanguard of contemporary thought. Like Hayden White or Peter Gay, he seems to have recognized that any historian's account is permeated with a certain style or order. History writing is never simply a verbal model, as it often pretends to be, of a significant historical event or object.[87] All historical accounts, whether of political events, societal situations, or works of art, are necessarily translations. The historian inevitably invokes some theory, some underlying rule or principle, so as to shape the dispersed historical facts into a meaningful configuration that makes order of their apparent chaos as surely as perspective construction orders the chaotic impressions reaching us from our visual world.

This recognition probably caused Panofsky to spend much of his early career analyzing the ideas of other art historians. Like Momigliano, he perceived the implicit danger of circularity in historical scholarship: the writing of history itself becomes a kind of history.[88] Its assumptions tend to go unchallenged because they belong to a well-established tradition of scholarship. The young Panofsky wrote about Riegl and Wölfflin, I suspect, because he was already aware that critical reflection upon contemporary scholarly work aids in the removal of limitations that we may unthinkingly impose upon artifacts of the past.

Although he always strove to comprehend the work of art in its aesthetic purity, unencumbered by explanations or arguments about what it represents, Panofsky discovered soon

enough in his historiographic research that a historian, in order to write at all, inevitably exploits a particular view that gives meaning to the data. The problem for the historian arises precisely when he or she becomes unwilling simply to draw up lists of historical artifacts and instead desires, as Vasari once remarked, to offer explanations for their existence.[89] Any historian worthy of recognition seeks to be curious as well as commemorative. As much as Panofsky criticized the authority of Riegl and Wölfflin, he undoubtedly respected their perspicacity. The last act of the great historian is always an act of the imagination. Something exists in the world of art that did not exist before Riegl and Wölfflin called attention to it: a revelation, a perception, an explanation, a provocation. And Panofsky expressed the hope that his own insights in some way might either match or evoke the original deed or object with which he was concerned:

> The humanist, dealing as he does with human actions and creations, has to engage in a mental process of a synthetic and subjective character: he has mentally to re-enact the actions and to re-create the creations. It is in fact by this process that the real objects of the humanities come into being. . . . Thus the art historian subjects his "material" to a rational archaeological analysis at times as meticulously exact, comprehensive and involved as any physical or astronomical research. But he constitutes his "material" by means of an intuitive aesthetic re-creation.[90]

In *The Past Recaptured*, Marcel Proust wrote that the problem of a writer who would recover the past is "to rediscover, grasp again and lay before us that reality from which we live so far removed and from which we become more and more separated as the formal knowledge which we substitute for it grows in thickness and imperviousness. . . . The grandeur of real art [is] . . . to grasp again our life—and also the life of others."[91] Panofsky believed that iconology could achieve a similarly meaningful evocation, "an intuitive aesthetic re-creation," with the work of art as a guide to a time long since past. In the hands of

a talented and sensitive scholar, one enchanted with the power of a singular work of art or with the genius of a particular historical period, he hoped that his "iconography turned interpretative" would engender research both circumspect and bold, both "archaeological" and poetic. The skilled historian would use iconology's underlying theoretical principles, in turn, to comprehend underlying historical principles, to penetrate beyond the facts of the work's existence into the mood, the desires, the beliefs and the motives of the individual and time that created it:

> The humanities . . . are not faced by the task of arresting what otherwise would slip away, but of enlivening what otherwise would remain dead. Instead of dealing with temporal phenomena, and causing time to stop [as do the sciences], they penetrate into a region where time has stopped of its own accord, and try to reactivate it. Gazing as they do at those frozen, stationary records of which I have said that they "emerge from the stream of time," the humanities endeavor to capture the processes in the course of which those records were produced and became what they are.[92]

Four years after Panofsky wrote this eloquent tribute to the historian's task, Ernst Cassirer, in an intriguing reversal of the direction of influence I have traced during the course of this essay, echoed Panofsky's faith in the recreative capacities of a judicious and imaginative historical discourse:

> Human works . . . are subject to change and decay not only in a material but also in a mental sense. Even if their existence continues they are in constant danger of losing their meaning. Their reality is symbolic, not physical; and such reality never ceases to require interpretation and reinterpretation. And this is where the great task of history begins. . . . Behind these fixed and static shapes, these petrified works of human culture, history detects the original dynamic impulses. It is the gift of the great historians to reduce all mere facts to their *fieri*, all products to processes, all static things or institutions to their creative energies.[93]

Writing of Vasari, Panofsky once said he was "a pioneer of a historical way of thinking—a way of thinking which in itself must be judged 'historically.'"[94] The same holds true of Panofsky and his pioneering efforts in twentieth-century art history. Confronting tradition as a young scholar, he dared to ask new questions and to invent fresh principles of interpretation. As I have tried to show, his work, like Vasari's, needs to be "judged historically"; it deserves to be situated in its own "context of discovery." I have investigated the "underlying principles" of Panofsky's art history by articulating the problems, tracing the influences, and noting the contradictions, not in order to deny the validity of his theories of art, but to reappraise the scope of his imagination and to identify its epistemological development. In principle, I think Panofsky would agree, iconology can well be thoughtfully applied to any cultural achievement, including his own.

Notes

1. Introduction: Historical Background

1. Ernst Gombrich, "A Plea for Pluralism," *American Art Journal* 3 (Spring 1971): 86. See also Gombrich, "Art and Scholarship," *College Art Journal* 17 (Summer 1958): 342–356.
2. David Rosand, "Art History and Criticism: The Past as Present," *New Literary History* 5 (Spring 1974): 436.
3. Svetlana Alpers, "Is Art History?" *Daedalus* 106 (Summer 1977): 9.
4. Jan Białostocki, "Iconography and Iconology," *Encyclopedia of World Art* 7 (1963): 773. I appropriate portions of Luigi Salerno's summary in "Historiography," in *Encyclopedia of World Art* 7 (1963), of the mid-nineteenth-century origin in art and scholarship of the formalistic approach, for in Chapter 2 we will be principally concerned only with its evolution at the turn of the century and beyond: "The concept of art as pure form (or pure visibility) was a reaction to the emphasis on content that had dominated the historiography of art [since the Renaissance]. In the latter half of the 19th century . . . , esthetic theory and the antisentimental, antinaturalistic trend which produced and was fed by impressionism brought into focus the need to consider form apart from its connection with the natural world. . . . The painter Hans von Marées led Konrad Fiedler and Adolf von Hildebrandt in the direction of formalism. Another impulse in this direction was provided by the psychological theory of *Einfühlung* (empathy) advanced by Robert Vischer in 1875. . . . Hence arose the late 19th- and early 20th-century propensity for analyzing the formal elements of a work of art in order to grasp their value as symbols of the artist's feelings. But it was Konrad Fiedler who really created the theory of pure form. Rejecting the concepts of Beauty and of Art, accepting the existence only of particular arts, he founded a science of art based on visual or formal laws—laws created by genius" (p.526). Also see Michael Podro, *The Manifold in Perception: Theories of Art from Kant to Hildebrand* (Oxford, 1972).

5. Henri van de Waal, "In Memoriam Erwin Panofsky, March 30, 1892–March 14, 1968," *Mededelingen der Koninklijke Nederlandse Akademie van Wettenschappen* 35 (1972): 231.

6. Eugene Kleinbauer, in his brief discussion of Semper in *Modern Perspectives in Western Art History: An Anthology of Twentieth-Century Writings on the Visual Arts* (New York, 1971), calls attention to the distinct Darwinian strain running throughout Semper's "scientific" explanation (p.20).

7. Cited in Salerno, 528. Further relevant and brief discussion of Croce and of the influence exerted by his 1902 *Estetica come scienza dell'espressione e linguistica generale* (Milan, 1902) can be found in Kleinbauer, 3, and in *History of Art Criticism* (1936; reprint, New York, 1964) by Lionello Venturi (a major disciple of Croce, as were von Schlosser in Germany and Collingwood in England), trans. Charles Marriott, ed. Gregory Battock, 338–339.

8. Arnold Hauser, *The Philosophy of Art History* (Cleveland, 1958), 236, 218. This theory of the connections between practicing artists and art historians could, of course, form the basis of a book in itself. Another related and very interesting topic would be a comparison of the criteria used by contemporary critics (e.g., Bell, Fry, Meyer-Graef) to assess contemporary works of art with the criteria employed by contemporary art historians to appraise works of art from the past. Regarding a slightly later period than that with which we are dealing here, see Christine McCorkel, "Sense and Sensibility: An Epistemological Approach to the Philosophy of Art History," *Journal of Aesthetics and Art Criticism* 34 (Fall 1975): 36–37. McCorkel has uncovered several interesting parallels among philosophical doctrines, art historical attitudes, and contemporary aesthetics.

9. Białostocki, 769–773.

10. *Hercules am Scheidewege und andere antike Bildstoffe in der neueren Kunst,* Studien der Bibliothek Warburg 18 (Leipzig/Berlin, 1930): "Und man kann an sich selber und anderen immer wieder die Erfahrung machen, dass eine gelungene Inhaltsexegese nicht nur dem 'historischen Verständnis' des Kunstwerks zugute kommt, sondern auch dessen 'ästhetisches Erlebnis,' ich will nicht sagen: intensiviert, wohl aber in eigentümlicher Weise zugleich bereichert und klärt" (p. x).

11. Paul Oskar Kristeller, review of *Renaissance and Renascences in Western Art,* by Erwin Panofsky, *Art Bulletin* 44 (1962): 67.

12. I have selected these three historians for my study of Panofsky for three principal reasons. The specter of Hegel haunted nineteenth- and early twentieth-century historiography, and no discussion of historical methodology in any field can fail to take account of his pervasive influence. Second, Burckhardt is often considered to be the "first" cultural historian. Even though Panofsky's brand of cultural history seems to exemplify Burckhardt's project in reverse —Panofsky worked outward from the work of art to a larger cultural

setting—Burckhardt's process of contextualization made his inter-
pretation meaningful. Wallace K. Ferguson, in *The Renaissance in His-
torical Thought: Five Centuries of Interpretation* (Cambridge, Mass.,
1948), wrote of Burckhardt's impact on historiography: "Historians,
daunted perhaps by the harmoniously integrated perfection of
Burckhardt's outline, were long content to illustrate it, to amplify
it in detail, or to remodel some particular feature of it without
abandoning its guiding principle" (p. 195). Third, Wilhelm Dil-
they—largely ignored today—seems in many ways closest in histori-
ographic sentiment to Panofsky. He was, above all, concerned with
the nature of historical thinking and with the justification of its
methods, and I find direct reflections of his concerns in Panofsky's
early writing. In the work of Dilthey, Geistesgeschichte came into its
own, as it focused on relationships between literature, music, and
philosophy. Max Dvořák brought the idea of Geistesgeschichte to
work in an analysis of the visual arts. See Hans Tietze, *Die Methode
der Kunstgeschichte: Ein Versuch von Dr. Hans Tietze* (Leipzig, 1913), for
a contemporary account and critique of art historical methodology as
it is indebted to Dilthey.

13. See, for example, Hegel's lectures compiled under the title *Reason in
History*, trans. R. S. Hartman (Indianapolis, 1953), originally pub-
lished as *Lectures on the Philosophy of History* in 1837; also, his *Encyclo-
pedia of Philosophy*, trans. G. E. Mueller (New York, 1959), and *Phe-
nomenology of the Spirit*, trans. A. V. Miller (Oxford, 1977). For the
complete twenty volumes of Hegel's work in German, see *Werke*, ed.
Eva Moldenhauer and Karl Markus Michel (Frankfurt, 1970).

14. Hegel, *Reason in History*, 68–69.

15. Ibid., 89–90.

16. *Logic of Hegel*, translated from *Encyclopedia of the Philosophical Sciences*
(1830) by William Wallace in 1873, 3d ed. (Oxford, 1975), 6.

17. Hegel, *Aesthetics: Lectures on Fine Art*, trans. T. M. Knox, vol. 1 (Ox-
ford, 1975), 299–300.

18. Hegel, *Reason in History*, 89.

19. Hauser makes this point throughout *The Philosophy of Art History*.

20. Jacob Burckhardt, *Force and Freedom: Reflections on History*, ed. and
trans. J. H. Nichols (New York, 1943), 80–82. For the complete edi-
tion of Burckhardt's work in German, see the fourteen volume *Jacob
Burckhardt: Gesamtausgabe* (Berlin, 1929–1934).

21. Benjamin Nelson and Charles Trinkaus, introduction to *The Civiliza-
tion of the Renaissance in Italy*, vol. 1 (1929; reprint, New York, 1958),
9.

22. Ernst Gombrich, *In Search of Cultural History* (Oxford, 1969), 15.

23. Burckhardt, *The Civilization of the Renaissance in Italy*, 95. See also *The
Letters of Jacob Burckhardt*, trans. Alexander Dru (New York, 1955),
for frequent references to cultural "spirits" and "styles" of civiliza-
tions.

24. Burckhardt, *Force and Freedom*, 80.
25. Ibid.
26. Burckhardt, *Der Cicerone: Eine Anleitung zum Genuss der Kunstwerke Italiens*, 4th ed., ed. Wilhelm Bode (Leipzig, 1879). Burckhardt maintained, as Earl Rosenthal has pointed out, "that the description of a cultural background should be kept separate from art and that only a loose relationship could be suggested" (in "Changing Interpretations of the Renaissance in the History of Art," in *The Renaissance: A Reconsideration of the Theories and Interpretation of the Age*, ed. Tinsley Helton [Madison, 1961], 54).
27. See, for example, Hayden White, *Metahistory: The Historical Imagination in Nineteenth-Century Europe* (Baltimore, 1973), 8, 18–21, 230–264.
28. Panofsky, introduction to *Studies in Iconology: Humanistic Themes in the Art of the Renaissance* (1939; reprint, New York, 1962), 30.
29. Ibid., 7.
30. Gombrich, *In Search of Cultural History*, 28.
31. Wilhelm Dilthey, "The Construction of the Historical World in the Human Studies," paper read before the Prussian Academy in January 1910 and published in its proceedings in December 1910. Excerpts and translations appear in H. P. Rickman, ed., *Wilhelm Dilthey: Pattern and Meaning in History: Thoughts on History and Society* (New York, 1961), 123. Rickman has primarily concentrated on vol. 7 of the *Gesammelte Schriften*, ed. B. Groethuysen, pt. 2 (Stuttgart, 1926), 145–148.
32. The term "historicism" has become ambiguous, to say the least, for it has come to be used in two quite distinct and somewhat contradictory senses. I quote from R. H. Nash, ed., *Ideas of History*, vol. 1, *Speculative Approaches to History* (New York, 1969): "The speculative philosophy of history is a result of attempts made by not only philosophers but also by historians and sociologists to discover the meaning of history as a whole. These speculative systems assume, for the most part, that there is some ultimate meaning in history which can be explained in terms of some historical law. This belief, usually coupled with some form of historical inevitability (either theistic or naturalistic), is often called 'historicism'. . . . There is another and quite different sense of historicism which . . . [is] associated with such thinkers as Dilthey, Croce, and Collingwood, that all ideas are rooted in some historical context and are therefore limited and relative. Historicists (in this second sense) also maintain that history must use different logical techniques from those used in the physical sciences. Failure to keep these two types of historicism distinct can lead to confusion" (pp.265–266n). It is faith in the first kind of historicism that Gombrich's colleague Karl R. Popper regarded as absurd in *The Poverty of Historicism* (Boston, 1957): "Belief in historical destiny is sheer superstition" (p. vii).
33. Rickman, 57.

34. Cited in Ferguson, 196.
35. Maurice Mandelbaum, *History, Man, and Reason: A Study in Nineteenth-Century Thought* (Baltimore, 1971), 5. For an analysis of the "fundamental conflicts of nineteenth century thinking," see also Richard E. Palmer, *Hermeneutics: Interpretation Theory in Schleiermacher, Dilthey, Heidegger, and Gadamer* (Evanston, 1969), 98ff. Geisteswissenschaften, claims Palmer, "became a meeting place for two fundamentally conflicting views of the proper way to study man" (p. 99).
36. For concise discussions of the idealist/positivist controversy, see also W. H. Walsh, *Philosophy of History: An Introduction* (New York, 1960), 21, 45–46, 60; William H. Dray, *Philosophy of History* (Englewood Cliffs, 1964), 3, 77; Roland Stromberg, *European Intellectual History since 1789*, 3d ed. (New York, 1981), 180–181; and W. M. Simon, *European Positivism in the Nineteenth Century: An Essay in Intellectual History* (Ithaca, 1963). In actuality, the distinctions between positivists and idealists were not as sharp as Mandelbaum would have us assume. The original idealist, Hegel himself, harbored what might even be called positivist inclinations, according to Herbert Marcuse in *Reason and Revolution* (cited in Dray, 77). Hegel had implied that "although the rationality of history [was] known to him in advance, he [was] content that for his readers this should be a 'hypothesis' or 'influence.' And he added: 'We must proceed historically-empirically.'" Stromberg reconciles the idealist and positivist tendencies in Hegel himself by paraphrasing Hegel this way: "We should study the actions, the empirical events, but we should not stop there; we should 'think them through' to discover their inner logic. . . . The mind of the historian, it is clear, must supply *some* sort of structure for the facts, which by themselves are without meaning. Hegel of course felt that there was a single objective pattern into which all would fit"(p. 65). And certainly Dilthey, with his belief "that objective history ought to rest on an objective study of human nature" (Walsh, 21), was in some ways allied with the positivist camp. On the other hand, the original positivist, Auguste Comte, idealistically urged historians not to remain preoccupied with particular events but instead to think them through, in opposition to the "empirical" historians, who asked that no sense be made of history's "fragmentary and unconnected facts" (quoted in Walsh, 156). In theory, the positivists simply tried to make the idealists acknowledge and verify their underlying assumptions about how history works, and in doing so, to realize that "all branches of knowledge which deserve their name depend on the same basic procedures of observation, conceptual reflection and verification" (Walsh, 45). But in practice, because of their insistent concentration on only the immediate data of experience, in many ways the positivists represent "a severe retrenchment or cutting back, intellectually and culturally, in order to get the advantages of clarity and certainty" (Stromberg, 208).
37. "Die Natur erklären wir, das Seelenleben verstehen wir," from

"Ideen über eine beschreibende und zergliedernde Psychologie" (1894), in vol. 5 of the *Gesammelte Schriften*, 143–144.

38. Rickman, 47. These are not exactly Dilthey's own words but a reconstruction of his sentiments by his English translator.

39. Panofsky, "The History of Art as a Humanistic Discipline," in *Meaning in the Visual Arts* (Garden City, 1955), 16–19.

40. Dilthey, *Einleitung in die Geisteswissenschaften* (1883), in vol. 1 of the *Gesammelte Schriften*, 254, here quoted from Theodore Plantinga, *Historical Understanding in the Thought of Wilhelm Dilthey* (Toronto, 1980), 109–110. See also Georg Iggers, *New Directions in European Historiography* (Middletown, 1975), 28.

41. Panofsky, "The History of Art as a Humanistic Discipline," 14.

42. Mandelbaum, 11–13, 20.

43. Plantinga, 57, 100. See Edmund Husserl, *Logische Untersuchungen*, 2 vols. (Halle, 1900–1901) (*Logical Investigations*, trans. J. N. Findlay, 2 vols. [London, 1970]).

44. Plantinga, 103–105. Also see Palmer, 104.

45. See David Couzens Hoy, *The Critical Circle: Literature, History, and Philosophical Hermeneutics* (Berkeley, 1978), 11.

46. Dilthey quoted in Rickman, 75; Palmer, 118–122; see also Plantinga, 104.

47. Dilthey's notes for *Plan der Forsetzung zum Aufbau der geschichtlichen Welt in den Geisteswissenschaften*, in vol. 7 of *Gesammelte Schriften*, 233. Cited in Plantinga, 106, in the translation given here.

48. The three stages are discussed and charted in Panofsky, introduction to *Studies in Iconology*, 3–17. This 1939 essay is also reprinted as "Iconography and Iconology: An Introduction to the Study of Renaissance Art," in *Meaning in the Visual Arts*, 26–54. It is most interesting to note that between the two publication dates Panofsky changed "iconographical analysis in the narrower sense" and "iconographical analysis in the deeper sense," respectively, to read "iconography" and "iconology." "Iconology" does not occur in the 1939 edition. See Chapter 6 for further discussion of this scheme.

49. Panofsky, introduction to *Studies in Iconology*, 11, n.3.

50. Ibid., 5.

51. Ferdinand de Saussure, *Course in General Linguistics*, ed. C. Bally and A. Sechehaye, trans. Wade Baskin (New York, 1959), 5.

52. Ibid., 9, and Jonathan Culler, *Structuralist Poetics: Structuralism, Linguistics, and the Study of Literature* (Ithaca, 1975), 8–9.

53. Saussure, 16.

54. Jonathan Culler, *The Pursuit of Signs: Semiotics, Literature, Deconstruction* (Ithaca, 1981), 24.

55. From Charles Sanders Peirce, *Collected Papers*, vol. 2, p. 276, cited in Culler, *The Pursuit of Signs*, 24. See, for example, Panofsky's reference to Peirce in "The History of Art as a Humanistic Discipline," 14.

56. The semiotic project as described by Culler in *Structuralist Poetics*, 4–5.

57. Ludwig Wittgenstein, *Tractatus Logico-Philosophicus*, trans. D. F. Pears and B. F. McGuinness (1922) (London, 1961).
58. Heinrich Wölfflin, *Principles of Art History: The Problem of the Development of Style in Later Art*, trans. M. D. Hottinger, 7th ed. (1932; reprint, New York, 1950), 230. The original *Kunstgeschichtliche Grundbegriffe: Das Problem der Stilentwicklung in der neueren Kunst* (Munich, 1915) reads: "Aber auch in der Geschichte der darstellenden Kunst ist die Wirkung von Bild auf Bild als Stilfaktor viel wichtiger als das, was unmittelbar aus der Naturbeobachtung kommt" (p. 242). See Hauser, 182, for another translation.

2. Panofsky and Wölfflin

1. William Heckscher, *Erwin Panofsky: A Curriculum Vitae* (Princeton, 1969), p. 7.
2. Lorenz Dittmann, *Stil, Symbol, Struktur: Studien zu Kategorien der Kunstgeschichte* (Munich, 1967), 51–52 (my translation).
3. Heinrich Wölfflin, foreword to *Kunstgeschichtliche Grundbegriffe: Das Problem der Stilentwicklung in der neueren Kunst*. This characteristic phrase is omitted from later editions of the *Principles of Art History: The Problem of the Development of Style in Later Art*; the later editions begin with prefaces to the sixth edition—perhaps because publishers are as wary today as Wölfflin anticipated they would be in 1915: "Kein Verleger kann auf die kostspieligen Bilderhefte sich einlassen, die die unentbehrliche Grundlage einer solchen 'Kunstgeschichte ohne Namen' sein wurden."
4. Hauser, *The Philosophy of Art History*, 220, 187.
5. Kleinbauer, *Modern Perspectives in Western Art History*, 27; Marshall Brown, "The Classic Is the Baroque: On the Principle of Wölfflin's Art History," *Critical Inquiry* 9 (December 1982): 379. For a catalog of the extensive critical literature on Wölfflin, see Meinhold Lurz, *Heinrich Wölfflin: Biographie einer Kunsttheorie* (Worms, 1981).
6. McCorkel, "Sense and Sensibility," 39. McCorkel sees Wölfflinian art history as being of central formative importance in the United States, despite the fact that, in German art history, two "orientations" were balanced: "formalism based on Wölfflin . . . and *Geistesgeschichte*, based on Dvořák" (p. 37). I shall discuss Dvořák's influence on German art history in Chapter 4.
7. Wölfflin, *Renaissance und Barock* (Munich, 1888); *Renaissance and Baroque*, trans. K. Simon (Ithaca, 1964). For a more detailed discussion of this work and its milieu, see Michael Podro, *The Critical Historians of Art* (New Haven, 1982), 98–105.
8. Wölfflin, *Klassische Kunst: Eine Einführung in die italienische Renaissance* (Munich, 1899); *Classic Art: An Introduction to the Italian Renaissance*, 8th ed., trans. Peter and Linda Murray, introduction by Herbert Read (Ithaca, 1952), v, xi. See Podro, *The Critical Historians of Art*,

110–116. Adolf Hildebrand, *Das Problem der Form in der bildenden Kunst*, 3d ed. (Strassburg, 1901). For a study of the connections between Burckhardt and his pupil, see *Jacob Burckhardt und Heinrich Wölfflin: Briefwechsel und andere Dokumente ihrer Begegnung*, ed. Joseph Gantner (Basel, 1948). On numerous occasions, Wölfflin objected to the "static" quality of Burckhardt's scheme.

9. Wölfflin, *Classic Art*, 287–288.

10. Wölfflin, *Principles of Art History*, 232. Wölfflin here uses the phrase in speaking of Dehio, who, he says, similarly believed in this formulation of periodicity in art. The original phrase is "eine innerlich weiterarbeitende Formengeschichte" in the first edition, *Kunstgeschichtliche Grundbegriffe*, 244. The ideas contained in this book first reached the public forum in a lecture delivered on December 7, 1911 (to which Panofsky later responded). See William S. Heckscher, "The Genesis of Iconology," in *Stil und Überlieferung in der Kunst des Abendlandes* (Berlin, 1967), 246. Wölfflin's lecture is reprinted in *Sitzungsberichte der Königlichen Preussischen Akademie der Wissenschaften* 31 (1912), 572–578.

11. Joan Hart, "Reinterpreting Wölfflin: Neo-Kantianism and Hermeneutics," *Art Journal* 42 (Winter 1982): 292.

12. Wölfflin, *Principles of Art History*, 227 (238 in the 1915 edition). The summary of five original categories was given by Wölfflin in his 1933 revision of *Kunstgeschichtliche Grundbegriffe*. The essay was reprinted in his *Gedanken zur Kunstgeschichte: Gedrucktes und Ungedrucktes*, 4th ed. (Basel, 1947), 19. The five categories, in German, are: (1) linear (plastisch) versus malerisch, (2) flächenhaft versus tiefenhaft, (3) geschlossene Form (tektonisch) versus offene Form (atektonisch), (4) vielheitliche Einheit versus einheitliche Einheit, and (5) absolute Klarheit versus relative Klarheit.

13. Rosenthal, 63. In the preface to his 1915 edition, he even calls his work a "natural history," viii.

14. Wölfflin, *Principles of Art History*, 216–217. In the original foreword of 1915, Wölfflin speaks of his similarities to Riegl in this regard. See Wölfflin's review of "Die Entstehung der Barockkunst in Rom," by Alois Riegl, *Repertorium für Kunstwissenschaft* 31 (1908): 356–357.

15. Brown, 380.

16. Hart, however, contends that "speculation that the comparative method originated in Hegel's dialectic has no basis in fact: neither Wölfflin nor his teachers had a particular interest in Hegel." The model derives instead from the methods of comparative philology practiced by his father, Eduard (p. 293). Brown, on the other hand, feels that Wölfflin always sustains a "difficult, Hegelian logic which regards contrast as a form of mutual dependence" (p. 385). In his 1921 review of the *Principles of Art History*, entitled "The Baroque," Roger Fry reports, "just once or twice [Wölfflin] lets himself go into almost Hegelian nebulosity and eloquence," *Burlington Magazine* 39 (September 1921): 147. Wölfflin (and Fry), claims Brown, could have

picked up Hegel's formal system of logic through Fiedler's 1887 essay "Über den Ursprung der künstlerischen Thätigkeit," reprinted in *Schriften zur Kunst*, ed. Hans Marbach (Leipzig, 1896).

17. Wölfflin, "Das Erklären von Kunstwerken" (1921), reprinted in *Kleine Schriften*, ed. J. Gantner (Basel, 1946), and quoted in Dittmann, 50. See *Principles of Art History*, 9 (also 9 in the 1915 edition). It is interesting to note that just a decade later, Panofsky would think it "untraditional" to talk about matters of content (see Chapter 1). For Wölfflin's progressive estrangement from cultural history, see Lurz, 124–160.

18. Meyer Schapiro, "Style," in *Anthropology Today: An Encyclopedic Inventory*, ed. A. L. Kroeber (Chicago, 1953), 298.

19. Hauser, 166, 167, 169, 173–174. The quoted passage appears on p. 169.

20. Dilthey, from "Shakespeare und seine Zeitgenossen," in *Die grosse Phantasiedichtung*, 53–54, cited in Plantinga, 89.

21. *Apology*, 22, in *The Dialogues of Plato*, ed. B. Jowett, vol. 2 (1871; reprint, Oxford, 1924), 114. I thank Keith Nightenhelser for locating this passage for me. The notion continued to be much debated during the 1950s. William Wimsatt's and Monroe Beardsley's statement that "the design or intention of the author is neither available nor desirable as a standard for judging the success of a work of literary art," in "The Intentional Fallacy," in *Philosophy Looks at the Arts: Readings in Aesthetics*, ed. J. Margolis (New York, 1962), 92, was challenged by E. D. Hirsch, with his faith in the meaningfulness of authorial intention. See E. D. Hirsch, Jr., *Validity in Interpretation* (New Haven, 1967), 11. On the other side once again, much recent work in contemporary semiotics makes the role of creator irrelevant to the almost autonomous signifying process of a work of art.

22. I. M. Bocheński, *Contemporary European Philosophy: Philosophies of Matter, the Idea, Life, Essence, Existence, and Being*, 2d ed. (Berkeley, 1956), 130, 136. Husserl's major work, *Logische Untersuchungen*, appeared in 1900–1901. See also Eugene Kaelin, *Art and Existence: A Phenomenological Aesthetics* (Lewisburg, 1970), 56.

23. Bocheński, 137–138.

24. Wölfflin, *Principles of Art History*, 11 (11–12 in the 1915 edition).

25. Ibid., 230 (242 in the 1915 edition).

26. David Irwin, ed., *Winckelmann: Writings on Art* (London, 1972), 55–56; Wölfflin, *Principles of Art History*, 9 (9 also in the 1915 edition).

27. McCorkel, 39–40.

28. For a fuller treatment of Wölfflin's Neo-Kantianism, as well as his hermeneutics, see Hart's essay. Wölfflin, *Principles of Art History*, 230–231 (241–242 in the 1915 edition).

29. Wölfflin, *Principles of Art History*, preface to the sixth edition (1922). We will soon see how far Panofsky is willing to go in refusing to acknowledge this subtle distinction.

30. Ibid., 29 (33 in the 1915 edition).

31. Quoted in Peter Gay, *Style in History* (New York, 1974), 195.
32. Wölfflin, *Principles of Art History*: "Die Anschauung ist eben nicht ein Spiegel, der immer derselbe bleibt, sondern eine lebendige Auffassungskraft, die ihre eigene innere Geschichte hat und durch viele Stufen durchgegangen ist" (226; 237 in the 1915 edition).
33. Hariolf Oberer and Egon Verheyen have published, in German, a selected collection of Panofsky's essays, *Erwin Panofsky: Aufsätze zu Grundfragen der Kunstwissenschaft* (Berlin, 1964), and the essay "Das Problem des Stils in der bildenden Kunst" appears in that anthology. The essay was originally published in *Zeitschrift für Ästhetik und allgemeine Kunstwissenschaft* 10 (1915): 460–467, but the pages cited parenthetically after the quotations are from the Oberer and Verheyen edition. I have often and gratefully referred to a "rough" and "partial" English translation of this article produced by M. Podro for a Kunstwissenschaft seminar at the University of Essex, 1976–1977. However, most of the translated passages are my own, and where I paraphrase rather than directly translate Panofsky's words, I usually cite no exact page reference. The German original will appear, for the most part, in my notes.
34. "[Es] ist von so hoher methodischer Bedeutung, dass es unerklärlich und ungerechtfertigt erscheinen muss, wenn weder die Kunstgeschichte noch die Kunstphilosophie bis jetzt zu den darin ausgesprochenen Ansichten Stellung genommen hat" (p. 23).
35. "Jeder Stil . . . habe zweifellos einen bestimmten Ausdrucksgehalt; im Stil der Gotik oder im Stil der italienischen Renaissance spiegel sich eine Zeitstimmung und eine Lebensauffassung. . . . Aber alles das sei erst die eine Seite dessen, was das Wesen eines Stiles ausmache: nicht nur was er sage, sondern auch wie er es sage, sei für ihn charakteristisch: die Mittel, deren er sich bediene, um die Funktion des Ausdrucks zu erfüllen" (p. 23).
36. "Sondern werde nur aus einer allgemeinen Form des Sehens und Darstellens verständlich, die mit irgendwelchen nach 'Ausdruck' verlangenden Innerlichkeiten gar nichts zu tun habe, und deren historische Wandlungen, unbeeinflusst von den Mutationen des Seelischen, nur als Änderungen des Auges aufzufassen seien" (p. 23).
37. "Wir fragen nicht, ob Wölfflins Kategorien—die hinsichtlich ihrer Klarheit und ihrer heuristischen Zweckmässigkeit über Lob und Zweifel erhaben sind—die generellen Stilmomente der Renaissance- und Barockkunst zutreffend bestimmen, sondern wir fragen, ob die Stilmomente, die sie bestimmen, wirklich als blosse Darstellungsmodalitäten hinzunehmen sind, die als solche keinen Ausdruck haben, sondern 'an sich farblos, Farbe, Gefühlston erst gewinnen, wenn ein bestimmter Ausdruckswille sie in seinen Dienst nimmt'" (p. 24). See also Panofsky, "Zum Problem der Beschreibung und Inhaltsdeutung von Werken der bildenden Kunst," *Logos* 21 (1932): 103–119, where he continues to ask whether it is ever possible to consider style as devoid of expression (reprinted in Oberer and Verheyen, 85–97).

38. "Dass die eine Epoche linear, die andere malerisch 'sieht,' ist nicht Stil-Würzel oder Stil-Ursache, sondern ein Stil-Phänomen, das nicht Erklärung ist, sondern der Erklärung bedarf" (p. 29).

39. "So gewiss die Wahrnehmungen des Gesichts nur durch ein tätiges Eingreifen des Geistes ihre lineare oder malerische Form gewinnen können, so gewiss ist die 'optische Einstellung' streng genommen eine geistige Einstellung zum Optischen, so gewiss ist das 'Verhältnis des Auges zur Welt' in Wahrheit ein Verhältnis der Seele zur Welt des Auges" (p. 26).

40. Panofsky, we may remember, had Wölfflin making this explicit distinction on the first page of his text.

41. "Von einer Kunst, die Geschenes im Sinne des Malerischen oder Linearen ausdeutet, zu sagen, dass sie linear oder malerisch sieht, nimmt Wölfflin sozusagen beim Wort, und hat—indem er nicht berücksichtigt, dass, so gebraucht, der Begriff gar nicht mehr den eigentlich optischen, sondern einen seelischen Vorgang bezeichnet—dem künstlerisch-produktiven Sehen diejenige Stellung angewiesen, die dem natürlich-rezeptiven gebührt: die Stellung unterhalb des Ausdrucksvermögens" (p. 26).

42. It is especially curious and "confusing" here for Panofsky to take deliberate note of "distinctions" in Wölfflin, for he just finished saying (see the preceding paragraph) that Wölfflin was unaware of a dialectical model, although we have also observed that, earlier in his essay, Panofsky says Wölfflin was fully cognizant of two ways of talking about style in art.

43. Podro, trans., "Das Problem des Stils in der bildenden Kunst," 10n (see n. 33 above). As Podro also notes, "If any formal distinction can influence content—limit it—it does not follow that it is in itself to be counted a matter of content" (p. 111).

44. "Dass ein Künstler die lineare statt der malerischen Darstellungsweise wählt, bedeutet, dass er sich, meist unter dem Einfluss eines allmächtigen und ihm daher unbewussten Zeitwillens, auf gewisse Möglichkeiten des Darstellens einschränkt; dass er die Linien so und so führt, die Flecken so und so setzt, bedeutet, dass er aus der immer noch unendlichen Mannigfaltigkeit dieser Möglichkeiten eine einzige herausgreift und verwirklicht" (pp. 28–29).

45. Wölfflin, the *Principles of Art History*, 229–230, 227: "Wir stossen hier an das grosse Problem, ob die Veränderung der Auffassungsformen Folge einer inneren Entwicklung ist, einer gewissermassen von selber sich vollziehenden Entwicklung im Auffassungsapparat, oder ob es ein Anstoss von aussen ist, das andere Interesse, die andere Stellung zur Welt, was die Wandlung bedingt. . . . Beide Betrachtungsweisen scheinen zulässig d.h. jede für sich allein einseitig. Gewiss hat man sich nicht zu denken, dass ein innerer Mechanismus automatisch abschnurrt und die genannte Folge von Auffassungsformen unter allen Umständen erzeugt. Damit das geschehen kann, muss das Leben in einer bestimmten Art erlebt sein. . . . Aber wir wollen nicht

vergessen, dass unsere Kategorien nur Formen sind, Auffassungs-
und Darstellungsformen und dass sie darum an sich ausdruckslos
sein müssen" (241; 239 in the 1915 edition).

46. "Was Wölfflin selbst keinen Augenblick verkannt hat; das beweist
der Schlusspassus seines Aufsatzes 'Über den Begriff des Male-
rischen.' Allein er hat aus dem Satze: 'mit jeder neuen Optik ist auch
ein neues Schönheitsideal (scilicet: ein neuer Inhalt) verbunden'
nicht die—gleichwohl notwendige—Folgerung gezogen, dass dann
eben diese 'Optik' streng genommen gar keine Optik mehr ist,
sondern eine bestimmte Weltauffassung, die, über das, 'Formale'
weit hinausgehend, die 'Inhalte' mit konstituiert" (p. 31, n. 6).

47. In his 1933 "Kunstgeschichtliche Grundbegriffe: Eine Revision,"
Logos 22 (1933): 210–218, Wölfflin claims that "a cultural history
which would give the leading role to the visual arts has yet to be writ-
ten" (reprinted in *Gedanken zur Kunstgeschichte*, 24).

48. "Sie wird dabei aber nie vergessen dürfen, dass die Kunst, indem sie
sich für die eine dieser Möglichkeiten entscheidet und dadurch auf
die anderen verzichtet, sich nicht nur auf eine bestimmte Anschau-
ung der Welt, sondern auf eine bestimmte Weltanschauung festlegt"
(p. 29).

49. Gombrich, *The Sense of Order: A Study in the Psychology of Decorative Art*
(Ithaca, 1979), 201.

50. Hauser, 257, and Kleinbauer, 29.

51. Wölfflin, *Principles of Art History*: "Jeder Künstler findet bestimmte
'optische' Möglichkeiten vor, an die er gebunden ist. Nicht alles ist zu
allen Zeiten möglich. Das Sehen an sich hat seine Geschichte" (11; 11
in the 1915 edition).

52. Wölfflin, *Gedanken zur Kunstgeschichte*, 7.

53. Wölfflin, preface to the sixth edition of *Principles of Art History*
(1922), vii. Also "Verschiedne Zeiten bringen verschiedne Kunst her-
vor, Zeitcharakter kreuzt sich mit Volkscharakter" (9; 8 in the 1915
edition), "und es bleibt ein unverächtliches Problem, die Bedingung-
en aufzudecken, die als stofflicher Einschlag—man nenne es Tem-
perament oder Zeitgeist oder Rassencharakter—den Stil von Indivi-
duen, Epochen und Völkern formen" (11; 11 in the 1915 edition).

54. Kleinbauer, 154. Wölfflin's revision is reprinted in *Gedanken zur
Kunstgeschichte*, 18–24. Paul Frankl, *Die Entwicklungsphasen der
neueren Baukunst* (Leipzig, 1914), and Walter Timmling, "Kunstge-
schichte und Kunstwissenschaft," in *Kleine Literaturführer* 6 (Leipzig,
1923).

55. By 1924, almost a century later, when he paid a sixtieth birthday
tribute to Wölfflin, Panofsky had become far more lenient toward
the Wölfflinian categories and praised Wölfflin for "discovering the
special materialized formal principles" of particular "stylistic periods"
(in "Heinrich Wölfflin: zu seinem 60. Geburtstage am 21. Juni 1924,"
Hamburger Fremdenblatt [June 1924]).

56. Panofsky, "Die theoretische Kunstlehre Albrecht Dürers (Dürers

Ästhetik)" (inaugural diss., Freiburg, 1914). See also *Dürers Kunsttheorie, vornehmlich in ihrem Verhältnis zur Kunsttheorie der Italiener* (Berlin, 1915).

3. Panofsky and Riegl

1. Hauser, *The Philosophy of Art History*, 120. Compare Hauser's comment elsewhere that both Riegl and Wölfflin see the "same impersonal, ineluctably self-realizing principle" at work in history (p. 221). Actually, the dates of Riegl's and Wölfflin's works are roughly parallel. Riegl: *Stilfragen* (1893), *Spätrömische Kunstindustrie* (1901), *Das holländische Gruppenporträt* (1902); Wölfflin: *Renaissance und Barock* (1888), *Die klassische Kunst* (1899), *Kunstgeschichtliche Grundbegriffe* (1915). In his essay "Toward a New Social Theory of Art," Ackerman claims that Hegelian art history is most notably embodied in the works of Riegl and Wölfflin, *New Literary History* 4 (Winter 1973): 315–330.

2. Ludwig von Bertalanffy, *General System Theory* (London, 1968), 245, 240.

3. Gombrich, *The Sense of Order*, 180.

4. Henri Zerner, "Alois Riegl: Art, Value, and Historicism," *Daedalus* 105 (Winter 1976): 179. See also Otto Pächt, "Art Historians and Art Critics—VI, Alois Riegl," *Burlington Magazine* 105 (May 1963): 188. Riegl's "distinctive approach," says Pächt, "conditioned the frame of mind in which much subsequent research has been undertaken."

5. Benedetto Croce and his German disciple Julius von Schlosser thought likewise. As Pächt notes: "Croce-Schlosser draw the line between art and non-art immediately below the highest peaks. Questionable as the Croce-Schlosser propositions may be as practical alternatives, they have their relevance and special significance as an implicit protest against Riegl's alleged non-discrimination between art and artefact and his apparent indifference to the whole problem of quality and value in art. It is precisely here that other Riegl critics likewise see the most vulnerable point of his argument" (p. 193; J. von Schlosser, "Stilgeschichte und Sprachgeschichte der bildenden Kunst," *Sitzungsberichte der philosophisch-historischen Abteilung der Bayerischen Akademie der Wissenschaften*, 1935). One of the most articulate of Riegl's critics is Gombrich, in *Art and Illusion: A Study in the Psychology of Pictorial Representation*, 2d ed. rev. (Princeton, 1961), who criticizes Riegl without naming him: "The student of art is generally discouraged from asking this question [of whether or not an artist could have 'done otherwise' than he did]. He is supposed to look for explanations of style in the artist's will rather than in his skill. Moreover, the historian has little use for questions of might-have-been. But is not this reluctance to ask about the degree of freedom that exists for artists to change and modify their idiom one of the reasons

why we have made so little progress in the explanation of style?" (p. 77).

6. Riegl, *Stilfragen: Grundlegungen zu einer Geschichte der Ornamentik* (1893), 2d ed. (Berlin, 1923). Zerner calls him "the most influential art historian of the beginning of this century." However, "outside the German-speaking countries, . . . Riegl did not make much of a mark (the exception was Italy, where Bianchi-Bandinelli and Raghianti were particularly aware of his importance)" (p. 177). His writings have never been translated into English, with the one exception of his essay on Dutch group portraiture in the Kleinbauer anthology. See Gottfried Semper, *Der Stil in den technischen und tektonischen Künsten; oder, Praktische Aesthetik*, 2 vols., 2d ed. (Munich, 1878–1879).

7. Riegl, *Stilfragen*: "In diesem Kapital, das die Erörterung des Wesens und Ursprungs des geometrischen Stils in der Überschrift ankündigt, hoffe ich dargelegt zu haben, dass nicht bloss kein zwingender Anlass vorliegt, der uns nöthigen würde a priori die ältesten geometrischen Verzierungen in einer bestimmten Technik, insbesondere der textilen Künste, ausgeführt zu vermuthen, sondern, dass die ältesten wirklich historischen Kunstdenkmäler den bezüglichen Annahmen viel eher widersprechen. . . . Damit erscheint ein Grundsatz hinweggeräumt, der die gesammte Kunstlehre seit 25 Jahren souverän beherrschte: die Identificirung der Textilornamentik mit Flächenverzierung oder Flachenornamentik schlechtweg" (pp. viii–ix).

8. "Bleibt es doch in solchem Falle ewig zweifelhaft, wo der Bereich jener spontanen Kunstzeugung aüfhort und das historische Gesetz vor Vererbung und Erwerbung in Kraft zu treten . . . beginnt" (ibid., viii).

9. Gombrich, "Kunstwissenschaft," in *Das Atlantis Buch der Kunst: Eine Enzyklopädie der bildenden Kunst* (Zurich, 1952), 658 (my translation).

10. Margaret Iversen, "Style as Structure: Alois Riegl's Historiography," in *Art History* 2 (March 1979): 66. After *Stilfragen*, "Riegl seems to have followed a path parallel to that taken by the linguist Ferdinand de Saussure." Refer as well to Riegl, *Historische Grammatik der bildenden Künste*, ed. O. Pächt and K. Swoboda (Graz-Cologne, 1966), which established a "visual grammar," for lecture notes in 1899. For linguistic connections, refer also to Gombrich, *The Sense of Order*, 181, 193.

11. Riegl does, however, use the term in *Stilfragen*; on p. vii, he refers to the "frei schöpferischen Kunstwollen" (*Spätrömische Kunstindustrie* [1901] [Vienna, 1927]).

12. Otto Brendel, *Prolegomena to the Study of Roman Art* (1953; reprint, New Haven, 1979), 36. See also Podro, *The Critical Historians of Art*, 76, 97, and Schapiro, "Style," 302. The terms "haptic" and "optic" were recognized by Wölfflin as similar to his "linear" and "painterly" categories. "His [Riegl's] ideas are not new; the novelty lies more in

the words than in the state of affairs" (Wölfflin, review of *Die Entstehung der Barockkunst in Rom*, by Alois Riegl, 356–357).

13. "In Gegensatze zu dieser mechanistischen Auffassung vom Wesen des Kunstwerkes habe ich—soviel ich sehe, als Erster—in den *Stilfragen* eine teleologische vertreten, indem ich im Kunstwerke das Resultat eines bestimmten und zweckbewussten Kunstwollen erblickte, das sich im Kampfe mit Gebrauchszweck, Rohstoff und Technik durchsetzt" (Riegl, *Spätrömische Kunstindustrie*, 9). See Ernest K. Mundt, "Three Aspects of German Aesthetic Theory," *Journal of Aesthetics and Art Criticism* 17 (March 1959): 303.

14. Translated in Brendel, 26, from *Spätrömische Kunstindustrie*.

15. Gombrich, *Art and Illusion*, 18; Pächt, 190 (Pächt says he refined Gombrich's definition because Riegl said *Kunstwollen*, not *Kunstwille*), and Brendel, 31.

16. Gombrich, *Art and Illusion*, 19.

17. Brendel, 37.

18. On the one hand, see Salerno, "Historiography": "Riegl, recognizing the importance of the creative personality, took a position opposed both to romantic historiography and to positivism" (p. 526); on the other, see Zerner: "Riegl's effort to overthrow the supremacy of the individual creator as central to the significance of the work in favor of a higher communal point of view reflects a decidedly subversive Hegelian inheritance" (p. 179).

19. Dilthey, "Die Entstehung der Hermeneutik," *Philosophische Abhandlungen Chr. Sigwart gewidmet* (1900), 202, quoted in Hauser, 238. See also Chapter 1. Tietze, *Die Methode der Kunstgeschichte*, 14; quoted in Hauser, 220.

20. Pächt, 191.

21. Riegl, *Spätrömische Kunstindustrie*, 403: "Der Wandel in der spätantiken Weltanschauung war eine notwendige Durchgangsphase des menschlichen Geistes."

22. Iversen, 66. Also see discussion on Saussure in the first chapter here.

23. Zerner, 178; Iversen, 63; Gombrich, *The Sense of Order*, 195; Brendel, 28–36; and F. Wickhoff and W. Ritter von Hartel, *Die Wiener Genesis* (Vienna, 1895).

24. James Ackerman, "Western Art History," in *Art and Archaeology*, ed. J. Ackerman and Rhys Carpenter (Englewood Cliffs, 1963), 170–171.

25. Zerner, 180.

26. Pächt, 190.

27. Zerner, 181.

28. Riegl, "Naturwerk und Kunstwerk," in *Gesammelte Aufsätze*, ed. Karl Swoboda, introduction by Hans Sedlmayr (Augsburg/Vienna, 1929), 63.

29. Wölfflin, review of *Die Entstehung der Barockkunst in Rom*, by Alois Riegl, 356. Zerner contends that Riegl distinguished art from other

realms of activity only as a "methodological tactic." In Chapter 2, I attributed this modus operandi also to Wölfflin, even though Zerner stresses that Riegl's strategy is a more deliberate one than Wölfflin's (p. 185).

30. Riegl, *Spätrömische Kunstindustrie*: "Der Charakter dieses Wollens ist beschlossen in demjenigen, was wir die jeweilige Weltanschauung (abermals im weistesten Sinne des Wortes) nennen: in Religion, Philosophie, Wissenschaft, auch Staat und Recht" (p. 401). Compare "Naturwerk und Kunstwerk," in *Gesammelte Aufsätze*, 63 (translated in Zerner, 183–184): "If we take into consideration not only the arts, but any of the other large domains of human civilization—state, religion, science—we shall come to the conclusion that, in this domain as well, we are dealing with a relation between individual unity and collective unity. Should we, however, follow the direction of the will [*Wollen*] that particular people at a given time has followed in these various domains of civilization, it will necessarily turn out that this tendency is, in the last analysis, completely identical to that of the *Kunstwollen* in the same people at the same time."

31. Riegl, "Kunstgeschichte und Universalgeschichte," reprinted in *Gesammelte Aufsätze*, 3–9 (first printed in *Festgaben zu Ehren Max Büdingers* [Innsbruck, 1898]).

32. Gombrich, *Art and Illusion*, 19.

33. Hauser, 120.

34. Wölfflin, review of *Die Entstehung der Barockkunst in Rom*, by Alois Riegl, 357.

35. Panofsky, "Der Begriff des Kunstwollens," *Zeitschrift für Ästhetik und allgemeine Kunstwissenschaft* 14 (1920): 321–339 (reprinted in H. Oberer's and E. Verheyen's collection of Panofsky's essays). The pages cited in parentheses after the quotations are from the Oberer/Verheyen edition. M. Podro translated into English the major part of this article for his graduate seminar on Kunstwissenschaft at the University of Essex in 1976–1977. While I have frequently referred to his translation, most of the translated passages are my own, and where I paraphrase rather than directly translate Panofsky's argument, I usually cite no page reference. The German original is usually provided in my notes. Kenneth J. Northcott and Joel Snyder also translated this essay in 1981. See Erwin Panofsky, "The Concept of Artistic Volition," *Critical Inquiry*, 8 (Autumn 1981): 17–33.

36. "Eine rein historische Betrachtung, gehe sie nun inhalts- oder formgeschichtlich vor, erklärt das Phänomen Kunstwerk stets nur aus irgendwelchen anderen Phänomenen, nicht aus einer Erkenntnisquelle höherer Ordnung: eine bestimmte Darstellung ikonographisch zurückverfolgen, einen bestimmten Formkomplex typengeschichtlich oder aus irgendwelchen besonderen Einflüssen ableiten, die künstlerische Leistung eines bestimmten Meisters in Rahmen seiner Epoche oder sub specie seines individuellen Kunstcharakters erklären, heisst innerhalb des grossen Gesamtkomplexes der zu er-

forschenden realen Erscheinungen die eine auf die andere zurückbe-
ziehen, nicht von einem ausserhalb des Seins-Kreises fixierten
archimedischen Punkte aus ihre absolute Lage und Bedeutsamkeit
bestimmen: auch die längsten 'Entwicklungsreihen' stellen immer
nur Linien dar, die ihre Anfangs- und Endpunkte innerhalb jenes
rein historischen Komplexes haben müssen" (p. 33). How the term
"Archimedean viewpoint" became a phrase at issue in art historical
theory is not known, but we can find Worringer using it as early as
1907 in *Abstraction and Empathy: A Contribution to the Psychology of Style*,
trans. M. Bullock (New York, 1953), 4. The philosopher who looks
for some principle of certainty that he cannot derive from his own
perceptions can be traced directly back to Descartes.

37. "Und damit erhebt sich vor der Kunstbetrachtung die Forde-
rung—die auf philosophischem Gebiete durch die Erkenntnis-
theorie befriedigt wird—, ein Erklärungsprinzip zu finden, auf
Grund dessen das künstlerische Phänomen nicht nur durch immer
weitere Verweisungen an andere Phänomene in seiner Existenz
begriffen, sondern auch durch eine unter die Sphäre des empi-
rischen Daseins hinabtauchende Besinnung in den Bedingungen
seiner Existenz erkannt werden kann" (p. 33). This metaphor of lay-
ers of interpretation would later be central to Panofsky's levels of in-
terpretation in *Studies of Iconology*. Compare also the Freudian meta-
phor of the stratification of levels of meaning in the unconscious.

38. The words as I have translated them come in part from Mundt, 304.

39. Ibid. See also Hans Sedlmayr's introduction to Riegl's *Gesammelte
Aufsätze*.

40. Mundt, 304.

41. Sheldon Nodelman, "Structural Analysis in Art and Anthropology,"
Yale French Studies 36 and 37 (October 1966): 96.

42. Gerhart Rodenwaldt, "Zur begrifflichen und geschichtlichen
Bedeutung des Klassischen in der bildenden Kunst: Eine kunstge-
schichtsphilosophische Studie," *Zeitschrift für Ästhetik und allgemeine
Kunstwissenschaft*, 11 (1916): 123: "Eine Frage des Könnens existiert
[not "gibt es," as the passage was quoted by Panofsky] in der
Kunstgeschichte nicht, sondern nur die des Wollens. . . . Polyklet
hätte einen borghesischen Fechter bilden, Polygnot eine natu-
ralistische Landschaft malen können, aber sie taten es nicht, weil sie
sie nicht schön gefunden hätten" (quoted on p. 36 in Oberer and
Verheyen).

43. "Weil sich ein 'Wollen' eben nur auf ein Bekanntes richten kann,
und weil es daher umgekehrt auch keinen Sinn hat, da von einem
Nicht-Wollen in der psychologischen Bedeutung des Ablehnens (des
Nolle, nicht des Non-velle) zu reden, wo eine von dem 'Gewollten'
abweichende Möglichkeit dem betreffenden Subjekt gar nicht vor-
stellbar war: Polygnot hat eine naturalistische Landschaft nicht de-
shalb nicht gemalt, weil er sie als 'ihm nicht schön erscheinend'
abgelehnt hätte, sondern weil er sie sich nie hätte vorstellen können,

weil er—kraft einer sein psychologisches Wollen vorherbestim-
menden Notwendigkeit—nichts anderes als eine unnaturalistische
Landschaft wollen konnte; und eben deshalb hat es keinen Sinn, zu
sagen, dass er eine andersartige gewissermassen freiwillig zu malen
unterlassen hätte" (pp. 36–37). Note that Panofsky is trying to break
out of a system by using the terminology of that system.

44. Worringer, *Form in Gothic*, ed. Herbert Read (1912), rev. ed. (Lon-
don, 1957), 7.

45. Theodor Lipps, *Ästhetik: Psychologie des Schönen und der Kunst*, 2 vols.
(Hamburg/Leipzig, 1903–1906). William Heckscher notes that there
are "six calico-bound notebooks" that Panofsky, during the summer
of 1911, "filled with excerpts from the over 1,200 pages of Theodor
Lipps' work" (*Curriculum Vitae*, 9). Worringer, *Abstraction and Empathy*,
4. Note that Worringer did not completely adhere to Lipps's ideas,
the most notable difference between the two being Worringer's
refinement of the theory of empathy to include not "negative-em-
pathy" but the positive urge to abstraction. Panofsky's favorite aes-
thetician was, apparently, Viktor Lowinsky. See his "Raum und
Geschehnis in Poussins Kunst," *Zeitschrift für Ästhetik und allgemeine
Kunstwissenschaft* 11 (1916): 36–45.

46. "Das Kunstwollen als Gegenstand möglicher kunstwissenschaftlicher
Erkenntnisse keine (psychologische) Wirklichkeit ist" (p. 38).

47. "Zur Aufdeckung von prinzipiellen Stilgesetzen, die, allen diesen
Merkmalen zugrunde liegend, den formalen und gehaltlichen
Charakter des Stils von unten her erklären wurden" (p. 38). The
metaphor for the art theorist's perspective on all of these matters has
changed. Whereas before he was to do his elucidating from an Ar-
chimedean viewpoint above his objects, now he is below, looking up.

48. "Das Kunstwollen kann . . . nichts anderes sein, als das, was (nicht
für uns, sondern objektiv) als endgültiger letzter Sinn im künstle-
rischen Phänomene 'liegt'" (p.39).

49. "Polygnot kann die Darstellung einer naturalistischen Landschaft
weder gewollt noch gekonnt haben, weil eine solche Darstellung dem
immanenten Sinn der griechischen Kunst des 5. Jahrhunderts
widersprochen hätte" (46, n. 11). Compare Hauser, however, who
disagrees with this interpretation: "Now, perhaps in that particular
case both ability and will were lacking, but there certainly are other
cases in which, for example, an artist cannot cope with the natural-
istic intention that inspires him, and others in which a naturalistic
type of skill persists and sets a standard of skill, although an anti-
naturalistic style is already making itself felt. And why adduce such a
difficult and vague conception as 'the immanent intention of fifth
century Greek art' when it is simply a case of conditions in which
both the tradition of skill necessary for 'being able' and the conven-
tional basis for 'wanting' to produce a naturalistic landscape were
lacking. There may well have been some isolated personal attempts
of the most various kinds then, as there always are; but for the for-

mation of a style there must be some general practice of art to which the individual can attach himself or a consensus of taste upon which he can rely. Only in this sense can we accept the term 'immanent intention' in art history" (pp. 219–220).

50. Cassirer's *Kant Commentary* of 1916 (*Kants Leben und Lehre: Immanuel Kants Werke* [Berlin, 1918]) is an obvious theoretical source for some of the issues Panofsky discusses here. See Chapter 5 for my discussion of the way in which Cassirer follows Kant in finding an equivalent in the field of art for the concept of causality in science.

51. "So gewiss muss es auch Aufgabe der Kunstwissenschaft sein, a priori geltende Kategorien zu schaffen, die, wie die der Kausalität an das sprachlich formulierte Urteil als Bestimmungsmassstab seines erkenntnistheoretischen Wesens, so an das zu untersuchende künstlerische Phänomen als Bestimmungsmassstab seines immanenten Sinnes gewissermassen angelegt werden können" (p. 41).

52. "Eine Methode, wie Riegl sie inauguriert hat, tritt—richtig verstanden—der rein historischen, auf die Erkenntnis und Analyse wertvoller Einzelphänomene und ihrer Zusammenhänge gerichteten Kunstgeschichtsschreibung ebensowenig zu nahe, wie etwa die Erkenntnistheorie der Philosophiegeschichte" (p. 42).

53. "Kategorien nun aber, die nicht wie jene die Form des erfahrungsschaffenden Denkens, sondern die Form der künstlerischen Anschauung würden bezeichnen müssen. Der gegenwärtige Versuch, der keineswegs die Deduktion und Systematik solcher, wenn man so sagen darf transzendental-kunstwissenschaftlicher, Kategorien unternehmen will, sondern rein kritisch den Begriff des Kunstwollens gegen irrige Auslegungen sichern möchte, um die methodologischen Voraussetzungen einer auf seine Erfassung gerichteten Tätigkeit klarzustellen, kann nicht beabsichtigen, Inhalt und Bedeutung derartiger Grundbegriffe des künstlerischen Anschauens über diese Andeutungen hinaus zu verfolgen" (p. 41).

54. "Sie ersparen uns nicht das Bemühen um die unter die Sphäre der Erscheinungen hinuntergreifende Erkenntnis des Kunstwollens selbst" (p. 44).

55. Hauser, 147.

56. Podro, remark in 1976 seminar. See also Podro's discussion of Panofsky's essays in *The Critical Historians of Art*, 179–185.

4. Contemporary Issues

1. Hauser, *The Philosophy of Art History*, 204.
2. Michael Podro, Kunstwissenschaft seminar, University of Essex, 1976–1977. See also Podro's *The Critical Historians of Art*.
3. Colin Eisler, "Kunstgeschichte American Style: A Study in Migration," in *The Intellectual Migration: Europe and America, 1930–1960*,

ed. Donald Fleming and Bernard Bailyn (Cambridge, Mass., 1969), 605.

4. Hauser's survey of several of these notable examples has been most helpful. I have relied on his summary in several cases, but I have, for the most part, in addition to looking up some of Hauser's references, also combed the periodical stacks of the Warburg Library in London, excerpting here and there relevant articles from German art journals of the 1910s and 1920s.

5. Tietze, *Die Methode der Kunstgeschichte*. See also Tietze's 1925 *Lebendige Kunstwissenschaft: Zur Krise der Kunst und der Kunstgeschichte* (Vienna). For other contemporary "surveys" whose titles reveal the pervasive concern with theory, see August Schmarsow, "Kunstwissenschaft und Kulturphilosophie mit gemeinsamen Grundbegriffen," *Zeitschrift für Ästhetik und allgemeine Kunstwissenschaft* 13 (1918–1919): 165–190, 225–258; Georg Dehio, *Kunsthistorische Aufsätze* (Munich/Berlin, 1914); Max Eisler, "Die Sprache der Kunstwissenschaft," *Zeitschrift für Ästhetik und allegemeine Kunstwissenschaft* 13 (1918–1919): 309–316; Emil Utitz, *Grundlegung der allgemeinen Kunstwissenschaft*, 2 vols. (Stuttgart, 1914); and Max Dessoir, "Kunstgeschichte und Kunstsystematik," *Zeitschrift für Ästhetik und allgemeine Kunstwissenschaft* 21 (1927): 131–142.

6. Tietze, *Die Methode der Kunstgeschichte*, 2.

7. Ibid.: "Die irgendwie gruppiert werden müssen, um wissenschaftlich fassbar zu werden."

8. Ibid., 3. Since the Romantics, Tietze says, every scientific treatment of art has appeared to be a "horror and a sacrilege." Many commentators of the day voiced mottoes such as "art for the artists, and art history for the art historians." See, for example, Karl Frey, *Wissenschaftliche Behandlung und künstlerische Betrachtung* (Zurich, 1906), and Cornelius Gurlitt, "Die Kunstgeschichte für die Kunsthistoriker," *Berliner Architekturwelt* (April 1911). Vossler, for example, said in *Positivisimus und Idealismus in der Sprachwissenschaft* (Heidelberg, 1904), that if philologists cringe at the word "aesthetic," then they think of only the old aesthetics (art appreciation), not the new. All of the quoted passages were cited in *Die Methode der Kunstgeschichte*.

9. Cited in Białostocki, "Iconography and Iconology," 774. Riegl is treated fairly extensively in Tietze, *Die Methode der Kunstgeschichte*; Wölfflin, writing *Kunstgeschichtliche Grundbegriffe* at approximately the time that Tietze's book was published, is more cursorily surveyed—for example in a passing critique of *Prolegomena zu einer Psychologie der Architektur* (1886).

10. Ernst Heidrich, *Beiträge zur Geschichte und Methode der Kunstgeschichte* (Basel, 1917), 15. Warburg, of course, was one of the first scholars to treat the Middle Ages seriously.

11. Quoted in Kleinbauer, *Modern Perspectives in Western Art History*, 46. See Carl G. Heise, *Adolph Goldschmidt zum Gedächtnis, 1863–1944* (Hamburg, 1963).

12. Bernhard Schweitzer, "Die Begriffe des Plastischen und Malerischen als Grundformen der Anschauung," *Zeitschrift für Ästhetik und allgemeine Kunstwissenschaft* 13 (1918–1919): 259–269, cited in Hauser, 148. Edgar Wind, "Kritik der Geistesgeschichte: Das Symbol als Gegenstand kulturwissenschaftlicher Forschung," *Kulturwissenschaftliche Bibliographie zum Nachleben der Antike* 1 (Leipzig, 1934): vii–ix.

13. Edgar Wind, "Zur Systematik der künstlerischen Probleme," *Zeitschrift für Ästhetik und allgemeine Kunstwissenschaft* 18 (1924–1925): 438.

14. Wilhelm Pinder, *Das Problem der Generation in der Kunstgeschichte Europas* (Berlin, 1926), 14–15. See Hauser, 250.

15. Hauser, 248, paraphrasing Pinder.

16. Alexander Dorner, "Die Erkenntnis des Kunstwollens durch die Kunstgeschichte," *Zeitschrift für Ästhetik und allgemeine Kunstwissenschaft* 16 (1921–1922): 216.

17. Richard Hamann, "Die Methode der Kunstgeschichte," *Monatshefte für Kunstwissenschaft* 9 (1916): 64–104, and Karl Mannheim, *Beiträge zur Theorie der Weltanschauungsinterpretation* (1923), paraphrased in Hauser, 243. Paul Frankl, likewise, in *Die Entwicklungsphasen der neueren Baukunst* (1914), said an analyst has a right "to correct sources" (Hauser, 254).

18. Kleinbauer, 4. Julius von Schlosser, *Die Kunstliteratur: Ein Handbuch zur Quellenkunde der neueren Kunstgeschichte* (Vienna, 1924); also Schlosser, *Die Wiener Schule der Kunstgeschichte* (Innsbruck, 1934) and "Stilgeschichte und Sprachgeschichte der bildenden Kunst."

19. Max Weber, "Die 'Objektivität' sozialwissenschaftlicher und sozialpolitischer Erkenntnis," in *Gesammelte Aufsätze zur Wissenschaftslehre*, 2d ed. (Tübingen, 1951), 191; see Hauser, 213. See also Podro's comments on Weber's objections, in *The Critical Historians of Art*, 178–179.

20. Białostocki, 770.

21. Białostocki provides an extensive listing of iconographic research from several countries, even going in some cases as far back as the seventeenth century. Contemporary German scholarship includes J. Wilpert as the primary example, in *Die Malereien der Katakomben Roms* (1903), *Die römischen Mosaiken und Malereien der kirchlichen Bauten vom IV. bis XIII. Jahrhundert* (1916), and *I sarcofagi cristiani antichi* (1929–1936), but he also mentions K. Künstle's *Ikonographie der christlichen Kunst* (1926–1928), J. Sauer's *Symbolik des Kirchengebäudes und seiner Ausstattung in der Auffassung des Mittelalters* (1902), 2d ed. (1924), and J. Braun's *Tracht und Attribute der Heiligen in der deutschen Kunst* (1943), 772.

22. McCorkel, "Sense and Sensibility," 37.

23. Kleinbauer, 33. Meyer Schapiro notes the correspondence of these two "sciences" with positivist and idealist modes of interpretation in his review of *Kunstwissenschaftliche Forschungen*, vol. 2, ed. O. Pächt, in "The New Viennese School," *Art Bulletin* 18 (1936): "The distinction

made between the merely descriptive and classifying nature of the first science and the higher 'understanding' of the second is not so much a distinction between the values of observation and theory, such as agitates some physicists and philosophers of science, but corresponds rather to the distinction made by many German writers between the natural sciences, which 'describe' or classify atomistically the inorganic and lower organic worlds, and their own sciences of the spirit (*Geisteswissenschaften*) which claim to penetrate and 'understand' totalities like art, spirit, human life and culture. The great works of the latter depend on depth of insight, of the first, on ingenuity and exactness. Such a distinction, often directed against the plebeian manipulation and matter-of-fact, materialistic spirit of the best in natural science, puts a premium on wishful intuitiveness and vague, intangible profundity in the sciences that concern man" (p. 258).

24. J. P. Hodin, "German Criticism of Modern Art since the War," *College Art Journal* 17 (Summer 1958): 374; Sedlmayr, *Verlust der Mitte: Die bildende Kunst des 19. und 20. Jahrhunderts als Symptom und Symbol der Zeit* (Salzburg, 1948). Also see *Kunst und Wahrheit: Zur Theorie und Methode der Kunstgeschichte* (Hamburg, 1958).

25. We could, of course, affix the label "formalist" to a wide variety of enterprises—for example, at the other end of the spectrum from structuralist analysis, we could discuss Walter Friedländer's stylistic studies of the "anticlassical" style of Mannerism, first published in 1925 but delivered as an inaugural address at the University of Freiburg in 1914. See "Die Entstehung des antiklassischen Stiles in der italienischen Malerei um 1520," in *Repertorium für Kunstwissenschaft* 46 (1925): 49–86 (cited in Rosand, "Art History and Criticism," 436).

26. Sheldon Nodelman provides an interesting summary of this movement in "Structural Analysis in Art and Anthropology," 100. Kaschnitz, like B. Schweitzer (another structuralist; see above in Chapter 4 and also "Strukturforschung in Archäologie und Vorgeschichte," *Neue Jahrbücher für antike und deutsche Bildung* 4–5 [1938]), objected to the "prevailing terminology and methods of art history, most especially to those of Wölfflin, and to 'style-criticism' in general, [because] these are concerned solely with the effect of the work of art upon the beholder, with the 'impression,' rather than with the interior structure of the work itself." Compare this "structural" method with the later one of Lévi-Strauss. Nodelman says that the methods developed independently, although they share many fundamental precepts—for example, Kaschnitz notes that a culture apprehends space through binary oppositions in the same way that, according to Lévi-Strauss, it apprehends nature. See *Kunstwissenschaftliche Forschungen*, 2; *Mittelmeerische Grundlagen der antiken Kunst* (Frankfurt, 1944); and *Ausgewählte Schriften* (Berlin, 1965).

27. For example, through a three-dimensional grid of lines meeting at right angles, which Kaschnitz applies to a piece of Egyptian sculp-

ture, he is able to say that the vertical and right angles alone give the work its quality of authority. The work excludes the force of "animal energy" to an extreme; it gains its impressiveness from the "force of gravity which inheres in masses." From this description, he concludes that the "entire function of Egyptian monumental art is to exclude death, to conserve existence at the cost of petrifaction, by a process parallel to that of the mummification of the dead" (Nodelman, 98–99).

28. Ibid., 97.

29. Dvořák, "Das Rätsel der Kunst der Brüder van Eyck" in *Jahrbuch der kunsthistorischen Sammlungen des Allerhöchsten Kaiserhauses* 24 (1904): 161–317.

30. Kleinbauer, 397. Salerno, 527, says that Dvořák always linked the *evolution* of art with the *evolution* of the human spirit.

31. Cited in Dvořák, *Kunstgeschichte als Geistesgeschichte* (Munich, 1924), x (originally part of a 1920 lecture, "Über Kunstbetrachtung"). Also see Kleinbauer, 95–99.

32. Dvořák, *Idealism and Naturalism in Gothic Art*, trans. Randolph J. Klawiter (Notre Dame, 1967), 104 (originally published as *Idealismus und Naturalismus in der gotischen Skulptur und Malerei* [1918; reprint, Munich, 1928]).

33. Frederick Antal notes a concern with weltanschauung even in Riegl's late work: "Continuing Riegl, who, in his late phase, regarded his notion of the 'art will' as dependent on the outlook of the period in question, Dvořák, in his latter years, dealt with art history as part of the history of ideas, of the development of the human spirit" ("Remarks on the Method of Art History, I," *Burlington Magazine* 91 [1949]: 49). But as Salerno observes, the Vienna school always "adhered" to "a science of art based on visual or formal laws" (p. 526). Note that J. Strzygowski held the other chair of art history at Vienna and sought to establish evolutionary "facts" by way of stylistic comparisons. See Kleinbauer, 23. Ernst Heidrich's criticism of Riegl's strict evolutionary principles, in *Beiträge zur Geschichte und Methode der Kunstwissenschaft*, however, led Dvořák to react against so single-minded a view and to become more interested, later, in the history of ideas. See my earlier discussion of Riegl in Chapter 3.

34. Heckscher, "The Genesis of Iconology," 247, Schapiro, "The New Viennese School," 258, and Heckscher, 247.

35. Heckscher, 247.

36. Ibid., 240, 246. The word "iconology," of course, had a long and impressive lineage, beginning with Cesare Ripa's *Iconologia* of 1593, before it was appropriated by Warburg. G. J. Hoogewerff, "L'iconologie et son importance pour l'étude systématique de l'art chrétien, *Rivista di archeologia cristiana* 8 (1931): 53–82, gave the term a more precise definition: "After the systematic examination of the development of themes has been accomplished [iconography], iconology then poses the question of their interpretation. Concerned

more with the continuity than with the material of a work of art, it seeks to understand the symbolic, dogmatic, or mystical sense (even if hidden) in figural forms" (quoted in Białostocki, 774).

37. Kurt W. Forster, "Aby Warburg's History of Art: Collective Memory and the Social Mediation of Images," *Daedalus* 105 (Winter 1976): 169.

38. E. H. Gombrich, *Aby Warburg: An Intellectual Biography* (London, 1970). Gombrich traces, in particular, the role of Warburg's teachers and theoretical predecessors from Lessing through Lamprecht and discusses as well his debt to late nineteenth-century psychological theories, in particular to the "associationism" of Herbart.

39. Fritz Saxl, "The History of Warburg's Library (1886–1944)," was emended by Gombrich, having been unfinished in 1943, in *Warburg*, 327. See Gombrich, *Warburg*, 204: In "Lamprecht's terminology," *Universalgeschichte* "meant history without a one-sided political bias." See Lamprecht's model for his library, *Das Kgl. Sächsische Institut für Kultur- und Universalgeschichte bei der Universität Leipzig* (1909).

40. Forster, 170.

41. Gombrich, *Warburg*, 254.

42. Peter Gay, *Weimar Culture: The Outsider as Insider* (New York, 1968), 30–34. See also Dieter Wuttke, "Aby Warburg und seine Bibliothek," *Arcadia* 1 (1966): 319–333.

43. Heckscher, "The Genesis of Iconology," 240.

44. Gay, *Weimar Culture*, 1, 6.

45. Aby W. Warburg, *Ausgewählte Schriften und Würdingen*, ed. Dieter Wuttke (Baden-Baden, 1979). See also Gertrud Bing's edition in Italian, *La rinascita del paganesimo antico* (Florence, 1966), and Carl Landauer, "Das Nachleben Aby Warburgs," *Kritische Berichte* 9 (1981): 67–71.

46. Gombrich, *Warburg*, 309, 144, 312.

47. Heckscher, "The Genesis of Iconology," 247.

48. Gombrich, *Warburg*, 314.

49. Antal, 50, and Gertrud Bing, introduction to *Rinascita*, cited in Antal.

50. Gombrich, *Warburg*, 320, 127.

51. Forster, 172, 173.

52. Heckscher, "Petites Perceptions: An Account of Sortes Warburgianae," *Journal of Medieval and Renaissance Studies* 4 (1974): 101.

53. Gombrich, *Warburg*, 127.

54. Panofsky, "Aby Warburg," *Repertorium für Kunstwissenschaft* 51 (1930): 3 (originally published in *Hamburger Fremdenblatt* [October 28, 1929]).

55. Gombrich, *Warburg*: "In einer Zeit, wo die italienische Kunstentwicklung schon vor der Gefahr stand, durch den zu grossen Sinn für die ruhigen Zustände der Seele dem sentimentalen Manierismus einerseits und andererseits (durchstr.: dem barocken) durch Vorliebe für äusserliche übergrosse Beweglichkeit dem ornamentalen Manierismus der zerflatternden Linie zugetrieben zu werden, findet er

unbekümmert für die Darstellung des seelich bewegten Menschen eine neue Vortragsweise" (p. 101; also see pp. 184, 168).

56. Ibid., 125.

57. Ibid., 249, 213.

58. Forster, 174.

59. Gombrich, *Warburg*, 321, 215.

60. David Farrer, *The Warburgs: The Story of a Family* (New York, 1975), 129.

61. F. Saxl, *A Heritage of Images: A Selection of Lectures by F. Saxl*, ed. Hugh Honour and John Fleming, introduction by Ernst Gombrich (1957; reprint, London, 1970), 11 (remark by Gombrich).

62. The privatdozent, in the aristocratic structure of German universities, was an untenured instructor without a secure income who was awaiting a "call" to a tenured position and a guaranteed salary. The call was often politically tinged: "The power of the ministry of culture to select the candidates for university chairs from a list prepared by the faculty further insured stability . . . and similarity in social background" (Iggers, 83). See also Fritz K. Ringer, *The Decline of the German Mandarins: The German Academic Community, 1890–1933* (Cambridge, Mass., 1969). Panofsky was appointed to the rank of full professor in 1926. See his own account of the German system of education in "Three Decades of Art History in the United States," in *Meaning in the Visual Arts*, 335–337 (originally published as "The History of Art," in *The Cultural Migration: The European Scholar in America*, ed. W. R. Crawford [Philadelphia, 1953]).

63. Gombrich, *Warburg*, 316, 317. See also Saxl, "Die Bibliothek Warburg und ihr Ziel," in *Vorträge der Bibliothek Warburg 1921–1922* (Leipzig/Berlin, 1923).

64. Gombrich, *Warburg*, 317.

65. Panofsky, *Hercules am Scheidewege und andere antike Bildstoffe in der neueren Kunst*, quoted in Białostocki, 775.

66. Fritz Saxl, "Ernst Cassirer," in *The Philosophy of Ernst Cassirer*, ed. P. A. Schilpp (1949; reprint, La Salle, 1973), 47–48 (I shall henceforth designate the volume as Schilpp).

67. Ernst Cassirer, *Die Begriffsform im mythischen Denken*, Studien der Bibliothek Warburg 1 (Leipzig/Berlin, 1922); Saxl, 49.

68. Cassirer, *Individuum und Kosmos in der Philosophie der Renaissance*, Studien der Bibliothek Warburg 10 (Leipzig/Berlin, 1927). Note, in particular, the dedication addressed to Warburg on his sixtieth birthday. Mario Domandi's translation was published as *The Individual and the Cosmos in Renaissance Philosophy* (New York, 1963).

69. Panofsky, *Studies in Iconology*, 8.

5. Panofsky and Cassirer

1. Edgar Wind, "Contemporary German Philosophy," in *Journal of Philosophy* 22 (August 27, 1925): 477–493, and 22 (September 10,

1925): 516–530. Wind characterizes the neo-Kantians as showing a "tendency to eliminate the metaphysical elements in Kant and to develop the methodical parts of his philosophy" (p. 487).

2. Hermann Cohen, preface to first edition of *Logik der reinen Erkenntnis* (1902), xi, xiii, cited by Seymour W. Itzkoff, in *Ernst Cassirer: Scientific Knowledge and the Concept of Man* (Notre Dame, 1971), 28. Compare Artur Buchenau, "Zur methodischen Grundlegung der Cohenschen Ästhetik," in *Zeitschrift für Ästhetik und allgemeine Kunstwissenschaft* 8 (1913): 615–623. See the full quotation of Kant in Cassirer's *An Essay on Man: An Introduction to a Philosophy of Human Culture* (1944; reprint, New Haven, 1962), 180. *An Essay on Man* is a considerably condensed English translation of *The Philosophy of Symbolic Forms*. Feeling as did Lessing that "a big book is a big evil," Cassirer made a fresh start here and concentrated only on *The Philosophy of Symbolic Forms* as it dealt with "points . . . of special philosophical importance" (p. vii).

3. Charles Hendel, introduction to Ernst Cassirer, *The Philosophy of Symbolic Forms*, vol. 1, *Language* (New Haven, 1955), 3. The school was "founded" as early as 1870 by Hermann Cohen, who believed that "only by returning to Kant, could philosophy regain the precision of methods which it had lost during the romantic epoch" (Wind, "Contemporary German Philosophy," 479).

4. Panofsky to Heckscher, November 1946. See Heckscher, *A Curriculum Vitae*, 10.

5. Heckscher, private conversation, summer of 1983.

6. Cassirer, *The Problem of Knowledge: Philosophy, Science and History since Hegel* (1941), trans. W. H. Woglom and C. Hendel (New Haven, 1950), 2, 14; and Cassirer, *Language and Myth* (1925) (New York, 1946), 8. Compare Hendel's summary of this revolution in his introduction, 5–6, 8–10.

7. Wind, "Contemporary German Philosophy," 486.

8. Bocheński, 4.

9. See Wind, "Contemporary German Philosophy," 483, and Ingrid Stadler, "Perception and Perfection in Kant's Aesthetics," in *Kant: A Collection of Critical Essays*, ed. R. P. Wolff (London, 1968), 353–354.

10. Dimitry Gawronsky, "Cassirer: His Life and His Work," in Schilpp, 5–6, 15. Gawronsky suggests one of the reasons for the hatred other schools of philosophy exhibited toward the Marburgians: "Kant decisively broke with the naive and shallow belief of the German Enlightenment in the miraculous power of the intellect, with its tendency to solve with the help of trite and schematic reasonings all mysteries of the cosmos; he put the greatest stress upon the necessity of clear insight into the basic limitations which characterize the creative work of human reason" (p. 10). Fritz Ringer in *The Decline of the German Mandarins* also notes that, on the other hand, the members of the Marburg School were accused of harboring positivist inclinations because

of their emphasis on the natural sciences and systems of logic (pp. 306–307). See also Thomas E. Willey, *Back to Kant: The Revival of Kantianism in German Social and Historical Thought, 1860–1914* (Detroit, 1978), 170–173.

11. Gawronsky, 9.
12. Ibid., 10, and Wind, "Contemporary German Philosophy," 481.
13. Helmut Kuhn, "Ernst Cassirer's Philosophy of Culture," in Schilpp, 553.
14. Cassirer, "Leibniz' System in seinen wissenschaftlichen Grundlagen," in *The Problem of Knowledge*, viii. See his more recent discussion of Leibniz on pp. 14–15.
15. Quoted in Gawronsky, 17.
16. Cassirer, *Language*, 75.
17. Susanne K. Langer, "On Cassirer's Theory of Language and Myth," in Schilpp, 385, 387.
18. Fritz Kaufmann, "Cassirer, Neo-Kantianism, and Phenomenology," in Schilpp; see pp. 831–845 especially.
19. Gawronsky, 14. In 1923 he added a third volume on post-Kantian phenomenology, and in 1941 he finished the fourth, now published as *The Problem of Knowledge: Philosophy, Science, and History since Hegel.*
20. Hendel in his introduction to *The Philosophy of Symbolic Forms*, vol. 2, *Mythical Thought* (New Haven, 1955), ix–x. For Cassirer's own assessment of his debt to the Warburg Library and its scholars, see his preface to *Mythical Thought*, xviii. Consult my bibliography for further information about these works.
21. Gawronsky, 25. Kaufmann, however, in his article contradicts Gawronsky by saying that another Marburg scholar also had this idea: "Paul Natorp in *Allgemeine Psychologie* attempts a 'description of the formations of consciousness . . . which must not be restricted to the pure forms of knowledge, volition, and art, and furthermore, to the pure foundations of religious consciousness, but may be extended to the . . . imperfect objectifications of opinion, belief, and imagination—regardless of, and unlimited by, their inner relation to truth and the realm of laws. . . . Even the most irresponsible opinion, the darkest superstition, the most boundless imagination make use of the categories of objective knowledge; they are still ways of objectification, however poor the means and impure the performance of this process may prove to be'" (p. 834).
22. Langer, 393.
23. Cassirer, *Language*, 80–81.
24. Cassirer, *An Essay on Man*, 25, and Hendel, introduction to *Language*, 44.
25. Carl H. Hamburg, "Cassirer's Conception of Philosophy," in Schilpp, 94.
26. Ibid., 88.
27. W. C. Swabey, "Cassirer and Metaphysics," in Schilpp, 136.

28. Hendel, introduction to *Language*, 13. See Cassirer's summary of Kant's "schema," in *Language*: "For Kant the concepts of the pure understanding can be applied to sensory intuitions only through the mediation of a third term, in which the two, although totally dissimilar, must come together—and he finds this mediation in the 'transcendental schema,' which is both intellectual and sensory" (p. 200). Hendel declares that if Cassirer had not been so original, he might well have given *The Philosophy of Symbolic Forms* the title *Schema* (p. 15).
29. Cassirer, *Language*, 84.
30. Katharine Gilbert, "Cassirer's Placement of Art," in Schilpp, 609. See Hamburg, 85.
31. Langer, 393. Compare Cassirer's closing passage in the *Language* volume: "The characteristic meaning of language is not contained in the opposition between the two extremes of the sensuous and the intellectual, because in all its achievements and in every particular phase of its progress, language shows itself to be *at once* a sensuous and an intellectual form of expression." Also see Hendel, introduction to *Language*, 50–53, and compare Robert Hartman's quotation of a passage in vol. 2 of *The Philosophy of Symbolic Forms* ("Cassirer's Philosophy of Symbolic Forms," in Schilpp, 293): "The characteristic and peculiar achievement of each symbolic form—the form of language as well as that of myth or of theoretical cognition—is not simply to receive a given material of impressions possessing already a certain determination, quality and structure, in order to graft on it, from the outside, so to speak, another form out of the energy of consciousness itself. The characteristic action of the spirit begins much earlier. Also, the apparently 'given' is seen, on closer analysis, to be already processed by certain acts of either the linguistic, the mythical, or the logico-theoretical 'apperception.' It 'is' only that which it has been *made* into by those acts. Already in its apparently simple and immediate states it shows itself conditioned and determined by some primary function which gives it significance. In this primary formation, and not in the secondary one, lies the peculiar secret of each symbolic form."
32. Cassirer, *Language*, 107.
33. Hendel, introduction to *Mythical Thought*, viii.
34. Cassirer, *Mythical Thought*, 29.
35. Cassirer, *Language*, 137.
36. Hendel, introduction to *Language*, 54.
37. Cassirer, *Language*, 122.
38. Walter Eggers, "From Language to the Art of Language: Cassirer's Aesthetics," in *The Quest for the Imagination*, ed. O. B. Hardison (Cleveland, 1971), 98, and E. D. Hirsch, *Validity in Interpretation*, 225.
39. Cassirer, *Language*, 137.
40. Cassirer, *Mythical Thought*, 23.

41. Gombrich, *Warburg*, 88–89.
42. Cassirer, *Mythical Thought*, 4.
43. Ibid., 47, 14.
44. Cassirer, *Language and Myth* (1925), trans. Susanne Langer (New York, 1946), 13.
45. Ibid., 13, 99.
46. Cassirer, *The Philosophy of Symbolic Forms*, vol. 3, *The Phenomenology of Knowledge* (New Haven, 1955), 5–6, 35.
47. Ibid.: "The paradise of immediacy is closed to it: it must—to quote a phrase from Kleist's article 'On the Marionette Theater'—'journey round the world and see whether it may not be open somewhere in back'" (p. 40; also see pp. 22–23).
48. See, for example, Paul Ricoeur, *Freud and Philosophy: An Essay on Interpretation*, trans. D. Savage (New Haven, 1970), 9–11.
49. Cassirer *Language and Myth*, 8.
50. Cassirer, *Language*, 79.
51. Cassirer, *Mythical Thought*, 9, and Langer in her preface to *Language and Myth*, ix.
52. Swabey, 125.
53. Hendel, introduction to *Language*, 35, from *An Essay on Man*, 185.
54. Gawronsky, 14.
55. Cassirer, *Language*, 82. In *An Essay on Man*, Cassirer credits Wölfflin with having found such a structural scheme for the history of art: "As Wölfflin insists, the historian of art would be unable to characterize the art of different epochs or of different individual artists if he were not in possession of some fundamental *categories* of artistic description. He finds these categories by studying and analyzing the different modes and possibilities of artistic expression" (p. 69).
56. Cassirer, *Mythical Thought*, 11.
57. Cassirer, *Language*, 69, 77.
58. Hamburg, 92, and Cassirer, *Language*, 82.
59. Cassirer, *Language*, 114, 84.
60. Cassirer, *An Essay on Man*, 52. For Cassirer's own declaration of his debt to Hegel, see *Mythical Thought*, xv, and *The Problem of Knowledge*, 3.
61. Hendel, introduction to *Language*, 41.
62. Ibid., 34.
63. Cassirer, *Language*, 80–81.
64. Hartman (p. 312) translating Cassirer in *Das Erkenntnisproblem in der Philosophie und Wissenschaft der neueren Zeit*, vol. 1 (Berlin, 1906), 16.
65. Cassirer, *An Essay on Man*, 70. Compare Wölfflin in *Kunstgeschichtliche Grundbegriffe*, 227; in English translation: "For us, intellectual self-preservation demands that we should classify the infinity of events with reference to a few results."
66. Cassirer, *An Essay on Man*, 70–71, 68. Note the similarity of the language discussing "circularity" here with that in which Gombrich dis-

cusses the idea of the Hegelian wheel. Cassirer continues: "Language, myth, religion, art, science, history are the constituents, the various sectors of this circle" (p. 68).

67. Kant, *Kritik der reinen Vernunft*, 2d ed., as quoted by Cassirer in *Language*, 200.

68. Cassirer, *An Essay on Man*, 143.

69. Gilbert, 624–628. Also see K. Gilbert and Helmut Kuhn, *A History of Esthetics* (1939), 2d ed. (New York, 1972), 562.

70. Gilbert discerns Cassirer's influence on the early publications of the Warburg journal (begun in 1922) in its first long article, Jacques Maritain's "Sign and Symbol." Panofsky's article originally appeared as part of the 1924–1925 lecture series in the *Vorträge der Bibliothek Warburg*, 258–330, and was published by the Warburg Institute in 1927. It also appears in the Oberer and Verheyen anthology (pp. 99–167). I have, however, used the Warburg original, since an unpublished, anonymous, and intelligent English translation exists alongside the original on the shelves of the Warburg Library. The first set of page numbers cited in parentheses after the quotations is from the original Warburg edition, and the second set refers to the unpublished translation (available from the Warburg Library). Where particularly significant passages are quoted from this translation, I offer the original German in a footnote. See the contributions of both Panofsky and Cassirer at the Fourth Congress of Aesthetics, reprinted in *Zeitschrift für Ästhetik und allgemeine Kunstwissenschaft* 25 (1931): 52–54.

71. Marx Wartofsky, "Visual Scenarios: The Role of Representation in Visual Perception," in *The Perception of Pictures*, vol. 2, ed. M. A. Hagen (New York, 1980), 132. Also see Wartofsky, "Pictures, Representation, and the Understanding," in *Logic and Art: Essays in Honor of Nelson Goodman*, ed. R. Rudner and I. Scheffler (Indianapolis, 1972).

72. See, for example, Nelson Goodman, who in *Languages of Art: An Approach to a Theory of Symbols* (Indianapolis, 1976), 10–19, appears sympathetic to Panofsky; Gombrich, *Art and Illusion*; M. H. Pirenne, *Optics, Painting, and Photography* (Cambridge, 1970), chap. 7; James J. Gibson, "The Information Available in Pictures," *Leonardo* 4 (1971): 27–35; Julian Hochberg, "The Representation of Things and People," in *Art, Perception, and Reality*, ed. E. Gombrich, J. Hochberg, and Max Black (Baltimore, 1972); and Rudolf Arnheim, *Art and Visual Perception: A Psychology of the Creative Eye* (Berkeley, 1971), chap. 5.

73. Gombrich, "The 'What' and the 'How': Perspective Representation and the Phenomenal World," in *Logic and Art*, 138, 148.

74. Wartofsky, "Visual Scenarios," 132, 133, 140.

75. "Diese ganze 'Zentralperspektive' macht, um die Gestaltung eines völlig rationalen, d.h. unendlichen, stetigen und homogenen Raumes gewährleisten zu können, stillschweigend zwei sehr wesentliche Voraussetzungen: zum Einen, dass wir mit einem einzigen und unbe-

wegten Auge sehen würden, zum Andern, dass der ebene Durch-
schnitt durch die Sehpyramide als adäquate Wiedergabe unseres
Sehbildes gelten dürfe. In Wahrheit bedeuten aber diese beiden
Voraussetzungen eine überaus kühne Abstraktion von der
Wirklichkeit (wenn wir in diesem Falle als 'Wirklichkeit' den tatsäch-
lichen, subjektiven Seheindruck bezeichnen dürfen)" (p. 260; p. 2).

76. Panofsky, quoting Cassirer, *Die Philosophie der symbolischen Formen*,
vol. 2, *Das mythische Denken* (Berlin, 1925), 107ff. Compare Cassirer,
Language: "[We] all recognize that space in its concrete configuration
and articulation is not 'given' as a ready-made possession of the psy-
che, but comes into being only in the process or, one might say, in
the general movement of consciousness. . . . The spatial unity which
we build in aesthetic vision and creation, in painting, sculpture and
architecture, belongs to an entirely different sphere from the spatial
unity which is represented in geometrical theorems and axioms" (pp.
99, 96).

77. Panofsky, *Idea: A Concept in Art Theory* (1924), trans. J. J. S. Peake, 2d
ed. (New York, 1968), 5.

78. "Der dargestellte Raum ein Aggregatraum,—nicht wird er zu dem,
was die Moderne verlangt und verwirklicht: zum Systemraum. Und
gerade von hier aus wird deutlich, dass der antike "Impressionis-
mus" doch nur ein Quasi-Impressionismus ist. Denn die moderne
Richtung, die wir mit diesem Namen bezeichnen, setzt stets jene
höhere Einheit über dem Freiraum und über den Körpern voraus,
so dass ihre Beobachtungen von vornherein durch diese Vorausset-
zung ihre Richtung und ihre Einheit erhalten; und sie kann daher
auch durch eine noch so weit getriebene Entwertung und Auflösung
der festen Form die Stabilität des Raumbildes und die Kompaktheit
der einzelnen Dinge niemals gefährden, sondern nur verschlei-
ern—während die Antike, mangels jener übergreifenden Einheit,
jedes Plus an Räumlichkeit gleichsam durch ein Minus an Kör-
perlichkeit erkaufen muss, sodass der Raum tatsächlich von und an
den Dingen zu zehren scheint; und ebendies erklärt die beinahe
paradoxe Erscheinung, dass die Welt der antiken Kunst, solange
man auf die Wiedergabe des zwischenkörperlichen Raumes ver-
zichtet, sich der modernen gegenüber als eine festere und
harmonischere darstellt, sobald man aber den Raum in die Darstel-
lung miteinbezieht, am meisten also in den Landschaftsbildern, zu
einer sonderbar unwirklichen, widerspruchsvollen, traumhaft-kim-
merischen wird" (pp. 269–270; pp. 13–14).

79. "So ist *also* die antike Perspektive der Ausdruck einer bestimmten,
von dem der Moderne grundsätzlich abweichenden Raumanschau-
ung . . . und damit einer ebenso bestimmten und von der der Mo-
derne ebenso abweichenden Weltvorstellung" (p. 270; p. 14).

80. Panofsky's essay first appeared in *Monatshefte für Kunstwissenschaft*
14 (1921): 188–219 (reprinted, with Panofsky's own translation, as
"The History of the Theory of Human Proportions as a Reflection of

the History of Styles," in *Meaning in the Visual Arts*, 55–107). See Podro's discussion of this essay in the *The Critical Historians of Art*, 189–192.

81. Panofsky, "The History of the Theory of Human Proportions," 55–56.

82. Panofsky, *Die deutsche Plastik des elften bis dreizehnten Jahrhunderts*, 2 vols. (Munich, 1924). Renate Heidt, in a published 1977 German dissertation, *Erwin Panofsky—Kunsttheorie und Einzelwerk* (Cologne/Vienna, 1977), attempts to apply Panofsky's 1925 theoretical essay "Über das Verhältnis der Kunstgeschichte zur Kunsttheorie: Ein Beitrag zu der Erörterung über die Möglichkeit 'kunstwissenschaftlicher Grundbegriffe,'" *Zeitschrift für Ästhetik und allgemeine Kunstwissenschaft* 18 (1924–1925), to the practical concerns of his book on German sculpture. She finds this book, in comparison to his early theoretical work, an "academically sterile and unsatisfactory" ("akademisch steril und unbefriedigend") ahistorical account of the problem, and she also finds it revealing that at the same time that Panofsky was writing this stylistic account, he was deeply absorbed in his iconographic work on Dürer at the Warburg Library. I thank Creighton Gilbert for first bringing this manuscript to my attention. Heidt, however, only concentrates on one theoretical work and, as far as I can discern, is uninterested in the neo-Kantian genesis of even this one essay. Her bibliography is important, however, as it documents the continuing German response to Panofsky.

83. In Panofsky's neo-Kantian terms, by bringing unity to the manifold: "Auch das 'massenmässig' empfunde Kunstwerk bedarf ja, wenn anders es Kunstwerk sein soll, einer bestimmten Organisation, die hier wie überall nur darin bestehen kann, dass eine 'Mannigfaltigkeit' zur 'Einheit' gebunden wird" (pp. 17–18).

84. Cassirer, *Language*, 82.

85. "Und wiederum ist diese perspektivische Errungenschaft nichts anderes, als ein konkreter Ausdruck dessen, was gleichzeitig von erkenntnistheoretischer und naturphilosophischer Seite her geleistet worden war" (p. 285; p. 29). His much later work *Gothic Architecture and Scholasticism: An Inquiry into the Analogy of the Arts, Philosophy, and Religion in the Middle Ages* (1951) (New York, 1957) is evidence of Panofsky's continuing interest in this sort of approach.

86. "Wo die Arbeit an bestimmten künstlerischen Problemen so weit vorangeschritten ist, dass—von den einmal angenommenen Voraussetzungen aus—ein Weitergehen in derselben Richtung unfruchtbar erscheint, pflegen jene grossen Rückschläge oder besser Umkehrungen einzutreten, die, oft mit dem Überspringen der Führerrolle auf ein neues Kunstgebiet oder eine neue Kunstgattung verbunden, gerade durch eine Preisgabe des schon Errungenen, d.h. durch eine Rückkehr zu scheinbar "primitiveren" Darstellungsformen, die Möglichkeit schaffen, das Abbruchsmaterial des alten Gebäudes zur Aufrichtung eines neuen zu benutzen,—die gerade durch die

Setzung einer Distanz die schöpferische Wiederaufnahme der früher schon in Angriff genommenen Probleme vorbereiten" (p. 271–272; p. 16). His brief discussion of Romanesque art can serve as an example: "After the comparatively retrospective and therefore preparatory epochs of the Carolingian and Ottonian 'renaissances' the style we are accustomed to call 'Romanesque' is formed, and that style in its full maturity around the middle of the twelfth century completes the turning away from antiquity never wholly achieved in Byzantium. Now line is merely line, that is, a means of graphic expression *sui generis*, fulfilling its purpose in bounding and ornamenting a surface; and surface is merely surface, that is, no longer the indication, however vague, of immaterial space but the strictly two-dimensional top surface of a material pictorial vehicle. . . . For if Romanesque painting reduces body and space in the same way and with the same decisiveness to surface, by that very act it established for the first time the homogeneity between the two, changing their loose spatial unity into something firm and substantial. From now on for better or for worse body and space are joined together, and when later body is again freed from its bondage to surface, it cannot develop without out a corresponding development of space" (pp. 274–275; pp. 18–20).

87. George Kubler, *The Shape of Time: Remarks on the History of Things* (New Haven, 1962). I quote the opening sentences of Kubler's "Preamble": "Cassirer's partial definition of art as symbolic language has dominated art studies in our century. A new history of culture anchored upon the work of art as a symbolic expression thus came into being. By these means art has been made to connect with the rest of history. But the price has been high, for while studies of meaning received all our attention, another definition of art, as a system of formal relations, thereby suffered neglect. . . . The structural forms can be sensed independently of meaning."

88. Cassirer, *Language*, 97.

89. Cassirer, *Kants Leben und Lehre*. An English translation has recently appeared: Ernst Cassirer, *Kant's Life and Thought*, trans. James Haden (New Haven, 1981). I refer, however, to the original German.

90. Hendel, introduction to *Language*, 19, and *Kants Leben*: "Die Wahrheit in ihrem eigentlichen und vollständigen Sinne wird sich uns erst erschliessen, wenn wir nicht mehr vom Einzelnen, als dem Gegebenen und Wirklichen beginnen, sondern mit ihm enden" (pp. 298–299).

91. Hendel, introduction to *Language*, 20.

92. Cassirer, *Kants Leben*, 360–361. In this context, Cassirer quotes Kant's example of a tree from the *The Critique of Judgement*, trans. James Creed Meredith (1928; reprint, Oxford, 1952), sec. 3(64). Meredith entitles this section "The Analytic of Teleological Judgement": "A tree produces, in the first place, another tree, according to a familiar law of nature. But the tree which it produces is of the same

genus. Hence, in its *genus*, it produces itself. . . . Secondly, a tree produces itself even as an *individual* . . . , but growth is here to be understood in a sense that makes it entirely different from any increase according to mechanical laws. . . . Thirdly, a part of a tree also generates itself in such a way that the preservation of one part is reciprocally dependent on the preservation of the other parts." Cassirer says that what is significant about this passage from Kant is that here "nature is not just regarded through laws of substantiality, causality, effect, etc.—but for the first time is described in terms of a quality peculiar to its being and becoming . . . a new deepening of the contents of nature" (p. 361).

93. Hendel, introduction to *Language*, 20; *Kants Leben*, 339. "Instead of regarding the process of time in which every preceding moment is intertwined with the present and loses its existence in it, let us think of the appearance of life as a mutual interlocking of single moments, where the past remains contained in the present and both are recognizable in the future" (pp. 358–359; see also 339).

94. Cassirer, *Kants Leben*, 328, 306, 303; also see Hendel, introduction to *Language*, 18–21.

95. Cassirer, *Kants Leben*, 322–332, 357–361. "The aesthetic formulation is immediately laid down in reality itself; but it is comprehended more deeply and purely and therefore more clearly. . . . the unity of being, which is put up before us, wants to be and can be nothing other than the reflection of a unity of mood and feeling which we experience in ourselves" (p. 357). See Hendel, introduction to *Language*, 19.

96. Cassirer, *Kants Leben*, 367, 330–333.

97. Ibid., 367, 332, 352. Compare Kant: "The sublime is [that which] in comparison [to which] . . . all else is small. . . . The sublime is that, the mere capacity of thinking which evidences a faculty of mind transcending every standard of sense" (sec. 25 of "Analytic of the Sublime").

98. Ibid., 328. "Das Einzelne weist hier nicht auf ein hinter ihm stehendes, abstrakt-Universelles hin; sondern es ist dieses Universelle selbst, weil es seinen Gehalt symbolisch in sich fasst." Also see Hendel, introduction to *Language*, 48.

99. Cassirer, *Kants Leben*, 304, 328, 363–364. Also see Podro, *The Critical Historians of Art*, 181–182.

100. Cassirer, *The Problem of Knowledge*, 121. Also see *Kants Leben*, 369.

101. Cassirer, *Kants Leben*, 371, 370. Compare Kant: "It is, I mean, quite certain that we can never get a sufficient knowledge of organized beings and their inner possibility, much less get an explanation of them, by looking merely to mechanical principles of nature. Indeed, so certain is it, that we may confidently assert that it is absurd for men even to entertain any thought of so doing or to hope that maybe another Newton may some day arise, to make intelligible to us even the genesis of but a blade of grass from natural laws that no

design has ordered" (sec. 14[75] of "Dialectic of Teleological Judgement").

102. Ibid. "Es widersetzt sich dieser Deutung nicht, sondern es bereitet sie vor. . . . Das Zweckprinzip selbst ruft das Kausalprinzip herbei und weist ihm seine Aufgaben an. . . . jede individuelle Form [schliesst] eine unbegrenzte Verwicklung in sich" (pp. 366, 372, 365).

103. Heidt, 201.

104. Jan Białostocki defines the German word *Sinn* in the following way: "It is the tendency one finds expressed in the choice and in the shaping of formal and figurative elements, and which can be discerned in the uniform attitude towards the basic artistic problems" (in "Erwin Panofsky [1892–1968]: Thinker, Historian, Human Being," *Simiolus kunsthistorisch tijdschrift* 4 [1970]: 73).

105. Gombrich, *Art and Illusion*, 277. Gombrich is here referring to the consistency of reading that illusion requires.

106. See Oberer and Verheyen, 49–75, 71 n. 11. The article was written as a response to Alexander Dorner, "Die Erkenntnis des Kunstwollens durch die Kunstgeschichte." Białostocki suggests that Panofsky's article might more aptly be entitled "Prolegomena to Any Future Art History Which Could Claim to Be a Science" (p. 73).

107. "Als etwas, das als 'immanenter Sinn' im künstlerischen Phänomene 'liegt'" (p. 49). Roughly translated, the passage continues: "We can only comprehend its valid a priori principles if we regard it in this way: that is, as an object of thought [*Denkgegenstand*], which is not primarily encountered in a *Wirklichkeitssphäre*, but rather, as Husserl says, in its *eidetischen* character."

108. "Indem sie nur die Stellung, nicht aber die möglichen Lösungen der künstlerischen Probleme auf Formeln bringen, bestimmen sie gleichsam nur die Fragen, die wir an die Objekte zu richten haben, nicht aber die individuellen und niemals vorauszusehenden Antworten, die diese Objekte uns geben können" (p. 56).

109. "Even if the kunstwissenschaftliche Grundbegriffe are doubtless based a priori, and therefore are valid independently of all experience, this is not to say that they are independent of all experience, that is, they can be based on purely intellectual routes" (p. 57).

110. Białostocki, "Erwin Panofsky," 73.

111. Panofsky said that the work of his friend Wind had not yet been published, but he hoped that it soon would be under the title "Ästhetischer und kunstwissenschaftlicher Gegenstand: Ein Beitrag zur Methodologie der Kunstgeschichte." It was finally published, but not under that cumbersome title. See Edgar Wind, "Zur Systematik der künstlerischen Probleme."

112. Oberer and Verheyen, 50. According to Cassell's 1909 (1936) German dictionary, *Fülle* means "fullness, abundance, plenty" and only rarely "contents." *Form* denotes "form, figure, make, or mode."

113. Białostocki, "Erwin Panofsky," 74.

114. "This line of thinking," according to Białostocki in "Erwin Panofsky,"

"leads Panofsky to formulate the system of three layers of opposed values present in every work of visual art:

1. elementary values (optical-tactile, i.e., space as opposed to bodies)
2. figurative values (depth-surface)
3. compositional values (internal links-external links, i.e., internal organical unity as opposed to external juxtaposition).

In order for a work of art to be created, a balance must be struck within each of these scales of value. The absolute poles, the limiting values themselves, are outside of art: purely optical values characterize only amorphous luminous phenomena. Purely tactile values characterize only pure geometrical shapes deprived of any sensual fullness. A solution which determines the position of the work of art at some point on any given scale at the same time determines its position on the other scales. To decide for surface (as opposed to depth) means to decide for rest (as opposed to movement), for isolation (as opposed to connection) and for tactile values (as opposed to optical ones): a typical example confirming the analysis quoted above may be the Egyptian relief. The individual work of art is not, as claimed by Wölfflin, defined by one antithetical category or the other, but is situated at some point on the scale between the limiting values. For instance, the scale 'optical-tactile' takes actual form in such categories as 'painterly' (near the 'optical' pole), through 'sculptural' (in the middle of the scale) to 'stereometric-crystalline' (closest to the ideal, untrodden pole of the absolute 'tactile' quality). The borderlines and the values attainable on the scale are conditioned by historical tendencies: the qualities considered as most painterly on the Renaissance scale moved closer to the tactile pole in the Baroque, because the whole scale had shifted towards the optical pole" (pp. 73–74). See Panofsky's later discussion of the same problem, in "The History of Art as a Humanistic Discipline," 21ff.

115. Białostocki, "Erwin Panofsky," 74.
116. These are the terms that he later employed in "The History of Art as a Humanistic Discipline," 14.
117. Cassirer, *Language*, 91.
118. "Denn sie ist ihrer Natur nach gleichsam eine zweischneidige Waffe. . . . sie bringt die künstlerische Erscheinung auf feste, ja mathematisch-exakte Regeln, aber sie macht sie auf der andern Seite vom Menschen, ja vom Individuum abhängig, indem diese Regeln auf die psychophysischen Bedingungen des Seheindrucks Bezug nehmen, und indem die Art und Weise, in der sie sich auswirken, durch die frei wählbare Lage eines subjektiven 'Blickpunktes' bestimmt wird" (p. 287; p. 31).
119. Cassirer, *Language*, 90.
120. "Verdammte Plato sie schon in ihren bescheidenen Anfängen, weil

sie die 'wahren Masse' der Dinge verzerre, und subjektiven Schein und Willkür an die Stelle der Wirklichkeit und des νόμος setze, so macht die allermodernste Kunstbetrachtung ihr gerade umgekehrt den Vorwurf, dass sie das Werkzeug eines beschränkten und beschränkenden Rationalismus sei. . . . Und es ist letzten Endes kaum mehr als eine Betonungsfrage, ob man ihr vorwirft, dass sie das 'wahre Sein' zu einer Erscheinung gesehener Dinge verflüchtige, oder ob man ihr vorwirft, dass sie die freie und gleichsam spirituelle Formvorstellung auf eine Erscheinung gesehener Dinge festlege" (p. 290; pp. 34−35).

121. Originally in Studien der Bibliothek Warburg 5 (Leipzig/Berlin, 1924), it was translated by J. J. S. Peake as *Idea: A Concept in Art Theory*, 51.
122. Ibid., 50−51, 206, n. 17.
123. Ibid., 126.
124. Gilbert and Kuhn, 560.
125. Cassirer, *Language*, 93.
126. "So lässt sich die Geschichte der Perspektive mit gleichem Recht als ein Triumph des distanziierenden und objektivierenden Wirklichkeitssinns, und als ein Triumph des distanzverneinenden menschlichen Machtstrebens, ebensowohl als Befestigung und Systematisierung der Aussenwelt, wie als Erweiterung der Ichsphäre begreifen; sie musste daher das künstlerische Denken immer wieder vor das Problem stellen, in welchem Sinne diese ambivalente Methode benutzt werden solle" (p. 287; p.31).
127. Cassirer, *Language*, 319.
128. A. J. Ayer, *Philosophy in the Twentieth Century* (New York, 1982), 118.
129. Wittgenstein, *Tractatus Logico-Philosophicus*, 2.1, 2.161, 2.17, paraphrased by Ayer, 112. Wittgenstein's work first appeared in 1921 under the title *Logisch-Philosophische Abhandlung* in the German journal *Annalen der Naturphilosophie*.
130. Russell, introduction to the *Tractatus*, xvii.
131. Wittgenstein, 2.0131.
132. Ibid., 5.62.
133. Nelson Goodman, *Ways of Worldmaking* (Indianapolis, 1978), 2−3.
134. Goodman, *Languages of Art*.
135. Panofsky, *Galileo as a Critic of the Arts* (The Hague, 1954).
136. "Es ist daher nicht mehr als selbstverständlich, dass die Renaissance den Sinn der Perspektive ganz anders deuten musste als der Barock, Italien ganz anders als der Norden: dort wurde (ganz im Grossen gesprochen) ihre objektivistische, hier ihre subjektivistische Bedeutung als die wesentlichere empfunden. . . . Man sieht, dass eine Entscheidung hier nur durch jene grossen Gegensätze bestimmt werden kann, die man als Willkür und Norm, Individualismus und Kollektivismus, Irrationalität und Ratio oder wie sonst immer zu bezeichnen pflegt, und dass gerade diese neuzeitlichen Perspektivprobleme die Zeiten, Nationen und Individuen zu einer besonders ent-

schiedenen und sichtbaren Stellungnahme herausfordern mussten" (p. 288; p. 32).

137. Panofsky, *Idea*: "Just as the intellect 'causes the perceptible world to be either not an object of experience at all or to be a nature' (Kant, *Prolegomena*, sec. 38), so, we may say, the artistic consciousness causes the sensory world to be either not an object of artistic representation at all or to be a 'figuration.' The following difference, however, must be remembered. The laws which the intellect 'prescribes' to the perceptible world and by obeying which the perceptible world becomes 'nature,' are universal; the laws which the artistic consciousness 'prescribes' to the perceptible world and by obeying which the perceptible world becomes 'figuration' must be considered to be individual—or to use an expression recently suggested by H. Noack, *Die systematische und methodische Bedeutung des Stilbegriffs* (diss. Hamburg, 1923), 'idiomatic'" (pp. 248–249, n. 38).

138. Cassirer, *Language*, 152. From Herder, "Über den Ursprung der Sprache" (1772), in *Werke*, ed. B. Suphan.

139. David Summers, "Conventions in the History of Art," *New Literary History* 13 (1981), 118.

140. Patrick A. Heelan, *Space-Perception and the Philosophy of Science* (Berkeley, 1983), 102.

141. "Auch die Spätbilder Rembrandts wären nicht möglich gewesen ohne die perspektivische Raumanschauung, die, die οὐσία zum φαινόμενον wandelnd, das Göttliche zu einem blossen Inhalt des menschlichen Bewusstseins zusammenzuziehen scheint, dafür aber umgekehrt das menschliche Bewusstsein zu einem Gefässe des Göttlichen weitet" (p. 291; p. 35).

142. Neither Cassirer nor Goethe, of course, is talking about perspective painting in particular. See *The Phenomenology of Knowledge*, 16, 25.

6. Later Work: An Iconological Perspective

1. The first two essays appeared, respectively, in Studien der Bibliothek Warburg 18 (1930) and *Logos* 21 (1932): 103–119. Gombrich views the Hercules paper as one of Panofsky's best: "What may have looked like a specialized and even marginal question, the transformations which the images of the ancient gods and stellar deities underwent in their migrations, appeared to offer a much more precise and manageable indicator of this link than the conventional approach through period styles. It was Panofsky who generalized this method and put it to the test in one of his most consistent books—also still untranslated—his *Hercules am Scheidewege* (1930), in which the various refractions and transmutations of a classical theme are brilliantly analysed as symptoms of changing philosophies" ("Obituary: Erwin Panofsky," *Burlington Magazine* 110 [June 1968]: 359). *Studies in Iconology* was originally delivered as the Mary Flexner Lectures at Bryn

Mawr: "The introductory chapter synthesizes the revised content of a methodological article published by the writer in 1932 ["Zum Problem der Beschreibung und Inhaltsdeutung von Werken der bildenden Kunst"] with a study on classical mythology in mediaeval art published in the following year by the writer in collaboration with Dr. F. Saxl" ("Classical Mythology in Mediaeval Art," *Metropolitan Museum Studies* 4 [1933]: 228–280, preface, xv).

2. As I noted in Chapter 1, between the dates when *Studies in Iconology* (1939) and *Meaning in the Visual Arts* (1955) were published, "iconographical analysis in the narrower sense" and "iconographical analysis in the deeper sense" were altered, respectively, to read "iconography" and "iconology." "Iconology" as a word does not appear in the introduction to the 1939 edition. When I refer to this introductory essay, I use *Studies in Iconology*. In "Iconography and Iconology: An Introduction to the Study of Renaissance Art," originally published in *Studies in Iconology* but reprinted in *Meaning in the Visual Arts*, Panofsky inserts a parenthetical paragraph on p. 32 to explain his renewed use of the word "iconology." For further discussion on the shift in vocabulary, see Joseph Margolis, *The Language of Art and Art Criticism* (Detroit, 1965), 79–80.

3. Panofsky, *Studies in Iconology*, 6, n. 1.

4. Panofsky, "Three Decades of Art History in the United States," 341.

5. Panofsky, *Studies in Iconology*, 8, 16.

6. Panofsky, "The Neoplatonic Movement and Michelangelo," in *Studies in Iconology*, 180, 182.

7. Panofsky, *Gothic Architecture and Scholasticism*, 21, 36, 38. M. Schapiro in "Style," in *Anthropology Today*, criticizes this sort of project as spurious, although he does not name Panofsky directly: "The attempts to derive style from thought are often too vague to yield more than suggestive *aperçus*; the method breeds analogical speculations which do not hold up under detailed critical study. The history of the analogy drawn between the Gothic cathedral and scholastic theology is an example. The common element in these two contemporary creations has been found in their rationalism and in their irrationality, their idealism and their naturalism, their encyclopedic completeness and their striving for infinity, and recently in their dialectical method. Yet one hesitates to reject such analogies in principle, since the cathedral belongs to the same religious sphere as does contemporary theology" (pp. 305–306).

8. Göran Hermerén, *Representation and Meaning in the Visual Arts: A Study in the Methodology of Iconography and Iconology* (Stockholm, 1969), 137.

9. Panofsky, *Studies in Iconology*, 7.

10. Hermerén, 138.

11. Forster, "Critical History of Art, or Transfiguration of Values?" *New Literary History* 3 (Spring 1972): 466.

12. Pächt, review of *Early Netherlandish Painting*, by Erwin Panofsky,

Burlington Magazine 98 (1956): 276. In "Is Art History?" Alpers criticizes Panofsky's understanding of Netherlandish painting on the grounds that he interprets Northern art mainly in terms of the Italian Renaissance because of his subordination of pictorial realism to meaning. His reading does not encourage one to see that the lure of "surface imitation" so frequently overshadows the role of verbal antecedents in the work of Northern artists, 5.

13. Panofsky, *Early Netherlandish Painting: Its Origins and Character*, 2 vols. (1953; reprint, New York, 1971), 137. Consider the extent to which this statement contradicts sentiments about the artist's intention expressed earlier in the critique of Riegl.

14. Pächt, review of *Early Netherlandish Painting*, by Erwin Panofsky, 276.

15. Białostocki, "Iconography and Iconology," 781.

16. Creighton Gilbert, "On Subject and Non-Subject in Italian Renaissance Pictures," *Art Bulletin* 34 (1952): 202–216.

17. I thank William Heckscher for translating and sharing this anecdote with me.

18. Panofsky, "Iconography and Iconology: An Introduction to the Study of Renaissance Art," in *Meaning in the Visual Arts*, 32, in a bracketed remark added to the original 1939 essay; *Early Netherlandish Painting*, 142–143.

19. Cited in Gombrich, "Obituary: Erwin Panofsky," 358.

20. Heckscher, *A Curriculum Vitae*, 14.

21. In Panofsky, *Meaning in the Visual Arts*, 12.

22. Panofsky, "Titian's *Allegory of Prudence*: A Postscript," in *Meaning in the Visual Arts*, 168. Published (in collaboration with F. Saxl) as "A Late-Antique Religious Symbol in Works by Holbein and Titian," in *Burlington Magazine* 49 (1926): 177–181.

23. Panofsky, *Studies in Iconology*, 16.

24. Schapiro, 305.

25. Panofsky, "The History of Art as a Humanistic Discipline," 16, 13–14.

26. Ibid., 14.

27. Panofsky, *Studies in Iconology*, 17. The sequence is, in fact, actually cyclical. See my discussion later in this chapter. See also "Zum Problem der Beschreibung und Inhaltsdeutung von Werken der bildenden Kunst," passim; for example, Oberer and Verheyen, 86: "Jede Deskription wird—gewissermassen noch ehe sie überhaupt anfängt —die rein formalen Darstellungsfaktoren bereits zu Symbolen von etwas Dargestelltem umgedeutet haben müssen; und damit wächst sie bereits, sie mag es machen wie sie will, aus einer rein formalen Sphäre schon in eine Sinnregion hinauf."

28. Ackerman, "The Historian as Critic," in *Art and Archaeology*, 152.

29. H. van de Waal, "In Memoriam Erwin Panofsky," 232. From Panofsky to J. G. van Gelder, June 2, 1965, cited by van de Waal: "But as regards the crucial question whether iconology is a discipline in its own right or just one of the methods that may be applied for the elu-

cidation of works of art, I always was, and still am, of the opinion that the second alternative is true. Being an eclectic by nature, I am basically opposed to all divisions, particularly within one discipline which, after all, has a history of at least five-hundred years. I even deplore the basic distinction which is made in this country between art historians and students of architectural history, and it would be a real misfortune if people were 'iconologists,' 'analysts of space,' 'analysts of color,' etc., instead of being art historians *tout court*. Of course, everybody has his natural predilections and shortcomings and should be conscious of these in order to develop some kind of humility" (p. 232, n. 10).

30. Svetlana Alpers and Paul Alpers, "'Ut Pictura Noesis'? Criticism in Literary Studies and Art History," *New Directions in Literary History*, ed. Ralph Cohen (Baltimore, 1974), 201 (reprinted from *New Literary History* 3 [Spring 1972]: 437–458).

31. From *Dr. Panofsky and Mr. Tarkington: An Exchange of Letters, 1938–1946*, ed. Richard M. Ludwig (Princeton, 1974), 12.

32. Gombrich, "Obituary: Erwin Panofsky," 358.

33. See Chapter 1.

34. Panofsky, "The History of Art as a Humanistic Discipline," 24. The phrase "piece of history" is employed by Alpers in "Is Art History?"

35. Giulio Carlo Argan, "Ideology and Iconology," *Critical Inquiry* 2 (Winter 1975): 304.

36. Gombrich, "Obituary: Erwin Panofsky," 358.

37. Heckscher, *A Curriculum Vitae*, 17. According to Heckscher, Panofsky illustrated this dictum, saying, "A saint receiving a rose from Heaven is improbable but convincing. If, on the other hand, Disraeli on entering Queen Victoria's drawing room finds the Queen smoking a big black cigar, this is possible but unconvincing and cannot therefore be admitted as a literary motif" (letter dated February 1948, quoted in Heckscher, 17).

38. Carlo Ginzburg, "Morelli, Freud, and Sherlock Holmes: Clues and Scientific Method," *History Workshop* 9 (1980), 11–12.

39. Jacques Barzun, "Cultural History as a Synthesis," in *Varieties of History from Voltaire to the Present*, ed. Fritz Stern (New York, 1956), 389, 394.

40. Rosand, "Art History and Criticism," 437.

41. Panofsky, "The Neoplatonic Movement and Michelangelo," 181–182.

42. Forster, "Critical History of Art, or Transfiguration of Values?" 467.

43. Lotte B. Philip, *The Ghent Altarpiece and the Art of Jan Van Eyck* (Princeton, 1971), and Michael Baxandall, *Painting and Experience in Fifteenth-Century Italy: A Primer in the Social History of Pictorial Style* (Oxford, 1972).

44. Henri Zerner, "L'art," in *Faire de l'histoire: Nouveaux problèmes*, ed. J. LeGoff and Pierre Nora, vol. 2 (Paris, 1974), 188. I thank Alison Kettering for making available an unpublished English translation of

this article by Peter Franco. "Seules des méthodes et des techniques d'interprétation permettent d'atteindre le sens. Le développement de Panofsky est à comprendre ainsi. Il a travaillé à mettre au point une méthode de lecture, limitée aux thèmes artistiques et valable seulement pour l'Occident chrétien. Mais sa visée est le niveau 'iconologique,' c'est-à-dire le sens objectif immanent. Ses disciples ayant perdu de vue ses préoccupations théoriques, que lui-même semble avoir de plus en plus négligées, la discipline qu'il avait établie s'est transformée en une technique isolée de déchiffrement. La visée du niveau iconologique est généralement abandonnée et, ce qui est plus grave, le déchiffrement iconographique se substitue trop souvent au sens."

45. Kleinbauer, 30, says the only recent "major theoretical treatise" is Kubler's *The Shape of Time: Remarks on the History of Things*.

46. Gerald Holton, *Thematic Origins of Scientific Thought: Kepler to Einstein* (Cambridge, Mass., 1973). I excerpt ideas in general from Holton's "Introduction," 11–44, 47–53, and from sec. 2 of chap. 6, "Poincaré and Relativity," 190–192.

47. Excerpted from Holton's headnote (p. 5).

48. Thomas Kuhn, *The Structure of Scientific Revolutions*, vol. 2, no. 2, of *International Encyclopedia of Unified Science*, 2d ed. (Chicago, 1970), 109, 113. Holton's discussion of these issues, of course, owes something to Kuhn's notion of paradigmatic shifts in scientific theory. Copernican astronomy is discussed at length by Kuhn as one particular paradigm that both initiated and resisted change.

49. Holton, 23, 24–27, 35–36. Holton suggests that the "most pervasive characteristic of modern science is the generally accepted thema of the unlimited possibility of *doing* science, the belief that nature is inexhaustibly knowable," 29.

50. In *Dr. Panofsky and Mr. Tarkington: An Exchange of Letters, 1938–1946*, 114. Also see Holton, 49.

51. Panofsky, *Studies in Iconology*, 16–17.

52. Ibid., 15, 8, 6, 11.

53. Ibid., 16. In this regard, see Paolo Rossi, *Philosophy, Technology, and the Arts in the Early Modern Era*, trans. S. Attanasio, ed. B. Nelson (New York, 1970).

54. Panofsky, *Galileo as a Critic of the Arts*. Panofsky, in questioning why Galileo had ignored Kepler's laws of planetary motion, "proposed that Galileo's decision rested on aesthetic grounds. He could not bring himself to accept Kepler's elliptical planetary orbits, for the ellipse, the wretchedly distorted version of the godlike circle, was the very signature of the Manneristic style of art that Galileo so despised. . . . the curious thing is that ultimately he was right" (Holton, 434).

55. Holton, 19.

56. Panofsky, *Studies in Iconology*, 7, 16.

57. See later pages of this chapter. It might be argued that there is a tautology here as well, as I noted earlier in this chapter. It seems to me,

however, it is finally a question of handling. This tautological scheme, if indeed it is one, is at least deliberately so, created in full awareness of its cyclicality.

58. Panofsky, *Studies in Iconology*, 15.

59. I borrow this terminology from Gerald Graff, *Literature against Itself: Literary Ideas in Modern Society* (Chicago, 1979), 48.

60. Argan, 299. See my discussion of Saussure in Chapter 1.

61. Note, for example, the French interest in Panofsky for precisely this reason. In the anthology of essays on Panofsky sponsored jointly by Pandora Editions and the Pompidou Centre, see especially the works by Hubert Damisch, "Panofsky am Scheidewege"; Alain Roger, "Le schème et le symbole dans l'œuvre de Panofsky", Jean Arrouye, "Archéologie de l'iconologie"; and Jean-Claude Bonne, "Fond, surfaces, support: Panofsky et l'art roman," all in *Erwin Panofsky: Cahiers pour un temps*, ed. Jacques Bonnet (Paris, 1983).

62. Christine Hasenmueller, "Panofsky, Iconography, and Semiotics," *Journal of Aesthetics and Art Criticism* 36 (Spring 1978): 297.

63. Panofsky, *Studies in Iconology*, 11.

64. Ibid., n. 3. Taking this view, I think we need not perceive the situation in the self-contradictory way that Graff does: "We have . . . numerous self-contradictory attempts in the twentieth century to define art as a discourse somehow both referential and non-referential, closed off from the external world yet embodying profound knowledge of the external world" (p. 37).

65. Argan, 302–303, 304.

66. Meyer Schapiro, "On Some Problems in the Semiotics of Visual Art: Field and Vehicle in Image-Signs," in *Semiotica* 1 (1969), 223. Compare *Words and Pictures: On the Literal and the Symbolic in the Illustration of a Text* (The Hague, 1973). Both works grew out of "Language, Symbol, Reality," a symposium held at St. Mary's College of Notre Dame, November 7, 1969. As Zerner notes in "L'art," Schapiro rather "unexpectedly" regards the status of perspective as "natural" (vs. "conventional"). Panofsky, of course, would write otherwise.

67. Argan, 302. Also see Summers, "Conventions in the History of Art," 110–111.

68. Panofsky, *Studies in Iconology*, 5. Compare Gombrich in *Art and Illusion*: "Just as the study of poetry remains incomplete without an awareness of the language of prose, so, I believe, the study of art will be increasingly supplemented by inquiry into the linguistics of the visual image. Already we see the outlines of iconology, which investigates the function of images in allegory and symbolism and their reference to what might be called the 'invisible world of ideas.' The way the language of art refers to the visible world is both so obvious and so mysterious that it is still largely unknown except to the artists themselves who can use it as we use all languages—without needing to know its grammar and semantics" (pp. 8–9).

69. Panofsky, *Studies in Iconology*, 11.

70. Panofsky, *Early Netherlandish Painting*, 137.
71. Panofsky, *Studies in Iconology*, 14.
72. Michel Foucault, *The Order of Things: An Archaeology of the Human Sciences* [*Les mots et les choses*] (1966; reprint, New York, 1970), xxii.
73. Ibid., xxiv, xi.
74. Panofsky, *Studies in Iconology*, 14.
75. Roger Chartier, "Intellectual History or Sociocultural History? The French Trajectories," in *Modern European Intellectual History: Reappraisals and New Perspectives*, ed. D. LaCapra and S. L. Kaplan (Ithaca, 1982). Chartier compares Febvre's work, in particular, to Panofsky's *Gothic Architecture and Scholasticism*: "Both of them, in parallel fashion and quite probably without reciprocal influence, were attempting in the same period to equip themselves with the intellectual means to conceptualize this 'spirit of the times,' this 'Zeitgeist'" (p. 18).
76. Fernand Braudel, *The Mediterranean and the Mediterranean World in the Age of Philip II*, 2 vols., 2d ed., trans. Siân Reynolds (New York, 1972), 1:16.
77. Ginzburg, 27.
78. Foucault remarked that he "tried to explore scientific discourse not from the point of view of the individuals who are speaking, nor from the point of view of the formal structures of what they are saying, but from the point of view of the rules that come into play in the very existence of such discourse" (p. xiv).
79. As time went on, Panofsky's "parallelizing" inclinations were increasingly counterbalanced by his attention to matters of connoisseurship. Julius Held, for example, in a review of *Early Netherlandish Painting* for the *Art Bulletin* 37 (1955), writes: "It is perhaps . . . important to point out that in *Early Netherlandish Painting*, more than in any of his previous works, even including the *Dürer*, Panofsky enters the fields of stylistic criticism and connoisseurship, and that he does it highly successfully" (p. 206).
80. Forster, in "Critical History of Art, or Transfiguration of Values?" 465. Svetlana Alpers and Paul Alpers in "'Ut Pictura Noesis'?" also spend time describing this problem and suggesting the ways in which art history as a discipline might profit from a more thorough familiarity with literary criticism.
81. Ackerman, *Art and Archaeology*, 142.
82. Alpers, "Is Art History?" 6.
83. Panofsky, *Studies in Iconology*, 27–28. Compare p. 4, n. 3, in "The History of Art as a Humanistic Discipline."
84. Panofsky, "The History of Art as a Humanistic Discipline," 24. For "checks" on historical objectivity, see p. 17 in the same essay.
85. Panofsky, "The History of Art as a Humanistic Discipline," 6, and "Three Decades of Art History in the United States," 321.
86. Alpers, "Is Art History?" 9.
87. A version of a notion often expressed in White, *Metahistory*. See Peter Gay, *Style in History*.

88. George Steiner, review of *Essays in Ancient and Modern Historiography* by A. Momigliano, *London Sunday Times* (July 17, 1977).
89. Vasari, *The Lives of the Artists*, ed. and trans. George Bull (London, 1965): "But I have remarked that those historians who are generally agreed to have produced the soundest work have not been satisfied just to give a bald narration of the facts but have also, with great diligence and the utmost curiosity, investigated the ways and means and methods used by successful men in forwarding their enterprises. . . . I have tried as far as I could to imitate the methods of the great historians. I have endeavoured not only to record what the artists have done but also to distinguish between the good, the better, and the best, and to note with some care the methods, manners, styles, behaviour, and ideas of the painters and sculptors; I have tried as well as I know how to help people who cannot find out for themselves to understand the sources and origins of various styles, and the reasons for the improvement or decline of the arts at various times and among different people" (pp. 83–84).
90. Panofsky, "The History of Art as a Humanistic Discipline," 14.
91. Marcel Proust, *The Past Recaptured*, trans. Frederick A. Blossom (New York, 1932), 224–225. Russel Nye's essay, "History and Literature: Branches of the Same Tree," in *Essays on History and Literature*, ed. R. H. Bremner (Columbus, 1966) prompted me to reread Proust.
92. Panofsky, "The History of Art as a Humanistic Discipline," 24.
93. Cassirer, *An Essay on Man*, 184–185.
94. Panofsky, "The First Page of Giorgio Vasari's 'Libro': A Study on the Gothic Style in the Judgment of the Italian Renaissance," in *Meaning in the Visual Arts*, 206 (originally published as "Das erste Blatt aus dem 'Libro' Giorgio Vasaris: Eine Studie über die Beurteilung der Gotik in der italienischen Renaissance mit einem Exkurs über zwei Fasadenprojekte Domenico Beccafumis," in *Städel-Jahrbuch* 6 [1930]: 25–72).

Selected
Bibliography

Works by Erwin Panofsky

The bibliography includes only works consulted in the discussion. For a complete listing of all of Panofsky's works, see *Erwin Panofsky: Aufsätze zu Grundfragen der Kunstwissenschaft*, ed. Hariolf Oberer and Egon Verheyen (Berlin, 1964). The library at the Institute for Advanced Study in Princeton has a list of addenda and revisions to this bibliography that was prepared by Gerda Panofsky in March 1983.

Panofsky, Erwin. "Aby Warburg." *Repertorium für Kunstwissenschaft* 51 (1930): 1–4. (Originally published in the *Hamburger Fremdenblatt*, October 28, 1929).
———. *Albrecht Dürer.* 3d ed. Princeton, 1948.
———. "Der Begriff des Kunstwollens." *Zeitschrift für Ästhetik und allgemeine Kunstwissenschaft* 14 (1920): 321–339.
———. "The Concept of Artistic Volition." Trans. Kenneth J. Northcott and Joel Snyder. *Critical Inquiry* 8 (Autumn 1981): 17–33.
———. "In Defense of the Ivory Tower." In *Association of Princeton Graduate Alumni, Report of the Third Conference.* Princeton, 1953.
———. *Die deutsche Plastik des elften bis dreizehnten Jahrhunderts.* 2 vols. Munich, 1924.
———. *Dürers Kunsttheorie, vornehmlich in ihrem Verhältnis zur Kunsttheorie der Italiener.* Berlin, 1915.
———. *Early Netherlandish Painting: Its Origins and Character.* Charles Eliot Norton Lectures, 1947–1948. 2 vols. 1953. Reprint. New York, 1971.
———. "Die Entwicklung der Proportionslehre als Abbild der Stilentwicklung." *Monatshefte für Kunstwissenschaft* 14 (1921): 188–219. (Reprinted in translation in *Meaning in the Visual Arts* [Garden City, 1955]).

———. "Die Erfindung der verschiedenen Distanzkonstruktionen in der malerischen Perspektive." *Repertorium für Kunstwissenschaft* 45 (1925): 84–86.

———. "The First Page of Giorgio Vasari's 'Libro': A Study on the Gothic Style in the Judgment of the Italian Renaissance." In *Meaning in the Visual Arts*. Garden City, 1955. (Originally published as "Das erste Blatt aus dem 'Libro' Giorgio Vasaris: Eine Studie über die Beurteilung der Gotik in der italienischen Renaissance mit einem Exkurs über zwei Fasadenprojekte Domenico Beccafumis," *Städel-Jahrbuch* 6 [1930]: 25–72.

———. *Galileo as a Critic of the Arts.* The Hague, 1954.

———. *Gothic Architecture and Scholasticism: An Inquiry into the Analogy of the Arts, Philosophy, and Religion in the Middle Ages.* 1951. Reprint. New York, 1957.

———. "Heinrich Wölfflin: Zu seinem 60. Geburtstage am 21. Juni 1924." *Hamburger Fremdenblatt*, June 21, 1924.

———. *Hercules am Scheidewege und andere antike Bildstoffe in der neueren Kunst.* Studien der Bibliothek Warburg 18. Leipzig/Berlin, 1930.

———. "The History of Art as a Humanistic Discipline." In *Meaning in the Visual Arts*. Garden City, 1955. (Originally published in *The Meaning of the Humanities*, ed. T. M. Greene [Princeton, 1940]).

———. "The History of the Theory of Human Proportions as a Reflection of the History of Styles." In *Meaning in the Visual Arts*. Garden City, 1955. (Originally published as "Die Entwicklung der Proportionslehre als Abbild der Stilentwicklung," *Monatshefte für Kunstwissenschaft* 14 [1921]: 188–219).

———. *Idea: A Concept in Art Theory.* Ed. J. J. S. Peake. 2d ed. New York, 1968. (Originally published as *"Idea": Ein Beitrag zur Begriffsgeschichte der älteren Kunsttheorie*, Studien der Bibliothek Warburg 5 [Leipzig/Berlin, 1924]).

———. "'Imago Pietatis': Ein Beitrag zur Typengeschichte des 'Schmerzensmannes' und der 'Maria Mediatrix.'" In *Festschrift für Max J. Friedländer zum 60. Geburtstage*. Leipzig, 1927.

———. "Letter to the Editor." *Art Bulletin* 22 (1940): 273.

———. *The Life and Art of Albrecht Dürer* (1943). 4th ed. Princeton, 1955.

———. *Meaning in the Visual Arts: Papers in and on Art History.* Garden City, 1955.

———. "The Neoplatonic Movement and Michelangelo." In *Studies in Iconology*. 1939. Reprint. New York, 1962.

———. "Note on the Importance of Iconographical Exactitude." *Art Bulletin* 21 (1939): 402.

———. "Die Perspektive als 'symbolische Form.'" In *Vorträge der Bibliothek Warburg* 1924–1925. Leipzig/Berlin, 1927.

———. "Das Problem des Stils in der bildenden Kunst." *Zeitschrift für Ästhetik und allgemeine Kunstwissenschaft* 10 (1915): 460–467.

——. *Renaissance and Renascences in Western Art.* 1960. Reprint. New York, 1969.

——. *Sokrates in Hamburg.* 1931. Reprint. Hamburg, 1962.

——. "Stellungnahme zu: E. Cassirer, Mythischer, ästhetischer und theoretischer Raum." Remarks made at the Vierter Kongress für Ästhetik und allgemeine Kunstwissenschaft, Hamburg, 1930. (Reprinted in *Beilageheft zur Zeitschrift für Ästhetik und allgemeine Kunstwissenschaft* 25 [1931]: 53–54).

——. *Studies in Iconology: Humanistic Themes in the Art of the Renaissance.* Mary Flexner Lectures on the Humanities. 1939. Reprint. New York, 1962.

——. "Die theoretische Kunstlehre Albrecht Dürers (Dürers Ästhetik)." Inaugural diss., University of Freiburg, 1914.

——. "Three Decades of Art History in the United States." In *Meaning in the Visual Arts.* Garden City, 1955. (Originally published as "The History of Art," in *The Cultural Migration: The European Scholar in America,* ed. W. R. Crawford [Philadelphia, 1953]).

——. "Titian's *Allegory of Prudence*: A Postscript." In *Meaning in the Visual Arts.* Garden City, 1955. (Originally published with Fritz Saxl as "A Late Antique Religious Symbol in Works by Holbein and Titian," *Burlington Magazine* 49 [1926]: 177–181).

——. "Über das Verhältnis der Kunstgeschichte zur Kunsttheorie: Ein Beitrag zu der Erörterung über die Möglichkeit 'kunstwissenschaftlicher Grundbegriffe.'" *Zeitschrift für Ästhetik und allgemeine Kunstwissenschaft* 18 (1924–1925): 129–161.

——. "Zum Problem der Beschreibung und Inhaltsdeutung von Werken der bildenden Kunst." *Logos* 21 (1932): 103–119.

Panofsky, E., and Panofsky, Dora. *Pandora's Box: The Changing Aspects of a Mythical Symbol.* 2d ed. New York, 1962.

Panofsky, E., and Saxl, Fritz. "Classical Mythology in Mediaeval Art." *Metropolitan Museum Studies* 4 (1933): 228–280.

——. *Dürers "Melencolia I": Eine quellen- und typengeschichtliche Untersuchung.* Studien der Bibliothek Warburg 2. Leipzig/Berlin, 1923.

Panofsky, E., and Tarkington, Booth. *Dr. Panofsky and Mr. Tarkington: An Exchange of Letters, 1938–1946.* Ed. Richard Ludwig. Princeton, 1974.

Additional Early Sources

Buchenau, Artur. "Zur methodischen Grundlegung der Cohenschen Ästhetik." *Zeitschrift für Ästhetik und allgemeine Kunstwissenschaft* 8 (1913): 615–623.

Burckhardt, Jacob. *Der Cicerone: Eine Anleitung zum Genuss der Kunstwerke Italiens* (1855). 4th ed. Ed. Wilhelm Bode. Leipzig, 1879.

——. *The Civilization of the Renaissance in Italy* (1860). 2 vols. Ed. Benjamin Nelson and Charles Trinkaus. 1929. Reprint. New York, 1958.
——. *Force and Freedom: Reflections on History* (1871). Ed. and trans. J. H. Nichols. New York, 1943.
——. *Gesamtausgabe.* 14 vols. Berlin, 1929–1934.
——. *The Letters of Jacob Burckhardt.* Trans. Alexander Dru. New York, 1955.
Burckhardt, Jacob, and Wölfflin, Heinrich. *Briefwechsel und andere Dokumente ihrer Begegnung.* Ed. Joseph Gantner. Basel, 1948.
Cassirer, Ernst. "Der Begriff der symbolischen Form im Aufbau der Geisteswissenschaften." In *Vorträge der Bibliothek Warburg 1921–1922.* Leipzig/Berlin, 1923.
——. *Die Begriffsform im mythischen Denken.* Studien der Bibliothek Warburg 1. Leipzig/Berlin, 1922.
——. "Eidos und Eidolon: Das Problem des Schönen und der Kunst in Platons Dialogen." In *Vorträge der Bibliothek Warburg 1922–1923.* Leipzig/Berlin, 1924.
——. *Das Erkenntnisproblem in der Philosophie und Wissenschaft der neueren Zeit.* 2 vols. Berlin, 1906–1908.
——. *An Essay on Man: An Introduction to a Philosophy of Human Culture.* 1944. Reprint. New Haven, 1962.
——. *Hermann Cohens Schriften zur Philosophie und Zeitgeschichte.* 2 vols. Berlin, 1928.
——. *Idee und Gestalt: Goethe, Schiller, Hölderlin, Kleist.* Berlin, 1921.
——. *Individuum und Kosmos in der Philosophie der Renaissance.* Studien der Bibliothek Warburg 10. Leipzig/Berlin, 1927.
——. *Kants Leben und Lehre: Immanuel Kants Werke.* Berlin, 1918.
——. *Kant's Life and Thought.* Trans. James Haden. New Haven, 1981.
——. *Language and Myth* (1925). Trans. Susanne K. Langer. New York, 1946.
——. *The Philosophy of Symbolic Forms.* Vol. 1, *Language.* Vol. 2, *Mythical Thought.* Vol. 3, *The Phenomenology of Knowledge* (1923–1929). Trans. Ralph Manheim. Introd. Charles Hendel. New Haven, 1955.
——. *The Problem of Knowledge: Philosophy, Science, and History since Hegel* (1941). Trans. W. H. Woglom and C. Hendel. New Haven, 1950.
——. *Substanzbegriff und Funktionsbegriff: Untersuchungen über die Grundfragen der Erkenntniskritik.* Berlin, 1910.
——. *Zur Einsteinschen Relativitätstheorie: Erkenntnistheoretische Betrachtungen.* Berlin, 1921.
Dehio, Georg. *Kunsthistorische Aufsätze.* Munich/Berlin, 1914.
Dessoir, Max. "Kunstgeschichte und Kunstsystematik." *Zeitschrift für Ästhetik und allgemeine Kunstwissenschaft* 21 (1927): 131–142.
Dilthey, Wilhelm. *Gesammelte Schriften.* 18 vols. Stuttgart, 1913–1977.

——. *Pattern and Meaning in History: Thoughts on History and Society.* Ed. H. P. Rickman. New York, 1961.

Dorner, Alexander. "Die Erkenntnis des Kunstwollens durch die Kunstgeschichte." *Zeitschrift für Ästhetik und allgemeine Kunstwissenschaft* 16 (1921–1922): 216–222.

Dvořák, Max. *Idealism and Naturalism in Gothic Art* (1918). Trans. R. J. Klawiter. Notre Dame, 1967.

——. *Kunstgeschichte als Geistesgeschichte.* Munich, 1924.

——. "Das Rätsel der Kunst der Brüder van Eyck." *Jahrbuch der kunsthistorischen Sammlungen des Allerhöchsten Kaiserhauses* 24 (1904): 161–317.

Eisler, Max. "Die Sprache der Kunstwissenschaft." *Zeitschrift für Ästhetik und allgemeine Kunstwissenschaft* 13 (1918–1919): 309–316.

Fiedler, Konrad. "Über den Ursprung der künstlerischen Thätigkeit." In *Schriften zur Kunst,* ed. Hans Marbach. Leipzig, 1896.

Frankl, Paul. *Die Entwicklungsphasen der neueren Baukunst.* Leipzig, 1914.

Friedländer, Walter. "Die Entstehung des antiklassischen Stiles in der italienischen Malerei um 1520." *Repertorium für Kunstwissenschaft* 46 (1925): 49–86.

Fry, Roger. "The Baroque." *Burlington Magazine* 39 (September 1921): 145–148.

Hamann, R. "Die Methode der Kunstgeschichte und die allgemeine Kunstwissenschaft." *Monatshefte für Kunstwissenschaft* 9 (1916): 64–104.

Hegel, G. W. F. *Aesthetics: Lectures on Fine Art.* 2 vols. Trans. T. M. Knox, Oxford, 1975.

——. *Encyclopedia of Philosophy.* Trans. G. E. Mueller. New York, 1959.

——. *Logic of Hegel.* Pt. 1, *Encyclopedia of Philosophical Sciences.* Trans. William Wallace (1873). 3d ed. Oxford, 1975.

——. *Phenomenology of the Spirit.* Trans. A. V. Miller. Oxford, 1977.

——. *The Philosophy of Hegel.* Ed. Carl J. Friedrich. New York, 1953.

——. *Reason in History.* Trans. R. S. Hartman. Indianapolis, 1953.

——. *Werke.* 20 vols. Ed. Eva Moldenhauer and Karl Markus Michel. Frankfurt, 1970.

Heidrich, Ernst. *Beiträge zur Geschichte und Methode der Kunstgeschichte.* Basel, 1917.

Hildebrand, Adolf. *Das Problem der Form in der bildenden Kunst* (1893). 3d ed. Strassburg, 1901.

Hoogewerff, G. J. "L'iconologie et son importance pour l'étude systématique de l'art chrétien." *Rivista di archeologia cristiana* 8 (1931): 53–82.

Husserl, Edmund. *Logical Investigations.* 2 vols. Trans. J. N. Findlay. London, 1970.

Kant, Immanuel. *The Critique of Judgement.* Trans. James Creed Meredith. 1928. Reprint. Oxford, 1952.

Kaschnitz-Weinberg, Guido von. *Ausgewählte Schriften.* Berlin, 1965.

———. *Kunstwissenschaftliche Forschungen.* Vol. 2. Berlin, 1933.

———. *Mittelmeerische Grundlagen der antiken Kunst.* Frankfurt, 1944.

Lipps, Theodor. *Ästhetik: Psychologie des Schönen und der Kunst.* 2 vols. Hamburg/Leipzig, 1903–1906.

Lowinsky, Viktor. "Raum und Geschehnis in Poussins Kunst." *Zeitschrift für Ästhetik und allgemeine Kunstwissenschaft* 11 (1916): 36–45.

Pinder, Wilhelm. *Das Problem der Generation in der Kunstgeschichte Europas.* Berlin, 1926.

Proust, Marcel. *The Past Recaptured.* Trans. Frederick A. Blossom. New York, 1932.

Riegl, Alois. *Gesammelte Aufsätze.* Ed. Karl Swoboda. Introd. H. Sedlmayr. Augsburg/Vienna, 1929.

———. *Historische Grammatik der bildenden Künste.* Ed. Karl M. Swoboda and Otto Pächt. Graz, 1966.

———. *Spätrömische Kunstindustrie* (1901). Vienna, 1927.

———. *Stilfragen: Grundlegungen zu einer Geschichte der Ornamentik* (1893). 2d ed. Berlin, 1923.

Rodenwaldt, Gerhart. "Zur begrifflichen und geschichtlichen Bedeutung des Klassischen in der bildenden Kunst: Eine kunstgeschichtsphilosophische Studie." *Zeitschrift für Ästhetik und allgemeine Kunstwissenschaft* 11 (1916): 113–131.

Saussure, Ferdinand de. *Course in General Linguistics.* Ed. C. Bally and A. Sechehaye. Trans. Wade Baskin. New York, 1959.

Saxl, Fritz. "Die Bibliothek Warburg und ihr Ziel." In *Vorträge der Bibliothek Warburg 1921–1922.* Leipzig/Berlin, 1923.

Schapiro, Meyer. "The New Viennese School." *Art Bulletin* 18 (1936): 258–266.

Schlosser, Julius von. *Die Kunstliteratur: Ein Handbuch zur Quellenkunde der neueren Kunstgeschichte.* Vienna, 1924.

———. "Stilgeschichte und Sprachgeschichte der bildenden Kunst." *Sitzungsberichte der philosophisch-historischen Abteilung der Bayerischen Akademie der Wissenschaften* (1935).

———. *Die Wiener Schule der Kunstgeschichte.* Innsbruck, 1934.

Schmarsow, August. "Kunstwissenschaft und Kulturphilosophie mit gemeinsamen Grundbegriffen." *Zeitschrift für Ästhetik und allgemeine Kunstwissenschaft* 13 (1918–1919): 165–190, 225–258.

Schweitzer, Bernhard. "Die Begriffe des Plastischen und Malerischen als Grundformen der Anschauung." *Zeitschrift für Ästhetik und allgemeine Kunstwissenschaft* 13 (1918–1919): 259–269.

———. "Strukturforschung in Archäologie und Vorgeschichte." *Neue Jahrbücher für antike und deutsche Bildung* 4–5 (1938): 162–179.

Sedlmayr, Hans. *Kunst und Wahrheit: Zur Theorie und Methode der Kunstgeschichte.* Hamburg, 1958.
——. *Verlust der Mitte: Die bildende Kunst des 19. und 20. Jahrhunderts als Symptom und Symbol der Zeit.* Salzburg, 1948.
——. "Zu einer strengen Kunstwissenschaft." *Kunstwissenschaftliche Forschungen* 1 (1931): 7ff.
Semper, Gottfried. *Der Stil in den technischen und tektonischen Künsten; oder, Praktische Aesthetik.* 2 vols. 2d ed. Munich, 1878–1879.
Tietze, Hans. *Lebendige Kunstwissenschaft: Zur Krise der Kunst und der Kunstgeschichte.* Vienna, 1925.
——. *Die Methode der Kunstgeschichte: Ein Versuch von Dr. Hans Tietze.* Leipzig, 1913.
Timmling, Walter. "Kunstgeschichte und Kunstwissenschaft." In *Kleine Literaturführer* 6. Leipzig, 1913.
Utitz, Emil. *Grundlegung der allgemeinen Kunstwissenschaft.* 2 vols. Stuttgart, 1914.
Vasari, Giorgio. *The Lives of the Artists.* Ed. and trans. George Bull. London, 1965.
Venturi, Lionello. *History of Art Criticism.* Trans. Charles Marriott. Ed. Gregory Battock. 1936. Reprint. New York, 1964.
Waetzholdt, William. *Deutsche Kunsthistoriker, von Sandrart bis Rumohr* (1921–1924). 2 vols. 2d ed. Berlin, 1965.
Warburg, Aby. *Ausgewählte Schriften und Würdingen.* Ed. Dieter Wuttke. Baden-Baden, 1979.
——. *La rinascita del paganesimo antico.* Ed. Gertrud Bing. Florence, 1966.
Weber, Max. *Gesammelte Aufsätze zur Wissenschaftslehre.* 2d ed. Tübingen, 1951.
Wickhoff, Franz, and von Hartel, W. Ritter. *Die Wiener Genesis.* Vienna, 1895.
Wind, Edgar. "Contemporary German Philosophy." *Journal of Philosophy* 22 (August 27, 1925; September 10, 1925): 477–493; 516–530.
——. "Kritik der Geistesgeschichte: Das Symbol als Gegenstand kulturwissenschaftlicher Forschung." In *Kulturwissenschaftliche Bibliographie zum Nachleben der Antike* 1. Leipzig, 1934.
——. "Zur Systematik der künstlerischen Probleme." *Zeitschrift für Ästhetik und allgemeine Kunstwissenschaft* 18 (1924–1925): 438–486.
Wittgenstein, Ludwig. *Tractatus Logico-Philosophicus* (1922). Trans. D. F. Pears and B. F. McGuinness. London, 1961.
Wölfflin, Heinrich. *Classic Art: An Introduction to the Italian Renaissance.* 8th ed. Trans. Peter Murray and Linda Murray. Introd. Sir Herbert Read. Ithaca, 1952.
——. *Gedanken zur Kunstgeschichte: Gedrucktes und Ungedrucktes.* Ed. J. Gantner. 4th ed. Basel, 1947.

——. "In eigener Sache: Zur Rechtfertigung meiner 'Kunstgeschichtliche Grundbegriffe' (1920)." In *Gedanken zur Kunstgeschichte: Gedrucktes und Ungedrucktes,* ed. J. Gantner. 4th ed. Basel, 1947.

——. *Die klassische Kunst: Eine Einführung in die italienische Renaissance.* Munich, 1899.

——. *Kleine Schriften.* Ed. J. Gantner. Basel, 1946.

——. *Kunstgeschichtliche Grundbegriffe: Das Problem der Stilentwicklung in der neueren Kunst.* Munich, 1915.

——. "Kunstgeschichtliche Grundbegriffe: Eine Revision," *Logos* 22 (1933): 210–218.

——. *Principles of Art History: The Problem of the Development of Style in Later Art* (1915). 7th ed. Trans. M. D. Hottinger. 1932. Reprint. New York, 1950.

——. "Das Problem des Stils in der bildenden Kunst." *Sitzungsberichten der Königlichen Preussischen Akademie der Wissenschaften* 31 (1912): 572–578.

——. *Renaissance and Baroque.* Trans. K. Simon. Ithaca, 1964.

——. *Renaissance und Barock.* Munich, 1888.

——. Review of *Die Entstehung der Barockkunst in Rom,* by Alois Riegl. *Repertorium für Kunstwissenschaft* 31 (1908): 356–357.

Worringer, Wilhelm. *Abstraction and Empathy: A Contribution to the Psychology of Style* (1907). Trans. M. Bullock. New York, 1953.

——. *Form in Gothic* (1912). Ed. Herbert Read. Rev. ed. London, 1957.

Recent Criticism

Ackerman, James. "Toward a New Social Theory of Art." *New Literary History* 4 (Winter 1973): 315–330.

Ackerman, James, and Carpenter, Rhys, eds. *Art and Archaeology.* Englewood Cliffs, 1963.

Alpers, Svetlana. *The Art of Describing: Dutch Art in the Seventeenth Century.* Chicago, 1983.

——. "Is Art History?" *Daedalus* 106 (Summer 1977): 1–13.

Alpers, Svetlana, and Alpers, Paul. "'Ut Pictura Noesis'? Criticism in Literary Studies and Art History." In *New Directions in Literary History,* ed. Ralph Cohen. Baltimore, 1974. (Reprinted from *New Literary History* 3 [Spring 1972]: 437–458).

Antal, F. "Remarks on the Method of Art History." Pts. 1 and 2. *Burlington Magazine* 91 (1949): 49–52, 73–75.

Argan, Giulio Carlo. "Ideology and Iconology." *Critical Inquiry* 2 (Winter 1975): 297–305.

Arnheim, Rudolf. *Art and Visual Perception: A Psychology of the Creative Eye.* Berkeley, 1971.

Arrouye, Jean. "Archéologie de l'iconologie." In *Erwin Panofsky: Cahiers pour un temps*, ed. Jacques Bonnet. Paris, 1983.

Ayer, A. J. *Philosophy in the Twentieth Century*. New York, 1982.

Barzun, Jacques. "Cultural History as a Synthesis." In *Varieties of History from Voltaire to the Present*, ed. Fritz Stern. New York, 1956.

Baxandall, Michael. *Painting and Experience in Fifteenth-Century Italy: A Primer in the Social History of Pictorial Style*. Oxford, 1972.

Bertalanffy, Ludwig von. *General System Theory: Foundations, Development, Applications*. London, 1968.

Białostocki, Jan. "Erwin Panofsky (1892–1968): Thinker, Historian, Human Being." *Simiolus kunsthistorisch tijdschrift* 4 (1970): 68–89.

———. "Iconography and Iconology." *Encyclopedia of World Art* 7 (1963): 769–786.

Bocheński, I. M. *Contemporary European Philosophy: Philosophies of Matter, the Idea, Life, Essence, Existence, and Being*. 2d ed. Berkeley, 1956.

Bonne, Jean-Claude. "Fond, surfaces, support: Panofsky et l'art roman." In *Erwin Panofsky: Cahiers pour un temps*, ed. Jacques Bonnet. Paris, 1983.

Bonnet, Jacques, ed. *Erwin Panofsky: Cahiers pour un temps*. Paris, 1983.

Braudel, Fernand. *The Mediterranean and the Mediterranean World in the Age of Philip II*. 2 vols. Trans. Siân Reynolds. 2d ed. New York, 1972.

Brendel, Otto. *Prolegomena to the Study of Roman Art*. 1953. Reprint. New Haven, 1979.

Brown, Marshall. "The Classic Is the Baroque: On the Principle of Wölfflin's Art History." *Critical Inquiry* 9 (December 1982): 379–404.

Bryson, Norman. *Vision and Painting: The Logic of the Gaze*. New Haven, 1983.

Carr, E. H. *What Is History?* George Macaulay Trevelyan Lectures. New York, 1961.

Chartier, Roger. "Intellectual History or Sociocultural History? The French Trajectories." In *Modern European Intellectual History: Reappraisals and New Perspectives*, ed. D. LaCapra and S. L. Kaplan. Ithaca, 1982.

Chastel, André. "Erwin Panofsky: Rigueur et Système." In *Erwin Panofsky: Cahiers pour un temps*, ed. Jacques Bonnet. Paris, 1983.

A Commemorative Gathering for Erwin Panofsky at the Institute of Fine Arts. New York, March 21, 1968.

Culler, Jonathan. *The Pursuit of Signs: Semiotics, Literature, Deconstruction*. Ithaca, 1981.

———. *Structuralist Poetics: Structuralism, Linguistics, and the Study of Literature*. Ithaca, 1975.

Damisch, Hubert. "Panofsky am Scheidewege." In *Erwin Panofsky: Cahiers pour un temps*, ed. Jacques Bonnet. Paris, 1983.

Dilly, Heinrich. *Kunstgeschichte als Institution: Studien zur Geschichte einer Disziplin*. Frankfurt, 1979.

Dittmann, Lorenz. *Stil, Symbol, Struktur: Studien zu Kategorien der Kunstgeschichte*. Munich, 1967.

Dray, William H. *Philosophy of History*. Englewood Cliffs, 1964.

Eggers, Walter F., Jr. "From Language to the Art of Language: Cassirer's Aesthetic." In *The Quest for the Imagination*, ed. O. B. Hardison. Cleveland, 1971.

Eisler, Colin. "Kunstgeschichte American Style: A Study in Migration." In *The Intellectual Migration: Europe and America, 1930–1960*, ed. D. Fleming and B. Bailyn. Cambridge, Mass., 1969.

Farrer, David. *The Warburgs: The Story of a Family*. New York, 1975.

Ferguson, Wallace K. *The Renaissance in Historical Thought: Five Centuries of Interpretation*. Cambridge, Mass., 1948.

Finch, Margaret. *Style in Art History: An Introduction to Theories of Style and Sequence*. Metuchen, 1974.

Forrsman, Erik. "Ikonologie und allgemeine Kunstgeschichte." *Zeitschrift für Ästhetik und allgemeine Kunstwissenschaft* 12 (1967): 132–169.

Forster, Kurt W. "Aby Warburg's History of Art: Collective Memory and the Social Mediation of Images." *Daedalus* 105 (Winter 1976): 169–176.

———. "Critical History of Art, or Transfiguration of Values?" *New Literary History* 3 (Spring 1972): 459–470.

Foucault, Michel. *The Order of Things: An Archaeology of the Human Sciences* [*Les mots et les choses*]. 1966. Reprint. New York, 1970.

Gardiner, Patrick. *Theories of History: Readings from Classical and Contemporary Sources*. Glencoe, 1959.

Gawronsky, Dimitry. "Cassirer: His Life and His Work." In *The Philosophy of Ernst Cassirer*, ed. P. A. Schilpp. 1949. Reprint. La Salle, 1973.

Gay, Peter. *Style in History*. New York, 1974.

———. *Weimar Culture: The Outsider as Insider*. New York, 1968.

Gibson, James J. "The Information Available in Pictures." *Leonardo* 4 (1971): 27–35.

Gilbert, Creighton. "On Subject and Non-Subject in Italian Renaissance Pictures." *Art Bulletin* 34 (1952): 202–216.

Gilbert, Katharine. "Cassirer's Placement of Art." In *The Philosophy of Ernst Cassirer*, ed. P. A. Schilpp. 1949. Reprint. La Salle, 1973.

Gilbert, Katharine E., and Kuhn, Helmut. *A History of Esthetics* (1939). 2d ed. New York, 1972.

Ginzburg, Carlo. "Morelli, Freud, and Sherlock Holmes: Clues and Scientific Method." *History Workshop* 9 (1980): 5–36.

Gombrich, E. H. *Aby Warburg: An Intellectual Biography*. London, 1970.

———. *Art and Illusion: A Study in the Psychology of Pictorial Representation*. 2d ed. rev. Princeton, 1961.

———. "Art and Scholarship." *College Art Journal* 17 (Summer 1958): 342–356.

———. *In Search of Cultural History.* Oxford, 1969.

———. "Kunstwissenschaft." *Das Atlantis Buch der Kunst: Eine Enzyklopädie der bildenden Kunst.* Zurich, 1952.

———. "Obituary: Erwin Panofsky." *Burlington Magazine* 110 (June 1968): 357–360.

———. "A Plea for Pluralism." *American Art Journal* 3 (Spring 1971): 83–87.

———. *The Sense of Order: A Study in the Psychology of Decorative Art.* Ithaca, 1979.

———. *Tributes: Interpreters of Our Cultural Tradition.* Ithaca, 1984.

———. "The 'What' and the 'How': Perspective Representation and the Phenomenal World." In *Logic and Art: Essays in Honor of Nelson Goodman,* ed. R. Rudner and I. Scheffler. Indianapolis, 1972.

Goodman, Nelson. *Languages of Art: An Approach to a Theory of Symbols.* Indianapolis, 1976.

———. *Ways of Worldmaking.* Indianapolis, 1978.

Graff, Gerald. *Literature against Itself: Literary Ideas in Modern Society.* Chicago, 1979.

Hadjinicolaou, Nicos. *Art History and Class Struggle.* Trans. Louise Asmal. London, 1978.

Hamburg, Carl H. "Cassirer's Conception of Philosophy." In *The Philosophy of Ernst Cassirer,* ed. P. A. Schilpp. 1949. Reprint. La Salle, 1973.

Hardison, O. B. *The Quest for the Imagination: Essays in Twentieth-Century Aesthetic Criticism.* Cleveland, 1971.

Hart, Joan. "Reinterpreting Wölfflin: Neo-Kantianism and Hermeneutics." *Art Journal* 42 (Winter 1982): 292–300.

Hartman, Robert S. "Cassirer's Philosophy of Symbolic Forms." In *The Philosophy of Ernst Cassirer,* ed. P. A. Schilpp. 1949. Reprint. La Salle, 1973.

Hasenmueller, Christine. "Panofsky, Iconography, and Semiotics." *Journal of Aesthetics and Art Criticism* 36 (Spring 1978): 289–301.

Hauser, Arnold. *The Philosophy of Art History.* Cleveland, 1958.

Heckscher, William. *Erwin Panofsky: A Curriculum Vitae.* Princeton, 1969. (Reprinted from the *Record of The Art Museum, Princeton University* 28 [1969] with appendixes 1–4 added; the original paper was read at a symposium held at Princeton University on March 15, 1969, to mark the first anniversary of Panofsky's death).

———. "The Genesis of Iconology." In *Stil und Überlieferung in der Kunst des Abendlandes: Akten des 21. Internationalen Kongresses für Kunstgeschichte in Bonn, 1964.* Vol. 3, *Theorien und Probleme.* Berlin, 1967.

———. "Petites Perceptions: An Account of Sortes Warburgianae." *Journal of Medieval and Renaissance Studies* 4 (1974): 101–135.

Heelan, Patrick A. *Space-Perception and the Philosophy of Science*. Berkeley, 1983.

Heidt, Renate. *Erwin Panofsky—Kunsttheorie und Einzelwerk*. Cologne/Vienna, 1977.

Heise, Carl G. *Adolph Goldschmidt zum Gedächtnis, 1863–1944*. Hamburg, 1963.

Held, Julius. Review of *Early Netherlandish Painting*, by Erwin Panofsky. *Art Bulletin* 37 (1955): 205–234.

Hendel, Charles. Introduction to Ernst Cassirer, *The Philosophy of Symbolic Forms*. New Haven, 1955.

Hermerén, Göran. *Representation and Meaning in the Visual Arts: A Study in the Methodology of Iconography and Iconology*. Stockholm, 1969.

Hirsch, E. D., Jr. *Validity in Interpretation*. New Haven, 1967.

Hochberg, Julian. "The Representation of Things and People." In *Art, Perception, and Reality*, ed. E. Gombrich, J. Hochberg, and Max Black. Baltimore, 1972.

Hodin, Josef P. "Art History or the History of Culture: A Contemporary German Problem." *Journal of Aesthetics and Art Criticism* 13(1955): 469–477.

——. "German Criticism of Modern Art since the War." *College Art Journal* 17 (Summer 1958): 372–381.

Holly, Michael Ann. "Panofsky et la perspective." In *Erwin Panofsky: Cahiers pour un temps*, ed. Jacques Bonnet. Paris, 1983.

Holton, Gerald. *Thematic Origins of Scientific Thought: Kepler to Einstein*. Cambridge, Mass., 1973.

Hoy, David Couzens. *The Critical Circle: Literature, History, and Philosophical Hermeneutics*. Berkeley, 1978.

Iggers, Georg G. *New Directions in European Historiography*. Middletown, 1975.

Irwin, David. *Winckelmann: Writings on Art*. London, 1972.

Itzkoff, Seymour W. *Ernst Cassirer: Scientific Knowledge and the Concept of Man*. Notre Dame, 1971.

Iversen, Margaret. "Style as Structure: Alois Riegl's Historiography." *Art History* 2 (March 1979): 62–72.

Kaelin, Eugene F. *Art and Existence: A Phenomenological Aesthetics*. Lewisburg, 1970.

Kaufmann, Fritz. "Cassirer, Neo-Kantianism, and Phenomenology." In *The Philosophy of Ernst Cassirer*, ed. P. A. Schilpp. 1949. Reprint. La Salle, 1973.

Klein, Robert. "Studies on Perspective in the Renaissance." In *Form and Meaning: Writings on the Renaissance and Modern Art*, trans. M. Jay and L. Wieseltier. Princeton, 1979.

Kleinbauer, Eugene. *Modern Perspectives in Western Art History: An Anthology of Twentieth-Century Writings on the Visual Arts*. New York, 1971.

Kristeller, Paul Oskar. Review of *Renaissance and Renascences in Western Art*, by Erwin Panofsky. *Art Bulletin* 44 (1962): 65–67.

Kubler, George. *The Shape of Time: Remarks on the History of Things.* New Haven, 1962.

Kuhn, Helmut. "Ernst Cassirer's Philosophy of Culture." In *The Philosophy of Ernst Cassirer*, ed. P. A. Schilpp. 1949. Reprint. La Salle, 1973.

Kuhn, Thomas. *The Structure of Scientific Revolutions.* Vol. 2, no. 2, of *International Encyclopedia of Unified Science.* 2d ed. Chicago, 1970.

Kultermann, Udo. *Geschichte der Kunstgeschichte: Der Weg einer Wissenschaft.* Vienna, 1966.

Landauer, Carl. "Das Nachleben Aby Warburgs." *Kritische Berichte* 9 (1981): 67–71.

———. "The Survival of Antiquity: The German Years of the Warburg Institute." Ph.D. diss., Yale University, 1984.

Langer, Susanne K. "De Profundis." *Revue internationale de philosophie*, vol. 110, no. 4 (1974): 449ff.

———. "On Cassirer's Theory of Language and Myth." In *The Philosophy of Ernst Cassirer*, ed. P. A. Schilpp. 1949. Reprint. La Salle, 1973.

Lurz, Meinhold. *Heinrich Wölfflin: Biographie einer Kunsttheorie.* Worms, 1981.

McCorkel, Christine. "Sense and Sensibility: An Epistemological Approach to the Philosophy of Art History." *Journal of Aesthetics and Art Criticism* 34 (Fall 1975): 35–50.

Mandelbaum, Maurice. *History, Man, and Reason: A Study in Nineteenth-Century Thought.* Baltimore, 1971.

Margolis, Joseph. *The Language of Art and Art Criticism.* Detroit, 1965.

Marin, Louis. "Panofsky et Poussin en Arcadie." In *Erwin Panofsky: Cahiers pour un temps*, ed. Jacques Bonnet. Paris, 1983.

Moretti, Franco. *Signs Taken for Wonders: Essays in the Sociology of Literary Forms.* London, 1983.

Mundt, Ernest K. "Three Aspects of German Aesthetic Theory." *Journal of Aesthetics and Art Criticism* 17 (March 1959): 287–310.

Nash, Ronald H., ed. *Ideas of History: Speculative Approaches to History.* Vol. 1. New York, 1969.

Nodelman, Sheldon. "Structural Analysis in Art and Anthropology." *Yale French Studies* 36 and 37 (October 1966): 89–103.

Nye, Russel. "History and Literature: Branches of the Same Tree." In *Essays on History and Literature*, ed. R. H. Bremner. Columbus, 1966.

Pächt, Otto. "Art Historians and Art Critics—VI, Alois Riegl." *Burlington Magazine* 105 (May 1963): 188–193.

———. "Panofsky's *Early Netherlandish Painting.*" *Burlington Magazine* 98 (1956): 110–116, 266–277.

Palmer, Richard *Hermeneutics: Interpretation Theory in Schleiermacher, Dilthey, Heidegger and Gadamer.* Evanston, 1969.

Philip, Lotte B. *The Ghent Altarpiece and the Art of Jan Van Eyck.* Princeton, 1971.

Pirenne, M. H. *Optics, Painting, and Photography.* Cambridge, 1970.

Plantinga, Theodore. *Historical Understanding in the Thought of Wilhelm Dilthey.* Toronto, 1980.

Podro, Michael. *The Critical Historians of Art.* New Haven, 1982.

——. "Hegel's Dinner Guest and the History of Art." *New Lugano Review* (Spring 1977): 19–25.

——. *The Manifold in Perception: Theories of Art from Kant to Hildebrand.* Oxford, 1972.

——. "Panofsky: De la philosophie première au relativisme personnel." In *Erwin Panofsky: Cahiers pour un temps,* ed. Jacques Bonnet. Paris, 1983.

——, trans. "Panofsky's 'Das Problem des Stils in der bildenden Kunst.'" Typescript. University of Essex, 1976.

——, trans. "Panofsky's 'Der Begriff des Kunstwollens.'" Typescript. University of Essex, 1976.

Popper, Karl R. *The Poverty of Historicism.* Boston, 1957.

Ragghianti, Carlo. *L'arte e la critica.* Florence, 1951.

Recht, Roland. "La méthode iconologique d'Erwin Panofsky." *Critique* 24 (March 1968): 315–323.

Ricoeur, Paul. *Freud and Philosophy: An Essay on Interpretation.* Trans. Denis Savage. New Haven, 1970.

Ringer, Fritz K. *The Decline of the German Mandarins: The German Academic Community, 1890–1933.* Cambridge, Mass., 1969.

Roger, Alain. "Le schème et le symbole dans l'oeuvre de Panofsky." In *Erwin Panofsky: Cahiers pour un temps,* ed. Jacques Bonnet. Paris, 1983.

Rosand, David. "Art History and Criticism: The Past as Present." *New Literary History* 5 (Spring 1974): 435–445.

Rosenthal, Earl. "Changing Interpretations of the Renaissance in the History of Art." In *The Renaissance: A Reconsideration of the Theories and Interpretations of the Age,* ed. Tinsley Helton. Madison, 1961.

Roskill, Mark. *What Is Art History?* New York, 1976.

Rossi, Paolo. *Philosophy, Technology, and the Arts in the Early Modern Era.* Trans. S. Attanasio. Ed. B. Nelson. New York, 1970.

Salerno, Luigi. "Historiography." *Encyclopedia of World Art* 7 (1963): 507–534.

Saxl, Fritz. "Ernst Cassirer." In *The Philosophy of Ernst Cassirer,* ed. P. A. Schilpp. 1949. Reprint. LaSalle, 1973.

——. *A Heritage of Images: A Selection of Lectures by Fritz Saxl.* Ed. H. Honour and J. Fleming. Introd. E. Gombrich. 1957. Reprint. London, 1970.

Schapiro, Meyer. "On Some Problems in the Semiotics of Visual Art:

Field and Vehicle in Image-Signs." *Semiotica* 1 (1969): 223–242. (Originally presented at the Second International Colloquium on Semiotics, Kazimierz, Poland, September 1966).

——. "Style." In *Anthropology Today: An Encyclopedic Inventory*, ed. A. L. Kroeber. Chicago, 1953.

——. *Words and Pictures: On the Literal and the Symbolic in the Illustration of a Text.* The Hague, 1973.

Simon, W. M. *European Positivism in the Nineteenth Century: An Essay in Intellectual History.* Ithaca, 1963.

Stadler, Ingrid. "Perception and Perfection in Kant's Aesthetics." In *Kant: A Collection of Critical Essays*, ed. R. P. Wolff. London, 1967.

Steiner, George. Review of *Essays in Ancient and Modern Historiography*, by Arnaldo Momigliano. *London Sunday Times*, July 17, 1977.

Stromberg, Roland N. *European Intellectual History since 1789* (1966). 3d ed. New York, 1981.

Summers, David. "Conventions in the History of Art." *New Literary History* 13 (1981): 103–125.

Swabey, William Curtis. "Cassirer and Metaphysics." In *The Philosophy of Ernst Cassirer*, ed. P. A. Schilpp. 1949. Reprint. La Salle, 1973.

van de Waal, Henri. "In Memoriam Erwin Panofsky, March 30, 1892–March 14, 1968." *Mededelingen der Koninklijke Nederlandse Akademie van Wettenschappen* 35 (1972): 227–244.

Walsh, W. H. *Philosophy of History: An Introduction.* New York, 1960.

Wartofsky, Marx. "Pictures, Representation, and the Understanding." In *Logic and Art: Essays in Honor of Nelson Goodman*, ed. R. Rudner and I. Scheffler. Indianapolis, 1972.

——. "Visual Scenarios: The Role of Representation in Visual Perception." In *The Perception of Pictures*, vol. 2, ed. M. A. Hagen. New York, 1980.

Werckmeister, O. K. "Radical Art History." *Art Journal* 42 (Winter 1982): 284–291.

White, Hayden. *Metahistory: The Historical Imagination in Nineteenth-Century Europe.* Baltimore, 1973.

White, John. *The Birth and Rebirth of Pictorial Space.* 2d ed. New York, 1972.

Willey, Thomas E. *Back to Kant: The Revival of Kantianism in German Social and Historical Thought, 1860–1914.* Detroit, 1978.

Wimsatt, William, and Beardsley, Monroe. "The Intentional Fallacy." In *Philosophy Looks at the Arts: Readings in Aesthetics*, ed. J. Margolis. New York, 1962.

Wuttke, Dieter. "Aby Warburg und seine Bibliothek." *Arcadia* 1 (1966): 319–333.

Zerner, Henri. "Alois Riegl: Art, Value, and Historicism." *Daedalus* 105 (Winter 1976): 177–188.

——. "L'art." In *Faire de l'histoire: Nouveaux problèmes*, vol. 2, ed. J. LeGoff and Pierre Nora. Paris, 1974. (Unpublished translation by Peter Franco).

Zupnick, Irving. "The Iconology of Style." *Journal of Aesthetics and Art Criticism* 19 (Spring 1981): 263–273.

Index

Cited works are entered under the author's name, except for Panofsky's, which are listed as separate entries.

Library of Congress Cataloging in Publication Data

HOLLY, MICHAEL ANN.
 Panofsky and the foundations of art history.

 Bibliography: p.
 Includes index.
 1. Panofsky, Erwin, 1892–1968. 2. Art—
Historiography. I. Title.
N7483.P3H64 1984 709'.2'4 84-45143
ISBN 0-8014-1614-0 (alk. paper)